THE ASIAN COLLECTIONS
ART GALLERY OF NEW SOUTH WALES

THE ASIAN COLLECTIONS
ART GALLERY OF NEW SOUTH WALES

ART
GALLERY
NSW

THIS PUBLICATION HAS BEEN MADE POSSIBLE WITH THE GENEROUS SUPPORT OF THE GORDON DARLING FOUNDATION, WITH FURTHER ASSISTANCE FROM VISASIA.

 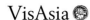

First published 2003
Art Gallery of New South Wales
Art Gallery Road, The Domain, Sydney 2000, Australia
www.artgallery.nsw.gov.au

Cataloguing-in-publication data:
Art Gallery of New South Wales.
The Asian collections / Art Gallery of New South Wales.
ISBN: 0 7347 6351 4
1. Art Gallery of New South Wales – Catalogs. 2. Art – New South Wales – Sydney – Catalogs. 3. Art, Asian – Catalogs.
708.99441

Photography by Jenni Carter
Copy editing by Jennifer Blunden
Design by Mark Boxshall
Pre-press by Spitting Image, Sydney
Printed by Samhwa Printing Co Pty Ltd, Seoul

Cover: Kainosho Tadaoto (1894–1978), Japan, (detail) *Beauty looking back* c1928 (also page 278).
© Kainosho Tadaoto Estate
Frontispiece: The new Asian galleries, opened in 2003.

EDITOR
Jackie **Menzies**

CONTRIBUTORS
Ajioka Chiaki, Curator of Japanese Art
Judy **Annear**, Senior Curator of Photography
Edmund **Capon**, Director
Liu Yang, Curator of Chinese Art
Jackie **Menzies**, Head Curator of Asian Art
Natalie **Seiz**, Assistant Curator of Asian Art
Haema **Sivanesan**, Assistant Curator of Asian Art

For the sake of simplicity diacritics have not been used in the text. Dates are given in the Common Era form – CE (Common Era), BCE (Before the Common Era). Measurements are listed as height x width x depth.

THE ART GALLERY OF NEW SOUTH WALES WISHES TO ACKNOWLEDGE AND THANK THE MANY DONORS WHO HAVE CONTRIBUTED TO THE DEVELOPMENT OF THE ASIAN COLLECTIONS THROUGH THE CONTRIBUTION OF FUNDS AND WORKS OF ART. MAJOR DONORS ARE:

Art Gallery of New South Wales Foundation
Art Gallery Society of New South Wales
The late Alex Biancardi
The late Fred and Ella Bodor
The late Sydney Cooper
Dr Peter Elliott
Graham E Fraser
The late Laurence G Harrison
Dr James Hayes
Idemitsu Kosan Co Ltd
Angela Isles
The Japan Foundation
Rev Muneharu Kurozumi
The late Kenneth and Yasuko Myer
The late J Hepburn Myrtle
Klaus Naumann
Nomadic Rug Traders
Anthony Odillo Maher
The Margaret Hannah Olley Art Trust
The late Norman Sparnon
J A and H D Sperling
The late Edward and Goldie Sternberg
Mr F Storch
D G Wilson Bequest Fund
Dr John Yu AC and Dr George Soutter

opposite: (detail) Luohan 1100s–1200s, China (also page 96).

INTRODUCTION

The geography of South, Southeast and East Asia ranges from tropical jungles to frozen peaks, from lush temperate pastures to arid deserts. The cultures, languages and ideologies of this vast region, now home to over half the world's population, are just as diverse. The Western perspective often tends to view Asia as one broad culture but the patterns and variations that have evolved over centuries of accepting, absorbing and sometimes rejecting, influences, invasions and ideas have created a family of cultures, often related yet richly distinctive.

The range of the arts of Asia in terms of history, time, ideology, function and aesthetic temperament is, therefore, immense. It would be ambitious beyond measure to seek a comprehensive representation across such a vast panorama and our collections bear the imprint more of individual taste and interest than of universal representation. Thus it is that the initiatives and personal interests of individuals, both collectors and curators, have played a crucial role in the shaping and development of our Asian art collections.

The very first works of Asian art to enter the then new Art Gallery of New South Wales in 1879 were a group of Japanese ceramics, bronzes, cloisonné enamels and lacquers, all of contemporary date, which had been shown that same year in Sydney's International Exhibition. Seen as objects of curiosity and emblems of an exotic and unknown culture, they were admired for their mysterious unfamiliarity and their technical dexterity. However, they were also regarded more as 'manufactures' than works of art with the result that these original acquisitions failed to stir the imaginations of the people of Sydney and made little impact upon the subsequent development of the gallery's Asian collections. The history of an appreciation and understanding of the arts of Asia in Sydney may be embodied in the fact that it was not until exactly 100 years after those first acquisitions that a curatorial department of Asian art was established, in 1979.

In 1972 as part of the new Captain Cook wing a small Asian art gallery was opened. Major extensions in 1998 incorporated a substantial gallery of Asian art with a fully operational Japanese tea room. The opening of the second Asian gallery in 2003 has now doubled the area, providing extended collection galleries and space for a continuing program of changing exhibitions.

While it was works of Japanese origin that founded the gallery's Asian collections, it is the arts of China that came to dominate. In 1962 Sydney Cooper, who had collected Chinese art with some enthusiasm, donated a large number of works, mainly ceramics including Han and Tang tomb figures and, later, an impressive Song dynasty carved wood figure of Guanyin. The Cooper gift was probably, in retrospect,

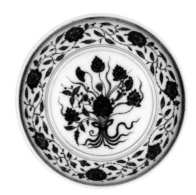

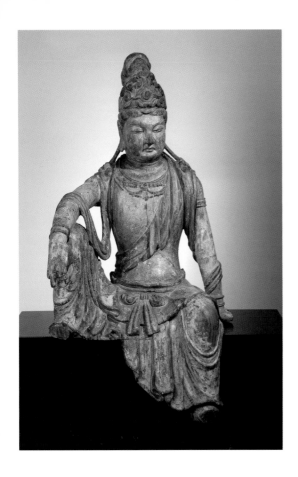

more significant in fostering an interest among Sydney's collectors in Asian and Chinese art for, in the following years, there was a marked increase in activity. Central to that growing interest were a small number of collectors, in particular the late Hepburn Myrtle and the late Laurence Harrison, the former a noted collector of Ming and Qing imperial porcelains and the latter a devotee of celadons. Their contributions now form a significant part of the gallery's Chinese ceramic collection. More recently the Chinese and Southeast Asian collections have been enriched through the generous support of the late Edward and Goldie Sternberg with acquisitions that include an impressive 1.5 metre high green-glazed Han dynasty model of a tower, a fine blue and yellow hibiscus dish of the Hongzhi period of the Ming dynasty, and a number of Chinese paintings and calligraphies. This small group of benefactors has laid the foundations of our Chinese collection and, in doing so, provided the basis for its expansion and more complete representation. In the process of evolution certain strengths have emerged which now characterise the Chinese collection – for example, Han and Tang dynasty tomb figures, Buddhist sculptures, later paintings, and imperial porcelains of the Ming and Qing dynasties.

The Japanese collection is distinguished in its representation of fine Edo period screens and

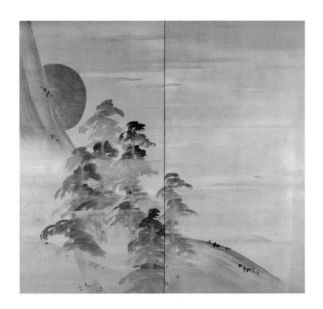

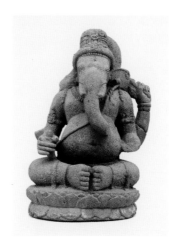

paintings, many of which were acquired through the support of two other of the Asian collections' greatest benefactors, the late Ken and Yasuko Myer. A unifying theme in these works is a devotion to the distinctive Japanese aesthetic, one so beautifully evoked by, for example, the mysteriously poignant two-fold screen *Full moon over pine covered mountain* by Watanabe Shiko, the dramatic flourish of black ink in Suzuki Shonen's *Pine trees* screens, and the more recent, unusual and certainly more instinctively modern screen of *Spring cherry blossoms and autumn maples* by Kawabata Gyokusho. The modern flavour to so much Japanese art and design, from such unlikely sources as a Momoyama period *namban* screen of Portuguese officers to *ukiyo-e* paintings, appears as a guiding if unstated principle in the evolution of the gallery's Japanese collection. It is further illustrated in an ever-increasing range of contemporary Japanese ceramics and 20th-century graphic works in which are evoked those essentials of the Japanese aesthetic – a sensitivity to material, studied asymmetry, an inevitable sense of tradition and yet a unique quality of modernity.

The heritage of the Japanese tradition is demonstrated in the form of individual works of distinction, such as a Fujiwara period carved wood figure of Amida Buddha, a magnificent 14th-century Taima mandala and a flamboyant yet elegant pair of colourful gold ground screens by Kano Eino depicting The Three Friends – pine, bamboo and prunus.

Beyond China and Japan, the arts of Tibet, India and Southeast Asia are increasingly a focus of attention. As recently as two decades ago the representation of these regions was minimal, but acquisitions in the past few years of, for example, a superb 15th-century Tibetan *thangka* depicting Vaishravana, another similarly exquisite but later example illustrating the Medicine Buddha, Bhaishajyaguru, and a number of Himalayan works from the collection of the late Alex Biancardi have added great depth and quality to these hitherto under-represented aspects of the gallery's Asian collections.

Similarly the arts of India were until recently a neglected area but again recent acquisitions – of sculptures and miniature paintings in particular – have dramatically enhanced the collection. In seeking to capture the essence of artistic and cultural traditions within the relatively limited scope of our collection, the Indian aesthetic is wonderfully expressed in works of sculpture and such acquisitions have been a guiding influence. In these endeavours we have been assisted by, among others, Margaret Olley, who has supported the purchase of classic and evocative examples such as a superb 11th-century Chandella period image of Vishnu and deities that in its detail and spiritual sensuality is the embodiment of the Indian ideal.

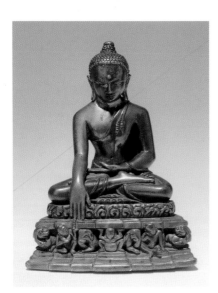

So too are the recently acquired life-sized 10th-century Central Indian images of the Buddhist deities Tara and Avalokiteshvara which, their impressive size and contemplative presence apart, are characterised by a subtle contrast of detail, in the ornamentation and jewellery for example, with the sensuous simplicity of the figures.

The proximity of Southeast Asia, Australia's close economic and social ties with the region, and the absence of a tradition of long-standing intellectual engagement with East Asia such as those which have tended to dominate European and American relations with Asia, have determined a real and continuing interest in the arts and cultures of the Southeast Asian region. To some extent our art collections and the benefactors who have supported them reflect this bias. Ranging from Khmer ceramics and sculptures (such as a superb bronze Hevajra funded by the Sternbergs) to Indonesian works which include a magnificent and impressively scaled Central Javanese figure of Amitabha Buddha dating from the 7th to 9th centuries, Vietnamese ceramics (such as an exotic 15th-century blue-and-white porcelain dragon ewer) and Thai sculptures, ceramics and lacquers, the Southeast Asian collections are developing strongly.

The historical arts of Asia are an indisputable encyclopedia of human achievement and imagination; indeed it is those arts that have shaped both our image and our perception of the Asian region and its multitude of identities. With such strong and powerful traditions it is often easy to overlook the living arts that are the inheritors of that great wealth of history and the expressions of a similarly vast range of contemporary values and imaginations across Asia. Increasingly we are concerned with the arts of contemporary Asia and our collections too are reflecting that interest. From the works of such internationally recognised artists as Miyajima, Xu Bing and Nam June Paik to the products of modern ceramicists, calligraphers, painters, printmakers and photographers, the arts of present-day Asia are an indelible part of the image of Asian art in the Art Gallery of New South Wales.

Edmund Capon
Director

above: **Seated Buddha** late 1100s, Burma, brass and copper, 12 cm. Purchased 1997. 83.1997

opposite: **(detail) Ragaputra Velavala of Bhairava** c1710, India (also page 40).

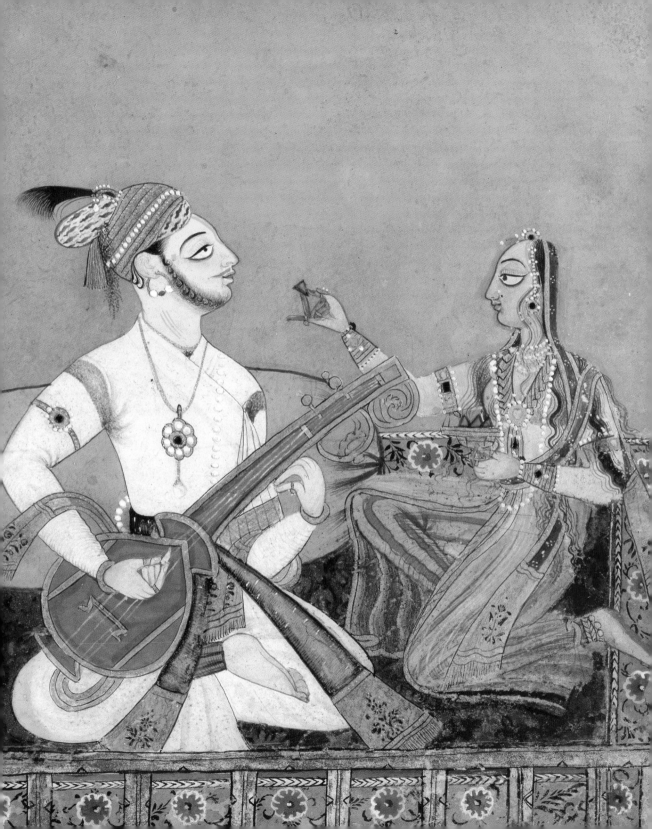

INDIA

THE REALM OF THE HINDU GODS

From its ancient origins in the Indus Valley region, Hinduism has developed as a complex and syncretic religion that combines age-old ritual practices, devotionalism (*bhakti*) and folk beliefs with a sophisticated philosophy. It is not possible to reduce Hinduism to a single teaching or ideology. Nevertheless, one of Hinduism's most characteristic features is its distinctive pantheon of gods. This pantheon includes the major deities Vishnu (the Preserver), Shiva (the Destroyer) and Devi (literally 'goddess'), worshipped in their numerous incarnations.

In the Hindu tradition the gods are ever-present and eternal. They manifest themselves in myriad forms, including theriomorphic (half-animal, half-human) as well as suprahuman. Such images suggest that while the deities are human-like in appearance, they are at once beyond the human dimension. Thus the more powerful, that is the more 'divine' or 'transcendental', the deity, the more arms and sometimes the more heads he or she will have. So while the anthropomorphic representation of the gods suggests their immanent presence, the multi-headed, multi-limbed form of a god or goddess describes the deity's all-pervading omnipotence.

VISHNU

Vishnu is regarded as a compassionate deity who is charged with maintaining the order of the universe. Vishnu 'descends' to earth in an incarnate form, as an avatar to rescue the world from calamity. Perhaps the best-known avatar (incarnation) of Vishnu is Krishna, the mischievous dark-skinned cowherd who is the subject and hero of numerous stories and miniature paintings. Other avatars include Matsya, the fish avatar (represented in the collection by two paintings, one from the courts of Bikaner and a Kalighat school painting, illustrated page 48); Varaha, the boar-headed incarnation of Vishnu (represented in a Pala period sculpture from Bengal); and Rama, the hero of the Ramayana who is popularly represented in Indian paintings at the event of his coronation in the city of Ayodhya. However, when order prevails in the world Vishnu is depicted as floating on the cosmic ocean, reclining on the coils of the serpent Sesha.

SHIVA

The powerful Hindu god Shiva is a paradoxical deity who is at once the destroyer of the world but also inextricably linked with creation. The most sacred form of this deity is the *linga*, literally a sign or mark, a non-figural (or aniconic) symbol, sometimes visualised as a column or cosmic pillar (*axis mundi*) but also described as a phallus, which signifies the deity's creative or generative potential. The *linga* in the gallery's collection conforms to iconographic

convention, but what is of particular interest here is that it was created in Southeast Asia.

From as early as the 5th century, Indian merchants and traders took Hinduism to the trading ports of Southeast Asia, into countries such as Cambodia, Vietnam and Indonesia. Perhaps Hinduism's most vital contribution to Southeast Asian cultures was its ability to centralise a dispersed population through the institutionalisation of a religio-political order. Within this system the *devaraja* (god-king) had the power to rule a community, to build cities in accordance with a sacred geography and to forge an integrated socio-economic structure which brought wealth and prosperity to the kingdom. This correspondence of the religious and the political is suggested in art through images of deities which are also portraits of kings. One such object in the gallery's collection is a seated figure of Shiva (page 299), which originates from the ancient kingdom of Champa. Like the Hinduised Khmer kings, Cham rulers also adopted Shiva as their patron deity, as the founder and protector of their kingdoms. The unique stylisation of this figure, with his distinctive moustache, suggests that the image of the deity may also have been a posthumous portrait of a king, and a means of consolidating the king's power and authority.

There are numerous gods and celestials associated with Shiva, including the elephant-headed deity Ganesha, who is the lord of Shiva's troops (*gana*). A sculpture of Ganesha from Hinduised Java (page 11) shows this deity's association with Shiva through the ornaments and insignias worn on his body: the vertical third eye at the centre of his forehead, the snake worn across his chest as a sacred thread, and the elaborate headdress ornamented with a crescent moon and skull were all also worn by Shiva. Another deity associated with Shiva is the youthful Kumara, or Kartikkeya, an important deity among south Indian Hindus and also once a tutelary deity of the Gupta kings (c300–600 CE). Kumara is represented in the collection by an early sculpture from central India which depicts this deity as a heroic god. He can be recognised by the distinctive triple-parted hairdo as well as by the tiger-claw amulet worn at his neck. Ganesha and Kumara are both regarded as the sons of Shiva with his consort, the goddess Parvati.

DEVI

In Hinduism, the goddess is often described as *shakti*, literally meaning power, force, energy, but also referring to the active power of a god. The goddess who best exemplifies this idea of energy or active power is Durga, an archetypal deity who is popularly depicted at her moment of triumph, slaying the buffalo-headed demon Mahisha.

In the Hindu temple, images of the various goddesses are ubiquitous. The Seven Mother Goddesses, for example, is an archaic and esoteric group positioned variously on the walls of a temple in accordance with the desired end. Technical treatises suggest that these goddesses may be positioned so as to achieve the destruction of one's enemies or to increase the population of the village. The mother goddess relief in the gallery's collection (see page 20) is in the form of a lintel, suggesting that in this instance the goddesses were placed to fulfil the more modest purpose of protecting the entrance to a shrine.

Along with images of the goddesses, depictions of voluptuous and languorous women were also common on the walls of Hindu temples, for example the gallery's female torso (page 22) dating to the Chandella period. Along with other iconographic images from the temple walls, images of celestial beauties (*surasundari*) were regarded as auspicious and were associated with notions of ritual efficacy. An Orissan text on iconography, the *Shilpa Prakasha* (light on art) states:

As a house without a wife, as frolic without a woman,
So, without the figure of a woman the monument will
be of inferior quality
And will bear no fruit.

THE SCULPTURAL FORM OF THE HINDU TEMPLE

The Hindu temple was the primary site of sculptural and iconographic innovation, receiving the patronage of great kings and also enjoying the benefaction of wealthy donors. During the Hindu dominated period of India (c700s–1500s), the temple was the epicentre of the great towns, the place where anonymous artists and artisans produced some of the most iconic works of Indian sculpture. Indeed the temple was itself the pre-eminent sculptural form. Monumental in structure, temples were built using a simple post-and-beam method, with the dressed stones being placed one on top of the other using socket and dowel joints. As the temple rose in height, mud ramps were built to help carry the stone into position. Once the structure had been erected, sculptors carved the decorative and iconographic motifs directly onto the temple walls. Sculptures such as the gallery's female torso attest to this method of construction, its exaggerated proportions due in part to the Indian love of voluptuous forms but also to the fact that the block of stone onto which the sculpture was carved would have keyed into the structure of the temple to form part of a wall.

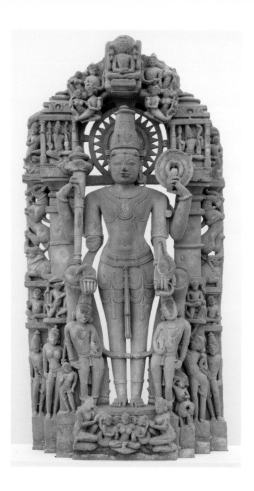

INDIA, probably Madhya Pradesh state
Chandella dynasty (c900–1100 CE)
Vishnu and his avatars
sandstone, 110 cm
Gift of the Margaret Hannah Olley Trust in memory
of Stewart Giles 1991
268.1991

A key sculpture in the gallery's collection
is this stele of Vishnu dating to the
Chandella period. Iconographically
complex and technically sophisticated,
sculptures such as this covered the entire
structure of a Hindu temple. In this stele
the figure of the central deity wears a tall
crown and is depicted with a square face,
broad shoulders, narrow waist and
tapering limbs. The deity's body is stylised
and smooth, not defined in any way by
the muscles or skeletal structure of his
anatomy, yet displaying a firmness,
naturalism and vitality. The identity of
the deity is defined by jewellery and
ornaments – crown, earrings, bracelets,
necklaces, waistbands, leg drops and
so on. This interest in the decorative
treatment of sculptural forms reached its

zenith during this so-called 'medieval'
period of Indian art, but despite this
artistic zeal sculptures always conformed
to the iconographic conventions outlined
in the various technical treatises on Indian
image-making.

Vishnu holds his distinguishing
attributes – the mace, the wheel (*chakra*)
and the conch shell. These represent the
powers of the god and describe the deity
as the embodiment of divine justice: the
conch symbolises sound as the origin of
Creation, the wheel symbolises the
cosmic law, the mace, the power of the
cosmic law. Immediately to either side of
the central figure are Vishnu's attributes
of the conch and wheel personified as
celestial beings. The surrounding figures
represent Vishnu's ten avatars.

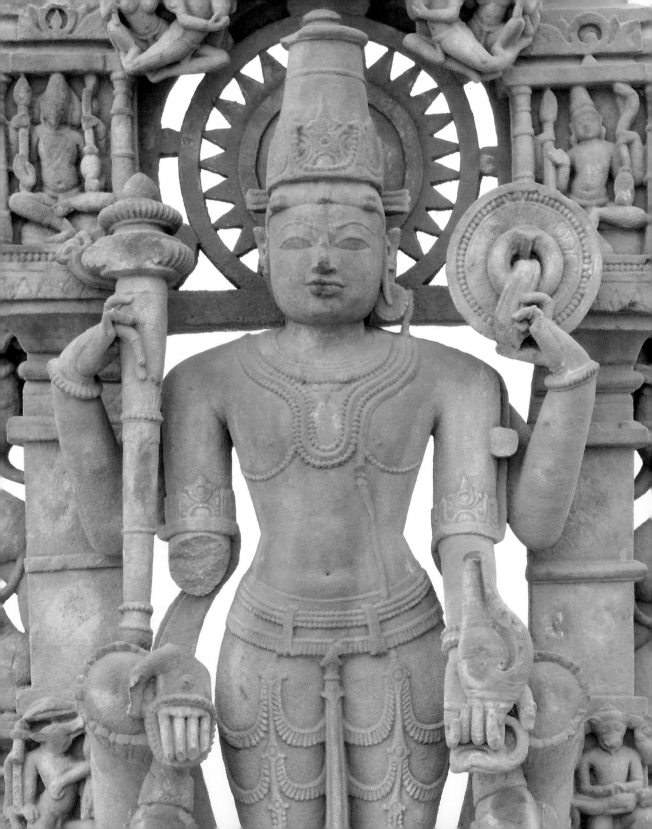

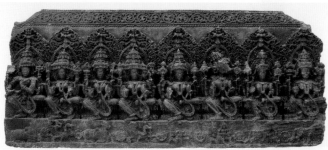

Karnataka state, Mysore
Shiva and Parvati early 1900s
colours, gold, stucco on cloth, 33.5 x 21.1 cm
Gift of Mr F Storch 1994
361.1994

Karnataka state
Hoysala period (c1100–1310)
**Seven Mother Goddesses
(*Saptamatrika*)** 1100s
black schist, 40.5 x 98 cm
Gift of Sir James Plimsoll 1978
6.1978

This intricately carved panel is typical of
the reliefs found on Hoysala period
temples of the Deccani region of India.
It depicts the Seven Mother Goddesses,
an esoteric group of deities that
represents the powers of the gods and
has a protective function. Usually the
group is associated with Shiva, indeed
Shiva in the form of Virabhadra leads
the group. From left to right following
Virabhadra, the goddesses are: Brahmani,
the four-headed counterpart of Brahma,
the maker of the universe; Maheshvari,
the counterpart of Shiva; Kaumari, the
counterpart of Kumara, the warrior son
of Shiva and Parvati; Vaishnavi, the
counterpart of Vishnu, the preserver
or protector; the boar-headed Varahi,
counterpart of Varaha, an incarnation of
Vishnu; Indrani, the counter-part of Indra,
the Vedic king of the gods; and finally
on the far right, is Chamunda, the
personification of Shiva's power.

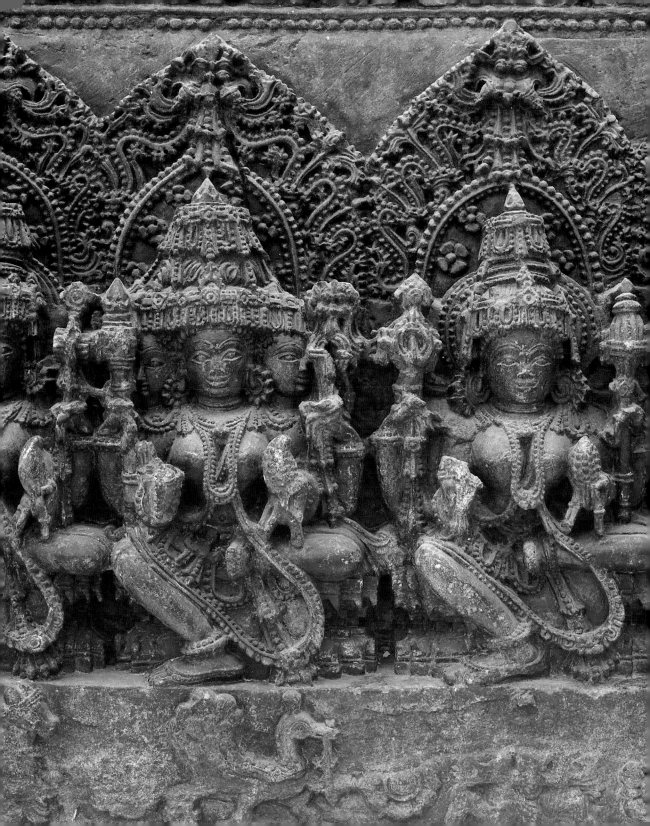

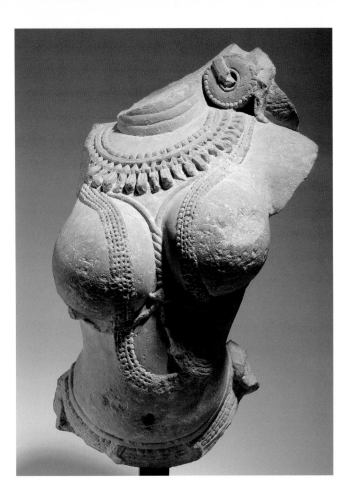

Madhya Pradesh state
Chandella period (900–1100 CE)
Female torso
sandstone, 53 cm
Gift of the Margaret Hannah Olley Trust 1990
239.1990

Most likely the torso of a celestial woman
or *surasundari*, this sculpture embodies
the Indian ideals of feminine beauty: full,
spherical breasts set close, narrow wasp-
like waist, ample hips and elaborate
jewellery that accentuates the soft tactility
of the flesh. This kind of representation
of the feminine was included in the
iconographic program of the Hindu
temple in order to improve its power.

Uttar Pradesh or Rajasthan state
**Durga slaying the titan Mahisha
(*Durga Mahishasuramardini*)** c900s
red sandstone, 140 cm
Purchased with funds provided by the Art Gallery
Society of New South Wales 1999
163.1999

According to mythology, the titan (*asura*)
Mahisha gained such enormous power
through the performance of penance that
he threatened the stability of the world.
The gods, becoming increasingly helpless
against him, begged assistance from the
goddess Durga and armed her with their
combined energies, weapons and powers.
Thus empowered, Durga attacked and
vanquished the buffalo-headed *asura*. In
this impressive, early representation,
Durga attacks Mahisha and with one foot
on his neck spears his bovine body with
her trident. Durga's lion mount (*vahana*)
aids her by attacking Mahisha's haunches.
The goddess, beautiful and serene,
maintains an almost detached calm that
belies the enormous drama and
significance of her triumph. Although the
goddess appears as an invincible
Amazonian warrior, to her worshippers
Durga is a maternal deity, a mother-
goddess and protector of her devotees.

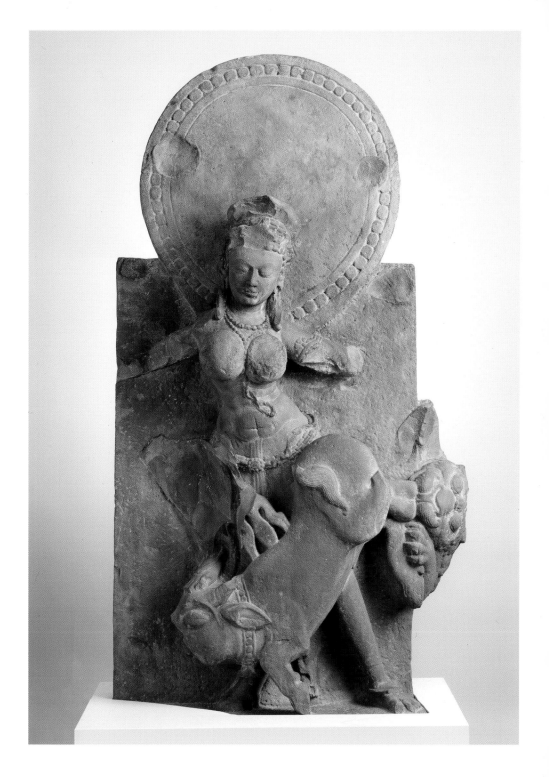

BUDDHIST ART

Like Hinduism, the Buddhist faith originated in India. Yet while in Hinduism there are innumerable deities, Buddhism focuses on the Buddha, who is the archetype of enlightened consciousness. 'Buddha' is not a name but a title indicating someone who has attained Enlightenment, and for Buddhists it has never been limited to the designation of a single human personality. Furthermore, in the Buddhist concept of the universe there are many realms or Buddha Lands, each presided over by a Buddha. Buddhist texts (sutras) mention incomprehensible numbers such as eighty-four hundreds of thousands of Buddha Lands, each of which has existed for many aeons or *kalpa*. The Buddhist concept of time is reflected in the definition of a *kalpa*: the duration of a *kalpa* is the time required for a celestial maiden to wear away a five-kilometre cubic stone if she brushed it once with her garments every three years.

There has been one person who achieved Enlightenment in this historical era in this world, and became a Buddha. Known as the Historical Buddha, he lived c563–483 BCE, and since he was born into the Shakya clan, he is also known as Shakyamuni (sage of the Shakyas). By his own attainment of Enlightenment (*bodhi*), he proved it was possible for all sentient beings. In fact the seeds of Buddhahood lie within everyone. Documentation and illustration of the Historical Buddha's life focus on the Eight Great

Events. The four more important of these are: his Birth in the grove at Lumbini, his Awakening under a pipal or *bodhi* tree at Bodhgaya, his First Sermon, and his 'Death', the Parinirvana, when he passes into eternal life.

There are two main schools of Buddhism: both arose in India but are now practised in different parts of the world. The earlier monastic tradition of Theravada, which has diffused predominantly through Sri Lanka, Burma, Cambodia and Thailand, emphasises the attainment of Enlightenment for oneself alone. In Mahayana Buddhism, found in China, Korea, Japan, Vietnam and Indonesia, the aim of the practitioner is to first become a bodhisattva, a being who has reached the point of achieving Nirvana or Buddhahood but postpones his or her own Enlightenment to help others achieve theirs. Bodhisattvas do not appear in Theravada Buddhism.

The teachings of Buddhism are contained within the Four Noble Truths: all existence is characterised by suffering; this suffering is caused by desire; desire needs to be eliminated; and the way to eliminate desire is to follow the Eightfold Path – right view, right resolve, right speech, right action, right livelihood, right effort, right mindfulness and right concentration (*samadhi*). A Buddhist's aim is the achievement of Nirvana, the freedom from *samsara* (the endless cycle of death and rebirth) caused by our *karma* (the

universal law of cause and effect whereby deeds of past lives affect present and future lives). Buddhism developed a huge body of scriptures, known as the Tripitaka, or 'Three Baskets', written in the Sanskrit and Pali languages (Pali, a North Indian dialect, is the sacred language of Theravada Buddhism). The Tripitaka were translated into other languages as Buddhism spread out from India.

The image of the Buddha originated in India, yet there is still much debate over when and where within India the first images were actually made. Images of the Buddha, synonymous with wisdom and compassion, have been set out in descriptions that originated in the various Buddhist sutras and texts. According to the Pali Commentaries, the image of the Buddha is prescribed by descriptions of 32 major 'marks' (*lakshana*) and 80 minor ones that are supposed to characterise the body of a Buddha. Not all the marks appear on every Buddha image. First among the 32 signs is the *ushnisha*, the protuberance on the top of his head indicative of supreme wisdom and cosmic consciousness. Other distinguishing features include the *urna* or spiral of hair on the forehead between the eyebrows, webbed fingers, very long arms, and palms and soles marked by wheels. Another important aspect of Buddha images is the group of symbolic hand gestures, known as *mudra*, which echo various events in his life. For example, in

Theravada Buddhism one of the most common images is the seated Buddha with his right hand 'touching the earth' in the religious gesture (or *mudra*) which is synonymous with the attainment of Enlightenment. Furthermore, the Buddha image is usually coloured gold to indicate the 'fiery energy' (*tejas*) he radiates. The luminous aureole that surrounds the head, or the whole body, of the Buddha is also symbolic of the immeasurable light with which he illuminates all worlds.

The focus of early Buddhist worship was the stupa, a memorial mound raised over the mortal remains of the Buddha Shakyamuni. Other aniconic (non-figural) representations of the Buddha's presence include an empty throne, a pillar and footprints. Some of the earliest sculptures in the gallery's Asian collection are Buddhist, from sites in the northern part of the sub-continent where the two formative and important schools of Buddhist art developed: those of Mathura and Gandhara. The latter occupied large areas of what today are northwest India, Pakistan and Afghanistan. The gallery has a few examples of Gandharan buddhas dressed in the robes of monks, befitting the Buddha's stance of World Renouncer.

Mahayana Buddhism expanded from India into Central Asia, across the Silk Route to China, then to Korea and Japan. Theravada Buddhism spread southwards to Sri Lanka, and then on to Southeast

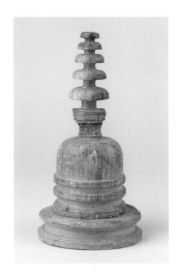

PAKISTAN (Gandhara)
Kushan dynasty (50–c600 CE)
Votive stupa with base c50 CE
schist, 23 cm
Bequest of Alex Biancardi 2000
27.2000

Asia, both mainland countries such as Thailand and Cambodia, and the insular realm of Indonesia. Sri Lanka became an important centre for the transmission of Buddhism, particularly after the Mongol invasion in the 1100s and the suppression of Buddhism in India.

Stylistically the Buddhist art of Southeast Asian countries is a fusion art of local, neighbouring and imported Indian traditions. Certainly contacts between the Indic world and Southeast Asia were extensive, with one of the major influences being the art of the Pala period (c730–1250) of eastern India. Other influences at different times were China, the Burmese kingdom of Pagan, the Indonesian kingdom of Srivijaya, and the Arab world. Different regional Indian styles, from those of the great monastery sites of Nalanda in the north to Nagapattinam and Amaravati in the south, were also transmitted to various parts of Southeast Asia from about the 7th century, most commonly through pilgrims carrying statuettes of bronze, stone or other materials, which subsequently became models for larger, locally made images.

The stupa is probably the most revered symbol in Buddhism. Its shape is based on the memorial mound raised over the mortal remains of the Buddha Shakyamuni. For the early Buddhists, the stupa was a symbol both of the Buddha's Parinirvana (extinction) and of the faith itself. Images of the stupa abound in Buddhist art, in media as diverse as stone, bronze, crystal and gold. This formally proportioned stupa is typical in construction: a base, a hemispherical body surmounted by a *harmika* (a square structure derived from the fenced enclosures of early shrines), and crowned by a multi-tiered umbrella.

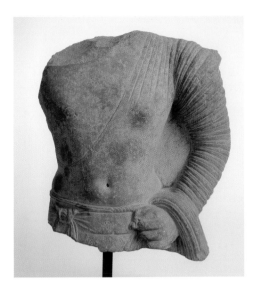

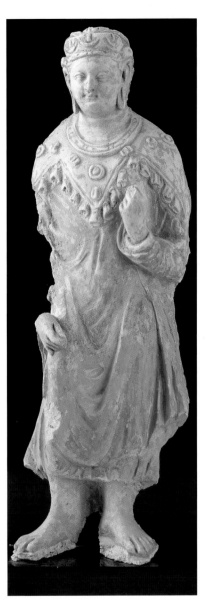

Uttar Pradesh state, Mathura
Kushan dynasty (50–c600 CE)
Torso of a Buddha c100 CE
mottled red sandstone, 47 cm
Gift of Alex Biancardi 1998
114.1998

The youthful male torso is characteristic
of the important Mathura school that
flourished in northern India under the rule
of the Kushan dynasty. Carved from the
mottled red sandstone found around
Mathura, it demonstrates the skill of the
Indian sculptor in eliciting from hard stone
the soft contours of a youthful body
beneath transparent robes. The absence
of this fragment's head and right hand
(which would have been held in a specific
gesture, or *mudra*) prevents its precise
identification.

AFGHANISTAN (Gandhara), Fonduqistan
Figure of Buddha 500s–600s CE
stucco with traces of pigment, 51.5 cm
Purchased 1996
268.1996

This fragile, and hence rare, stucco
image of the Buddha comes from the
little-studied temple site of Fonduqistan
to the west of present-day Kabul. The
figure is an example of the so-called
Irano-Buddhist style of Buddhist sculpture
found in the region bordering the Hindu
Kush northeast of Afghanistan. Ultimately
this style had its genesis in the remarkable
florescence of Buddhist creativity that
distinguished the ancient Indian province
of Gandhara during the first four centuries
CE. The tasselled, four-pointed chasuble
is distinctive to Fonduqistan pieces, while
the soft, idealised face with its gentle
smile and the naturalistic handling of
drapery, body and posture, are part of the
Gandharan legacy. His crown indicates he
is a monarch, conflating the idea of the
Buddha as ruler of the physical and
spiritual realms.

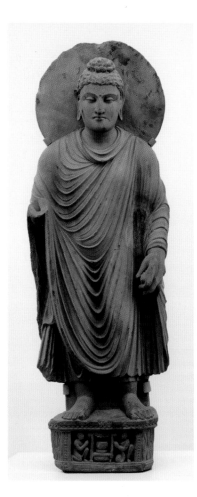

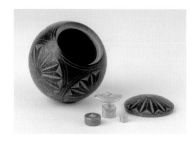

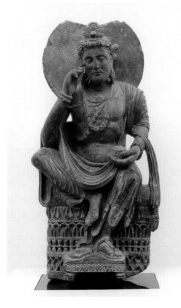

PAKISTAN (Gandhara), Swat Valley
Figure of the Buddha c150 CE
schist, 109 cm
Gift of Josef and Regina Neumann 1986
85.1986

The Gandhara area of northwest India
gave rise to the first representations of the
Buddha in human form in the 2nd century
BCE. This standing figure shows a Greco-
Roman influence in its classic facial
features and the drapery-like folds of the
robe. The left hand grasps a corner of the
robe while the right hand would have
faced palm out and fingers upright in the
abhaya mudra (gesture of fearlessness).

PAKISTAN (Gandhara)
Kushan dynasty, 50–c600 CE
Reliquary box with lotus design
schist, contents gold, 8.7 cm (diameter)
Bequest of Alex Biancardi 2000
28.2000.a-e

This rare box is in remarkable condition
and still contains its precious relics, most
likely because it was preserved inside a
stupa. The contents are essentially intact
and comprise the gold finial of a stupa
(consisting of a square entablature, or
harmika, and parasol), a small round gold
box filled with tiny beads and rock dust,
and a larger round copper box, the
contents of which have been removed.
The box resembles the one held in the left
hand of the bodhisattva shown right.

PAKISTAN (Gandhara), Swat Valley
**Stele with bodhisattva seated in
contemplation** 200s CE
grey schist, 77 cm
Purchased 1997
7.1997

The halo behind the bodhisattva's
crowned head indicates divinity, and it
is tempting to identify him as the
bodhisattva form of the Buddha of the
Future, Maitreya – the spherical reliquary
he holds in his left hand could well be a
substitute for a stupa, the symbol of
Maitreya. The figure is seated in a classic
contemplative pose, deep in meditation,
his right elbow resting on his knee.
The strongly modelled body and deeply
carved swathes of robe reflect the strong
Hellenistic influence that impacted on
the area of ancient Gandhara with the
eastward expansions of Alexander the
Great. The strings of charms around his
neck are typical of Gandharan figures;
atypical is the tally wicker seat on which
he sits.

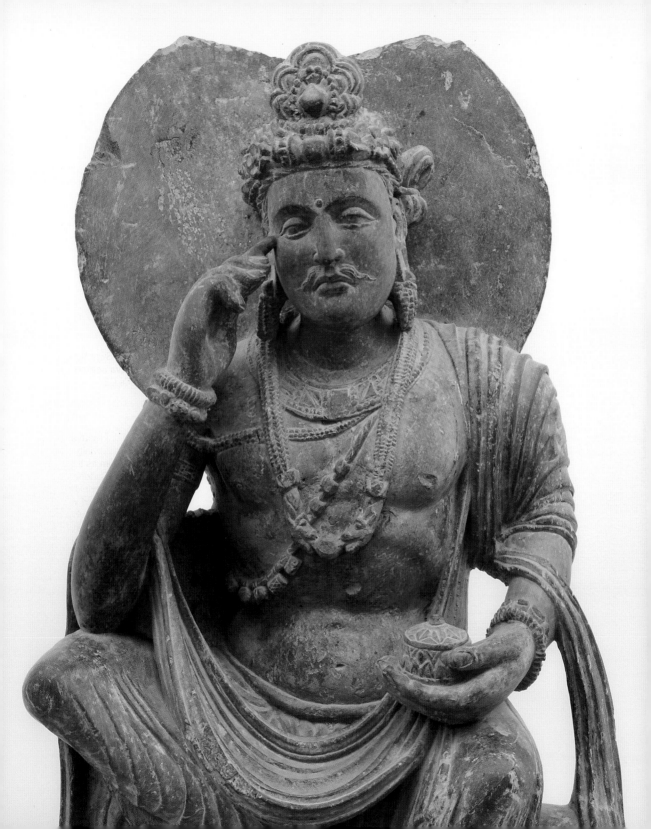

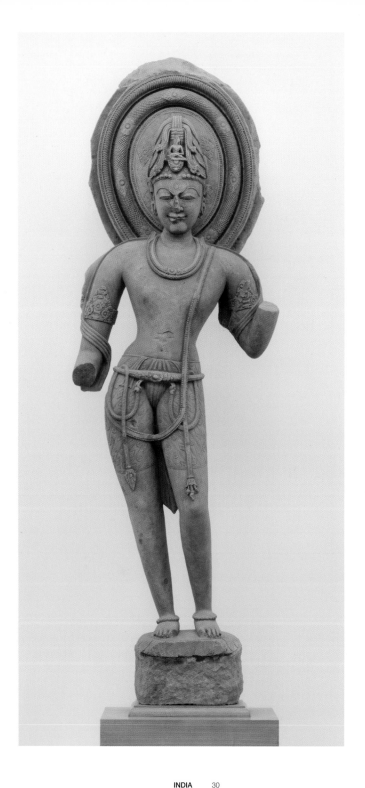

Uttar or Madhya Pradesh state
Avalokiteshvara 900s
sandstone, 220 cm
Purchased 2003
29.2003

This impressive figure can be identified
as the bodhisattva Avalokiteshvara by
the image of the Buddha shown seated
in his piled up hair. An embodiment of
compassion, Avalokiteshvara became the
most popular Buddhist deity from the
Kushan period on the subcontinent and
also in the Himalayan countries of Nepal
and Tibet. He is here portrayed as a
heroic but graceful figure. As the poet
monk Buddhakara wrote:

*May that great saint, his body formed of
moonlight,*
within whose towering headdress [sits]
Amitabha ...
dispel your grief and grant you
*the streaming nectar of his peaceful
happiness.*

The figure stands in the triple-flexed pose
called *tribhanga* that is found in much
Indian and even Chinese sculpture.
Originally he would have been four-armed
as were many early images of
Avalokiteshvara, but only vestiges of the
second pair of arms can be seen.

Uttar or Madhya Pradesh state
Tara 900s
sandstone, 178 cm
Purchased 2003
28.2003

The female emanation of Avalokiteshvara,
Tara is said to have been born from his
tears to help him with his work and to
embody the feminine aspect of
compassion. Like Avalokiteshvara, she is
a saviour deity and was no less popular
among Mahayana Buddhists. This is
possibly one of the largest images of the
goddess known to have been produced
on the Indian subcontinent. While it may
not have formed a pair with the
Avalokiteshvara opposite, it certainly
shares the same qualities of monumental
grandeur and majestic elegance. Likely
they adorned the same monument, which
must have been a temple of enormous
proportions, thereby indicating the
continued popularity of the faith in central
India around 900. The sensuous form of
her body conforms with the ideals of
Indian iconography: the torso has the
hourglass form of a *damaru* (double-
headed drum), with rounded shoulders,
full spherical breasts, soft belly and
tapering limbs.

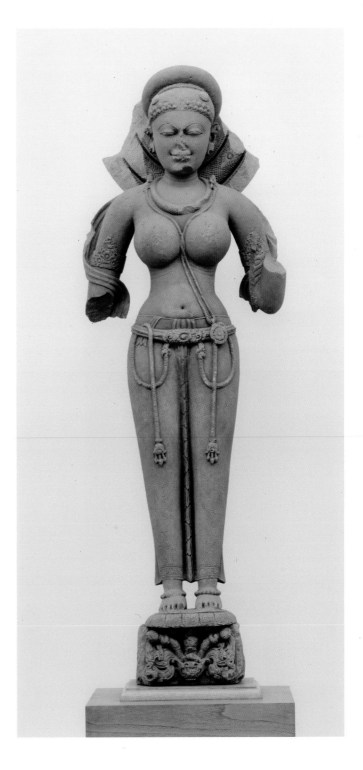

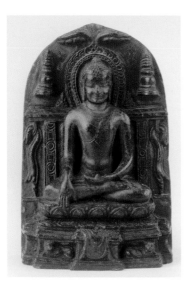

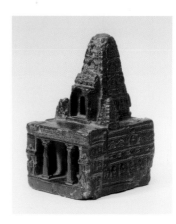

Bihar state
Pala period (c730–1250 CE)
Seated Buddha c1000 CE
stele, dark grey chlorite, 18.9 x 12 x 5.9 cm
Bequest of Alex Biancardi 2000
21.2000

Carved from the smooth, black stone typical in Pala sculpture, this image depicts the Buddha seated with his legs folded in *vajrasana* and his right hand in the earth-touching gesture (*bhumisparsha mudra*) referred to as 'Buddha subduing Mara'. This *mudra* is explained as follows: while the Historical Buddha Shakyamuni was meditating beneath a bodhi tree in his search for Enlightenment, he was approached by Mara, the god of desire and death, intent on preventing him from reaching his goal. Mara coaxed, then threatened the Buddha to abandon his efforts. Finally the Buddha-to-be extended his right hand to touch the earth and summon the earth goddess to witness his entitlement to attain Enlightenment. Images of the Buddha seated with his right hand in this *mudra* appear in stone and bronze throughout Southeast Asia. A most unusual feature of this figure is the incised decoration on the back (above centre). Such a design is most commonly seen on the front of a Tibetan metal *ga'u* (portable reliquary) used to hold relics, prayers and other sacred objects.

Bihar state, Bodhgaya
Pala period (c730–1250 CE)
Model of the temple at Bodhgaya
chlorite, 8.8 x 5.4 x 6.8 cm
D G Wilson Bequest Fund 2000
10.2000

The temple at Bodhgaya marks the site where the Buddha attained Enlightenment (*bodhi*) and has thus become an important place of pilgrimage for Buddhists. The portable model of the temple is finely carved with friezes depicting scenes from the life of the Buddha, bodhisattvas and other guardian figures. Models such as this were sold to pilgrims as souvenirs of their visit and might have been kept on the worshipper's home altar.

MUGHALS AND MAHARAJAS:
THE MINIATURE PAINTINGS OF COURTLY INDIA

The tradition of miniature or manuscript painting has had a long and complex history in India. Among the earliest examples are the illustrated palm leaf (and later paper) manuscripts of the Buddhists and Jains. These early paintings, dating from at least the 11th century, were usually illustrations to sutras or other sacred texts (an example of this early style is *The 14 auspicious dreams of Queen Trishala* on page 36). They were commissioned by the religious community and wealthy merchants who set up great libraries in which the manuscripts were housed. Thus they were not commissioned as works of art but to gain religious merit. Regardless, these early manuscript illustrations have had a great influence on the development of Indian painting traditions both technically and stylistically, contributing the intricate patterning, bold colouring and flat composition so characteristic of Indian painting styles. But perhaps the most significant influence on the development of Indian painting came with the arrival of Islam.

The first wave of Islamic conquest came in 1206, when the Turko-Afghan Sultanate of Delhi was established. However the full impact of Islamic influence was not felt until the establishment of the Mughal empire in 1526. The Mughals brought to India a worldly curiosity, urbanity and elegance, and, importantly, a guild of painters from the leading courts of Persia. Under the rule of Akbar (r1556–1605) and later Jahangir, these imperial workshops cultivated the art of manuscript painting with great zeal, taking the medium to the zenith of luxury and refinement. The Persian origins of Mughal painting are reflected in *Cyrus administering justice* (page 37), dating to the late Akbarian period but demonstrating the enduring influence of Persian sources in the Mughal courts. During Akbar's reign, stencils were regularly imported from Persia and artists travelled from the Safavid and Timurid courts to work in the Mughal workshops. Yet despite this exchange, Mughal painting developed as a unique and confident tradition in its own right.

In Akbar's court, skilled artists were rewarded with orders of merit. Even though prominence was given to master artists, Mughal manuscripts were by and large collaborative productions. The labour-intensive work of producing a miniature painting was divided among artists with various specialties: foundation drawing, background drawing, figure drawing, colouring, calligraphy, portraiture and the drawing of animals. Other craftspeople produced the paper, pigments and paints, and the exquisitely decorated mounts. Between each stage of painting the surface was burnished and gilt was applied to give the dazzling finish that was characteristic of Mughal works. Finally the paintings were bound into lavish albums. Mughal miniatures were prestigious emblems of power which reflected the wealth and refinement of their imperial patrons.

From at least the 1500s, two related themes were emerging in the development of Mughal painting: firstly an interest in the recording and documentation of history and secondly a concern for naturalism. These themes were distinct from the religious, mythological and poetic themes of pre-Mughal and Rajput painting. Under Jahangir (r1605–27) the imperial workshop developed a lyrical, understated style; the bright jewel-like colours and dynamic composition of the Akbarian period were tempered to produce softer, muted, naturalistic tones inspired in part by European prints. With its restrained use of colour and lyrical composition, *Emperor Jahangir returning from a hunt* (pictured page 38) is suggestive of this shift in Mughal taste, and also conveys the Mughal interest in portraiture and historical documentation. Another important feature of the paintings produced during Jahangir's reign was the attention paid to the rendering of animals and the recording of natural history, interests which are also recorded in this painting.

From the time of Akbar, the Mughal courts sought, with varying degrees of success, to reconcile Hindu and Muslim ideologies – or at least to engage with Hindu culture in order to gain the confidence of the Hindu maharajas. To some extent, this cross-cultural exchange was facilitated by court workshops where artisans of different ethnicities and denominations worked together. *Ibrahim Adham ministered by angels* (also page 38) is an example of this kind of exchange. The painting depicts a favourite Muslim story, but reveals the hand of Hindu artists in its character and stylisation. Conversely, the art of the Rajput courts also shows varying degrees of Mughal influence which reflected the various political alliances that were being forged.

Rajput painting refers to the work produced for the Hindu *kshatriyas,* or 'warriors', who conquered and founded kingdoms in northern and western India. This genre of painting flourished in two clearly defined regions: the desert plains of the modern state of Rajasthan and the Pahari region in the northwestern foothills of the Himalayas. In the Rajasthani plains, key schools of painting developed in the kingdoms of Mewar and Bundi but later also flourished in smaller principalities such as Kishangarh, Jodhpur and Bikaner. In the Himalayan foothills key schools included those at Basohli, Kangra and Guler. Compared with the worldly opulence and refined elegance of Mughal painting, the paintings of the Rajput courts appear, at first glance, other-worldly. The themes that preoccupied the Rajput artists and their patrons were largely poetic and mythical, concerned with a romantic world of gods, heroes, demons and divine lovers.

The stories of the blue-god Krishna were a recurring subject, and his dalliance with the *gopis* (milkmaids)

was ubiquitous. For example, in *Circular dance of Krishna and the milkmaids* (page 42) the youthful god dances with the besotted village milkmaids in a forest clearing under a moonlit sky. Each maid is so enchanted by Krishna that she believes that she alone is dancing with the divine hero. Unbeknown to them, Krishna is able to multiply his form by means of his magic (*maya*), as an illusion to satisfy each one of the milkmaids. As this painting suggests, scenes of romantic love are a prevalent theme in Rajput painting and the divine love of Krishna and his mistress Radha represented the ideal upon which secular and poetic representations of love were modelled. Radha and Krishna are depicted at the centre of this circular dance.

Other genres representing the rhetoric of love include the Baramasa or 'Songs of the 12 months', which depict the moods of love according to the 12 months or seasons. The month of Bhadon (page 41) is one of the most popularly represented months in this genre. It illustrates the rainy season, when the landscape is lush and flourishing. The theme of love is also apparent in ragamala paintings, paintings representing 'a garland of musical modes'. In these works the heroes and heroines, ragas and raginis, are depicted in accordance with an established iconography and form a folio of usually 36 ragas. The artist's task in rendering this genre is to evoke a mood – whether love, loneliness, heroism, devotion or despair. In *Ragaputra Velavala of Bhairava* (page 40) for example, the intimacy of the lovers is evident but is reinforced by the use of intense colour and allegorical motifs such as the twin pines with intertwining creepers. *Vasant ragini* (page 42), which depicts spring, the season of love, is a joyous and exuberant rendering that visualises the mood and emotion of this season through line and colour. Later Rajput paintings, however, reflect the influence of Mughal tastes; works such as *Palace being prepared for festivities* (page 44) and the various equestrian portraits indicate a shift towards documentation and the tendency towards a more formal style.

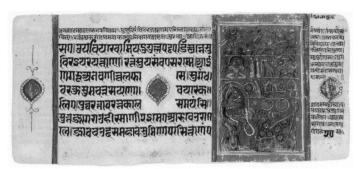

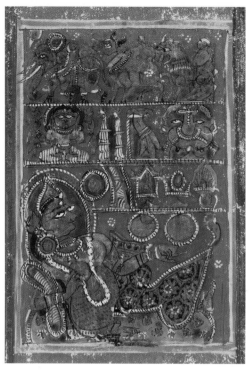

Western India, probably Gujarat state
The 14 auspicious dreams of Queen Trishala early 1500s
folio from the *Kalpasutra*
opaque watercolour with gold on paper,
11 x 7.5 cm
Purchased 1969
EP2.1969

The most popular of all of the Jain scriptures was the *Kalpasutra,* or 'Book of precepts', which is believed to have been composed around 300 BCE. This sutra is a biography of the last *jina*, or Jain 'conqueror', Mahavira (c599–527 BCE) and this scene from the *Kalpasutra* illustrates Mahavira's mother Queen Trishala's dream in which she sees 14 auspicious objects that allude to the miracle of Mahavira's birth. The objects are: a lion, an elephant, a bull, the goddess Lakshmi, a pair of garlands, the moon, the sun, a banner, an overflowing pot, a lake with lotuses, the milky ocean, a celestial chariot, a heap of jewels and a smokeless fire. These are symbols of kingship or sovereignty and indicate the importance of the newborn child.

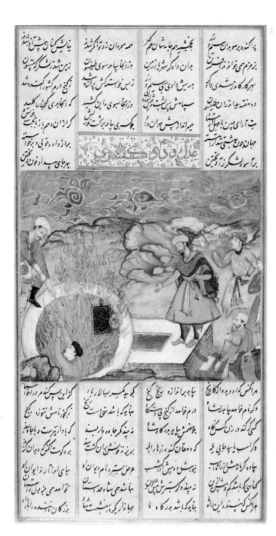

North India
Mughal (1526–1748)
Cyrus administering justice c1585
opaque watercolour with gold on paper,
24 x 12.8 cm
Gift of Michael Hobbs 2001
334.2001

This finely painted miniature depicts the ruler Cyrus the Great, who unified vast territories across the Iranian plateau to form the Achaemenid empire. The format of the manuscript is typically Persian: the image occupies a rectangular band at the centre of the page and is surrounded by four narrow columns of calligraphy. However, the stylisation of the figures and the exquisite naturalistic rendering of their faces is characteristically Mughal, showing the Indian adaptation of the Persian miniature painting form.

North India
Late Mughal
Study for a portrait of a nobleman c1800
ink on paper, 18.4 x 13 cm sheet (irreg)
Bequest of Mr J Kitto 1986
123.1986

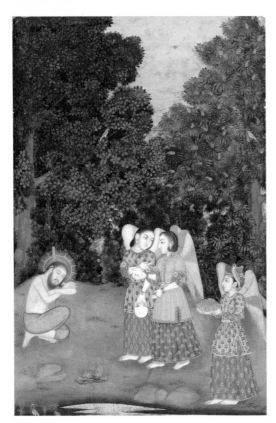

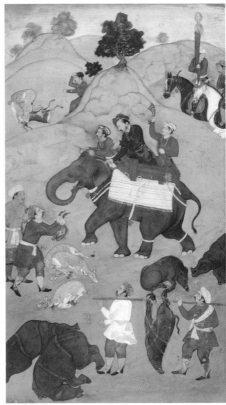

Bhupat Das (dates unknown)
West Bengal, Murshidabad
Provincial Mughal
Ibrahim Adham ministered by angels
c1760
opaque watercolour with gold on paper,
18.7 x 12 cm
Purchased 1962
EP7.1962

Ibrahim Adham (died c778 CE) was a
Prince of Balkh (ancient Bactria, now
Afghan Turkestan), who governed a large
province in the northeast of Persia. He
renounced his throne to live as an ascetic
in the wilderness. He is regarded as one
of Islam's earliest ascetics, a great Sufi
master and a prominent mystic. In this
painting, Ibrahim Adham is attended to
by angels who bring him food and water.
The name of the artist, Bhupat Das, is
given in an inscription on the waterflask.

North India
Imperial Mughal
Emperor Jahangir returning from a hunt
c1610
opaque watercolour with gold on paper,
19.7 x 11.2 cm
Bequest of Miss Gwendolen Griffiths 1968
EP1.1968

The Mughals introduced to India the idea
of documentary painting, which included
the genre of portraiture. In these portraits
the subject was often depicted in profile
carrying accoutrements befitting their
status or against a backdrop which
characterised their personality. Here, the
Mughal emperor Jahangir (r1605–1627)
sits astride an elephant, surveying the
scene of his hunting triumph. The scene
reflects both the emperor's bravery and
prowess but also his interest in nature,
as conveyed through the detailed animal
studies: the commotion of a leopard
savaging an antelope or the pathos of the
dead rhinoceroses. These vignettes are
brought together by the centralised figure
of Jahangir triumphant in his conquering
of nature.

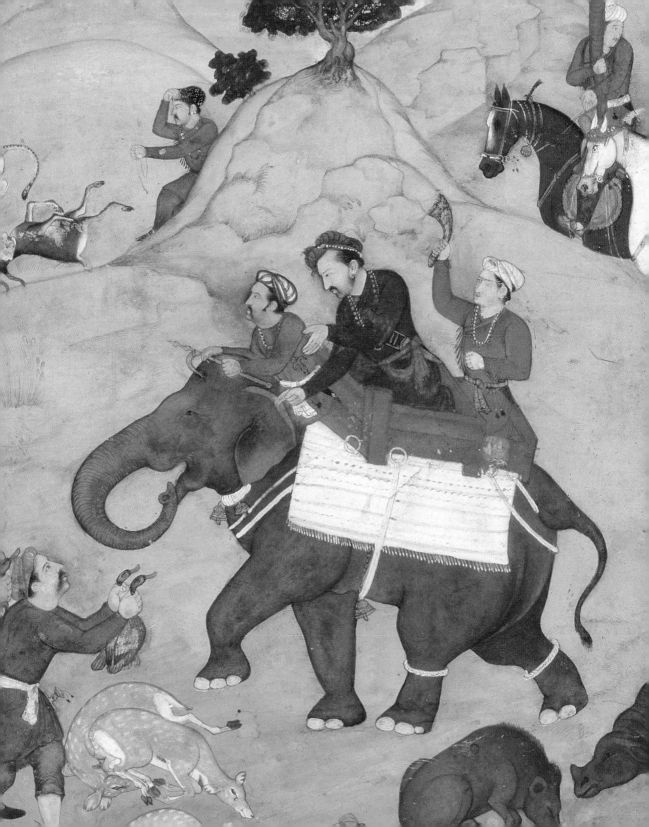

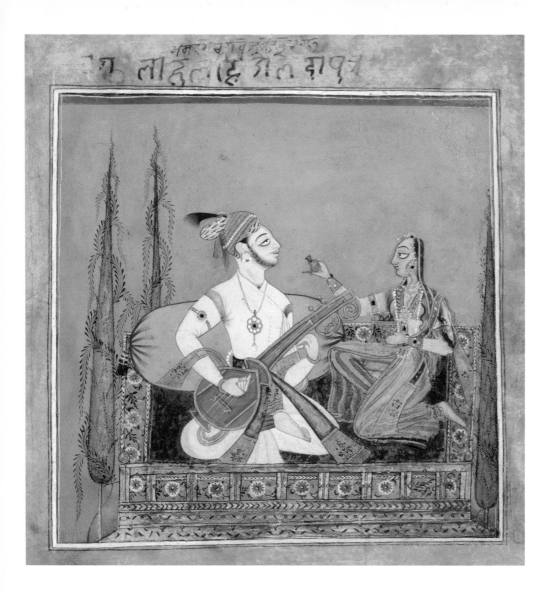

Punjab Hills, Basohli
Ragaputra Velavala of Bhairava c1710
opaque watercolour with gold on paper,
16.4 x 16.6 cm
Gift of the Margaret Hannah Olley Trust 1992
199.1992

This richly painted picture depicts the scene of a lovers' tryst. The young hero is dressed in a long, pleated white *jama* with a broad side sash, a turban adorned with feathers, and pearl strings while the heroine wears a diaphanous outer garment over colourfully striped brocade trousers. The heroine offers her lover *paan*, a mildly intoxicating concoction of betel leaf wrapped around a mixture of lime, spices crushed areca nut and

condiments, while the hero serenades her with a stringed instrument known as a *rabab*. The intensity of the lovers' mood is heightened by the flatly painted orange background, orange being associated with themes of erotic love. This mood of eroticism is further reinforced by the allegorical motif of pines entwined with creepers.

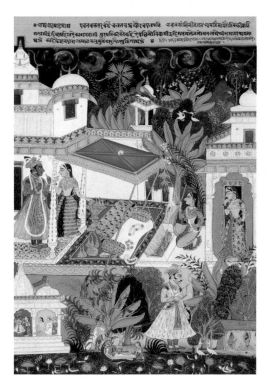

Rajasthan state, Bundi
The month of Ashadha c1675
from a Baramasa series
opaque watercolour on paper, 25.7 x 18 cm
Gift of the Margaret Hannah Olley Trust 1991
371.1991

Rajasthan state, Bundi
The month of Bhadon c1675
from a Baramasa series
opaque watercolour on paper, 25.3 x 16.3 cm
Gift of the Margaret Hannah Olley Trust 1991
370.1991

The month of Ashadha (June-July) is signalled by hot, swirling winds which blow dust and scorch the vegetation, and by storm clouds which mark the beginning of the rainy season and cause the birds to take flight. This painting however gives emphasis to a lovers' tryst. Here you see the heroine persuading her lover not to leave her during the month of Ashadha. She beckons him to sit with her under a canopy set out with bolsters, garlands and wine. The picture is composed to evoke all the viewer's senses – the smell of the humid monsoon winds, the sound of the gurgling fountain and the taste of wine – as a means to evoke the mood and character of the season.

The month of Bhadon (August–September), during the monsoon season, is a time when men return home from their work away from the village; it is a time when they are re-united with their lovers, wives and families. In this painting from the kingdom of Bundi in Rajasthan, the hero and heroine stand on a balcony, looking out over the monsoon scene. The skies are dark, illuminated only by flashes of thunder and the landscape is lush and green. Rajput artists rarely sketched from nature but drew their repertoire of birds, plants and animals from memory. Here the artist has rendered the scene playfully, with animals leaping and cavorting in the pouring rain.

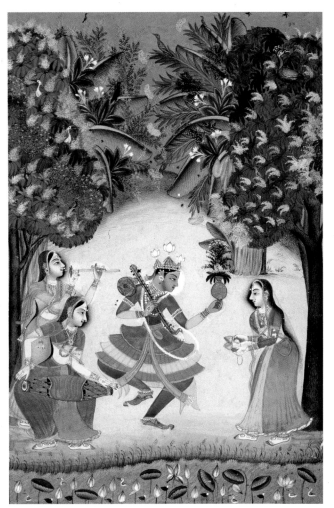

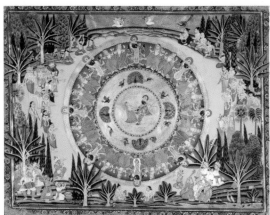

Rajasthan state, Kota
Vasant ragini c1770
opaque watercolour with gold on paper,
18.2 x 12.2 cm
Purchased 1997
82.1997

Scenes illustrating the musical modes, or ragas, were a popular genre in Indian painting. These ragas were usually associated with a particular season or time of day. *Vasant ragini* represents spring – joyous and celebratory – and depicts the god Krishna at the centre of the picture dancing and playing the *vina*. He carries in his left hand a vase of flowers and wears an elaborate costume, jewellery and unusual tasselled shoes. He is accompanied by three women, each playing a flute, a double-faced drum (*mridangam*) and cymbals. The scene takes place in the clearing of a forest glade, against a backdrop of lush, flowering trees and birdsong. Vasant is one of the more popular scenes of the ragamala.

Rajasthan state, Bundi
Circular dance of Krishna and the milkmaids c1850
opaque watercolour with gold on paper,
61 x 80 cm
Purchased 1995
216.1995

This exceptionally large and beautiful depiction of the circular dance the *rasalila* shows Krishna at the centre of the painting dancing with Radha. Surrounding the couple is a circle of dancing peacocks, each flanked by two excited hens. A third circle, or mandala, depicts Krishna's *maya,* the illusion by which he replicates himself so each *gopi* (milkmaid) believes that she alone is dancing with the heroic god. At the bottom of the picture are two groups of royal musicians and looking on are groups of gods, devotees and holy men. The *rasalila* is the ultimate statement of the devotional cult of *bhakti*, or total surrender to a personal god. It conveys the worshipper's intense longing for the deity, where the eroticism of the *gopis'* desire gives way to the mysticism of their encounter with the bucolic god.

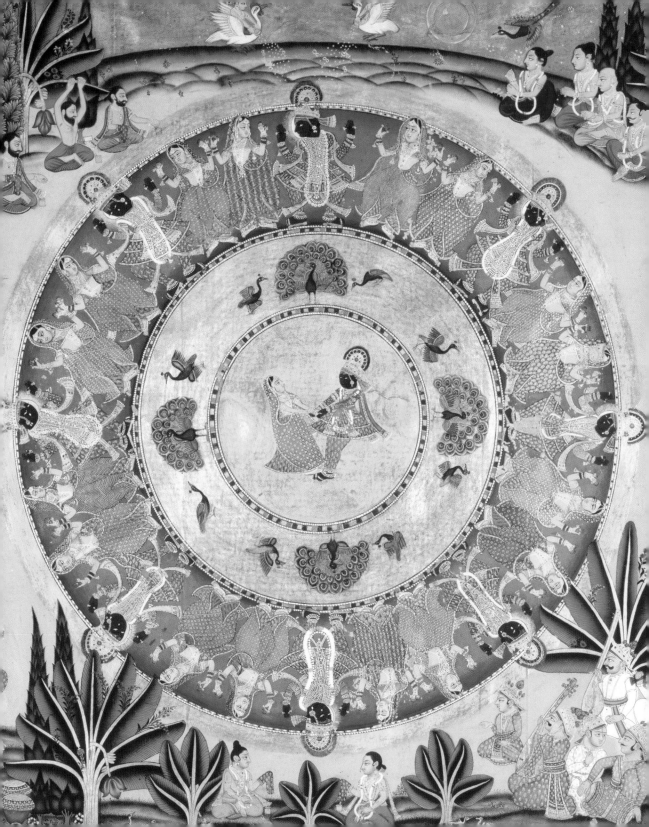

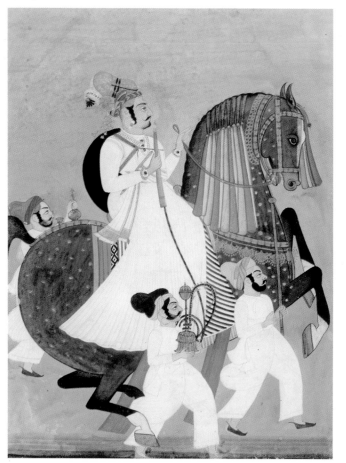

Rajasthan state, Jodhpur
Portrait of Raja Kesari Singhji of Jodhpur on horseback c1830
opaque watercolour on paper, 27.2 x 20.3 cm
Gift of Margaret Olley 2000
128.2000

This painting in the Marwari style depicts a rajah of Jodhpur on horseback, accompanied by an entourage of courtiers. The bold colours, strong linework and formal composition set against a flat background are typical of this style. The rajah wears the distinctive turban of the region, while his dappled horse is decorated with a patterned rug, tassels across his chest and ribbons in his mane. The painting conforms to a fairly standard format of equestrian portrait, and its static formality shows the influence of the Mughal style. The rulers of Jodhpur had a complex and uneasy relationship with their imperial overlords, nevertheless the Mughals had a profound impact on the art of this Rajput court.

Rajasthan state, Jaipur
Palace being prepared for festivities 1800s
opaque watercolour on paper, 21.8 x 30.7 cm
Bequest of Mr J Kitto 1986
133.1986

This rather late painting from the court of Jaipur is unusual in representing an everyday scene from courtly life rather than the highly romanticised or religious themes common to Rajput miniatures. It shows a courtier directing the servants of the court as they lay out carpets for an event, perhaps a performance or the daily *darbar,* or audience, with the maharajah. It is interesting to note the attempt at using perspective and the documentary style of the composition, which relinquish previously accepted pictorial conventions.

FOLK PAINTINGS AND SOUVENIR PICTURES

An often-neglected area in the study of Indian painting relates to the works that were produced around the major pilgrimage centres of India. Since ancient times, the great temples have been important centres of the arts. Kings and wealthy merchants patronised their construction and the sculptures and icons found within. But Hindu temples all over India were also important centres for folk artists, who plied their trade to pilgrims journeying for great distances, often on foot, to glimpse the powerful deities housed within these sanctums. Towns such as Puri, Kolkata (Calcutta) and Thanjavur (Tanjore) still enjoy a celebrated status amongst Hindu pilgrims. However, the celebrity of the paintings produced in these towns is due in part to the patronage of the British, who also bought the cheaply produced paintings as souvenirs.

Perhaps the best known of all 'pilgrim paintings' are the Kalighat paintings produced in the bazaars around the temple of the goddess Kali at Kalighat on the Hooghly River near Kolkata. Kalighat paintings were first produced in the early 1800s by Bengali *patuas*, or itinerant scroll painters/storytellers or bards, who arrived in this flourishing centre of the British Raj. It is likely that the development of the Kalighat style was a reaction to multiple influences, but essentially the *patuas* simplified their traditional and painstaking painting styles to create cheap and quickly produced pictures which could be sold from their studio-stalls in the bazaars outside the temple. While these paintings are characterised by an exuberant use of line, the style appears to owe its confidence and coherence to a close-knit community of artists working together to produce a viable product for a very specific market.

Kalighat artists generally worked in tight-knit family groups to form a kind of production line. The head of the household was the master artist who produced the prototype or stock pictures, which were copied with slight variations over and over again. This master artist would outline the picture with pencil on paper then pass it on to another member of the family, who quickly laid on colour in broad, sweeping strokes. Another member would add the fine linework and perhaps highlights of silver paint, while another member would add the inscription. This kind of 'production line' system led to a standardisation of the picture format, a characteristic of many Kalighat paintings.

Souvenir paintings were also produced in Orissa, where the annual chariot procession of the local deity Jagannatha (from which we derive the English word 'juggernaut') attracted, and continues to attract, thousands of pilgrims. These paintings typically use a bold but limited colour palette of red, black, white and yellow as determined by the use of natural pigments.

The cheaply produced pilgrim paintings from Orissa are derived from a more sophisticated tradition of

painting on cloth (*patachitra*). These cloth paintings were compositionally more complex and refined, and were used to decorate the thresholds and sanctums of Orissan temples. One such example is the painting *Ganesha and the Mahavidyas* (page 50), which depicts the popular deity in the centre of a circular composition, or mandala, surrounded by a group of esoteric goddesses known as the Mahavidyas. Due to its esoteric subject, the painting was most likely made for the specific purpose of worship. However, paintings of this type were also bought by pilgrims.

In the south of India painting traditions flourished in the courts and centres at Thanjavur (Tanjore), Mysore and Kerala and were derived from the murals which decorated the walls and ceilings of the temples and palaces. Highly stylised and beautifully patterned, these murals typically depicted various scenes and stories taken from the mythologies of the Hindu gods. With the patronage of merchants and pilgrims, the mural paintings were transferred onto the more portable medium of cloth supported on a wooden baseboard and painted with gesso, white lead, gouache and gold-leaf, for example the painting of *Shiva and Parvati* from Mysore (page 20).

Alongside these paintings for local patrons, a parallel tradition of painting for the British servants of the East India Company developed. These paintings, known as Company school paintings, included a vast and disparate collection of works on paper, mica, shell, ivory and glass, and were made specifically to cater to British tastes.

The most popular subjects in Company school paintings were those of the 'natives' and their occupations. Company artists also produced souvenir paintings of the Hindu gods, of festivals, rituals and processions. Generally, the artists were trained in the traditional styles of painting. In Thanjavur (where the gallery's collection of Company paintings originated), artists would have been trained in a style not dissimilar from the Mysore style of *Shiva and Parvati*, but gradually, to satisfy the tastes of British patrons, the indigenous idiom was transformed through a conscious attempt to develop western-style illusionism, naturalism and perspective. Artists also began to modify their colour range, discarding the brilliant colours of the miniature tradition and adopting a more muted colour palette, typical of European engravings. With the emergence of photography and the introduction of the oleographic (coloured) print, however, Company school paintings themselves became obsolete, giving way to new techniques and tastes in art production.

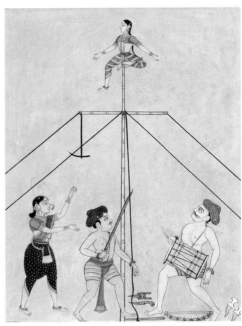

Tamil Nadu state, Thanjavur (Tanjore)
Company school
A farmer and his wife c1800
opaque watercolour on paper, 22.5 x 18 cm
Gift of Mr George Sandwith 1957
9639

Tamil Nadu state, Thanjavur (Tanjore)
Company school
Itinerant acrobats c1800
opaque watercolour on paper, 22.8 x 18.1 cm
Gift of Mr George Sandwith 1957
9644

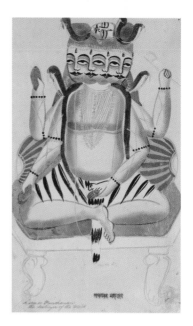

West Bengal, Calcutta
Kalighat school
Matsya, the fish avatar of Vishnu
late 1800s
watercolour on paper, 42.5 x 27.3 cm
Purchased 1959
EP2.1959

The Hindu gods and goddesses were
popular subjects for the Kalighat artists.
Vishnu in one of his ten incarnations or
avatars was a particular favourite, as for
example in this painting of Vishnu as the
fish avatar, Matsya.

West Bengal, Calcutta
Kalighat school
**The goddess Durga, mother of
Ganesha** late 1800s
watercolour on paper, 42.9 x 25.7 cm
Purchased 1959
EP3.1959

The goddesses of special importance
in Bengal were another favourite subject.
In this painting of Durga the usually
fearsome goddess is shown as the gentle
mother of the elephant-headed god
Ganesha, whom she carries on her knee.
The composition is typical of the style,
emerging from the need to produce
pictures quickly and cheaply.

West Bengal, Calcutta
Kalighat school
A five-faced Shiva late 1800s
watercolour on paper, 42.5 x 25.1 cm
Purchased 1959
EP6.1959

This painting of Shiva is of special interest
as the composition and stylisation are
particularly imaginative and skilful. The
great god Shiva is depicted with four
arms, five faces and seven eyes, the
multiplicity of eyes alluding to the deity's
omniscience.

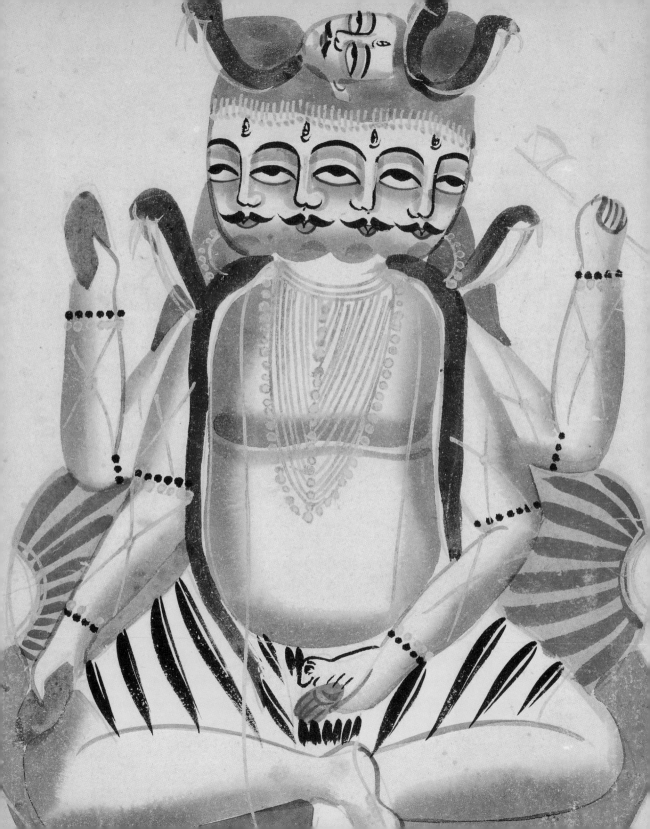

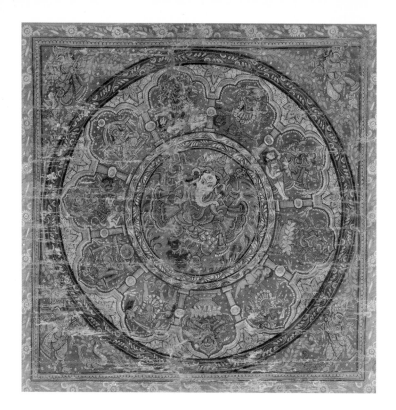

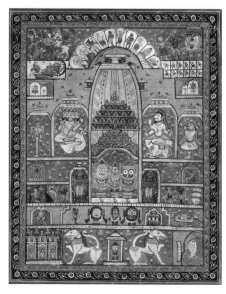

Orissa state, Puri
Deities enshrined in the Jagannatha temple early 1900s
pigment on 'pata' cloth, 76 x 61 cm
Purchased 1996
583.1996

Orissa state, Puri
Ganesha and the Mahavidyas 1800s
pigment on 'pata' cloth, 58.3 x 58.5 cm
D G Wilson Bequest Fund 2000
87.2000

Ganesha, god of wisdom and success and the remover of obstacles, is worshipped at the commencement of any undertaking. It is rare to see Ganesha as the central figure in a mandala, and rare too to see him dancing with a group of goddesses called the Mayavidyas (the Great Knowledge). The Mahavidya goddesses are all emanations of the Great Goddess, and their cult has remained especially popular in Bengal and Orissa. The inclusion of the goddesses indicates this painting was meant for tantric worship.

The celebrated Jagannatha temple at Puri in Orissa was built in the 1100s and is the centre of the cult of the deity Jagannatha, the Lord of the World. This painting shows the principal deity of this famed temple accompanied by his brother Balabhadra (left) and sister Subhadra (centre), their startling, semi-anthropomorphic forms suggesting that they were probably folk or tribal deities eventually incorporated into the pantheon of orthodox Hinduism. While their forms are solid and heavy, the artists' linework is sinuous and rhythmic, revealing an interest in pattern and decorative treatment. Also included are the various shrines, gates and tanks enclosed within that sacred monument, and scenes from the Ramayana. It is likely that a painting such as this would have been produced as a souvenir for pilgrims to the temple.

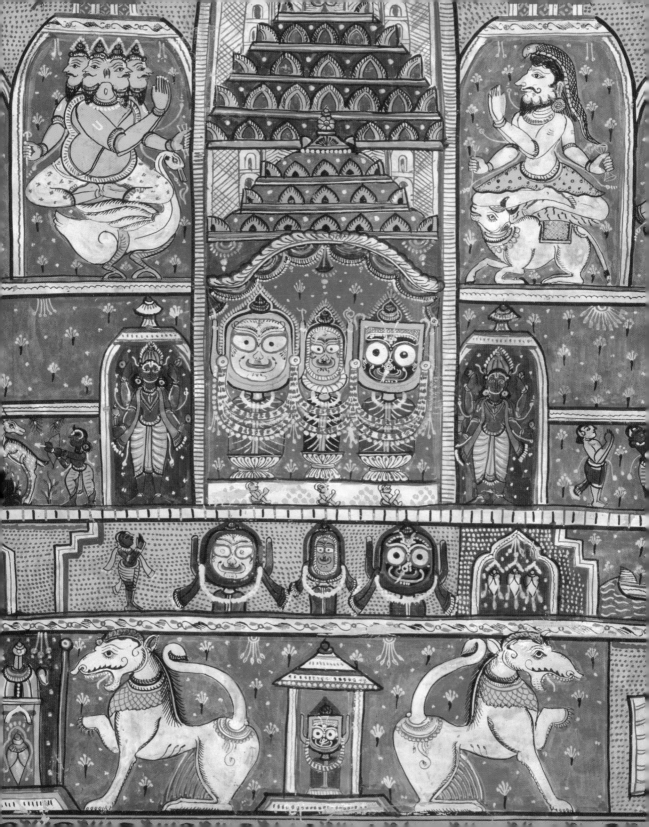

CONTEMPORARY PAINTING IN URBAN AND VILLAGE INDIA

As the tradition of courtly painting evolved through a long history and complex web of cultural exchange, so too contemporary art practice in India reveals a rich inheritance of visual and cultural references which continue to shape its ongoing progress. The shades of a courtly past still linger in the narrative quality of many contemporary artists' practices. Yet the impact of colonisation and its attendant project of modernity has clearly caused a rupture which has created a fraught conflict between notions of tradition and change, globalisation and national identity, the individual and the community – dualities defined to a large extent by the tensions between the urban and the village. The juggernaut of modernity instituted enormous changes in the practice of art in India, art being no longer the purview of a court-patronised guild system but the privilege of gentleman artists who were academically trained in the European tradition. The sheer impact of these new ideas, techniques, influences and expectations was enormous and caused what some scholars now describe as a sense of alienation or even despair. But at least in the early period of India's modern history a sense of cultural cohesion was achieved through the struggle for Independence.

A leading artist of pre-Independence India was Jamini Roy, a modernist trained at the Calcutta Art School but keenly involved in the Bengali nationalist movement. Having mastered and abandoned academic styles of painting for their association with colonialism, Roy turned to indigenous sources as a means of defining a uniquely 'Indian' style of painting. More recently, folk and tribal painting traditions have enjoyed a status of their own, emerging from the preserve of ethnography and anthropology to acquire a value as art. This can be credited in part to a broadening 20th-century interest in the non-canonical art forms of the 'Third World'. But this new found status of India's tribal and folk arts can also be attributed to non-government organisations which have encouraged the transfer of ephemeral designs onto paper as a means of generating income for drought-stricken communities, thereby making folk and tribal designs and artworks readily accessible.

Among the earliest tribal forms to enjoy the status of art were the wall paintings and pictograms produced by the Warli tribe of Maharashtra in western India. These designs, traditionally painted with red ochre and white rice paste on the mud walls of village huts during marriage ceremonies, are now rendered in poster colour on paper.

The significance of tribal and folk art in the context of attempting to define a uniquely Indian modernity is that it foils any attempt to reduce India to a singular essence. It reveals the complexity of India's various cultures and forms a mode of resistance to the forces of globalisation, which want to reduce Indian culture

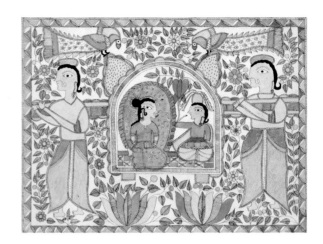

Bihar state, Mithila
Madhubani style
Couple in a palanquin carried by kahars (marriage scene) c1980
pen and ink on paper, 56 x 76.5 cm
Gift of Claudia Hyles 1999
79.1999

to a homogenous idea. Where academically trained contemporary artists have self-consciously struggled with the kinds of issues raised by modernity – issues which centre upon questions of how to proceed following the rupture caused by colonisation – village artists have displayed a vigour, confidence and ability to adapt and assimilate influences despite shifting circumstances. This kind of confidence can be found in the work of the late artist Jangarh Singh Shyam (page 56).

An influential institution in the development of India's contemporary art has been the fine arts department at the University of Baroda. Founded in 1949 to offer art as a professional vocation, the Baroda school, as it is also known, has recently been interested in closing the distinction between fine and popular or folk art. One of the artists of the Baroda school represented in our collection is Bhupen Khakhar (page 57).

Jamini Roy (West Bengal 1887–1972)
Three men in a boat c1942
gouache on board, 27.8 x 40.5 cm
Purchased 1994 © Jamini Roy Estate
20.1994

Adapting the traditions of local and
indigenous folk and tribal painters, Roy
developed a bold, graphic style which
he took to its logical conclusion. Fuelled
by a romantic and ultimately orientalist
ideology, Roy sought to renounce his elite
status as an artist, setting up a workshop
where anonymous artists created works
collaboratively. Works such as *Gopini* and
Three men in a boat are typical of Roy's
paintings, which attempt to locate a
distinctive Indian modernity at the limit of
the village and the urban, the tribal and
the modern.

Jamini Roy (West Bengal 1887–1972)
Gopini c1941
gouache on board, 44.8 x 26.5 cm
Gift of Oscar Edwards 1958 © Jamini Roy Estate
9670

Minakshi (Maharashtra b1968)
Agriculture in different seasons 1992
rice paste and poster colour on paper,
58.5 x 91.1 cm
Purchased 1993 © Minakshi
350.1993

Here you see the cycle of agricultural activity that takes place during the year: ploughing the soil, sowing the seed, harvesting the crop and threshing the grain. The painting has the diagrammatic quality of a pictogram but is rendered with an exquisite attention to detail that captures the nuances of everyday life. The artist's eye for detail and delight in celebrating everyday events, weaving them into larger compositions, distinguishes Minakshi's art practice. The distinctive hand of the artist is significant in a context where the images and designs of folk and tribal artists can be readily commodified.

Jangarh Singh Shyam
(Bhopal 1961–2001)
Tithee bird 1991
poster colour on paper, 56 x 71 cm
Purchased 1993 © Jangarh Singh Shyam
348.1993

Jangarh Singh Shyam was 'discovered' by the renowned Indian modernist painter J Swaminath, and as a young man made the transition from village life to work in Bhopal in Madhya Pradesh. However it would be a mistake to think of Shyam as a tribal artist; indeed he was not born into a community of artists but a community of bards. Instead, Shyam was a tribal *and* an artist, who was able to translate the songs and stories of his people into exquisitely rendered paintings. *Tithee bird* is typical of Shyam's prodigious style. Vibrant, colourful, dynamic and expressive, his work gives life and vision to a world of myriad myths animated by the animals, birds, mountains and deities of his village home.

Nalini Malani (Mumbai b1946)
Lohar Chawl 1991
from the 'Hieroglyph' series
bound book, 33 photocopied monotypes worked
in mixed media, 22.3 x 27.8 cm (leaf)
Purchased 1994 © Nalini Malani
358.1994

Nalini Malani currently enjoys considerable international fame. Having trained at the distinguished J J School of Art in Bombay, Malani explores the political and postcolonial issues of urban and Third World poverty, decay, exploitation and violence. These complex and difficult themes are brought closer to home through her use of a narrative style and her innate interest in, and profound respect for, the human subject affected by this turmoil. In her 'Hieroglyph' series Malani creates a layering of images produced by techniques she calls 'cloning': monoprints photocopied and worked over in ink, charcoal, watercolour, pen and collage. Malani fashions a complex, layered image which alludes to the multifaceted urbanity of a small street in an area of Mumbai known as Lohar Chawl. She uses her practice to give vision to those stories which history often sweeps aside.

Bhupen Khakhar (Mumbai 1934–2003)
Bathing Ghat 1992
colour lithograph, 37.5 x 53.5 cm
Purchased 1994 © Bhupen Khakhar
356.1994

Khakar's works often address the theme of homosexuality in a society still shrouded by a Victorian morality. This work reflects upon the irony of this moral situation, juxtaposing homoerotic scenes with imagery from ancient Hindu temples where erotic scenes commonly formed part of the essential iconography. While Khakhar's work addresses a serious social issue facing Indian society, he adopted a playful, sometimes 'kitsch' and even irreverent style, which was often informed by the calendar images, movie billboards and cheap oleographs of India's popular press.

HIMALAYAS

The gallery has only a small collection of Tibetan art but it includes several rare and significant pieces. Most relate to Buddhism, echoing the art of Tibet in general, where religion has played a pivotal role in the creation and patronage of art.

Tibetan Buddhism, or Vajrayana, is the most expanded and esoteric form of Buddhist practice and features a bewildering array of deities: innumerable Buddhas, gods and goddesses, animistic spirits, demons, mythological creatures, protector deities, teachers and venerable persons. Although this extensive pantheon ultimately defies classification, most deities belong to one of five families, each of which is headed by a transcendent Buddha or Tathagata. Each Tathagata in turn represents a cardinal direction, colour, element and human passion: Amitabha (West), the Buddha of Infinite Light; Akshobhya (East), 'the Unshakeable'; Vairochana, the Lord of the Centre; Ratnasambhava (South), literally the Buddha of Precious Birth; and Amoghasiddhi (North), the Buddha of All-Encompassing Wisdom. The five Tathagatas (depicted on the ritual crown, page 62) are the core of Vajrayana.

Vajrayana was systematised in India around the 5th century and entered Tibet in the 7th century. Vajrayana literally means the diamond or unbreakable path as a reference to the indestructible nature of Buddhahood. The quintessential symbol of this tradition is the *vajra*, a Sanskrit term meaning both diamond and thunderbolt. *Dorje* is the equivalent word in the Tibetan language. Tibetan deities are often shown holding the *vajra* as a weapon for the destruction of both internal and external enemies. Along with the *ghanta* (bell), the *vajra* is an important implement in rituals of worship.

Vajrayana teaches that every sentient being is potentially a Buddha but that human ignorance clouds this potential. The goal of *bodhicitta,* or an enlightened mind, is achieved through practices which develop the ideals of *prajna* (wisdom or insight) and *upaya* (compassion or means). In this context, the various Tathagatas and their associated deities represent aspects of this primordial Buddha-nature. The aim for the practitioner is to integrate these qualities into his or her self in order to achieve Enlightenment. One means of achieving this is through meditation, a one-pointed, sustained and focused visualisation which can be developed into complex sequences and structures. In the Tibetan tradition images are created as aids to transformation leading to the experience of *bodhicitta*. But just as these images lead the viewer or practitioner towards a transcendental experience, Tibetan images and works of art are also a means of making present the spiritual principle that is embodied by the deity depicted in the image. The work of art is thus a medium – the means

and support to an experience of Buddhahood – intended not simply to be 'looked at' but 'entered into' for the purpose of meditative visualisation.

One of the unique visual forms of the Tibetan tradition is the *thangka,* a kind of 'portable icon' painted or sometimes embroidered on a sized cotton or linen canvas. The term refers to a specific format for the presentation of images of deities or mandalas, mounted on cloth. The cloth mount is integral to the *thangka* as it is used to create and maintain a consecrated space, in other words a defined space for the purpose of ritual or meditational worship. For this reason *thangkas* are usually mounted on plain blue silk or on Chinese brocade with celestial patterns such as phoenix, dragons, lotus and so on. Mounted on this silk cloth, the central image is surrounded by thin bands of red and yellow, either edged in silk or painted onto the border of the canvas. Attached to the top and bottom of the silk mount are two rods which allow the *thangka* to be easily rolled up for storage or transportation. Also frequently attached to the bottom of the mount is another small, rectangular piece of silk to serve as a 'door' through which the practitioner may enter into this consecrated realm. *Thangkas* usually have a cover of gossamer silk to protect the consecrated image and in some cases also to protect the uninitiated viewer from the powers invested in the icon.

The central deity depicted on a *thangka* generally conforms to a strict iconography as outlined in the technical treatises and canonical literature of Tibetan Buddhism. Stylistically, however, they may reflect the influence of Chinese, Nepali or Indian aesthetic traditions. Along with images of all kinds, *thangkas* were transported from monastery to monastery, carried on pilgrimages, or shared between temples or households. These sorts of practices encouraged the dispersal of images and the inter-mingling of styles and techniques, resulting in the hybrid character that is so typical of Tibetan paintings.

Tibetan artists worked in guilds and although the iconographic form of the *thangka* was determined in accordance with ritual prescriptions, the stylistic and decorative treatment of the composition was left to the artist. An aspiring artist may spend many years perfecting his drawing skills before gaining permission to paint. Pattern books recorded designs for landscape features, the treatment of figures, clothing and decoration, and are revealing in terms of understanding how painting traditions and styles developed and were passed down. The small double-sided ink sketch on cloth (page 66), once part of a larger folio, is possibly one such example.

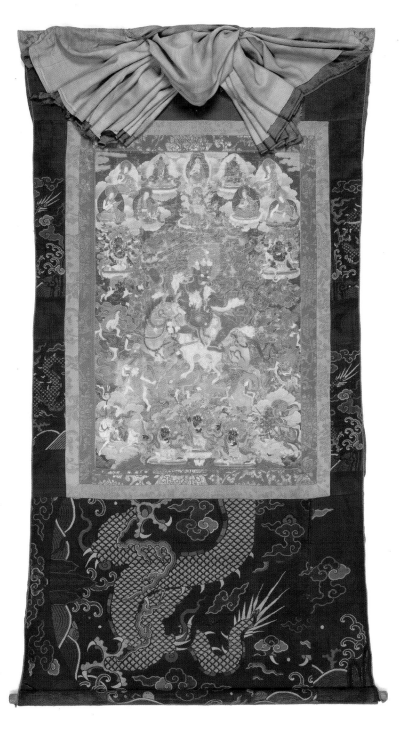

TIBET
Phalden Lhamo and her retinue 1700s
thangka, distemper on sized cotton,
66.5 x 48 cm (image), 139 x 82.2 cm (overall)
Purchased 1962
EP2.1962

Phalden Lhamo is a major protector deity
and the only goddess in the group of
deities known as the Dharmapala. A
favourite deity of the Gelukpa ('Yellow
Hat') sect, Phalden Lhamo is regarded as
a protector of the Dalai Lama and the city
of Lhasa. As a protector deity, Phalden
Lhamo is depicted with a wrathful
demeanour, riding an untamed mule
through a sea of entrails and blood. Blue-
black and haggish with three bulging
eyes, upturned nose, ferocious mouth
and flaming hair topped by a skull crown,
she holds a skull bowl filled with bleeding
organs and plucked-out eyeballs, and
brandishes a *vajra*-topped club. Below,
her retinue includes the minor female
divinities (*dakinis*) Makaravaktra
('crocodile-faced'), who leads her mule,
and Simhavaktra, the red-bodied, lion-
faced deity. This *thangka* retains its
traditional silk brocade mount.

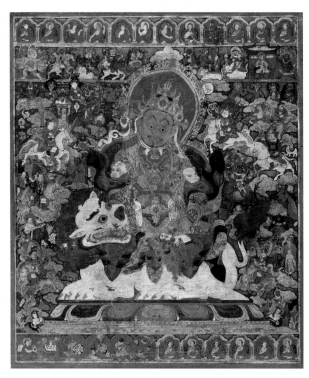

TIBET
Five-pointed ritual crown 1700s
leather with gilding and fabric, 78 cm (length)
Gift of J A and H D Sperling 1999
114.1999

TIBET
Vajra 1700s
silver gilt, 20 cm (length)
Gift of Mr F Storch 1980
9.1980

Meaning both 'diamond' and 'thunderbolt', the *vajra* is the quintessential symbol of Vajrayana Buddhism. This finely cast ritual *vajra* has five ribs at each end – four outer ribs, each with a *makara* (crocodile) form at the base, and a central shaft. The prongs symbolise the five Tathagatas. The bridge between the two ends is spherical in shape with lotus forms to either side and signifies the void or emptiness of nirvana. The *vajra* and the bell were both kept on an altar as symbols of wisdom and compassion, and were held by the worshipper during rituals.

TIBET
Vaishravana, god of wealth 1400s
thangka, distemper on cotton, 48.4 x 40 cm (image)
Purchased 1997
367.1997

This *thangka* of the Dharmapala (protector) deity Vaishravana is one of the earliest in the gallery's collection. Vaishravana is venerated as a god of wealth, guardian deity of the North and a follower of the bodhisattva Avalokiteshvara. He is shown seated on a white snow lion, holding a jewel-spitting mongoose and a victory banner or standard. As is typical of *thangkas*, the deity is the central focus of the painting and is shown front-on, though sometimes in a schematic style. The picture plane is flat with no attempt at perspective. Rather the deity and his entourage are depicted in accordance with a hierarchical arrangement. While this format and iconography conform to an accepted convention, it shows the complex compositional treatment favoured by the Newari artists of Nepal. This example also shows the influence of Chinese painting styles in its use of flat, loose colour, its decorative treatment and stylisation, and in the clothing of the central deity.

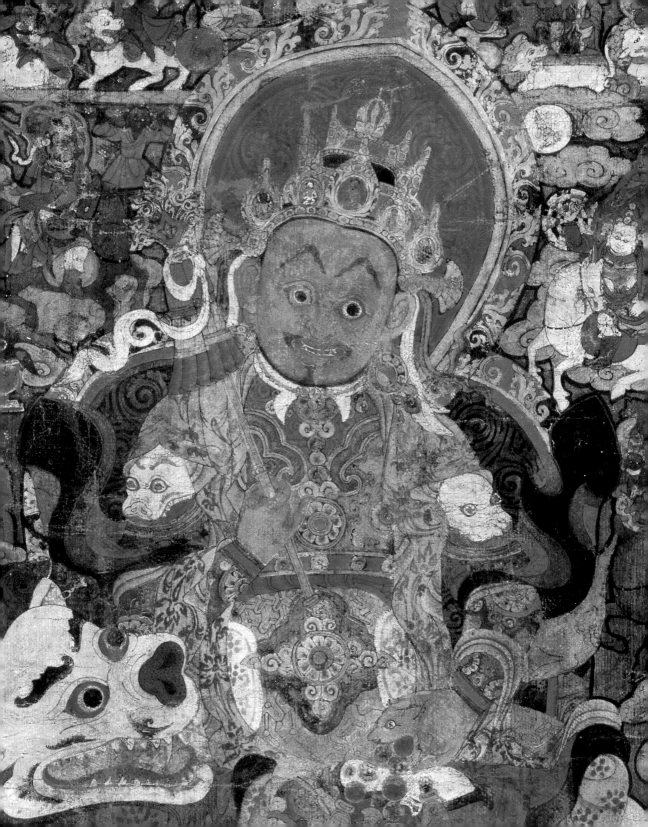

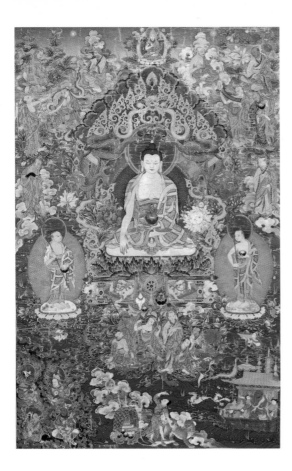

TIBET, Menri style
Bhaishajyaguru, the Medicine Buddha
1800s
thangka, distemper and gold on sized cotton, 63 x 49 cm
inscribed as being painted at the Tsedong monastery, Tsang
D G Wilson Bequest Fund 1999
67.1999

This *thangka* is distinctive for its use of rich and intense colour, predominantly blue, gold and green. The central deity holds a begging bowl containing a sprig of the medicinal myrobalan plant. Seated on a lotus pedestal supported on a lion throne, the Medicine Buddha wears the patched robes of a monk and is accompanied by his disciples and the 18 *arhats* or 'saints' of Tibetan Buddhism. Directly above the Buddha's head is Tsong Khapa, an important reformer of Buddhism in Tibet and the founder of the Gelukpa or 'Yellow Hat' order of monks. A *thangka* such as this may have been commissioned to commemorate a significant occasion or life ceremony, to accrue merit for the donor or as homage to the abbot. The dedication of an image of the Medicine Buddha may suggest

that it was commissioned at a time of illness, or perhaps as a wish for good health.

Interestingly, this *thangka* bears an inscription which indicates that it was painted at the Tsedong monastery in Tsang, Central Tibet, for Rise Gdong Sprul Sku, who was the reincarnated abbot (*lama*) of that monastery. Although it is not known who commissioned it and what their relationship was to the abbot, it is not unusual to find *thangkas* with dedications or inscriptions recording the names of donors and the circumstances surrounding the commission. This inscription reminds us of the *thangka's* donative function, as works created as a tribute designed to bring merit to oneself and others.

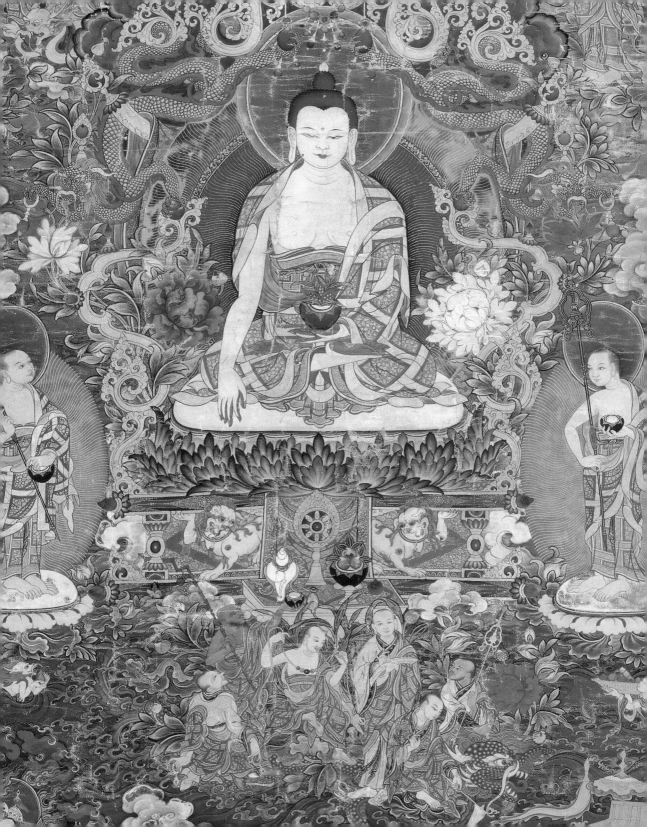

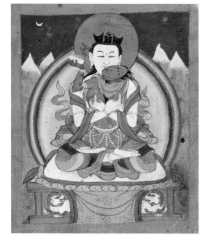

SOUTHERN TIBET
The seven Buddhist treasures
1600s–1700s
gouache on cotton, 10.5 x 9 cm
Gift of Marie-Francoise Fatton 2000
18.2000

SOUTHERN TIBET
Karma Pa and consort 1600s–1700s
gouache on cotton, 10.5 x 9.2 cm
Gift of Marie-Francoise Fatton 2000
17.2000

Tsakali are painted 'initiation cards' unique to the Tibetan tradition. Unlike *thangkas*, these icons are images in miniature which focus on one aspect or attribute of a deity. A set of cards forms a mandala of images and is employed in various ritual situations including the transmission of teachings, as aids for meditation, in funerary rites and as substitutes for ritual objects when they are difficult to obtain. The two *tsakalis* illustrated here are most likely from the same set. Each card is rendered in flat, primary colours, with the image composed of simple shapes outlined with fluid black lines. They have both been consecrated with the mantra of the deity inscribed on the back.

CENTRAL or EASTERN TIBET
Mahasiddha 1700s
ink on primed cotton, 19.5 x 21 cm (irreg)
D G Wilson Bequest Fund 1999
132.1999

This cloth from an artist's sketchbook depicts the Mahasiddha or 'great mystics'. On this side is Maitrichen, in standing yogic posture, and on the other side is Draken seated in a Chinese-style landscape. The sure and confident linework suggests the hand of an accomplished draftsperson although traces of underdrawing and the artist's study of detail can be seen. While it has been suggested that these sketches formed part of an artist's pattern book, this set also has the quality of a practice pad or study drawings, especially in the rendering of the deer accompanying the dynamic figure of Maitrichen.

TIBET
Banquet for the Dharmapalas 1700s
distemper on cotton, 48.5 x 100 cm
D G Wilson Bequest Fund 1999
68.1999

This unusual and esoteric painting depicts a symbolic set of ornaments (*rgyan tshogs*) used as an offering, usually to one of the protector deities known as Dharmapala (protectors of the faith). The iconography of this picture, described as a 'banquet for the Dharmapalas' (*bskang rdsas*) is complex and centres on a celestial palace signifying Mount Meru, the spiritual centre of the Buddhist cosmos. To the far right is Vaishravana wearing Chinese-style armour and riding a white snow lion. The deities to the left are harder to identify – perhaps they are the great protector deity Mahakala to the far left and the Mongolian warrior god Begtse carrying a sword and trident. In the foreground are a horde of animals – buffalo, goats, horses, dogs, lions, tigers – and in the middle-ground, to the left of Mount Meru, are the eight auspicious Buddhist symbols. At the far right, beneath Vaishravana, are the seven treasures of the universal ruler (*chakravartin*) and scattered throughout the picture are various kinds of offerings: *tormas* (cakes of flour and butter), bowls of food, an array of musical instruments. Images of this type were usually painted on the walls of shrines dedicated to the protector deities. Only very few were painted on cloth (the best known and most spectacular example is in the collection of the Philadelphia Museum of Art).

CHINA

BRONZES AND JADES

The origins of metallurgy in China go back to pre-historic times. Bronze fragments have been found at sites of the Neolithic Yangshao culture that date to around 4700 BCE. By the great Bronze Age of the Shang and Zhou dynasties (c1700–221 BCE) bronze was being used extensively for military, agricultural and industrial purposes, in cult rituals and as political capital. With ritual and war often said to be the primary concerns of a nation, weapons and ritual vessels were among the most elegant of the bronze objects produced. Their unrivalled quality, originality and beauty have made them the hallmark of China's antiquity, while the extent of their use reflects the central roles they played across social and official strata.

The *ding,* or cauldron, is one of the most common vessels among the extensive repertoire of ritual bronzes. Square, rectangular or circular in form, they were used for holding and heating food during ceremonies. The mysterious *taotie* animal face motif often seen on *ding* and other bronze vessels is the most pervasive and powerful motif of Bronze Age China. Many interpretations of the *taotie* have been offered. It was thought to have served a protective role for the offerings placed within, or to ward off evil spirits. One early tradition, as recorded by the author of *Zuozhuan* (Master Zuo's commentaries on the spring and autumn annals) of the Warring States

period (476–221 BCE), referred to it as the image of a harmful spirit. The depiction of these demons on ritual vessels acted as a forewarning and was believed to give protection should the demons or dangers be encountered abroad.

The use of jades in ritual, ceremonies and as decorative items in the Shang and Zhou dynasties by the aristocracy created such demand that a thriving jade industry developed. Jade's symbolism derives from its physical attributes: its extreme hardness, its incorruptible beauty in terms of colour, texture and translucence, and its sensuous tactile quality when polished. Its rarity and costliness have added to its potency as a symbol of purity and excellence, and as a metaphor of human virtue. Jade played an important part in burials, where various jades of symbolic shapes were placed around the body and were used to seal the body's seven orifices, including a flat plaque in the form of a cicada placed in the mouth of the deceased.

There are two types of jade: nephrite and jadeite. The true jade prized by the Chinese throughout history is nephrite. Since Neolithic times this tough translucent stone has been revered for its mystery and magic and has been carved to produce the most prized ceremonial implements and ornaments. Jadeite is another mineral only discovered by Chinese jade carvers in Burma in the 1700s.

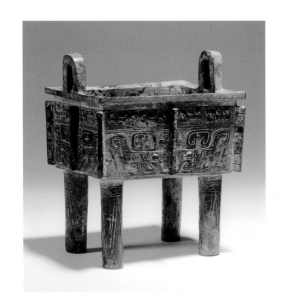

Shang dynasty (c1700–1027 BCE)
Rectangular cauldron *fang ding*
1100s–1000s BCE
bronze, 21.3 x 17.3 x 14 cm
Bequest of Kenneth Myer 1993
573.1993

The powerful images of mystical animals used to decorate ritual bronzes have their fullest expression in this example. In each of the six panels on the upper part of the main body is a *kuei* dragon, an archaic creature which symbolises rain and fertility. The central flange on each main face forms the central ridge of a *taotie* mask comprised of two confronting *kuei* dragons. Both the dragon motif and *taotie* are set off by a ground of squared spirals (*leiwen*). The incised designs on the cylindrical legs echo the cicada pattern on the vessel opposite. The four characters 大嬲婦沫 indicate that the vessel was made for a deceased lady of the Damin clan.

EXCAVATING AND COLLECTING EARLY BRONZES

Due to the long-standing practice of burying artworks with the deceased, China's cultural legacy, unlike those of the earliest Western civilizations, was preserved beneath rather than on the surface of the ground. Elaborate Shang and Zhou funerary traditions have preserved countless bronze artefacts of varying shapes and sizes. A bronze *li* cauldron in the gallery's collection (page 72) is associated with such a cultural phenomenon. Evidenced by the inscription incised along the inner edge of the wide lip, the cauldron is apparently associated with the ancient state of Guo that came into being in the early Western Zhou dynasty (c1000s–771 BCE), when the Zhou king created a fief for the Guo clan in the area of modern Xingyang and Zhiyi in Henan province.

As primary collectors of antique bronzes, the imperial households of subsequent dynasties have played a key role in instigating and encouraging an interest in ritual bronzes and in making them a focus for connoisseurship. In the early 1100s, the famous 'artist' emperor Huizong of the Song dynasty (r1101–25) organised and published a catalogue that contained some 839 bronzes in the imperial collection. This catalogue, along with several others that appeared around the same time, initiated a long tradition of authentication and connoisseurship.

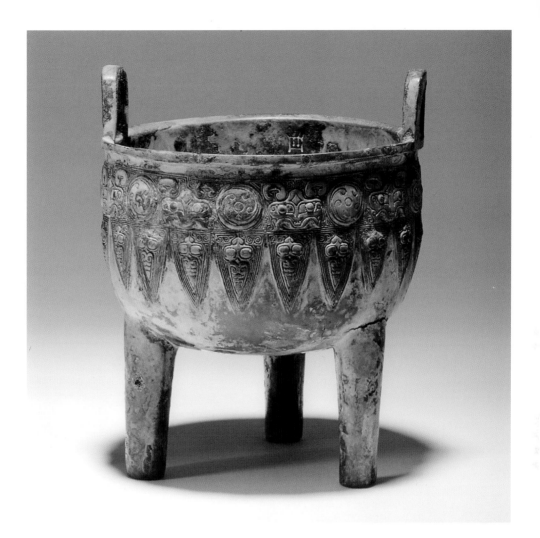

Shang dynasty (c1700–1027 BCE)
Circular cauldron *ding*
1100s–1000s BCE
bronze, 21.5 x 18 cm
Bequest of Kenneth Myer 1993
572.1993

The exterior body is decorated with hanging blades filled with cicadas, a symbol of rebirth in China. Above these is a band with alternating whorl circles and metamorphic faces of the mystical animal *taotie*, each dominated by large eyes and curving horns. As with all such bronzes, this *ding* was made from ceramic piece-moulds which had been sharply incised with intricate designs that were then perfectly rendered in bronze. The three characters incised inside the tripod 箙父庚 indicate that the vessel was cast for the deceased father of the Fu clan on the day of *geng*. This *ding* is significant

not only because of its superb quality but also its prestigious provenance: it was formerly in the Chinese imperial collection from at least the early 1700s to the late 1800s. Over the years 1749–51, under the auspices of Emperor Qianlong of the Qing dynasty, the courtier Liang Shizheng and others compiled a fully illustrated catalogue, the *Xiqing gujian,* of the 1529 bronzes owned by the emperor. Some of these works were removed from the imperial palace in Beijing and fell into the hands of private collectors during the turbulent period at the end of the Qing dynasty.

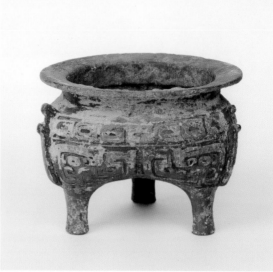

Western Zhou dynasty (c1100–771 BCE)
Ritual vessel *zun* 1000s BCE
bronze, 25 cm
Gift of Giuseppe Eskenazi 2003
253.2003

In early script, the character *zun* is written in the form of two hands holding a wine cup. The shape of the vessel and its pictographic depiction suggest it was used as a ritual object for wine. The *zun* was one of the most popular vessel shapes in the Shang and early Zhou periods. The rendering of the *taotie* mask on this vessel exhibits characteristics descended directly from Anyang period motifs of the late Shang dynasty (1318–1046 BCE). The inscription cast in the interior centre 父丁 reads as *fuding*, and indicates that this *zun* was made for the deceased father on the day of *ding*.

Western Zhou dynasty (c1100–771 BCE)
Cauldron *li* late 800s BCE
bronze, 12.4 x 15.8 cm
Bequest of Kenneth Myer 1993
574.1993

This vessel exhibits the usual triple-vertical division, and contains some of the most typical features of the middle to late Zhou style. The upper belt on main body is decorated with the so-called 'scale band' in flat relief. The decoration is divided into three panels by three flanges that correspond to the legs. An inscription of six characters 虢仲作姞尊鬲 incised along the inner edge of the wide lip reads: 'Guo Zhong made [for the Lady] Ji [this] honoured *li* [cauldron]'. The inscription is significant, since it clearly indicates that the cauldron was associated with the ancient state of Guo.

During the transitional period from Western to Eastern Zhou (770–256 BCE), when the Zhou king's power was in decline, a strong neighbouring state of Guo, the Jin, under the rule of Marquis Xian, annexed Guo in 655 BCE. Although we know the state of Guo did exist during the Western Zhou, its history has been unclear. The discovery of some 234 tombs at Shangcunling in Sanmenxia, Henan, in 1956–57, however, began to shed some light. Among over 9000 objects excavated

from these tombs were only 181 bronzes. In 1990 archaeologists excavated a Guo royal cemetery to the north of the original excavation site. To date they have excavated five large tombs that belonged to two marquises, one crown prince, one consort and one senior courtier. Tomb 2009 was the largest and contained the fullest assemblage of bronze ritual vessels, 200 in total. Most of these bronzes bear the inscription of 'Guo Zhong', the name of the tomb occupant who was one of the state's rulers. On the basis of historical records and the stylistic features of the bronzes discovered in the tomb, some scholars consider that Marquis Guo Zhong (named Changfu), may have lived during the reign of King Li (r877–841 BCE), and was the aide-de-camp of the Zhou king. Not only can this *li* therefore be precisely dated to the late 800s BCE, it also adds to our understanding of China's tradition of burying artworks with the deceased.

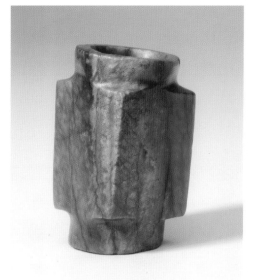

Shang dynasty (c1700–1027 BCE)
Ceremonial blade c1600s BCE
nephrite, 52.4 x c 9.5 x c 0.2 cm
Gift of Dr J L Shellshear 1954
9039

In shape, this ceremonial or funerary jade is reminiscent of a Neolithic stone harvesting knife, even down to the perforations along the unsharpened edge. On the original these would have served to attach a backing or grip for the hand. To make the blade, its outline would first have been drawn on a flat slab sawn from the block. Jade is so hard it cannot be cut with metals; the Chinese used an abrasive sand with a greater degree of hardness. During the Shang period such replicas of tools were used as ceremonial emblems.

Late Neolithic/Shang dynasty
Ritual disc *bi* c1900s–1500s BCE
nephrite, 0.8 x 15.5 cm
Gift of Mr Graham E Fraser 1988
187.1988

Shang dynasty (c1700–1027 BCE)
Ritual disc *huang*
nephrite, 6 x 12 cm, 6.6 cm (hole diameter)
Gift of Anne Ryan in memory of her brother Patrick 1998
289.1996

Western Zhou dynasty (c1100–771 BCE)
Ritual jade *cong*
nephrite, 8.2 x 4.5 x 4.5 cm
Gift of Mr Graham E Fraser 1993
331.1993

Bi, a disc with a central perforation, and *cong*, a roughly square cross-section with a circular bore, are two of the most familiar jade ritual objects of ancient China. The number of *bi* and *cong* discovered throughout late Neolithic and Bronze Age tombs and burial sites is testimony to their significance in ancient rituals and ceremonies, although their meaning and function remain uncertain. As Western Zhou ritual texts refer to *bi* and *cong* as offerings to heaven and earth respectively, they have become symbols of heaven and earth. They were usually found together in tombs.

The gallery's example of a *bi* is a rich, opaque green. The term *bi* has been applied to discs with small central holes. If the hole is larger in proportion to the whole area of the disc, then the jade is generally known as a *huang* in Chinese. Like the *bi* disc, the *huang* ring is also a major type of ancient ritual jade, existing in China as early as the 5th millennium BCE. Two types were popular: the plain ring and the ring with a central vertical collar. The gallery's *huang* ring is a rich, opaque, creamy green with milkish and brown patches or veins.

The example of a *cong* is made of brownish yellow stone with brown veins and a partially glassy polish. Unlike the richly ornamented examples from the early period, most jade *cong* from the Western Zhou dynasty were without any decoration.

BRONZE MIRRORS

Chinese bronze mirrors are generally thin circular discs, slightly convex on the polished reflecting side and decorated with cast designs of a symbolic nature on the reverse. A small loop or pierced dome at the centre of the reverse side was used to attach a cord. The earliest known mirrors date from at least the late Western Zhou period (900s–800s BCE) but it was during the Han and Tang dynasties that large numbers of highly ornamented mirrors were produced. Their reflective function made them a vehicle for the expression of a fascinating range of mythological and cosmological ideas and beliefs.

Warring States period (476–221 BCE)
Mirror with T-motif design
bronze, 0.4 x 13.1 cm
Gift of Mr Graham E Fraser 1986
170.1986

Here four slanting T-shapes are superimposed on the background pattern of hook-and-spiral motifs familiar to Warring States bronze vessels. The 'T' motif relates to lozenge designs found on other mirrors of this date but they may also represent the pictogram for mountain suggesting an allusion to the enduring tradition of the landscape and the natural world. Stylised floral motifs emerge from each corner of the central square.

Western Han dynasty (206 BCE – 8 CE)
Mirror with *caoye* design
bronze, 0.5 x 13.1 cm
Gift of Mr Graham E Fraser 1986
171.1986

The distinctive *caoye*, or grass and leaf, pattern is defined by the symmetrical motif resembling an ear of corn and the trefoil forms which appear on the main ground of the mirror around the central square. An inscription cast into the square band reads: *jianri zhiming, tianxia daming* (may you see the light of the sun and may the world enjoy great lightness), suggesting that the design symbolises a form of cosmological harmony.

Han dynasty (206 BCE–220 CE)
Mirror with TLV design
bronze, 0.5 x 14.3 cm
Gift of Mr Graham E Fraser 1988
515.1988

One of the most characteristic and
symbolically complex of the cosmological
mirrors of the Han dynasty is the so-called
TLV type. The name derives from the
geometric shapes set in fixed places on
the sides of the central square and on
the inner circle. The square within a
circle design has clear cosmological
connotations although the precise
meaning of the diagram is not known.
On this example the 12 animals of the
zodiac are cast within the central square
band. The inscription in the narrow circle
around the central design includes
references to notions of immortality and
the heavens: 'Ascending to the great
mountains to encounter the immortals,
you will drink from the sweet jade spring
and will soar into the sky by riding on
a dragon and cloud; may you enjoy
your lifelong official career and your
descendents enjoy lasting fortune; may
your prosperity and joy be endless.'

Warring States/early Western Han period
(c300s–200s BCE)
Mirror with linked arc design
bronze, 0.5 x 11.3 cm
Bequest of Kenneth Myer 1993
577.1993

Archaeological discoveries suggest that
this type of mirror was popular during the
Warring States and early Western Han
periods. The design of concave arcs and
the background pattern of scrolling
dragons on a spiral-motif ground are
typical of mirrors of the time.

Liao dynasty (906–1125)
Box and cover dated 1026
silver gilt, 4 x 10 cm
Gift of Giuseppe Eskenazi 1998
281.1998.a-b

Although silverwork has a long history in China, the Tang dynasty is generally recognised as the period when the finest silverware was produced. The Liao dynasty was one of several periods of barbarian rule in China. At this time the Qidan Tartars gained control of much territory in the north of Tang China, and like other invaders, infused Chinese culture with their own. Two decorative styles of Liao silverware can be distinguished: the first proclaims a taste quite alien to the Chinese, with decoration in a manner distinct from the Tang tradition of central China; the other style is based on sophisticated Chinese models. This silver box, with the phoenixes in repoussé amid formalised foliage and the traced floral and cloud-scroll decoration, is much in the style of the Tang and Song periods, and exemplifies the continuation of Chinese taste into the late Liao period. Inside, the bottom of the box is engraved with an inscription which reads: 'In the *bingyin* year of Taiping reign [corresponding to 1026 CE], a box of ambergris and jujube [?] is presented as a

tribute to the Wenzhongwang fu [Mansion of the Cultivated and Loyal Marquis]. Seventy nine [?]'.

According to *Liaoshi* (history of the Liao dynasty), the name associated with the Wenzhongwang was that of Han Derang (941–1011), a Chinese administrator and military commander under two Liao emperors. His brilliant career brought him high rank and honourable titles. Upon his death in 1011 he was given the title Wenzhong (Cultivated and Loyal).

Although a number of refined Liao silverworks were unearthed recently from a broad area across Inner-Mongolia, Liaoning, Jilin and Hebei, it is rare to find silverwork bearing both a date and an inscription for tribute. The significance of the silver box is therefore twofold: first, the piece can be used as a reference in dating other Liao silverwork; secondly, it provides a material document in the study of the tribute-system of the Liao period.

Song dynasty (960–1279)
Vessel in the archaic g*u* form
bronze with gold and silver inlays,
23.5 x 4.8 cm (lip diameter)
Purchased with funds provided by the Asian Collection Benefactors' Program 1997
433.1997.a-b

This bronze vessel demonstrates the persistence of a taste for antique bronzes that was sustained throughout Chinese history by the literati. It takes the shape of the *gu,* an ancient form of ritual wine goblet of the Shang and Zhou dynasties that was re-interpreted and copied during the Song to Ming dynasties. The flaring upper part is decorated by four blades which contain motifs of schematic *taotie* masks, dragons and geometric patterns. The blades may well represent the cicada, a symbol of rebirth associated frequently with burial objects. In each of the upper four quarters are dragons with open jaws and curved horns. Below, the zoomorphic motifs in the four sections can be viewed as two groups and form two *taotie* masks. Over the whole body of the vessel the animal motifs are rendered in inlaid gold and silver sheet metal and wires, against a backdrop of *leiwen,* or thunder pattern.

Ming dynasty (1368–1644)
Pouring vessel _he_ in archaistic style
bronze with silver and gold inlays,
22 x 24.8 x 18.5 cm
Purchased 1990
1357.1990

In terms of shape, the _he_ dates back to
the middle Shang dynasty. The popularity
of this shape among Song cognoscenti
can best be explained by its
representation in the _Xuanhe bogu tu lu_
(the Xuanhe album of antiquities), a 30-
volume catalogue of the Song imperial
collection which was completed in the
early 1100s and was the most famous
and influential of the printed volumes on
ancient bronze collections. This bronze in
fact more closely resembles the
imaginative and stylised depiction in the
album than any Shang _he_. Its inlaid
decoration exemplifies this transmutation:
the use of inlays in bronzes, an innovation
acquired from the nomadic cultures of the
Central Asian steppes, does not even
appear until the post-Shang period of the
Warring States (476–221 BCE).

Hu Wenming (active late Ming dynasty)
Ming dynasty, Wanli period (1573–1619)
**Censer _gui_ with 14 auspicious motifs
around rim**
copper with applied cast bronze handles and
parcel gilt band, 7.5 x 11.7 cm (bowl)
Purchased 1997
368.1997

The Ming esteem for early bronzes led to
the production of contemporary copies for
use on household altars as well as for
secular use. Hu catered to this market,
specialising in wares for the Chinese
scholar, specifically those for the incense
cult. His family studio was active in the
late Ming in the key cultural area known
as Jiangnan to the southwest of Shanghai
in Jiangsu province, a famous centre for
metalcraft. Wares such as this censer
represent the fascinating co-operation
between the elite scholars, who evolved
a distinctive aesthetic, and the artist-
craftspeople they commissioned to
articulate this aesthetic. Out of this co-
operation came some outstanding works
of art, particularly in metalwork, much of
which, like this censer, was archaistic in
flavour.

TOMB SCULPTURE

From the mid Zhou era (around the 6th century BCE), the Shang practice of human sacrifice in association with burial was gradually replaced by the more humane tradition of furnishing tombs with facsimile models of the people and animals that had been in the service of the deceased during life. The extraordinary realism of these models has established the tomb figure tradition as both unique and familiar. Ranging from buildings, animals, courtiers, servants, dancers, musicians, guardians and grooms, they have come down through buried history to give a colourful and informative panorama of life in ancient China.

Known as *mingqi,* the models were originally made of wood and later of pottery. As the Western Zhou ritual text *Liji* (record of ritual) explains, the name suggests their function was confined to the field of ritual activities, since *ming* denotes *shenming* or 'spiritual beings' and *qi* stands for 'object'. The gallery's collection includes fine examples of *mingqi* from the Han (206 BCE – 220 CE) and Tang (618–906) dynasties. It was around the time of the early Han dynasty that the making of *mingqi* underwent a significant change in technique. Whereas in earlier times the figurines had been individually modelled, they were now made from moulds. In the Han dynasty single glaze colours were also used for ornamenting certain (usually animal or architectural) tomb models, but in the Tang dynasty the use of colour and multi-colour glazes became widespread, some with the further embellishment of painting and gilding.

Following the fall of the Han dynasty, China was embroiled in almost four centuries of internecine conflict and intermittent foreign invasion. And yet this was a surprisingly lively time for the arts, with the added inspiration of Buddhism and new contacts with foreign influences, all of which laid the foundations for a flowering of the arts during the cosmopolitan Tang dynasty.

In Tang dynasty China, thriving commerce attracted merchants from Persia, India and kingdoms in Central Asia across the fabled Silk Roads. Large foreign communities formed within China, and talented foreigners attained fame and fortune. Central Asian music and dance were extremely popular, and male and female dancers were imported from Samarkand and Tashkent in Sogdiana. Depictions of foreign figures, particularly those serving at the courts of the Tang imperial and aristocratic families as grooms and attendants, were found on all artistic media but most significantly in the great range of tomb figures. The careful and often eccentric attention to 'foreign' detail, such as eyes, noses, beards and other distinctively Western features, make the range of tomb figures uniquely informative about court and daily life in Tang dynasty China.

The colourful and imaginative spirit of Tang China that was so stimulated and enriched by the trade with Western Asia is echoed in the silks, silverwork and ceramics of the age. Yet there can be no more evocative symbol of this often referred to 'Golden Age' in China's history than the Tang horse, represented in the gallery's collection by a number of examples. The most splendid is a three-colour (*sancai*) glazed model of a horse and rider from a retinue of military figures once placed in the tomb of a member of the royal house, a dignitary or military official (page 86).

A rebellion in 735 CE led by General An Lushan signalled the beginnings of the decline of the Tang dynasty. This uprising was indicative of a widespread dissatisfaction with the extravagant luxury of the court, and while it was suppressed it marked a watershed in the history of the Tang which continued to be disturbed by internal uprisings as well as external invasions. With the demise of the Tang dynasty, the tomb figure tradition that had flourished with such evocative reality was severely diminished. In the succeeding Yuan and Ming dynasties, pottery tomb models continued to be made but in neither the quality nor quantity of those of the gregarious Tang dynasty.

Han dynasty (206 BCE – 220 CE)
Two model houses early 1st century CE
earthenware
house with dog: 21 x 29 (roof) x 9.7 cm
house with two kneeling figures:
20 x 28.4 (roof) x 5 cm
Gift of Lily Schloss in honour of Goldie Sternberg 2002
132.2002, 133.2002

Models of houses, granaries, wells and stoves from this period abound as burial objects in the Guangdong area, and tell us much about the architecture and way of life in the southern region. In this type of house, elevated on a series of wooden piles (*ganlan* in Chinese), people lived on the upper storey while the lower storey served as a shed for domestic animals. The wooden construction is indicated on the models by incised lines on the front and side walls. Four round holes on the bottom were intended for the insertion of clay or wooden sticks, to represent the wooden piles on which such buildings stood.

Han dynasty (206 BCE – 220 CE)
Watch tower 1st–2nd centuries CE
earthenware, 144.8 x 38.5 x 38.5 cm
Edward and Goldie Sternberg Chinese Art
Purchase Fund 1992
308.1992.a-e

This exceptionally large model of a
defensive watchtower, excavated from a
tomb in Henan province in the Yellow
River valley, reminds us of the constant
threat to China from nomadic hordes
sweeping into its northern regions (the
reason for the construction of the Great
Wall of China). The four-storey building is
manned by guards holding crossbows
(which the Chinese invented) on the lower
level and alert sentinels above. Every
architectural detail is observed, from the
balconies and large overhanging eaves to
window shutters, providing an accurate
re-creation of wooden prototypes that
have long since disappeared. The low-
fired lead glaze found on many Han
mingqi is thought to have been produced
to emulate the patination of the esteemed
bronzes of earlier burials.

Han dynasty (206 BCE – 220 CE)
Watchdog
earthenware, 31.5 x 28 x 12.4 cm
Gift of Mr T T Tsui 1995
298.1995

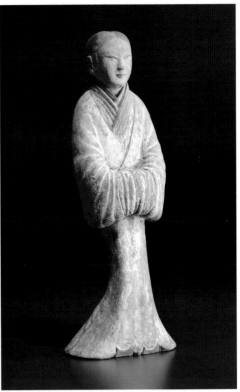

Han dynasty (206 BCE – 220 CE)
Equestrian figure
earthenware, 34.9 x 25.6 cm
Purchased 1995
119.1995

This figure is distinguished by the
extraordinary amount of bright, original
pigment that remains. The sturdy horse
stands foursquare. The soldier on his back
wears armour over a short red tunic with a
thick, white collar, a black border on the
skirt, hair drawn up under a red helmet
tied beneath the chin, and hands
positioned and drilled to hold reins. Larger
but stylistically similar figures, dated to the
early Western Han, were unearthed in
1965 at Yangjiawen, near Xianyang,
Shaanxi province.

Eastern Han dynasty (25–220 CE)
Figure of a lady
earthenware with traces of pigment and paint,
40.3 cm
Gift of Sydney Cooper 1962
EC14.1962

With her hands politely clasped within the
voluminous sleeves of her costume, this
is among the finest of the Han dynasty
figures in the collection. Her distinguished
but humble demeanor suggests that she
represents a courtly attendant. It is a
figure of extraordinary grace and eloquent
simplicity, characteristic of the
sophisticated Han style. Typically such
models were made from moulds, the
parts then luted together and the details
finished by hand before the firing process.
The figure was then covered with a white
slip, which served as a base for the detail
painting of which only traces remain.

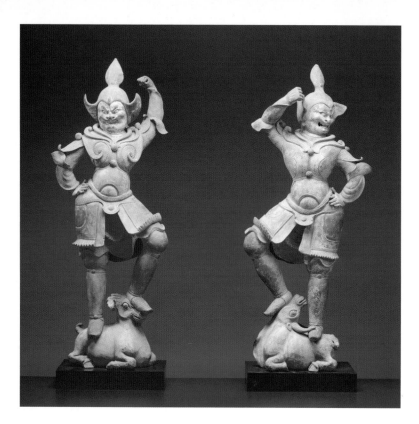

Tang dynasty (618–906)
Pair of tomb guardian figures
late 500s – early 600s
earthenware, 93 x 39 x 23 cm, 92 x 39 x 23 cm
Art Gallery of New South Wales Foundation
Purchase 1990
249.1990 a-b

This magnificent and fearsome pair of
unglazed guardian figures would have
been placed in two corners of a tomb
chamber. Together with a pair of less
ferocious civilian images placed in the
other two corners, they were charged
with the task of warding off any evil spirits
that might infect the tomb. Militaristic
and semi-mythical, these particular figures
are clearly from the tomb of an important
Tang dignitary or member of the royal
family, and are outstanding in their detail,
sculptural quality and the sheer vigour of
their presence. Originally they would have
held weapons. The beasts on which they
stand are unusual; one appears to be an
ox, the other a goat.

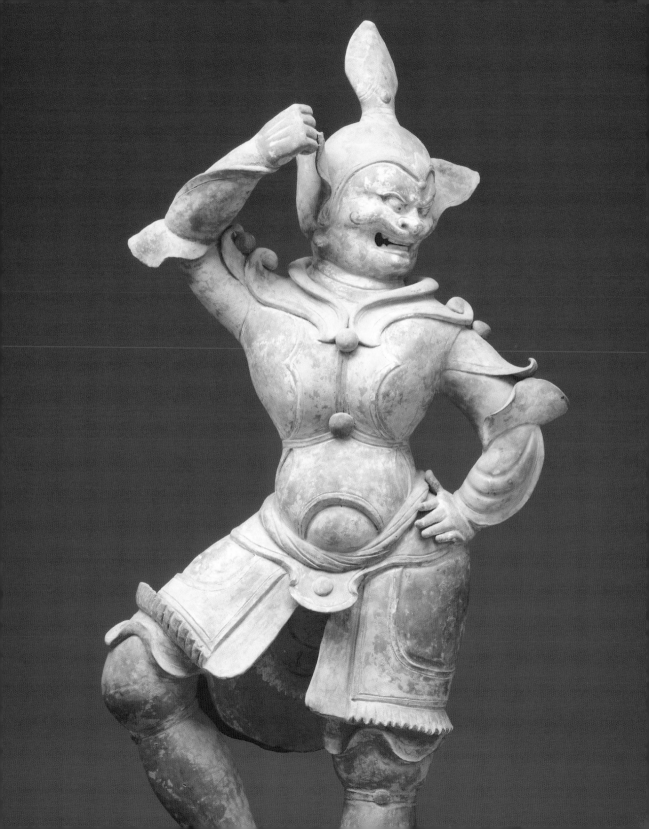

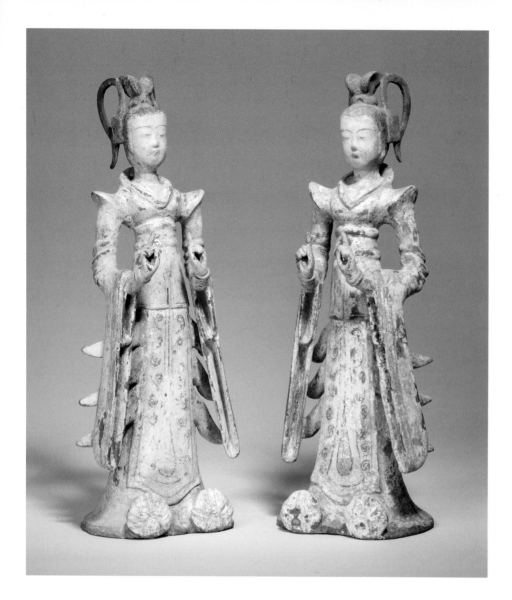

Tang dynasty (618–906)
Two court ladies late 600s
earthenware with traces of colour over a white
slip, 36.8 cm each
Gift of Sydney Cooper 1962
EC26.1962, EC27.1962

The most elegant of the Tang tomb figures on display is undoubtedly this pair of slender and graceful models of court ladies. They are often identified as princesses, but are possibly dancers whose elaborate costumes and high coiffures were the height of fashion in Tang China. The pieces can be dated on the basis of the high-waisted dresses. Such fashions were popular in the late 600s. However in the early 700s, when Emperor Ming Huang fell in love with Yang Gueifei, whose fuller figure needed more voluminous robes, fashions had to change.

Tang dynasty (618–907)
Polo players
painted unglazed earthenware,
35.5 x 35.7 x 14.3 cm
Gift of Mr Sydney Cooper 1962
EC28.1962, EC29.1962

Along with the merchants and other
travellers who came to Tang China from
Central Asia came foreign sports. Among
them was polo, an old game that probably
originated in Persia. Polo attracted
countless male and female enthusiasts in
the Tang dynasty, from the highest walks
of life to ordinary citizens. The game
occupied an exalted place in court life.
The royal family had its own polo field,
and a special official position named
daqiu gongfeng or 'polo-player in
attendance' was created to award those
mastering the game. The ebullient spirit
of the age is clearly echoed in these
sculptures: two female figures, dressed
as men and astride galloping horses,
concentrate on their game of polo. Their
tense postures vividly capture the high
speed, the interaction between horse and

rider, and the physical endurance of both.
In the repertoire of tomb figures, the
activities and poses of women are more
limited than those of male figures, so it is
refreshing to find figures such as these
equestriennes. The figurines were made in
reddish earthenware, unglazed. Traces of
white pigment, and of red on the horses'
manes and vermilion on the riders'
costumes, are visible.

Tang dynasty (618–906)
Figure of a camel c700s
earthenware with *sancai* (three-colour) glazes,
77.5 x 56 x 25 cm
Purchased 1990
1350.1990

This large and naturalistically modelled figure of a braying Bactrian camel would have been placed in the tomb of a deceased member of a Tang royal or aristocratic family along with numerous other figures of soldiers, guardians, horses, courtly ladies, entertainers and others in the service of the deceased. The pack, which hangs down on either side of the camel's body, is shaped to represent an ogre or lion's head. Behind the pack and over a fringed saddlecloth are tent poles for camping at night on a long journey across Asia. Camels were central to the Silk Route trade and its associated wealth. From the 500s, models of camels were included in the repertoire of tomb figures, reflecting the crucial role they played in the extensive trade across Central Asia. Realistically modelled, the small (empty) humps on this camel indicate he is at the end of a journey.

Tang dynasty (618–906)
Equestrian figure c700 CE
earthenware with *sancai* (three-colour) glazes,
40.6 x 39.5 x 12.5 cm
Purchased with funds provided by the Art Gallery Society of New South Wales 1979
83.1979

Lively horses splashed with colour and standing in a wide array of poses are among the most famous examples of Tang *mingqi.* The rider of this horse, his felt hat and facial features indicating a man of Turkic origin, characterises the ethnic mix of Tang China. The effect of the piece has been heightened by the casual application of coloured glazes, poetically, rather than accurately, called *sancai* (three-colour) glazes. The dominant colours of this palette are amber-brown, green and cream. It is thought this style of decoration, popular on *mingqi,* may have been derived from the tie-dyed textiles of Central Asia, which the Chinese came across through the Silk Route trade.

BUDDHIST ART

As Buddhism spread from its birthplace in India eastwards across the mountains and deserts of Central Asia into China in the 1st and 2nd centuries and on to Korea and Japan, northwards and westwards into Pakistan and Afghanistan, and southwards to Southeast Asia, it carried with it an iconography and an art that has inspired creative instincts to the present day. The material legacy of Buddhism in China and elsewhere is an extraordinary, compelling and diverse wealth of art. While from the 1300s, Buddhism in its homeland, India, was largely eclipsed by native Hinduism and by Islam, the faith continued to flourish in East and Southeast Asia. Probably the most important reason for Buddhism's tenacious longevity is its essentially contemplative nature. Based on a veneration of the forces and patterns of the natural world, its traditional mystic and meditative philosophies found a sympathetic audience among the people of East and Southeast Asia.

The style and imagery of art in the service of Buddhism was determined by iconographical, liturgical and to some extent by ritualistic functions. As an iconographical art it was essentially a figurative tradition and one principally confined to the arts of painting and sculpture. In introducing and sustaining hitherto unfamiliar figurative concepts into the artistic traditions of China, its impact upon the arts was profound. For example, monumental figurative sculpture was a virtually alien tradition in China until the arrival of Buddhism, which then provided a significant and continuing inspiration.

The immediate origins of the sculptural style of Buddhist art in China lie not in India but in the Gandharan art of Pakistan and Afghanistan of the 2nd to 5th centuries. This distinctive tradition, embodying Indian origins with a legacy of classical Greek influences, is demonstrated in two works in the gallery's collection (pictured page 28). Under the patronage of the ruling dynasty of north China, the Gandharan style reached its zenith in the second half of the 5th century in the massive rock-hewn carvings at the Yungang cave temples near Datong in northern Shanxi province. This idiom is echoed in the gallery's small sandstone votive stele of a seated Buddha dating from about 490–500 (page 91).

By the early 500s a profound change in approach had occurred because of the increasing 'sinicisation' of the Buddhist establishment and Chinese Buddhist sculpture assumed a style that, in its formalism and aesthetic austerity, more accurately reflected past Chinese traditions. Characterised by an elongation of the figure and an imposed geometry in the drapery, the style is well illustrated in two of the gallery's sculptures: a fine Northern Wei stele and a beautiful and finely carved limestone stele of the Eastern Wei dynasty (pages 92 and 93).

By the end of the 6th century fresh stylistic influences that had been carried from India along the ancient Silk Roads together with doctrinal developments in which the subjective appeal of the Paradise sutras gained ascendancy, instilled a new sense of naturalism in the Buddhist art of China. This considerable stylistic shift is well illustrated in the gallery's monumental and serene marble figure of the Buddha from the Sui dynasty (page 94). The elegant austerity of the early 6th-century style with its emphasis on the attenuation of the figure and the geometry of the drapery façade is here replaced by a volume-conscious image defined with sophisticated simplicity by the minimal pleats and folds of the robes. It is a style that conveys a hint of the human dimension which is in considerable contrast to the iconic formalism of the Northern Wei period and the early 6th century. In the succeeding Tang dynasty (618–906), when the Chinese empire expanded westwards and southwards and its gregarious embrace of new and foreign ideas reached unprecedented levels, Buddhism flourished under the continuing benefit of imperial patronage. Buddhist art also flourished in an increasingly appealing and naturalistic spirit that is illustrated in the gallery's limestone figure of a bodhisattva dating from the early part of the Tang dynasty (page 94). Indian influences are apparent in the subtle inflections of the body, the so-called

tribhanga pose, which brings a hint of unaccustomed sensuality to the usually objective Chinese aesthetic.

During the later Tang and succeeding dynasties Buddhism in China suffered from the loss of imperial patronage and increasingly became an extension of the established folklore of the country as opposed to a rigorous ideological philosophy. As a result Buddhist art lost that quality of spiritual rectitude which had been a characteristic of early Chinese Buddhism but nonetheless gained an appealing immediacy. This attitude instilled a more commonplace and secular image and character, which is well illustrated in the Song dynasty carved wood figure of the bodhisattva Guanyin.

The dominance of images of bodhisattvas, the compassionate beings who delay their own Enlightenment and remain earthbound in order to assist all sentient beings on their path to Enlightenment, in the Buddhist art of post-Tang China is illustrated in two particularly beautiful works. The style of the Song carved wood Guanyin (page 10) is evoked in an image of a gilt-bronze bodhisattva seated in the dignified but deliberately relaxed pose of 'royal ease', echoing the secular, almost seductive, nature of later Chinese Buddhist art (page 96). Its characteristic qualities of delicate incised ornamentation, the fluent robes and draperies and the subdued exoticism of the jewellery are also seen in the impressive gilt-bronze figure of

another luxuriously embellished bodhisattva, perhaps Maitreya, seated on a throne-like plinth in the so-called 'European' manner with legs apart and both feet on the ground (page 98).

As the repertoire of deities became more limited, other, more secular figures appeared, such as the luohan, a disciple of the Historical Buddha Shakyamuni. The luohan is depicted in a rare and beautiful painting dating from the Song dynasty (page 96, detail page 7). The exquisite detail in the rendering of the decoration of the robes and the fine defining lines are wholly characteristic of the Song aesthetic of refinement. Another aspect of the evolution of Buddhism at this time was the increasing reliance on the imagery and iconography relating to China's native legends and myths. An example is the impressive gilt bronze image of a Buddhist temple guardian figure, or *veda* in Sanskrit (Wei To in Chinese), dating from the late Ming or early Qing dynasty (page 99). Like the Buddhist guardian figure, or *lokapala*, from which this image is ultimately derived, it is characterised by a fierce countenance but has now assumed a less Buddhist appearance with a military costume in the traditional Chinese style.

Another aspect of this secularisation, or perhaps 'sinicisation', of Buddhism had its origins in the early Tang dynasty as a unique blend of Mahayana and traditional Chinese, especially Daoist, notions. The meditative, or Chan, school of Buddhism maintains the view that universal 'Buddha nature' is present in us all and may be realised directly, between master and pupil, without resource to rational thought, theories, canons or texts. Hence it developed an appealingly unconventional approach that was to attain widespread popularity in China and subsequently an indelible presence as the Zen school of Buddhism in Japan. The nature of Chan Buddhism was such that it did not require the support of iconography and imagery but survived in the minds and imaginations of the Chinese people, and most especially among the poets, painters and dreamers through the Song, Yuan, Ming and Qing dynasties. Formal icons were not in the Chan repertoire but often humorous, evocative and highly individual graphic interpretations were, from the classic and eccentric paintings of the Song masters to much later works by such artists as Wang Zhen, whose endearing and positively cranky image of the Chan patriarch Bodhidharma entitled *Nine years facing the wall* is the perfect expression of the Chan personality (page 168).

It was during the Song dynasty that Confucianism re-emerged as a kind of universal doctrine embodying both the earthly and abstract values which determined and fulfilled the practical and spiritual needs of the people. While the rise of neo-Confucianism contributed to the continued decline of Buddhism in

China, the faith was by no means extinguished. As interest in the more traditional forms of Buddhism that had flourished in the Tang and pre-Tang eras with the support of successive imperial houses waned, Tibetan Lamaism gained in popularity. It has survived to this day as the principal form of Buddhist practice in China. Around the middle of the first millennium a magical and mystical form of Buddhism, known as Tantrism, spread to Tibet and was transmitted to China, where it enjoyed only limited acceptance. Lamaism, which takes it name from the priests or 'lamas', is a form of Mahayana Buddhism which developed out of Tantrism in Tibet. Central to its belief is that salvation may be achieved primarily through ritual action and meditation. Hence the proliferation of colourful and exotic gods and deities that characterise Sino-Tibetan art in the Yuan, Ming and Qing dynasties. A fine example is the gilt bronze image of a seated Buddha inscribed with the mark of the Qianlong reign (1736–95), together with brief Mongolian, Tibetan and Sanskrit inscriptions (page 98).

Northern Wei dynasty (386–534)
Seated Buddha stele c500
sandstone, 24.5 x 32 cm
Edward and Goldie Sternberg Chinese Art
Purchase Fund 2001
2.2001

The distinctive feature of this small votive stele is the manner in which the robes on the main Buddha figure are carved: the incised lines of the drapery folds and the u-form patterns over the chest are in the Gandharan style of Pakistan and Afghanistan, which so influenced early Chinese Buddhist sculpture. On the facing edge of the plinth are two partially legible inscriptions. The one on the right reads 'For [our] deceased father, Ren Zhenxing in earnest [devotion to the Buddha]' which indicates that the stele was dedicated for the deceased father of Ren Zhenxing. The one on the left reads 'Our deceased father Ren A'dao is in attendance on the Buddha ... [characters illegible] respectfully ...'

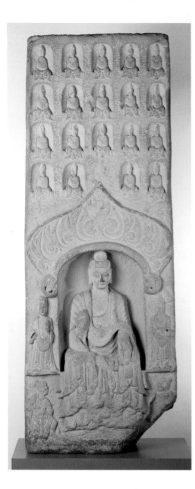

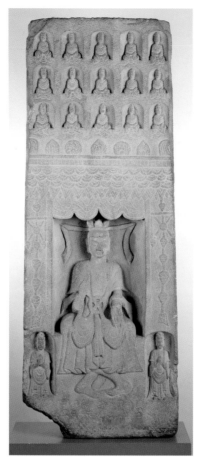

Eastern Wei dynasty (534–550)
Buddhist stele 534–550 CE
limestone, 61 cm
Purchased 1988
128.1988

With his right hand raised in the *abhaya mudra* and the left in the *varada mudra*, Shakyamuni Buddha stands flanked by the two bodhisattvas, probably Avalokiteshvara and Mahasthamaprapta. Carved in high relief on the halo are celestial musicians and a pair of *apsaras* (celestial beings) that support an image of the seated Buddha, possibly Prabhutaratna, the Buddha of the Past, who vowed to be present whenever the Lotus Sutra was invoked. The stele is carved from an exceptionally fine-grained limestone similar to that used in a large group of recently discovered 6th-century Buddhist sculptures from the Qingzhou region of Shandong province. The quality of the stone allowed for a high degree of refinement and meticulous detail in the carving, making this an especially fine and beautiful example of early Chinese Buddhist art.

Northern Wei dynasty (386–534)
Votive stele c530
sandstone, 14.8 cm
Purchased with the assistance of the Art Gallery Society of New South Wales and the Edward and Goldie Sternberg Chinese Art Purchase Fund
1995
202.1995

The front of this four-sided stele (pictured left) is carved with a principal image of Shakyamuni Buddha. His right hand is raised in the *abhaya mudra* (gesture of reassurance) and his left hand is pendant in the *varada mudra* (gesture of compassion). The Buddha is flanked by the standing bodhisattvas Avalokiteshvara (Guanyin) and, probably, Mahasthamaprapta (Dashizhi). The reverse side is dominated by an image of a seated Maitreya, the

Future Buddha, but here shown as a bodhisattva. Both these main images are carved in the formalised and elongated style characteristic of the early 500s. The surfaces are carved with numerous small Buddha images in niches bearing the names of donors and the phrase 'dedicated to the Buddha'. A dedicatory inscription on the upper right side of the stele, partially damaged, begins, '… *chang yuan nian* …', the absence of the first character precludes a precise date but indicates either 512, 525 or 535.

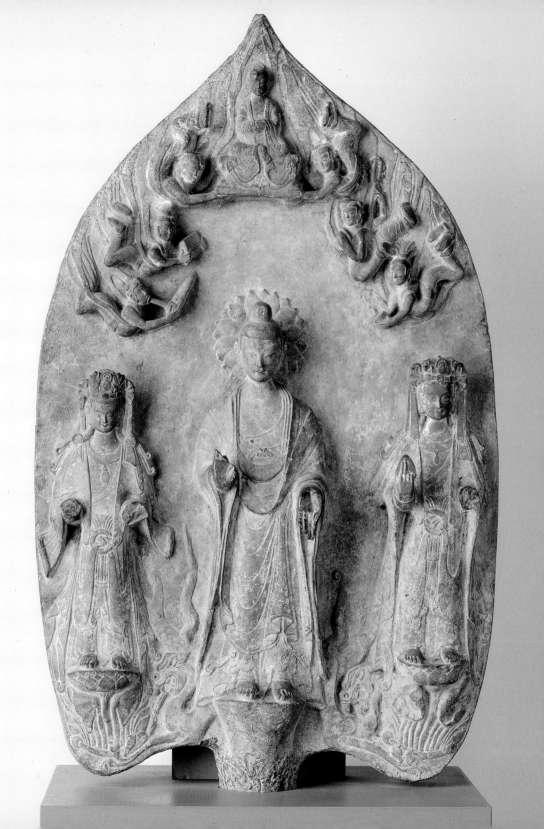

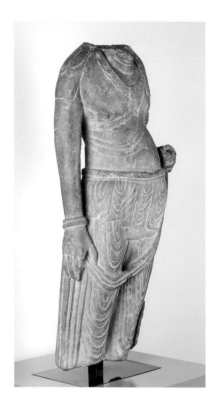

Tang dynasty (618-906)
Standing bodhisattva 700s
limestone, 109 cm
Purchased with funds from the Sydney Cooper
Bequest and Rene Rivkin 1982
241.1982

Carved from a hard, dark grey limestone
characteristic of Henan province, this
image of a bodhisattva, one who defers
his or her own Enlightenment in order to
help all sentient beings achieve theirs,
shows the new ideas of naturalism that
are characteristic of the Buddhist
sculptural style in Tang China. The subtle
but evocative lilt to the pose, known as
the *tribhanga*, the hint of seduction in the
bare chest and the figure-defining fall of
the draperies were all inspired by Indian
styles, which were most influential at this
time. A particular feature of this example
is the unusual and distinctive treatment of
the hair in a series of formalised curls on
the back of the shoulders.

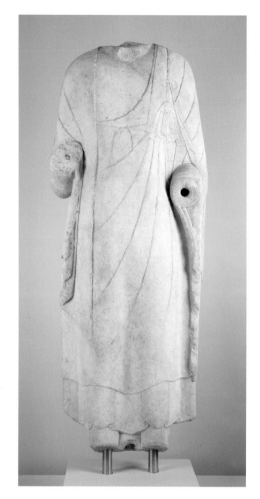

Sui dynasty (581–618)
Standing Buddha
marble, 210 cm
Art Gallery of New South Wales Foundation
Purchase 1997
432.1997

This monumental and imposing image of
the Buddha conveys great spiritual power
and presence with sophisticated
simplicity. The Buddha wears the regular
monk's dhoti, which is looped over his left
shoulder and held by a floral-like tassel.
The figure is distinguished by the eloquent
economy of the carving and the elegant
fall of the draperies, which are indicated
by a few simple, fluent lines. On the
reverse the simplicity is even more

pronounced but no less convincing. An
unusual feature on the back is the flaming
pearl or *cintamani* (wish fulfilling) jewel
carved towards the base of the figure.
The identity of the Buddha is uncertain
but it is most likely to be Amitabha, the
Buddha of the Western Paradise. The
distinctive micaceous white marble
material is consistent with sculptures from
the Dingzhou region of Hebei province.

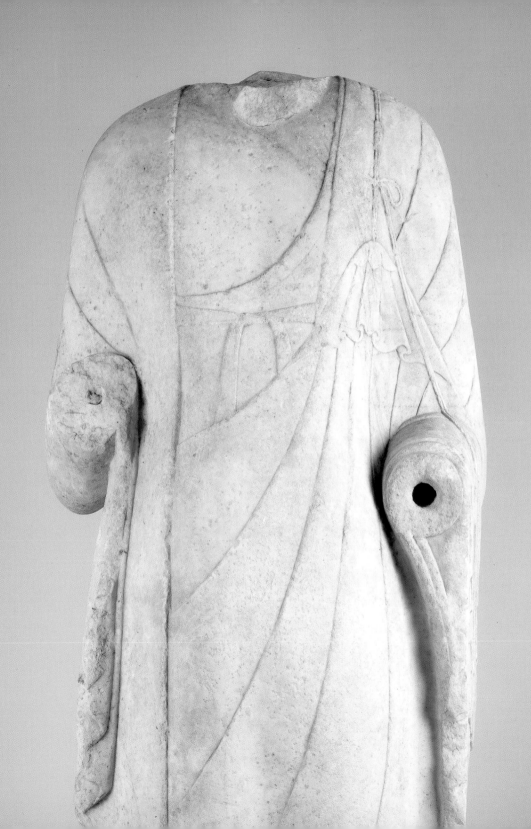

Southern Song dynasty (1127–1279)
Luohan 1100s–1200s
(detail) page 7
hanging scroll, ink and colour on silk,
118 x 40.2 cm
Purchased in memory of Goldie Sternberg 2003
110.2003

Luohans, or arhats, are disciples of the
Buddha and guardians of Shakyamuni's
interpretation of the Buddhist scriptures.
They are ascetics who have travelled the
Eight-fold Path and attained not
Buddhahood but Enlightenment, and are
thus freed from the fetters of the material
and secular world. In Chinese Buddhism
there are either 16 or 18 luohans. They are
depicted as highly distinctive individuals,
but clearly modelled on human
counterparts, and usually with their own
identifying symbol or emblem. In its quiet
and meticulous detail and rich technique,
this rare and beautiful painting of a luohan
is typical of the Song style. Depicted
characteristically as a monk, the figure sits
calmly beneath a canopy with his shoes
carefully placed below and his staff at his
side. On the table beside is an incense
burner in the form of an archaic bronze
vessel.

Yuan dynasty (1279–1368)
Seated bodhisattva
gilt bronze, 28 cm
Edward and Goldie Sternberg Chinese Art
Purchase Fund 2002
104.2002

This particular manifestation of the
bodhisattva seated in the 'royal ease'
pose on a rocky plinth is generally known
as 'water and moon' or *nanhai* ('Southern
Seas') Guanyin. These two appellations
appear to be interchangeable; both have
associations with water, with the former
usually rendered in painted form and the
latter in sculptural form. The terms appear
in Chinese Buddhist texts as far back as
the 700s. This image is more likely to be
the *nanhai* ('Southern Seas') interpretation,
in which role there is reference to Mt
Potalaka on the southern coast of India
where the Bodhisattva Avalokiteshvara
kept a benign eye on the faithful at sea.
Thus in China this version of the
bodhisattva also assumed a role as the
patron of seafarers.

Qing dynasty, Qianlong period (1736–95)
Seated Buddha
gilt bronze, 30.2 cm
Purchased 1996
479.1996

The Buddha sits with his right hand in the earth-touching gesture (*bhumisparsha mudra*), an attribute of the Transcendental Buddha Akshobya, characteristically shown as strong, pensive and imperturbable. Around the base are brief inscriptions in Sanskrit, Mongolian and Tibetan, and in Chinese the reign mark of the Qianlong emperor. This image of the Buddha reflects the influence of the Sino-Tibetan tradition in later Chinese Buddhist art.

Yuan dynasty (1279–1368)
Seated bodhisattva 1300s
gilt bronze, 69 cm
Purchased 1996
566.1996

The deity in this imposing gilt bronze image is probably the Future Buddha, Maitreya, but shown here as a bodhisattva. This identification is based on the figure being seated in the so-called European style with both legs pendant and the hands held in the *dharmachakra mudra* (teaching or turning the wheel of the law) – both mannerisms are generally associated with the Future Buddha. Also

visible are the now broken stems of the lotus flower traditionally held by Maitreya. The ornate dhoti tied at the waist and elaborate necklaces, headdress and jewellery are all characteristic features of bodhisattva images at this time. In later periods and in yet another form, Maitreya became one of the most popular of Buddhist images as Budai: a manifestation of the Future Buddha always represented as a fat, jolly fellow often known as the 'Laughing Buddha' (see Liu Xiao Xian's work, page 181 for an image of Maitreya in the form of Budai).

Ming dynasty (1368–1644)
Guardian figure
gilt bronze, 140.6 cm
Gift of Captain Francis Hixson 1905
1309

This commanding and fearsome gilt bronze figure depicts Wei To, a military bodhisattva who protects the Buddhist religion. His image was usually placed in the first hall of a Buddhist monastery. Dressed as a Chinese warrior in the elaborate armour worn by military heroes and originally holding a sceptre-shaped weapon (now missing), this figure reputedly came from the Palace of Longevity (Wanshougong) outside Beijing. The lion headdress symbolises Wei To's ferocity and his countenance, his determination to defend the faith of Buddhism.

EARLY CERAMICS

Through the gallery's collection can be traced much of the history of Chinese ceramics. The earliest example is one of the various types of Neolithic painted jars which have been found in sites across China. Archaeologists have now determined China's Neolithic age dates back to the 6th–5th millennium BCE, when the country was inhabited by village-based communities whose different cultures can be identified by their ceramic wares. At this time and in the succeeding Bronze Age, purely utilitarian ceramics tended to be undecorated, apart from occasional patterns achieved from cloth impressions or incisions into the damp clay, as demonstrated by the few pieces in the collection. Funerary and ceremonial jars, on the other hand, were painted.

Early in the Shang dynasty (c1700–1027 BCE), distinguished by its fabulous ritual bronzes, high-fired ash-glazed ceramics began to be produced. Requiring a firing temperature of more than 1100°C, these ornamental glazes were made possible by Chinese kiln construction and firing methods that were not achieved in West Asia or Europe until the 1700s. Further technical developments in Chinese ceramics were motivated by the search for a pure white body, and the skills to control and colour glazes gradually evolved, at first mainly in northern kilns but then in southern kilns as well. The Tang dynasty (618–906), distinguished by the quality and imagination of its arts, saw the production of fine quality whitewares that were the real precursors to porcelain. Moreover, the repertoire of shapes was greatly extended through contacts with the West as exemplified in the Tang glazed amphora (page 103) whose shape is ultimately derived from Hellenistic prototypes.

During the Northern Song period (960–1126) China prospered and expanded. In the flourishing capital Kaifeng, the civil service developed to a high standard through education and competitive examination, trade brought wealth, and a lively urban culture arose. Art, philosophy and literature were nurtured – to the extent that the word 'Song' is synonymous with sophistication, elegance and quality. The famous Emperor Huizong (r1101–25) fostered a taste for undecorated, softly coloured ceramics whose warm, rich glazes and elegant designs constitute a unique vocabulary of ceramic form and style that has been emulated throughout the world in subsequent centuries. Superior in invention and quality to those produced in southern kilns, northern wares have long been admired by the scholars and literati of China. They are listed in the famous *Ge Gu Yao Lun* of 1388 (an early Ming publication of Chinese connoisseurship and the oldest comprehensive account of Chinese antiquities).

In 1126 the Jin, a non-Chinese people, swept into China, forcing the Song court to flee from Kaifeng to

Hangzhou in the south. The Southern Song court sought to recapture the cultural brilliance of the Northern Song period, and the arts, particularly painting and ceramics, flourished under munificent patronage. Hangzhou became a grander and more resplendent city than Kaifeng. The wealth of some of its merchants derived from the export of ceramics, which were sent east to Korea and Japan and south to Indonesia, as well as to Africa and Europe. Of the wares which also enjoyed local patronage, the ceramics of Longquan in Zhejiang province stand supreme. The kilns in Zhejiang province in particular expanded with orders for all sorts of wares.

The glorious Song dynasty ended when the Mongols, who had conquered the Jin to the north in 1234, pushed south to conquer China in 1279. Their period of foreign rule was to last until the restoration of Chinese rule with the Ming dynasty in 1368.

Five types of ceramics produced during the Song dynasty have been designated the 'five great wares of China' since they set such high standards of innovation and technical perfection. These five great wares are Ding, Ru, Jun, Guan and Ge: the gallery has examples of Ding, Jun and Guan.

Qinghai province
Late Neolithic period (c2300–2000 BCE)
Jar with painted decoration
earthenware, 37.7 x 37 cm
Gift of Elisabeth M Smith 2002
294.2002

The geometric design on the upper portion of this jar is characteristic of the painted earthenwares of the Majiayao culture (c3300–2000 BCE). It belongs to the Mangchang phase (c2300–2000 BCE), named after a site at Machangyuan in the far western province of Qinghai.

Shandong (?) province
Longshan culture (c1300s–1000s BCE)
Tripod *li*
earthenware, 13.6 x 13.5 cm
Purchased 1983
231.1983

The *li* tripod is a uniquely Chinese cooking vessel, used for steaming. This so-called 'cord-marked' ware is typical of the large class of unglazed wares made for everyday use from Neolithic times through to the Zhou dynasty and later. The vessel comprises three mammary lobes standing on pointed feet, a shape probably inspired by leather prototypes.

North China
Han dynasty (206 BCE – 220 CE)
Jar with two loop handles
stoneware with incised decoration, 22 x 16.5 cm
Bequest of Eleanor Hinder through her executors
1975
265.1975

Here traces of glazing can be seen on the shoulder and the inside of the mouth. The glaze was formed by kiln ash – this use of chance glazing must have been employed for its decorative effect as by the Shang dynasty the Chinese had already developed more controlled methods of glazing. This piece and the *bu* storage jar (above centre) are important as early examples of the high-fired, ash-glazed stonewares central to Chinese ceramics. The shapes of these two examples demonstrate the two kinds of jars of the Han: one with a high neck spreading at the mouth, the other with a spherical body and flat mouth.

Jiangsu/Zhejiang province
Han dynasty (206 BCE – 220 CE)
Food storage jar *bu* 200s–300s
stoneware with olive glaze, 21.3 x 32.5 x 10.8 cm
(mouth diameter)
Gift of the Art Gallery Society of New South Wales
1962
EC1.1962

This piece is a typical example of the food storage jars found in tombs in the eastern region of China. From other existing examples, we can ascertain that these jars were originally made with covers that had a central knob. Early examples were made purely as funerary vessels (some have been found labelled and still containing foodstuffs in burial), but later pieces apparently served as storage jars and food containers in this life as well. As with other Han ceramic shapes, there was a bronze prototype, an obvious legacy of which is to be seen in the jar's mask handles, where the pattern is derived from the *taotie* mask, an important motif in ancient hieratic art.

North China
Sui dynasty (581–618)
Jar with cover
stoneware with olive green glaze, 19.5 x 15 cm
Gift of Graham E Fraser 1993
571.1993.a-b

This jar is an example of the early high-fired green glazed stonewares produced in the north of China from the 500s. Such pieces were the forerunners of the great northern and southern traditions of celadons. While the jar is a classic shape, it is rare to find a piece with its original lid.

North China
Sui/early Tang dynasty
Amphora 500s–600s
stoneware with translucent glaze, 30.7 x 14 cm
Purchased 1988
396.1988

Inspired by Western prototypes, this amphora is Greek in shape, here adapted by the use of dragon heads for handles. It is important technically as an example of the classic white wares produced just prior to the achievement of true porcelains. The term 'porcellaneous' stoneware is sometimes used to denote wares superior to ordinary stonewares, but not quite porcelain.

Henan province
Song dynasty (960–1279)
Vase c1200
stoneware with black glaze, 22 x 19 cm
Gift of Graham E Fraser 1993
332.1993

This is an example of the so-called black wares of northern China, which were produced at numerous kilns during the Song dynasty. Such ceramics were a popular ware for household use, rather than a quality ware produced in limited numbers for the delectation of connoisseurs. The appealing, rusty-brown splashes across the shoulder are the result of technical developments in kiln control: by around 1200 potters had learnt how to obtain patterns against the black glazed body by generating precipitations of iron oxide in a reducing atmosphere.

Henan/Hebei province
Yuan dynasty (1279–1368)
Cizhou ware jar
stoneware with black glaze decoration,
23.2 x 29.2 cm
Purchased 1965
EC3.1965

The most varied in shape and decorative techniques of the northern kiln wares were those of Cizhou, a diverse group of stonewares produced at a very large number of kilns distributed over the provinces of Henan and Hebei. Predominantly a monochrome ware glazed white, black or brown, the types of decoration include engraving or incising through a slip, the so-called cut-away design (when the slip is cut away to leave the design in the positive on the bare body) and painting over a slip. The potteries employed fine draughtspeople and in addition to slip decoration they occasionally used low-fired coloured glazes for decoration. This jar is a charming and unusual example.

DING WARE

The first of the classic wares to receive the patronage of the Northern Song court, Ding ware is distinguished by its thin white body, its warm, ivory-coloured glaze and the fluent beauty of its carved and incised decoration. The glaze has a tendency to pool in drops that Chinese poets have eloquently described as 'tear drops'. The Ding kilns are credited with several innovations in ceramic technology, including the method of firing upside-down (called *fushao*), which stopped the thinly potted, larger dishes from warping but also necessitated the application of a copper band to the unglazed rim. So subtle is the design on Ding ware that photographs still cannot do justice to the fluent beauty of its carved designs and the sensuous tactility of its glaze.

Hebei province
Northern Song period (960–1125)
Ding ware dish with design of lotus
1000s – early 1100s
porcelain with underglaze carved design, rim bound with copper, 4.3 x 19.7 cm
Bequest of Kenneth Myer 1993
581.1993

Hebei province
Northern Song period (960–1125)
Ding ware dish with peony design
1000s – early 1100s
porcelain with underglaze carved design, rim bound with copper; 6 x 30.4 cm
Anonymous gift 2000
134.2000

YAOZHOU WARE

Yaozhou ware was a widely distributed quality greenware believed to have been made for popular rather than court use. It was produced at kilns located north of Xian in Shaanxi province, and is named after the Song dynasty name for the area. It is the most highly regarded of the various green-glazed stonewares that in the West have been grouped together as 'northern celadon'. Characteristic of Yaozhou ware is the deep carving of the usually floral-inspired design, as exemplified in this shallow dish with its vibrantly carved peony decoration, where the pooling of the glaze in the deep and fluidly modulated carving emphasises the skilful design.

Shaanxi province
Northern Song period (960–1125)
Yaozhou ware dish
late 1000s – early 1100s
stoneware with carved and combed design under olive green glaze, 4.6 x 18.5 cm
Bequest of Kenneth Myer 1993
580.1993

Shaanxi province
Northern Song period (960–1125)
Yaozhou ware tripod censer
1000s–1100s
stoneware with moulded decoration, 9 x 11.7 cm
Gift of Laurence G Harrison 1990
102.1990

This rare censer echoes ancient bronze prototypes in its shape and decoration. Its characteristic olive green glaze was praised by poets as 'mysterious' (*mi*).

Shaanxi province
Jin dynasty (1115–1234)
Yaozhou ware bowl with chrysanthemum design
stoneware with carved decoration under olive green glaze, 9 x 21 cm
Purchased 1984
60.1984

After the fall of the Northern Song in 1127, many kilns in China's northern provinces that came within the domain of the Jin dynasty continued their production of northern celadon. Pieces such as this exemplify this continuity of production.

JUN WARE

Jun wares, produced close to the capital of Kaifeng, are related to the northern celadons and have a similar grey stoneware body. Their distinctive features are their simple and formal shapes and the rich lavender-blue glaze derived from an iron oxide in the glaze and reduction firing. These qualities are well illustrated in these examples. Later in the Song dynasty and more particularly in the Yuan period, copper was added to the glaze to produce contrasting splashes of red.

Song dynasty (960–1279)
Jun ware summer tea bowl
stoneware with green glaze, 5.5 x 10.5 cm
Bequest of Laurence G Harrison 1997
381.1997

This tea bowl, serenely beautiful in the simplicity of its form, is treasured for its unusual colour – green, rather than the more typical Jun blue.

Yuan dynasty (1279–1368)
Jun ware bulb bowl
stoneware with blue glaze, 6.8 x 21.2 cm
Purchased 1971
43.1971

JIZHOU WARE

The imperial court was forced to leave its capital at Kaifeng and flee south to Hangzhou in 1126. Among the southern kilns that were imposed upon to increase and improve production under the new patronage of the Southern Song court were those of Jian in Fujian province and Jizhou in Jiangxi province. These two centres were almost exclusively concerned with the production of tea bowls. The popularity of their bowls was a response to the rise of the tea cult and an aesthetic preference for drinking pale tea out of dark glazed bowls. The motif of the plum blossom appears in the art of Song dynasty China from the 1100s, with poets, court painters and craftspeople delighting in its transient beauty.

Jiangxi province
Southern Song period (1127–1279)
Jizhou ware tea bowl with slip design of plum blossom c1100s
stoneware, 5 x 11.1 cm
Gift of Graham E Fraser 1988
519.1988

Jiangxi province
Southern Song period (1127–1279)
Jizhou ware tea bowl c1100s
stoneware with 'tortoise shell' glaze,
5.4 x 10.5 cm
Purchased 1965
EC5.1965

Jiangxi province
Southern Song period (1127–1279)
Jizhou ware tea bowl c1100s
stoneware with resist design, 5.3 x 10.3 cm
Gift of Graham E Fraser 1988
520.1988

Such Jizhou ware glaze transmutations as 'partridge feather' and 'tortoise shell' were admired by the literati and Chan Buddhist monks. A Jizhou innovation was the use of cut-out paper patterns for reserve designs.

Zhejiang province
Southern Song period (1127–1279)
Ge ware tripod censer 1200s
stoneware with a crackled glaze, 7.5 x 9.8 cm
Bequest of Kenneth Myer 1993
584.1993

Popular among the Song court bureaucracy were ceramics with the appearance of 'crazing' (fine lines produced by the shrinking of the glaze in the kiln) in their thick glaze, enhanced by rubbing ink into the cracks. Wares such as this, known as Ge wares, are thought to have been produced at the Longquan kilns, probably only from the Yuan and early Ming periods, although traditionally they are considered a Song ware.

Zhejiang province
Southern Song period (1127–1279)
Guan ware brush washer in the shape of a plum blossom
stoneware with crackled glaze, 10.8 cm (diameter)
Gift of Mr J Hepburn Myrtle 1998
60.1998

'Guan' means 'official' and imperial Guan wares were made for the newly established Southern Song court after the style of wares made previously for the northern court at Kaifeng. Produced at the Guan kilns sited in present-day Zhejiang province, Guan wares, and Guan-type wares made at Longquan kilns, are among the most sumptuous of Song wares. Typically they are thin and dark-bodied, but thickly covered with many layers of lustrous greyish-green glaze with a mesh of crackle which has been enhanced by staining.

This piece exemplifies Southern Song taste and would have been among the desk accoutrements of a late Song literati aspiring to pursue a reclusive life of self-cultivation that focused on reading, poetry, painting and calligraphy.

YUE AND LONGQUAN WARES
Yue ware kilns hold a prestigious place in Chinese ceramic history. Located in Zhejiang province, the kilns produced the earliest green-glazed high-fired ceramics in the Tang dynasty. These wares were admired technically for their hardness and aesthetically for their shapes and colouring, qualities without precedent in China or elsewhere. The Yue ware tradition was continued at the Longquan kilns.

Zhejiang province, Shaoxing
Song dynasty (960–1279)
Yue ware covered box
stoneware with incised design, 3.5 x 6.2 cm
Bequest of Kenneth Myer 1993
579.1993.a-b

Zhejiang province
Ming dynasty (1368–1644)
Longquan ware stem cup 1300s
celadon, 12.7 x 12.9 cm
Bequest of Laurence G Harrison 1997
379.1997

A variety of decorative devices were employed on Longquan ceramics yet they were admired ultimately for their colour, which ranged from a pale blue-green to grey-green to olive. Song Longquan is the most esteemed as it attained an excellence of glaze and style which has never been surpassed. The subtle colours and elusive beauty of celadon have been compared by poets to jade, which from deep antiquity was considered the most precious of stones and symbolised the moral virtues of the Confucian scholar.

Zhejiang province
Ming dynasty (1368–1644)
Longquan ware dish with carved lotus design c1400–50
celadon, 6.5 x 46.5 cm
Bequest of Laurence G Harrison 1997
394.1997

The word 'celadon', still in popular usage, was introduced by a 19th-century French collector after a character in a 17th-century French play whose costume was a similar green in colour. The word does not occur in Chinese scholarship, where 'greenwares' is the preferred term.

Zhejiang province
Song, Yuan and Ming dynasties
Group of Longquan ware ceramics
Bequest of Laurence G Harrison 1997

from left:
Vase in the shape of a well bucket
celadon, 12 cm
382.1997

Vase
celadon, 36.8 x 14.5 cm
389.1997

Bowl in shape of lotus leaf
celadon, 5.6 x 11.8 cm
380.1997

Covered vase
celadon, 26.7 cm
392.1997

Saucer dish with slip design of antelope and foliate edge
celadon, 3.5 x 12.8 cm
384.1997

THE MARVEL OF PORCELAIN

The Chinese have two basic terms for ceramics: *tao* meaning pottery in general, but also earthenware or low-fired ware; and *ci*, meaning high-fired ware whether porcelain or stoneware. The origin of the English word 'porcelain' is the Portuguese *porcellana*, meaning 'cowrie shell', and its use derives from the resemblance of the shell to the translucent white body of the Chinese ceramics imported into Europe from the 1500s. Porcelain is a white, hard-paste, translucent ware made by combining kaolin, a white-firing aplastic clay, with porcelain stone (petunste), a white highly feldspathic material found in deposits in southern China, and firing them to a high temperature. Europe did not discover the secret of making porcelain until the 1700s, and hence imported huge quantities of this greatly admired material.

As early as the Shang dynasty (c1700–1027 BCE) Chinese potters were making a high-fired whiteware, impervious to water and fired at about 1200°C. Tomb finds at the late Shang capital of Anyang in Henan province included white vessels made in imitation of the bronze vessels with which they were found, the earliest examples of a long tradition of ceramics inspired by bronze prototypes.

The tradition of high-fired whitewares continued into the Tang dynasty (618–906), when in the south in Jiangxi province the clays necessary for the production of the more appealing porcelain were discovered. By the beginning of the 11th century the kilns in Jiangxi province, blessed with an abundance of the required materials, were producing an extremely refined porcelain with a transparent glaze of a slightly bluish cast. Called *qingbai* (literally 'bluish white') or *yingqing* (shadow blue), it soon became an important export item, traded by the Chinese in exchange for spices, medicinal plants, cosmetics and other luxury goods. *Qingbai* porcelain was also popular with the local market, as demonstrated by the vast quantities that appear in Southern Song tombs. When the Mongols gained control of China and established the Yuan dynasty (1279–1368), their encouragement of the lucrative overseas trade transformed the kilns of Jiangxi, particularly those at Jingdezhen, into a series of industrial complexes. Most of the gallery's examples of *qingbai* porcelain were made for the lucrative export market to Southeast Asia.

During the Yuan dynasty, in the early 1300s, the pigment cobalt blue started being used for decorative purposes, thus instigating the magnificent and enduring tradition of blue-and-white porcelain. The technique of applying cobalt blue under the glaze was introduced through contact with West Asia, which was also the catalyst for new shapes and designs in Yuan porcelain.

EARLY MING PORCELAIN

When a combination of peasant rebellions and natural disasters brought to an end the Yuan dynasty and saw the restitution of Chinese rule in 1368, once again the arts flourished under a benevolent, if introverted, imperial patronage. Chinese porcelain produced in the 1400s, specifically under the reigns of the Ming emperors Yongle, Xuande and Chenghua, is esteemed for its quality of body, glaze, form and decoration. The standard was set by the Yongle emperor (r1403–24), who ruled over one of the most splendid periods in Chinese history. He established the imperial capital at Beijing and was responsible for the planning and construction of the Forbidden City, which still stands today as a monument to imperial grandeur and human aspiration. His patronage of the arts embraced a strong support of the porcelain factories at Jingdezhen, which began producing porcelains of the highest quality to imperial orders, some undecorated, others decorated in underglaze cobalt blue. The gallery's Yongle period dish (page 114) demonstrates the new standards: the paste was finer in grain and of a pure whiteness, the potting more skilful, the forms more elegant and the decoration more refined. Other fine gallery examples of 15th-century porcelain decorated in underglaze blue include a stem cup of the Xuande period and a deep bowl dating to about 1455.

LATE MING PORCELAIN

By the beginning of the 1500s the Ming dynasty had passed its zenith and was entering a gradual decline that impacted on the patronage of ceramics. Porcelain from this period has a different quality to the refined perfection of 15th-century porcelain: bodies are more robust and the decoration more exuberant and often more colourful. Illustrated books provided new sources of inspiration for designs that became more informal and naturalistic in order to achieve a wider appeal. The main technical innovation of this period was the introduction of medium-fired lead silicate glazes that could be used in a various ways. In one technique the design was executed by applying coloured glazes within incised outlines, as seen in the rare green and yellow stem bowl of the Zhengde period (page 120). In another, the design was painted with wax resist before glazing and firing.

The late Ming periods of Jiajing (1522–66), Longqing (1567–72) and Wanli (1573–1619) saw greater freedom in ceramic decoration and a liking for *wucai* (five-colour) enamel decoration. *Wucai*, a combination of underglaze blue and overglaze polychrome enamels, was an important innovation of the Jiajing period and one of the last major additions to the lexicon of ornamental techniques that were developed during the Ming dynasty.

QING PORCELAIN

When the Manchus overran China to establish the Qing ('pure') dynasty, they had little influence on China's cultural life. During the Qing dynasty (1644–1912) most porcelain was produced at Jingdezhen and can be classed into three types: *guanyao*, imperial or official ware; *minyao* or popular ware; and export ware. Imperial ware was produced at workshops set up and supervised by controllers appointed from the imperial household. The finest porcelain of the period was made between 1680 and 1753 after Emperor Kangxi instigated a regeneration of the Jingdezhen kilns by appointing the talented director Zang Yingxuan, who was followed by two more exceptional men – Nian Xiyao and Tang Ying.

The number, colour and design of porcelain used at the court was strictly regulated and manufactured only at the imperial kilns. Wares were made for household and ceremonial use as well as for imperial gifts, with many of the designs reflecting the strong interest of the Qing court in Ming porcelain of the 15th century.

The Qianlong reign (1736–95) is regarded as the most impressive period of Qing history. The emperor was a devotee of the arts and an enthusiastic collector of porcelains, even having his own poems inscribed on pieces. The official wares of Qianlong are technically faultless, confident in style and decoration, and determinedly Chinese in all respects with a clear preference for long-established patterns and shapes. Characteristic of this style is the gallery's moonflask (page 127), where the shape has a Ming prototype and the dragon is painted in underglaze copper red. Further proof of the antiquarian interests of the Qing court is the superb Yongzheng period bulb bowl with pale celadon glaze, made in emulation of Song celadons (page 128).

Throughout the Kangxi, Yongzheng and Qianlong periods – when the porcelain was of the highest quality – monochromes were an important and beautifully varied class of wares. The largest group is the copper reds, which range from dark crimson to pale red and are produced by firing in a reducing atmosphere (when the amount of oxygen allowed into the kiln is restricted). On display in the gallery is a red *meiping*, a purely Chinese shape specifically designed for the display of a branch of flowering plum (pictured page 128).

In the latter half of the 1700s official porcelain became characterised by over-elaboration; underglaze blue decoration was largely supplanted by opaque enamel colours, which sometimes covered the whole porcelain surface.

LATE IMPERIAL PORCELAIN

During the 1800s China faced disastrous economic and political problems, but production of imperial

porcelain was maintained until 1911 with little reduction in the levels of quantity but some loss of quality – for example in the first half of the century an almost imperceptible greying of body colour and little originality in design. But some new technical accomplishments were achieved, with more colourful, compositionally crowded designs, and a new type of 'medallion' bowl with external enamel and interior blue-and-white decoration was produced in the Jiaqing and Daoguang periods.

Jingdezhen was occupied by the Taiping rebels from 1853 to 1864. Decline continued, and the kilns never again attained the quality of the imperial wares of the 1400s and 1700s, although more recently they are beginning to regain their stature.

'Hill' censer 1200s
porcelain with *qingbai* glaze, 10 x 8.4 cm
Gift of Mr J Hepburn Myrtle 1990
250.1990 a-b

The so-called *qingbai* (bluish white) ware was popular with local as well as overseas markets. The prototype for this purely Chinese shape is the bronze *boshanlu* type believed to be a representation of Penglai-shan, the mythical abode of the Daoist Immortals.

Covered box 1100s–1200s
porcelain with *qingbai* glaze, 3.3 x 7 cm
Bequest of Kenneth Myer 1993
589.1993.a-b

All porcelains illustrated in this section were made at the Jingdezhen kilns in Jiangxi province, unless otherwise stated.

Ming dynasty, Yongle period (1403–24)
Dish with design of flowers of the four seasons
porcelain with underglaze blue decoration,
7.5 x 38 cm
Purchased 1988
514.1988

The Chinese taste for blue-and-white decoration had been instigated by Islamic markets in the Yuan dynasty. It was their patronage that had forced potters to devise methods of making a porcelain that was denser and harder, to resist the kiln hazards of firing large pieces and the possibility of damage en route overseas. The moulded cavetto and foliate rim on this piece were inspired by Persian metal prototypes. The design draws on the popular theme of flowers of the four seasons, although there was no prescribed selection of flowers since an artist was not unduly concerned with botanical accuracy. Here the central flower is the peony, an auspicious symbol of wealth. It is surrounded by flowers of the four seasons, with flowers of the 12 months in the cavetto. The rim is decorated with the *lingzhi* (fungus of immortality) motif.

Qing dynasty, Yongzheng (1723–35) mark and period
Dish with bouquet design
porcelain with underglaze blue decoration,
3.6 x 15.5 cm
Gift of Mr J Hepburn Myrtle 1992
194.1992

This small dish exemplifies the persistent admiration for classic Ming porcelains. In the high point of Qing ceramic porcelain, 'copies' such as this, which in shape and design emulate the Yongle example (right), were of superb quality.

Ming dynasty, Yongle period (1403–24)
Dish with bouquet design
porcelain with underglaze blue decoration,
7.4 x 40.9 cm
Bequest of Kenneth Myer 1993
575.1993

Ming dynasty, Xuande (1426–35) mark and period
Stem cup with design of the eight Buddhist emblems
porcelain with underglaze blue decoration, 10 x 11.9 cm
Purchased 1979
464.1979

This stem cup was used in Buddhist rituals, when it would have been filled with clear water and placed on an altar. Its decoration is appropriately Buddhist: the eight Buddhist emblems of the wheel of the law, the conch shell, the canopy, the vase, the paired fishes, the umbrella, the lotus and the endless knot, each surmounts a lotus bloom, the Buddhist symbol of purity. The cobalt blue has the characteristic technical feature of an unevenness of colour. Termed 'heaped and piled', this effect – in fact a lack of control of the cobalt – is esteemed by connoisseurs. Later 18th-century potters sought to emulate it, usually without success.

Ming dynasty, Xuande mark but c1455
Bowl
porcelain with underglaze blue decoration, 10.3 x 21.3 cm
Purchased 1975 ex collection Alfred Clark
56.1975

Although this bowl bears the Xuande mark (above right), noted Chinese ceramic authority Margaret Medley has dated it to the so-called Interregnum period between the Xuande and Chenghua periods. She did this mainly on a stylistic basis: 'the use of two stylised lotus of standard type on the outside separated from each other by the very unusual type with a central three spurred tip in the centre, a form quite familiar in Chenghua and later, but not in Xuande'. It was during the reign of the Xuande emperor that the practice of marking imperial porcelain with the reign mark began. This six-character mark, although not accurate in dating the piece, is well written.

Ming dynasty, Hongzhi (1488–1505) mark
and period
Dish with dragon design
porcelain with underglaze blue decoration,
4.4 x 21.5 cm
Gift from the collection of Mrs Orwell Phillips by
her children Florence Marks, Orwell Phillips and
Barbara Selby 1980
192.1980

Hongzhi mark and period blue-and-white
porcelain is rare in itself, but the design on
this piece – a dragon in a lotus pond rather
than the more frequently encountered
clouds – further enhances its rarity and
importance.

Ming dynasty, Hongzhi (1488–1505) mark
and period
Dish with hibiscus spray design
porcelain with underglaze blue and overglaze
yellow decoration, 5 x 26.7 cm
Edward and Goldie Sternberg Chinese Art
Purchase Fund 1989
366.1989

This blue and yellow dish has one of the
classic designs of Ming porcelain. While
the pattern was created in the Xuande
period, the use of the yellow ground
became the most popular treatment for
this design and perpetuated the tradition
of the 'imperial' yellow reserved for the
use of the emperor. From early Chinese
texts on ceramics we know that pieces
of the Hongzhi period were most admired,
both for the perfection of the body and
for the quality of the yellow glaze. Yellow
was the imperial colour, hence a common
feature of pieces made for use in the
Forbidden City in Beijing. Chinese
connoisseurs were particularly sensitive
to the quality of the tone of yellow on

imperial pieces, assessing it with accurate
and evocative descriptions such as the
soft colour of steamed chestnuts or the
brightness of sunflowers. The yellow on
this dish is particularly good.

Designs such as this were created by
the most regarded artists at the imperial
court in Beijing with the drawings sent
to the porcelain factories to be copied.
The draughtsmanship of the design is
exemplary: the central hibiscus spray
elegantly fills the space in complete
harmony with the form of the dish, while
the sparsely distributed leaves and
branches are beautifully placed in relation
to each other.

DOUCAI

Imperial porcelain of the Chenghua period is esteemed for the purity and quality of the porcelain clay, the innovation and delicacy of design and the perfection of the *doucai* ('contrasting colours') technique. This technique, in which overglaze enamels are applied to a design delineated in underglaze blue, must have been difficult and expensive for it is confined to small, intimate objects of exquisite refinement. So esteemed was Chenghua *doucai* that it was copied in succeeding centuries, most notably in the 1700s as demonstrated in the gallery's delicate example of the famous 'chicken cup' type (far right).

Ming dynasty, Chenghua (1465–87) mark and period
Jar with five quatrefoil panels
porcelain with underglaze blue and overglaze enamels in the *doucai* style, 12.1 cm
Anonymous gift 1939
6956.42

The six-character mark on the base of the jar indicates it was made before 1481, when the single character for 'heaven' replaced the reign mark. The freely drawn underglaze blue outlines are clearly visible beneath the adeptly applied overglaze enamels of iron red, green and dark yellow. This rare example has a companion piece (with cover) in the Palace Museum in Beijing, but few other examples exist of this important type of early *doucai* decoration.

Ming dynasty, Jiajing (1522–66) mark and period
Dish with ruyi design
porcelain with underglaze blue and overglaze enamels in the *doucai* style, 3.1 x 14.7 cm
Gift of Mr J Hepburn Myrtle 1990
227.1990

Judging by its quality, this small dish, with a delicately executed *doucai* design of interlocking *ruyi* lappets, was probably made early in the reign before standards declined as the Ming court was distracted by growing political and social problems. It is a direct copy of a Chenghua prototype.

Qing dynasty, Yongzheng (1723–35) mark
and period
Dish with design of five red bats
porcelain with underglaze blue and overglaze
enamels in the *doucai* style, 15.5 cm (diameter)
Purchased 1965
EC1.1965

The decoration on this classic Yongzheng
period dish convey birthday greetings and
Daoism: the scene of five red bats (*wu fu*,
a homonym for the Five Happinesses
which are health, wealth, many sons, a
long life and a peaceful death), peaches (a
symbol of longevity) and waves (indicating
the Daoist Eastern Seas, which contain
the Isles of Immortality). The small dish is
both exquisite in quality and of interest
technically. In line with the Yongzheng and
Qianlong periods' enthusiasm for reviving
classic Ming techniques and glazes, the
dish is decorated in the *doucai*
(contrasting colours) technique.

Qing dynasty (1644–1912)
Wine 'chicken' cup c1725–50
porcelain with underglaze blue and overglaze
enamels in the *doucai* style, 3.8 x 8.1 cm
Gift of Mr J Hepburn Myrtle 1992
193.1992

Chickens were considered an auspicious
emblem, hence the decoration and
name of this classic Chinese porcelain.
Decorated on one side with a scene of
rooster, hen and four chickens, on the
other with the same family but with two
of the chicks fighting over a worm, this
delicate cup is an excellent copy of a
Chenghua original.

Ming dynasty, Zhengde (1506–21) mark and period
Stem bowl with two dragons
porcelain with yellow and green enamel decoration, 10.8 x 15.8 cm
Purchased 1966
EC3.1966

This bowl, a successful integration of complex techniques, is another rarity within the Chinese porcelain repertoire. It comprises engraved designs – on the interior *anhua* (secret) decoration, and on the exterior two dynamic dragons among clouds – realised in brilliant emerald green and yellow ground enamels applied to the biscuit. To achieve the translucent brightness of the green, it was applied directly to the biscuit body. Firstly, the design was incised and covered with wax. Then the vessel was completely coated with a glaze and fired. The wax melted in the firing, and the exposed portion was later painted over with green enamel. The complex technique is another example of the lengths to which Chinese potters went in their search for new effects and clarity of colour.

Ming dynasty, Zhengde (1506–21) mark and period
Dish with dragon design
porcelain with green enamel decoration, 4.2 x 18 cm
Purchased 1964
EC2.1964

A unique green enamelled ware with a white ground is distinctive to the Zhengde period. Without exception this ware featured flying dragon motifs. The Zhengde mark (pictured) appears on the base in two columns in underglaze blue.

Ming dynasty, Wanli (1573–1619) mark and period
Pentafoil basin
porcelain with *wucai* enamel decoration, 6.8 x 27.5 cm
Gift from the J Hepburn Myrtle collection 1999
117.1999

Ming dynasty, Wanli (1573–1619) mark and period
Dish with design of dragon and phoenixes
porcelain with *wucai* enamel decoration, 4 x 27 cm
Purchased 1988
302.1988

Popular during the Wanli period was the use of the colourful *wucai* (five colours) enamels, when underglaze blue was combined with overglaze enamels. Red, green, yellow and black, and occasionally turquoise were used with unrestrained verve. Dragons were a lively Daoist-inspired choice for *wucai* decoration, as were flowers.

Ming dynasty, Jiajing (1522–66) mark and period
Dish with design of the Three Friends
porcelain with underglaze blue decoration,
3.2 x 17.6 cm
Gift of Florence Marks, Orwell Phillips and Barbara Selby 1980
193.1980

The Jiajing emperor was a faithful disciple of Daoism. The imperial partiality sparked a wave of enthusiasm for Daoist religion throughout the empire, and set a fashion in the decorative arts. Motifs relating to Daoism were most favourably employed in the decoration of ceramics as seen in this dish decorated in a rich blue with the motif of the Three Friends (prunus, pine and bamboo). The Three Friends are symbolic of independence, endurance and integrity. This new type of bright, strong blue was made from a cobalt known as Mohammedan blue.

Ming dynasty, Wanli (1573–1619) mark and period
Tripod censer
porcelain with underglaze blue decoration,
11 x 8.7 cm
Gift from the J Hepburn Myrtle collection 2000
133.2000

The glassy glaze has a blue tinge and at the mouth rim the glaze has broken in a few places in the 'tender edges', or in Japanese *mushikui,* effect. Both features are indications of the technical decline found on late Ming ceramics from non-imperial Jingdezhen kilns.

Ming dynasty, Wanli (1573–1619) mark and period
Fish bowl
porcelain with underglaze blue decoration,
38.5 x 65.5 cm
Purchased 1964
EC4.1964

Ming dynasty, Wanli (1573–1619) mark and period
Wall vase of double-gourd shape with flat back
porcelain with underglaze blue decoration,
32 x15.1 x 8 cm
Purchased 1988
301.1988

By the Wanli period, the imperial palace in Beijing was not as prescriptive about designs as it had been in the past, and there was a decrease in imperial orders as the court was distracted by more pressing political matters. Potters had to find new markets, so designs changed and new styles emerged. The literati were keen customers and would have bought works such as this wall vase with a popular figurative subject of scholars in a garden and the tripod censer in antiquarian style (above centre).

Qing dynasty, Kangxi period (1662–1722)
Pair of vases c1680–1700
porcelain with *famille verte* decoration,
27.5 and 28.5 cm
Purchased 1965
EC2.1965.1-2

These two vases on attached simulated
wood bases are the finest pieces of
Kangxi *famille verte* in the gallery's
collection. Both vases have the same
design but are executed by different
hands. This particular design would seem
to indicate the dependence of ceramic
decorators on woodblock printed
manuals, for it is almost an exact replica
of a work by the famous bird-and-flower
painter Chen Hongshou (1598–1652), who
contributed to such manuals and was an
innovative exponent of the academic style
of bird-and-flower painting that had
gained prestige in the Southern Song
dynasty.

Qing dynasty, Kangxi period (1662–1722)
Vase with ladies in landscape design
porcelain with *famille verte* decoration,
46.3 x 21.5 cm
Purchased 1977
224.1977

A popular innovation of the Kangxi period
was *famille verte*, a term coined in the mid
1800s by the French ceramic collector
Albert Jacquemart to refer to the prevailing
green colour in the overglaze decoration.
This style of pictorial decoration was
especially favoured at the imperial court.

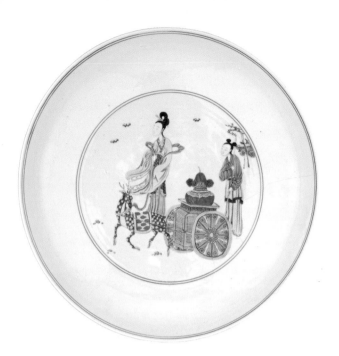

Qing dynasty, Kangxi (1662–1722) period
but Chenghua (1465–87) mark
Large dish early 1700s
porcelain with *famille verte* decoration,
7.2 x 39.6 cm
Gift of Mr J Hepburn Myrtle on the occasion of the
opening of the 1987 Asian Gallery
435.1987

Daoism provided the imagery of the
spotted deer, a symbol of longevity,
pulling a cart. The motif appears in this
charming design, laden with auspicious
connotations. The lotus-leaf covered jar
undoubtedly contains elixir, while the
maiden is probably Magu, who presents
peaches to Xi Wangmu, Queen Mother of
the West, on her birthday.

Qing dynasty, Kangxi (1662–1722) mark
and period
Imperial birthday dish with peach
porcelain with *famille verte* decoration,
5.5 x 28.6 cm
Purchased 1971
141.1971

The delicately painted peach, a symbol of
longevity, floats against a fine white
porcelain ground. The peach is inscribed
with the gold seal characters *wan shou* (a
myriad longevities), an imperial birthday
greeting. A similar birthday dish is in the
Percival David collection in London.

Qing dynasty, Kangxi (1662–1722) mark
and period
Bowl with dragon roundels
porcelain with underglaze blue decoration,
9.5 x 19.7 cm
Purchased 1965
EC7.1965

Qing dynasty, Yongzheng (1723–35) mark
and period
Fruit bowl
porcelain with underglaze blue decoration,
12 x 28.9 cm
Purchased 1966
EC2.1966

Qing dynasty, late Kangxi/early
Yongzheng period but Chenghua
(1465–87) mark
Dish early 1700s
porcelain with underglaze blue decoration,
39.2 cm (diameter)
Bequest of Mr Alan Renshaw 1975
285.1975

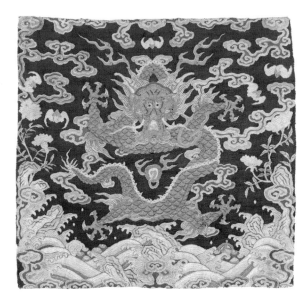

Qing dynasty, Qianlong period (1736–95)
Insignia badge for a noble
kesi (woven silk), 26 x 27.3 cm
Gift of Judith and Ken Rutherford 2000
189.2000

In the Ming and Qing dynasties the aristocracy as well as civil and military officials wore rank-defining badges on the front and back of their robes. The gallery is fortunate to have several of these fascinating symbols of China's established hierarchies. Civil officials wore badges displaying birds, and military officials badges displaying ferocious animals. Both groups were graded in nine ranks. Badges worn by the aristocracy are less common.

Rank badges are often referred to as 'pictures in silk' and this is a superb and rare example of a noble's badge, made in the unique Chinese style of *kesi*. It depicts a fully frontal five-clawed dragon, surrounded by cloud, peony, bat and *lingzhi* (magic mushroom) motifs. The square forms a perfect match to the porcelain moonflask and is another expression of the zestiness of the Qianlong period.

Qing dynasty, Qianlong (1736–95) mark and period
Moonflask with design of dragon and flaming pearl
porcelain with underglaze blue and red decoration, 30.5 cm
Purchased 1964
EC1.1964

In terms of purity of the porcelain body, the attainment of form, the vitality of colour and the vivacious design, this is another splendid piece. The use of underglaze copper red – brilliantly realised in the rampant five-clawed imperial dragon and flaming pearl – was restricted to official wares for reasons of expense and the difficulty of manufacture (the red pigment is difficult to fire because of its volatility). The gregarious and flamboyant nature of the Qianlong period, seen so well in this moonflask, is echoed in textiles such as the noble's badge above.

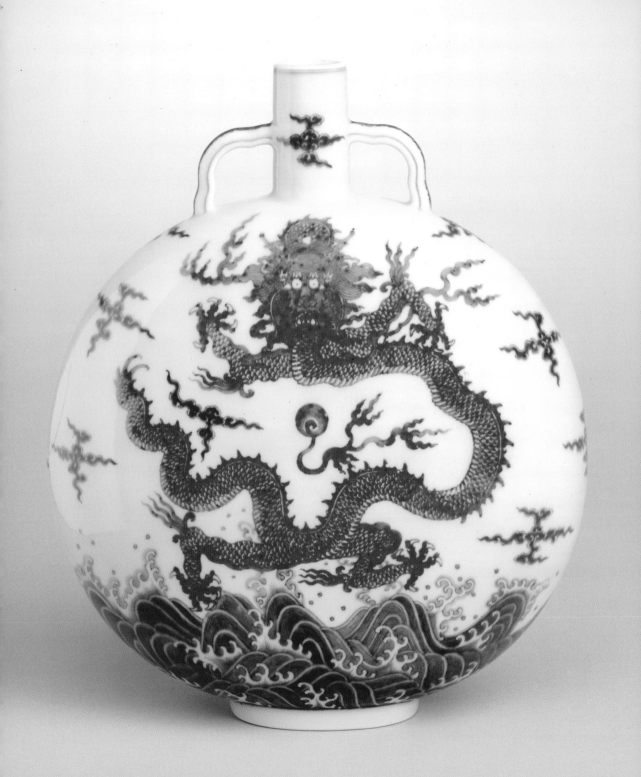

QING MONOCHROMES
The ceramics shown here illustrate the variety of colours produced during the Qing dynasty, when potters excelled in the application of overglaze enamels.

Yongzheng (1723–35) mark and period
Stem cup
porcelain with blue glaze, 10.6 cm
Purchased 1965
EC8.1965

Zhejiang province
Qianlong period (1736–95)
Longquan ware vase in double-gourd shape
celadon, 34.3 cm
Bequest of Laurence G Harrison 1997
387.1997

Yongzheng period (1736–95)
Vase with strap handles
porcelain with *clair de lune* glaze, 14 cm
Purchased 1921
9952.7

Yongzheng (1723–35) mark and period
Meiping (plum blossom vase)
porcelain with red glaze, 25.5 cm
Gift of Mr J Hepburn Myrtle 1988
190.1988

Yongzheng (1723–35) mark and period
Bulb bowl
celadon, 31.1 cm (diameter)
Bequest of Kenneth Myer 1993
576.1993

Qianlong (1736–95) mark and period
Dish
porcelain with red glaze, 16.3 cm (diameter)
Gift of Mr J Hepburn Myrtle 1984
64.1984

Qianlong period (1736–95)
Altar vessel *zun*
porcelain with yellow glaze, 29.2 x 24.1 cm
Purchased 1969
EC3.1969

Tongzhi period (1862–73)
Altar vessel *fi*
porcelain with yellow glaze, 29 x 27.5 cm
Purchased 1987
(601.1987)

Jiaqing period (1796–1820)
Ritual vessel *dou*
porcelain with amber glaze, 29.2 cm
Purchased 1967
EC5.1967

From the Qianlong period on, a separate
type of monochrome ware was produced
for ritual use by the emperor. These
vessels were catalogued in a book called
*The illustrated regulations for the
ceremonial paraphernalia of the Qing
dynasty* compiled in 1759. The pieces
were made in forms derived from ancient
bronzes and their colour was determined
by the Beijing temple they were made for,
such as yellow for use in the Temple of
Earth and blue for the Temple of Heaven.

Qing dynasty, Guangxu (1874–1908) mark and period
Bowl with floral design
porcelain with overglaze enamel decoration,
9.1 x 20.4 cm
Gift of Mr J Hepburn Myrtle 1983
221.1983

A dominant force in the last 60 years of the Qing dynasty was the ruthless Empress Dowager Cixi. Her taste in porcelain is reflected in the type often referred to as 'Empress Dowager' porcelain, said to have been made specially for her use during the reign of her nephew, the Guangxu emperor (1874–1908). Porcelains richly decorated with imperial yellow and pictorial scenes of birds and flowers were popular with her, as was the use of 'European green'.

Qing dynasty (1644–1912)
Bowl with foliate edge late 1800s
porcelain with enamel decoration including 'European green', 15.3 x 15.5 cm
Marks: on the side, 'springtime in Heaven and Earth one family' and 'Studio of Great Culture'; on the base 'eternal prosperity and enduring spring' (*yongqing changchun*)
Gift of Mr J Hepburn Myrtle 1990
253.1990

This bowl is part of a dinner service which carries the hallmark of a pavilion where the Empress Dowager once resided.

Republic period (1920s–30s)
Pair of bowls
Shining porcelain, four-character Qianlong mark within double square in blue enamel on base, 6.3 x 12.3 cm each
Gift of Mr J Hepburn Myrtle 1983
220.1983.1-2

A late technical innovation was the production of ultra thin, glassy porcelains called 'Shining' after the famous Jesuit brother and artist Castiglione (Chinese name Lang Shining). The decoration on many Shining ware pieces includes a poem at the end of which are two seals in vermilion, *shi* and *ning*. Bowls were customarily made in pairs, the decoration on one being an exact mirror image of the other. The bowls were invariably fired in the kiln mouth down, as evidenced by the unglazed rim, which is usually gilded.

EXPORT CERAMICS

Chinese ceramics were part of an extensive maritime trade that operated throughout Southeast Asia, mainly by Chinese and Arab ships until the arrival of the Europeans from the 1500s. Chronicles as early as the Han dynasty (206 BCE – 220 CE) refer to tributary envoys sailing from southern China to Nanhai (literally 'Southern Seas'). These contacts grew in the prosperous Tang dynasty and Chinese ceramics of the period, for example Xing and Changsha wares, have been found in the Philippines and other Southeast Asian sites. Most were the products of kilns in southern provinces such as Guangdong, Fujian and Jiangxi. The trade continued to grow, reaching its peak in the Yuan dynasty (1279–1368), when the Mongols who ruled China and were hungry for export income increased the number of kilns at the site of Jingdezhen in southern Jiangxi province. By the 1600s the Nanhai trade had petered out as the two main markets in the Philippines and Indonesia evaporated due to changing social patterns. The demand had been fuelled by the ancient funerary practice of burying ceramics and other prized possessions with the dead – a practice that disappeared under the influence of Christianity and Islam, both of which prescribe burial without accoutrement. (Christianity expanded through the Philippines from the arrival of the Spaniards in the 1500s). While Chinese ceramics formed the bulk of these pre-1500s grave goods, Thai and Vietnamese

ceramics have also been found. In the second half of the 20th century a market for these export wares among collectors has resulted in long-buried pieces being excavated (and looted) from grave sites in the Philippines and Indonesia. In addition, Chinese ceramic heirloom pieces, which were losing their cultural value as societies in Southeast Asia modernised, left for foreign mantelpieces.

Chinese trade ceramics comprise *qingbai* glazed wares, celadons, blue-and-white porcelain (of a lesser quality than imperial porcelain) and sturdy stoneware jars. The distinctive bluish tinted *qingbai* glazed wares were especially popular as grave goods. Production had originated at Jingdezhen, but was soon being copied at many kilns, particularly those in export-oriented provinces along the coast of South China such as Fujian and Guangdong. In Fujian, Dehua was the major production centre, producing much *qingbai* (usually not of the quality of Jingdezhen ware) which was exported through the busy port of Quanzhou. After the trade in ceramics for burial dwindled, Dehua's export markets shifted to the West, with the production of the popular porcelains known as *blanc de chine* for export by the Dutch East India Company in the 1600s and 1700s.

Celadons are one of the largest categories of trade ceramics, with those from the Longquan kilns in Zhejiang province predominant. Small celadon dishes

decorated with twin fish in relief and lotus petal-like grooves were common Chinese export wares of the 1200s, and have been found in the Philippines, Peninsula Thailand and other sites. Small Longquan jarlets were used as containers for ashes in Thailand and usually buried near the base of a stupa. In Indonesia wooden stoppers, carved with protective images, were inserted into celadon jars full of supernaturally potent contents which would have been specially concocted by a *datu,* a man who combined ritual knowledge with magic powers. Large celadon dishes have been found throughout Southeast Asia, from Luzon in the Philippines where some had been heirloom objects, through to Sumatra. The gallery has several examples, part of the very generous Laurence G Harrison Bequest made in 1997. Harrison was a keen collector of Chinese celadons, keeping them on display and in use around his house, offsetting their resonant greens with artfully placed ornaments of rose quartz.

A well-defined group of thinly potted blue decorated porcelain wares made its debut in the late 1500s and in all probability was made exclusively for export. Called *Kraak-porselein*, it was named after the Dutch term for the Portuguese *carracks*, or merchant ships, which carried the wares to Europe. The ware was exported in vast quantities to Europe, where its popularity is vouched for by its appearance in Dutch still lifes and interior scenes. Much of the enormous cargo of Chinese ceramics for the European market was carried by the Dutch East India Company (VOC), founded in 1602. The Dutch traded at first at Bantam (from 1596), and then the Moluccas since its main objective was the lucrative spice trade. In 1621 the VOC founded Batavia and it became the capital of the Dutch commercial empire in the Indies. Once spices had been secured the VOC turned its attention to Chinese porcelains, ordering from the base the company was allowed to establish in current-day Taiwan in 1624, and shipping through Batavia. After that, several hundred thousand porcelain pieces a year were shipped to a hungry European market. This enormous trade can only be hinted at through the gallery's holdings.

The drop in imperial orders for porcelain that accompanied the decline of the Ming dynasty was compensated for by overseas orders, particularly from the Dutch and the Japanese. The period from about 1620 to 1680 that coincided with stormy political upheavals, called the Transitional period, was a time of change in styles and techniques, prompted by foreign demands and the absence of court-imposed stereotypes. Soon after the imperial factories at Jingdezhen were rebuilt in 1683, the Chinese re-established their profitable export trade. Standards were high, and the very great quantities of porcelain

sent to the West during the late 1600s and early 1700s were of a quality that fully justifies the fame of 'Kangxi blue-and-white', a vogue for which swept through European, and especially Dutch, society at this period. A pattern much in fashion in the Kangxi period was the prunus blossom on a cracked ice background, commonly seen on the ever-popular ginger jar.

There had always been a market in Japan for Chinese ceramics. However, in the late Ming period, the Chinese began producing wares specifically to the taste of Japanese tea masters. Known as *ko-sometsuke* (old blue-and-white), this style of ware remains popular today.

Hebei province, Neiqiu
Tang dynasty (618–906)
Xing ware small dish 800s
white stoneware with overslip glaze, 4 x 13 cm
Gift of Graham E Fraser 1988
518.1988

Hunan province
Tang dynasty (618–906)
Changsha ware bowl with landscape design 800s
stoneware with enamel decoration (degraded), 5.6 x 15.3 cm
Gift of Dr John Yu and Dr George Soutter 2003
193.2003

On the left is a fine example of the type of whiteware produced in the northern province of Hebei for local markets, as well as the export markets of Southeast Asia and the Near East. Mentioned frequently in Chinese literature, Xing ware consists mainly of small utilitarian vessels mass-produced for everyday use (it is also known as Samarra ware as substantial quantities have been discovered at the important early Islamic site of Samarra on the Euphrates). With its characteristic free decoration, Changsha ware (above right) was also a major export item to Southeast Asia during the Tang dynasty.

Yuan dynasty (1279–1368)
Group of *qingbai* glazed ceramics
Gifts of Dr Peter Elliott 1998

These three pieces are examples of the
qingbai-glazed wares produced at the
Dehua kilns in Fujian province.

from left:
**Vase with onion head and wide sloping
shoulders**
porcelain with *qingbai* glaze and moulded
decoration, three-character potter's mark on base,
7.3 x 8.5 cm
229.1998

**Vase with slip decoration of sprays of
leaves**
porcelain with *qingbai* glaze, 12.2 cm
227.1998

**Vase with onion neck and slip
decoration**
porcelain with *qingbai* glaze, 8.6 x 6.9 cm
228.1998

Yuan dynasty (1279–1368)
Jingdezhen ware jar of cuboid form
porcelain with *qingbai* glaze, 7 x 6.5 cm
Gift of the Bodor family 1999
118.1999

Fujian province
Song dynasty (960–1279)
Dehua ware covered box 1200s
porcelain with *qingbai* glaze, 7.5 x 14.5 cm
Gift of Graham E Fraser 1988
521.1988.a-b

Covered boxes were produced in copious
quantities at workshops at Jingdezhen
and Dehua in Fujian province especially
for the export market.

Yuan dynasty (1279–1368)
Jingdezhen ware ewer of gourd form
porcelain with *qingbai* glaze, 11.3 x 9.5 cm
Gift of the Bodor family 1999
119.1999

Small ewers modelled with dragon
handles were one of several innovations
of the Yuan period. Iron spotting was
another innovation used by Jingdezhen
potters for pieces intended for the
Southeast Asian market, but was no
longer used after the 1300s.

Yuan dynasty (1279–1368)
Jingdezhen or Fujian ware lotus pond
1300s
porcelain with *qingbai* glaze, 4 x 10.5 cm
Edward and Goldie Sternberg Chinese Art
Purchase Fund 1999
106.1999

A delightful and freshly observed example
of *qingbai* ware in the form of four boys
playing in a lotus pond, this piece is rare
both in terms of its subject and the
technical distinction of being decorated
with splashed brown iron spots. Some are
placed with consideration, such as the
ones that define the boys' hair.

Zhejiang province
Longquan ware large shallow dish
early 1300s
celadon, 10 x 43 cm
Purchased 1980
104.1980

The techniques used to decorate
Longquan celadons are varied, and
include incising, moulding, stamping and
slip decoration. Designs were often floral,
even reminiscent of those realised in
underglaze blue at the imperial kilns of
Jingdezhen (compare the bouquet design
on page 108 with the Yongle dish on
page 115 – conceptually similar, yet
stylistically the Longquan piece is far
more fluid).

JAPAN, Edo period (1615–1868)
Hasami ware dish 1650–1700
stoneware with celadon glaze, 8.4 x 41.2 cm
Gift of Dr John Yu and Dr George Soutter 2000
130.2000

Hasami ware was produced at the
Mitsumata kilns in the fief of Omura, the
southern neighbour of Saga, home to the
Arita kilns. Arita introduced the techniques
of stoneware/porcelain production to the
Mitsumata kilns in the early 1600s. The
Mitsumata kilns produced wares for local
consumption and for export. Export
wares, destined for the Southeast Asian
market, were produced in the style of
earlier Chinese Longquan ware celadons,
which the Chinese were unable to supply
at the time. Dishes such as this were
popular in the Indonesian market.

Fujian province
Southern Song dynasty (1127–1279)
Bowl 1100s–1200s
celadon, 7.3 x 18.5 cm
Gift from the J Hepburn Myrtle collection 2003
154.2003

Zhejiang province
**Longquan ware dish with design of
two fish** late 1200s
celadon, 3.4 x 11.6 cm
Gift of Mr J Hepburn Myrtle 1970
EC1.1970

South China
Waterdropper in the form of a chicken and covered box with design of deer
1500s
porcelain with underglaze blue decoration,
8.8 x 11 cm (waterdropper), 3.5 x 9 cm (box)
Gifts of Anthony Odillo Maher 1998
17.1998, 23.1998 a-b

South China
Dish with single fish motif c1400
porcelain with underglaze blue decoration,
unglazed fish painted with a brown iron wash,
recessed 'hole-bottom' base, 12 cm (diameter)
Gift of Anthony Odillo Maher 1998
24.1998

The small 'hole bottom' dish decorated with a single fish, cleverly painted in iron glaze to simulate a goldfish colour, must have been very popular. Large numbers have been excavated at sites throughout Southeast Asia, predominantly in the Philippines at sites in southern Luzon and Manila.

Fujian province
Bowl with design of ducks and lotus
1500s
porcelain with underglaze blue decoration,
9.5 x 21 cm
Gift of Dr J Knox 1981
38.1981

Typical of export blue-and-white, this bowl features a boldly drawn design of lotus and ducks. Since they are known to mate for life, pairs of mandarin ducks became a popular auspicious symbol for a happy marriage and appear frequently in the Chinese decorative repertoire.

Jiangxi province
Ming dynasty, Tianqi period (1628–43)
Dish with design of He Xiangu
porcelain with overglaze enamel decoration,
15.9 cm (diameter)
Purchased 1966
EC9.1966

Jiangxi province
Ming dynasty, Tianqi period (1628–43)
Dish with landscape design
porcelain with underglaze blue decoration,
3.2 x 15 cm
Purchased 1980
103.1980

A type of export ware catering to Japanese taste was *ko-sometsuke* (old blue-and-white) which is distinguished by its casual decoration, eccentric shapes and defective edges where the glaze has broken away (an effect prized by the Japanese, who term it *mushikui,* 'insect eaten'). The small dish (top) depicts the Daoist Immortal He Xiangu who, according to popular legend, was a fairy whose diet of powdered mother-of-pearl and moonbeams gave her immortality. The seven-character poem has been translated as 'Born upon an auspicious cloud, she returns to the fairy grotto'.

KRAAK WARE
Made exclusively for export from the 1500s, *Kraak-porselein* was exported in vast quantities to Europe. When the collapse of the Ming dynasty interfered with Chinese porcelain production, the Dutch East India Company turned to Japan to fill its large quota of orders. The Arita kilns started to produce shapes and designs in imitation of Chinese styles. The examples on this page show Chinese originals, produced in Jiangxi province, and later Japanese copies of two popular forms, the dish and the kendi.

Ming dynasty (1364–1644)
Kraak ware dish c1615–25
porcelain with underglaze blue decoration,
3.9 x 20.6 cm
Gift of Mr J Hepburn Myrtle 1966
EC5.1966

The central design is a typical Kraak design but, according to Kraak ware expert Maura Rinaldi, borders like this, formed by two rows of short straight brushstrokes around a rounded and scalloped cavetto, are rare. As often on Kraak ware, the base has irregular radiating lines from the centre to the foot rim. These are known as chatter marks.

JAPAN, Edo period (1658–83)
Arita ware dish
porcelain with underglaze blue decoration,
21.3 cm (diameter)
Gift of Mr J Hepburn Myrtle 1967
EC2.1967

While the design on the front of this dish is very close to the Chinese original, one way of distinguishing the Japanese example is the presence of three or more spur marks on the base.

JAPAN, Edo period (1615–1868)
Arita ware kendi c1660–85
porcelain with underglaze blue decoration,
20.6 cm
Gift of Leslie Pockley 1986
84.1986

The *kendi*, a drinking water vessel with a spout but no handle, is a form distinct to Southeast Asia, where it has a long history. The name is thought to derive originally from the Sanskrit word *kundika* meaning a water vessel, and was an attribute of Hindu and Buddhist deities. Made in China as early as the Yuan dynasty, it was also known as a *gorgolet* (from the Portuguese *gorgoletta*). The main markets were Indonesia and Malaysia, and Chinese, Japanese and Thai potteries catered to this market, as well as local potteries. The shape became popular in Europe in the 1600s, as evidenced by its frequent appearance in 17th-century Dutch still life paintings.

Ming dynasty (1368–1644)
Kendi decorated with floral panels
late 1500s – early 1600s
porcelain with underglaze blue decoration,
19.6 cm
Gift of Anthony Odillo Maher 1998
18.1998

Ming dynasty (1368–1644)
Kraak ware kendi c1600–10
porcelain with underglaze blue decoration,
17.5 cm
Gift of Mr J Hepburn Myrtle 1983
208.1983

Two distinctive features of this classic
Kraak ware *kendi* are the thin, long spout
and the star-shaped mouth rim – these
resulted in the pieces being referred to
as 'pomegranate ewers'. The spout is
attached to the body with leaves moulded
in relief.

Ming dynasty (1368–1644)
Kraak ware bowl c1600–10
porcelain with underglaze blue decoration,
6 x 21.1 cm
Gift of Mr J Hepburn Myrtle 1990
252.1990

Named Klapmutsen (after the Dutch word
for a type of woollen cap whose shape
they resemble) bowls such as this are the
most typical and most un-Chinese of all
Kraak porcelain shapes. The unusual
shape may be due to the Dutch use of
heavy spoons, which required a sturdy
rim for them to rest on.

Qing dynasty, Kangxi period (1662–1722)
Ginger jar (with later cover)
porcelain with underglaze blue decoration,
26.5 x 22.1 cm
Purchased 1971
23.1971.a-b

Qing dynasty, Kangxi period (1662–1722)
Monteith c1710–20
porcelain with underglaze blue decoration,
15.6 x 32.9 cm
Gift of Mrs Margaret Strutt-Davies 1984
251.1984

This unusually shaped bowl illustrates
the use of Western shapes, often in silver
or pewter, as models for new Chinese
ceramic forms. The monteith, named after
a Scot, whose cloak's hem was notched
in the same way as the rim of this bowl,
was designed to chill wine glasses which
could be suspended in water. Wooden
models were often used to show
unfamiliar European shapes to Chinese
potters on the other side of the world.
The monteith first appeared in silver, but
then appeared in Dutch delftware as well
as Chinese porcelain.

SWATOW WARES

Swatow refers to a large family of coarse provincial porcelains, often with vigorously painted decoration. They were produced in imitation of Kraak porcelains in a number of kilns not far from the port of Shantou (Swatow in Dutch records) in Guangdong province in southern China. Swatow wares are roughly made, often with grit adhering to their foot rims, while their decorations have the freedom and verve characteristic of late Ming ceramics. They have been found along international trade routes of the late 1500s and 1600s. Most typical of Swatow wares are the large dishes, decorated in blue-and-white, polychrome enamels and, less commonly, monochrome colours over a slip decoration.

Large dish with design of two dragons c1600
porcelain with overglaze enamel decoration,
7.7 x 35.5 cm
Purchased 1988
44.1988

Large dish with floral design c1600
porcelain with slip decoration under blue glaze,
35.5 cm (diameter)
Gift of Dr Peter Elliot 1995
204.1995

Large dish with design of Chinese characters c1600
porcelain with enamel decoration, the characters in the central medallion read 'everything under the heavens' (*tian xia yi*), surrounded in a circle by the characters for the 24 points of the Chinese compass, 37.8 cm (diameter)
Gift of Anthony Odillo Maher 1998
16.1998

Dish with design of two deer c1600
porcelain with underglaze blue decoration,
8 x 38.3 cm
Gift of Anthony Odillo Maher 1998
20.1998

Dish with design of phoenix c1600
porcelain with underglaze blue decoration,
7.4 x 35.5 cm
Purchased 1983
230.1983

Dish with design of waterfowl c1600
porcelain with underglaze blue decoration,
9.8 x 42.8 cm (irregular)
Gift of Anthony Odillo Maher 1998
21.1998

Dish with design of two deer c1600
porcelain with underglaze blue decoration,
8 x 39 cm (irregular)
Gift of Mr F Storch 1988
397.1988

BENCHARONG WARES

The Thais developed a taste for Chinese porcelains made in shapes suited to their way of eating and living, and decorated with Thai motifs and in Thai taste. There are two categories of ceramics made at Jingdezhen for the Thai market: Bencharong (five-colour) wares and Lam Nai Tong (goldwashed) wares. It is not sure exactly where the ceramics were decorated, but it could well have been at Jingdezhen as well. Bencharong was first commissioned by the last kings of Ayuthya, who used it at court and on their numerous tours around the country. It is thought that Buddhist books and paintings were supplied as references and sent to Guangzhou merchants, who acted as intermediaries to the Chinese potters and decorators for all foreign orders. As with Western orders, new, alien ceramic shapes were communicated by maquettes in wood or perhaps metal.

Bencharong ware bowl decorated with Buddhist figures 1700s

porcelain with enamel decoration, 9.5 x 20 cm
Gift of Mr F Storch 1985
100.1985

This exceptionally fine piece of Bencharong dates to the late Ayuthya period (1350–1767), when the style arose. The bowl is decorated in deep and varied colours with alternate images of *thepanom* and *norasingh*, both minor Buddhist deities. Typically the *thepanom* sit cross-legged in a praying posture, nude except for a petalled collar, bracelets and crown, while the *norasingh*, believed to reside in the mythical Himaphan forest in the Himalayan mountains, have a human head, the hindquarters of a lion with a flame-tipped tail and the hoofs of a deer.

Bencharong ware dish decorated with two *thepanom* and two *norasingh* early 1800s

porcelain with enamel decoration, 15 cm (diameter)
Gift of Mr F Storch 1987
448.1987

This dish (and those pictured right) was produced for the Thai market during the reign of King Rama II (1809–24).

Bencharong ware jar *toh prik*
early 1800s
porcelain with enamel decoration and gold finial,
6 x 5.5 cm
Gift of Mr F Storch 1984
68.1984

Qing dynasty, Rama II period
Lai Nam Thong ware jar *toh prik*
early 1800s
porcelain with enamel decoration and gold finial,
7.5 x 3.7 cm
Gift of Mr F Storch 1984
69.1984

Qing dynasty, Rama II period
**Bencharong ware small tazza with
'trellis and rice ball' pattern** early 1800s
porcelain with enamel decoration, 12.2 cm
(diameter)
Gift of Mr F Storch 1987
452.1987

Lai Nam Thong ware spittoon
early 1800s
porcelain with enamel decoration, two copper
bands around body, 17.5 x 23.2 cm
Gift of Mr F Storch 1987
445.1987

Bencharong ware tazza early 1800s
porcelain with enamel decoration, 10 x 28 cm
Gift of Mr F Storch 1981
316.1981

South China
Martaban jar with four medallions
1700s
stoneware with stamped relief ochre decoration,
brown glaze, 29.8 x 28.5 cm
Gift of Laurence G Harrison 1981
112.1981

Some categories of export ceramics take their name from the port through which they were exported. Best known of these port wares are Martaban and Swatow. The so-called Martabans are named after the entrepot port of Martaban on the west coast of Burma, which was an important link in the China-India ceramic trade. Goods were transported overland from China to Martaban, and from there were shipped to West Asia, India and Africa in the Song and Ming dynasties. With the rise of the Thai kingdom of Ayuthya in the mid 1300s, another land route became important. Thus Arab, Indian and later European merchants stopping at Martaban demanded large jars in which to store water, wine, oil and other commodities for the next stage of their journey. They could be provided with Chinese, Thai or local Burmese jars – all referred to as Martabans. The port lost its importance when trading patterns changed and by the 1700s the great days of the Martaban trade were over.

Martaban ceramics, mainly sturdy, large storage jars, are found in abundance throughout the Indonesian archipelago, from the longhouses of northern Borneo to Sumatra and other islands. The jars play an integral part in tribal culture and were regarded as repositories of supernatural powers. They could be filled with local rice wine or even holy water from the Ganges. They were also used as funerary jars. In parts of Indonesia (where they are called *tempayan),* Malaysia and the Philippines myths concerning Martabans abound, and the jars were believed to be able to talk and are also given a sex.

Guangdong province
Globular jar decorated with relief 'head and hand' motif 1700s
stoneware with brown glaze, 47 cm
Gift of Mr F Storch 1992
195.1992

The round face on one side of the jar, and the human hand on the other are unusual design features. Scholar Barbara Harrisson has identified the hand as the armorial insignia of the city of Antwerp, which would have appeared on the city's coins from the 1600s on. The full face may also be a variation on the profiles found on coins. This curious pattern is one of numerous designs on Bornean heirloom jars that recall the close links between South China and West Borneo formed during the 1700s.

Qing dynasty (1644–1912)
Bleu de Hue bowl with dragon decoration 1800s
porcelain with underglaze decoration,
5.1 x 10.9 cm
Gift of Dr John Yu and Dr George Soutter 2002
168.2002

Qing dynasty (1644–1912)
Bleu de Hue dish decorated with cranes and pine tree 1800s
porcelain with underglaze decoration and metal rim, 1.9 x 16.4 cm
Gift of Dr John Yu and Dr George Soutter 2002
169.2002

A lesser-known Chinese export ware is *bleu de Hue*, blue-and-white porcelain made for the Vietnamese market from the 1700s, when kings of the Le-Trinh dynasty ordered wares from China for their court. The type is named after Hue, the 19th-century capital of the last royal dynasty in Vietnam, the Nguyen dynasty (1802–1945). Although Chinese artisans executed the painting, the Vietnamese rulers dictated the designs. Each ruler ordered ceramics of his own liking for use in his court, as well as presentation pieces to give to members of the royal families and mandarins.

Kitchen Qing dish with landscape design 1800s–1900s
porcelain with underglaze blue decoration,
3 x 18 cm
Gift of Rena Briand 2002
256.2003

Kitchen Qing dish with landscape design 1800s
porcelain with underglaze blue decoration,
24 cm (diameter)
Gift of Elisabeth M Smith 2002
291.2002

These two pieces are examples of 'Kitchen Qing', a term used to describe the large numbers of late blue-and-white export porcelain produced at Jingdezhen for everyday use by the Chinese throughout Southeast Asia.

Nonya ware covered jar *kamcheng*
1800s
porcelain with enamel decoration, 31 x 30 cm
Gift of Michael Gleeson-White 1988
160.1988

'Kamcheng' is a Hokkien word meaning 'covered jar'. A *kamcheng* was variously used as a container for water, pickles and other types of food. China exported a large number of these ceramics to the Straits Settlements communities in Penang, Malacca and Singapore in the 1800s, where a distinct culture evolved known by the Malay word *peranakan*, which describes those who were born locally, whether they be Chinese, Indian, Arab, Indonesian or another. The word Baba describes specifically Straights-born Chinese men, while the term Nonya is used for the women, and it is this latter term that has been adopted to describe the Chinese ceramics made at Jingdezhen to the order of Straits Chinese from the 1850s to the early 1900s. The wares were of two types: richly decorated enamel wares for use on auspicious occasions, and functional blue-and-white wares for everyday use.

LANDSCAPE PAINTING

Most of the pre-modern Chinese paintings in the gallery's collection date to the Ming or Qing dynasties, when the taste of the literati was influential and pervasive in cultural circles. The literati were an artistic and intellectual elite whose artistic endeavours and connoisseurship of art objects were judged according to subtle and complex standards. They were considered the culmination and embodiment of Chinese culture and learning.

Painters of standing in the gentry-literati society cultivated a deliberate amateurism that technically demanded less of the artists, and, more significantly, enabled their art to be produced outside of patronage networks. Although some of these artists were pure scholars with no official career, many held various positions in the imperial government. Understandably in a society dominated by capricious rulers and prone to political turmoil, an official career was beset with hardship and uncertainty. Hence the idea of eremitism remained popular, and the 'gentlemen in retreat', who sought spiritual freedom in seclusion away from the restraining social order and could escape from a society ruled by corrupt governments or foreign invaders, were deeply admired. Even those who could not keep far from the bustle of an official career were attracted to the idea of 'dwelling in retirement' as a counter to the reality of their world.

The 'hidden life' of study and the pursuit of artistic pleasures in one's spare time were therefore the ideal contrast to the restless and hazardous career of the government official. It was considered an important component of an elegant, unrushed disposition, which was close to the Confucian and Daoist ideal of loftiness and otherworldliness. In some families all members – both male and female – were dedicated to artistic pursuits. The hobby of art collecting was held in high regard. The popularity in painting of the subject of the so-called 'elegant gathering' attests to the social phenomenon of the time. Such compositions show the sensual pleasures of gentlemen meeting in landscaped gardens to appreciate natural beauty, compose paintings, calligraphy and poetry, and admire antiques while drinking wine.

In art, the literati were opposed to the professional artists working in the naturalistic manner, and tended to pursue a more expressive style incorporating poetic 'blandness'. They preferred the so-called *sanjue* or 'unexcelled in all three' – the combination of painted image, poetry and calligraphy.

THE MAGIC OF MOUNTAINS

From a very early time great mountains were regarded by the Chinese as embodiments of mysterious power and mountain-worship was one of the major elements of the Chinese state religion. In the cosmology of the Han dynasty (206 BCE – 220 CE), the great mountains

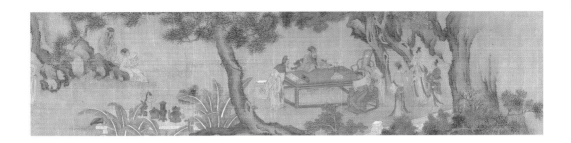

were forbidden spaces where gods and mysterious creatures resided. Mountains gradually became more familiar and provided havens for those who sought to attain supernatural powers or spiritual enlightenment. People who practised religious Daoism, which developed from the 2nd century CE onward, associated the great mountains with the theological concept of the realms of the immortals. Great mountains – the realm of immortals – were considered reachable by human beings but only through designated caves, called *dongtian* or 'cave heavens.'

Because of their sacred nature and associations, the great mountains were certainly the logical places for individuals to seek retreat. Those who were tired of the restraining social order or corrupt governments often chose to lead solitary lives in the mountains, dedicating themselves to the values of individualism, personal freedom, harmony with the processes of nature and the attainment of longevity or immortality. This long-standing conceptual link between mountains, superhuman power, auspicious animals and the quest for personal immortality had become a profound source of inspiration for artists. A mountain as the place of residence for a recluse has been one of the popular themes of Chinese painting. In Wang Jianzhang's *Returning home from gathering fungus* (page 148), a recluse is depicted returning to his home – a hut just beneath a strange, twisted, fungus-like mountain.

In Wu Li's hanging scroll *River and sky shrouded in the mist of sunset rain* (page 152), the same idea recurs, yet through a voice of scepticism.

Frequently the idea of mountain-reclusion is mingled with Buddhist concepts. On the one hand, the Buddhist monasteries scattered everywhere on mountains offered shelters wherein one took refuge to escape society, and the monastic life is often identified with the idea of eremitism; on the other hand, the idea of the wandering ascetic who 'goes forth into the houseless state' to eliminate 'the sorrows of birth, disease, old age and death' has merged with the idea of the retired gentleman-scholar who prefers the 'hidden life' of study and artistic pleasures to the restless and hazardous career of the government official. Fang Shishu's *The autumn mountain at sunset* (page 154) subtly reflects such ideas.

Gu Jianlong (1606–87) (attributed)
(detail) Elegant gathering in the Western Garden
handscroll, ink and colours on silk, 26.1 x 283 cm (painting), colophon dated 1705.
Purchased 1957
9417

Cheng Sui (1605–91)
Landscapes dated 1668
ink on paper, four leaves from two albums of
16 leaves, 35.5 x 44.2 cm each
Gift of Sydney Cooper 1962
EP39-47.1962

Cheng Sui, alias Muqian, was a native of
Shexian, Anhui province. Like many
traditional literati artists, Cheng mastered
painting, writing and poetry, as well as
seal carving. But above all, he was
considered a man of great moral integrity.

Cheng Sui belonged to a group of
loyalist-literati know as *yimin* or 'left-over
people', who refused to transfer their
political allegiance from the native Ming to
the alien Qing. His dissent was expressed
in the literary name he took for himself –
'Goudaoren' (dusty or grimy monk) – thus
indicating his regret and pain at being
unable to stop the foreign conqueror. The
effect of dynastical change on Cheng Sui
and his painting style is reflected in these
albums, painted in 1668, some two
decades after the decline of the Ming
dynasty. The choice of subject matter is
not new: we see simple huts standing by
shores, secluded temples concealed in
mountains, an isolated boat with a man
drifting between river and sky, and a

lonely scholar strolling alone along the
streamside. However, one can
immediately sense the certain plainness,
a melancholy and often bleak and lonely
feeling. All these sentiments were
reinforced by his characteristic dry and
bold brush outlines, added by small dots
of dry dark ink. Inscriptions were also
brushed with very dry ink, echoing the
brush works of the landscape. The one
illustrated here reads, 'Cheng Sui
captures an idea in the twelve moon of
the *wushen* year [1668] after snow'.

Wang Jianzhang (active c1620–50)
Returning home from gathering fungus
dated 1628
hanging scroll, ink and colour on paper,
85.4 x 51.2 cm
Purchased with funds provided by Mr Edward
Sternberg 1991
265.1991

The isolation of the figure in the painting,
the *dongtian*-like mountain sets, and the
magic fungus, all evoke the Daoist idea of
individuals seeking spiritual freedom and
immortality in the great mountains. Wang
Jianzhang was born in Quanzhou in Fujian
province, where local histories document
his skill at drawing but little more is known
of him. Some of his landscape paintings
reached Japan (the source of this
painting), probably through monks of the
Obaku sect of Zen Buddhism, which was
transferred to Japan after the fall of the
Ming. The poem reads:

Trees on the cliff cage clouds, half moist.
The brushwood gate beside a stream is
newly opened.
Facing the dawn, I seek for a poem, all
alone;
As I gather fungus the sun sets, and I
return.

Hua Yan (1682–1756)
Landscape after the style of Mi Fu
hanging scroll, ink on paper, 129.5 x 61 cm
Gift of the Art Gallery Society of New South Wales
1993
570.1993

This painting is in the style of the gifted landscapist Mi Fu (1052–1109), a member of an 11th-century coterie of scholar-artists who formulated the literati (*wenrenhua*) theory of painting. According to this theory the value of a painting lies not in its simulation of nature but in its transformation of nature into a vehicle that expresses the character and mood of the painter. For centuries this theory shaped the style of the scholar-amateur literati artists who worked in ink only. They scorned mere representation, aspiring to a deliberate awkward-looking style full of archaic reference tempered by an astringent intellectualism. In 18th-century Yangzhou, a wealthy class of merchants who sought to emulate the taste of the scholar-gentry class commissioned paintings in the literati style, such as this fine example by Hua Yan. One of the 'Eccentric Masters of Yangzhou', a loose group of artists producing their own unorthodox interpretations of literati painting, Hua Yan was noted for the virtuosity of his brushwork. By his time the Mi Fu style of building up landscape forms by a series of dots (particularly obvious in his mountains) was a classic in the stylistic vocabulary of literati artists.

Wu Li (1632-1718)
**River and sky shrouded in the mist of
sunset rain** dated 1671
hanging scroll, ink and colour on paper,
57.8 x 22.9 cm
Edward and Goldie Sternberg Chinese Art
Purchase Fund 1998
235.1998

This elegant scroll depicts a tranquil,
lyrical spring scene of river and hills which
appear to float on the water. Sunset rain is
suggested by the straw hats worn by the
tiny figure walking on the footpath and the
fishermen in their boats. The composition
follows the traditional principle of a bird's-
eye view of a staggered three-stage
structure of foreground, middle ground
and distance, each stretching almost
horizontally from the left and right. The
hills and mountains have an earthy effect
which mainly comes from the moss dots
but is enhanced by the textural strokes
and by a wash of light ink and green
colour over the darker portions. The whole
mass becomes a vivid depiction of the
geomorphology in Jiangnan region.

Wu Li, a native of Changsu, Jiangsu
province, was recognised as one of the
six leading orthodox painters of the early
Qing, together with the 'Four Wangs' and
Yun Shouping. His life, however, shows a
marked departure from those of the other
leading masters. While the Four Wangs
were involved in the official world, Wu Li
never served in the government but
gradually moved toward a life in search of
individualism, which finally led him to
convert to Christianity in 1681.

This scroll was executed when Wu Li
was 40 years old and just beginning his
search for non-Chinese religious
knowledge from Roman Catholic priests.
The composition is inscribed on the right
top as follows: 'The boat goes out daily
casting the nets. Floating on top of the
water are countless layers of peach
blossom petals. I enquire as to the
whereabouts of the immortal paradise,
only to be met by the river and sky
shrouded in the mist of sunset rain.
Inscribed at the morning window at the
new studio, for the older master Jiang
of the Siyuan Studio, on the second day
of the seventh moon of the year *xinhai*
[1671]. Wu Li of Yanling.'

The inscription is followed by a seal of
the artist, 'Wu Li'. There is another seal
of the artist in the lower left corner, 'Wu Li
of Yushan'. Two collectors' seals are also
seen in the lower left corner, 'Xu of
Wuxing' and 'Once in the collection of
Li of Menan'.

南田老人師董北苑
得其奥旨此爲伤之
林美 [seal]

Qian Du (1763–1844)
Landscape after Juran
one leaf from an album, ink on paper,
31.8 x 24.4 cm
Gift of Edmund Capon 2000
123.2000

Qian Du, alias Shumei, was a native of
Qiantang (now Hangzhou) in Zhejiang
province. He was the most accomplished
member of a family of painters and was
recognised for his skill in painting a
number of different subjects: landscape,
figures, ladies and flowers. Judging by
its subject, this leaf was originally part of
a larger set of copies of ancient
masterworks. Juran, the artist mentioned
by Qian Du in his inscription, was a great
landscape painter of the 10th century.
Along with his teacher Dong Yuan, they
created a new style of monochromatic
ink landscape painting that inspired a
large following. The most noticeable
characteristics of Juran's style were
copied in this painting. For instance, a
type of 'long hemp-fibre' stroke, which
has been employed for both the contour
and the texture of the mountain, and the
wet and heavy brush dots (*taidian* or
moss dots) applied to accent the hills.
In addition, the illusion of recession
developed by Dong Yuan and Juran has
been used to structure the composition.

In ancient China it was common
practice for an artist to learn painting by
copying ancient masterworks. The
Chinese believe that studying the ancients
and copying their works |provided the
insights and techniques essential for
personal expression. Chinese artists
embrace the idea that the past can
fertilise the present. A number of Qian
Du's paintings attest to his interest in an
archaic style, although many of his late

works suggest that he was able to
develop a personal style by blending
elements from the old masters with
individual qualities all his own.

Fang Shishu (1692–1751)
The autumn mountain at sunset
dated 1735
hanging scroll, ink and colour on paper,
162.5 x 68 cm
Edward and Goldie Sternberg Chinese Art
Purchase Fund 1999
120.1999

During the 1700s, Wang Yuanqi and Wang Hui were highly influential and attracted a great following of both pupils and imitators. Those who adopted the style of Wang Yuanqi are known as members of the Loudong school, the name of which – 'east of the River Lou' – came from Taichang, the home of Wang Yuanqi. Among his followers, Huang Ding, Fang Shishu's teacher, was perhaps the most accomplished. Therefore, although Fang Shishu, a native of Yangzhou, is not generally mentioned as an artist of the Loudong school, the fact that he was a pupil of Huang Ding makes him a part of this tradition. According to his biography, Fang Shishu was already considered better than his teacher at an early age. Even during his lifetime, people treasured and even forged his paintings. They believed that if he had lived longer, he might have had the same reputation as the two Wangs.

This painting exemplifies the Loudong school tradition, which has persisted in China until today. Characteristic are the dry-brush strokes. The evolution and perfection of this technique – from such Yuan painters as Huang Gongwang (1269–1354) and Ni Zan (1301–74), through Wu school artists such as Wen Zhengming (1470–1559) and Songjiang painters such

as Dong Qichang (1555–1636), to early Qing classicising artists such as Wang Yuanqi – represent a persistent quest for a means of expressing the spirit of the literati in its purest, simplest and highest form.

Although in this painting the otherworldliness has been suggested by the sparse autumnal scene and by the dry-brush strokes, the reference to the concept of transcendental realms is still very subtle.

The expressive content is not readily apparent unless one conjugates the image with the poem inscribed on the painting, which reads:

Thin mists fade away at sunset,
The smooth lake ripples like green jade.
The autumn is arriving, from the mountain ridges where tumi [a Chinese wild bush] grows,
A man is walking across the bridge.
The colours of the trees block the view of the serene sky,
The ringing bells indicate an old temple afar.
The westerly wind blows through one's hair,
It is time to sail off, rowing a boat made of mulan [magnolia].

Here is felt the mixture of reflection on seasons gone, the gentry ideal of the

'retired life' and the religion of free nature. The temple bell further suggests how much the idea of a monastic career has been amalgamated with such sentiment. Since *mulan,* or magnolia, is a well known metaphor referring to the famous poet Qu Yuan (c340 –286 BCE), with reference to the purity of one's inner world, to sail off symbolises the moral integrity and rustic simplicity which traditionally belong to the ideal life of the retired gentleman. The lines echo a popular theme in Chinese painting: the so-called *yuyin* or 'reclusion in a fishing boat' theme. Those who sail off on boats in the mountain stream were not fishermen but rather recluses. The painting is dated in Fang's colophon to 1735.

An unexpected inscription by the later artist Wang Zhen (1867–1938) appears on the side of the scroll. Wang's poem is written on the mount and is an allusion to his Buddhist faith:

Strolling along the western banks of the stream,
With the autumnal clouds filling the gully,
While hearing the sounds of bells fading into the clouds
One suddenly realizes the truth of Chan Buddhism.
Inscribed by Wang Zhen, white dragon hermit, in the year renxu. [1922]

Yu Shaozhi (Ming dynasty)
(detail) Calligraphy (constantly changing clouds) 1600s
handscroll, ink on paper, 31 x 318 cm
Edward and Goldie Sternberg Chinese Art
Purchase Fund 1991
367.1991

The 'Three Perfections', painting, poetry and calligraphy, embody the highest visual, philosophic and aesthetic ideals of the Chinese scholar. Of these, however, calligraphy is the most esteemed in that it combines the intellectual and moral dimensions of content with the emotive and visual qualities of the art of writing. As much emphasis was placed upon the expressiveness and fluency of the calligraphy as on its meaning. Of the many groups and styles of calligraphy, the cursive *caoshu*, literally 'grass script', is among the most expressive and visually exciting, characterised by its sense of spontaneity, speed and emotive energy.

This scroll comprises three poems composed by the artist under the title of *Constantly changing clouds,* which is written in four large characters at the beginning. While little is known of Yu Shaozhi, except that he came from Wuyuan in Anhui province and was active in the 1600s, the status of this work is indicated in a poetic inscription, dated 1916, by the great late Qing dynasty master Wu Changshuo, which praises the quality of this calligraphy.

Zhu Nan (Qing dynasty)
Calligraphy 1700s
set of four hanging scrolls, 30.5 x 128 cm each
Edward and Goldie Sternberg Chinese Art
Purchase Fund 1992
59.1992.1-4

Zhu Nan was a noted and recorded
calligrapher in 18th-century Qing China.
This set of scrolls is executed in cursive
script, with all the quiet drama,
spontaneity and emotive variation that
are characteristic of the style. They read
(from right to left):

*The calligraphy of Wang Youjing [Wang
Xizhi] of the Jin dynasty is unique and
powerful, superior to any before and after
him. / His brushwork is like a flying dragon
and dancing phoenix, and resembles
astonishing thunder and falling rocks. /
It contains the vitality of expression, the
spirit of the mountain and forest, and the
beauty of the pavilion. Everything about it
is so admirable. / His writing is so unique
in history, it is treated as a great treasure.
I wrote this to Ting Gui, my kindest brother,
for your instruction [signed Zhu Nan].*

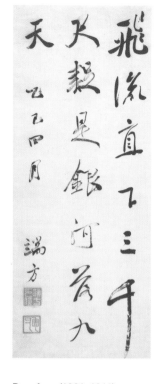

Zuo Zongtang (1812–85)
Calligraphy (couplet in running script)
pair of hanging scrolls, ink on paper,
141 cm x 34.8 cm each
Gift of James Hayes 2003
254.2003.a-b

A native of Xiangyin, Hunan province, Zuo Zongtang was an eminent figure of 19th-century China. His fame as a military leader and statesman almost overwhelmed his achievements in calligraphy. He studied geography and military strategy in his youth, and recognition of his talent by Zeng Guofan, one of the most important generals in modern history, and Emperor Xianfeng (r1851–61), initiated his long military career. As the right hand of Zeng, he served the Qing regime for some 30 years, suppressing various rebellions including the Taiping uprising.

In spite of his arduous duties, Zuo Zongtang was a renowned calligrapher, even during his own times. Although his best known calligraphy is *xiaozhuan,* or lesser seal-script, a style developed during the Qin dynasty (221–206 BCE), his skill in *xingshu,* or running script, is excellent too, as demonstrated in this couplet. The derivation of his style from *xiaozhuan* is apparent. As one can see, here the smooth and regular manner of the lesser seal-script has been dissolved into the elegance of the running script style. The scrolls read:

Written for the fourth brother Zicheng as he requested
A merciful nature is the source of longevity;
The wise mind resembles a pearl with a winging perforation. Zu Zongtang.

Although the couplet is undated, on the basis of a seal on the work, it is tenable that it was done during the last decade of his life. The characters contained in this seal, 'Qinggong taibao' refer to an honourable title, 'The guardian of the heir apparent', that was bestowed to him by the imperial house after Zuo Zongtang recaptured the city Hangzhou from the Taiping rebels in 1864.

Duanfang (1861–1911)
Calligraphy (Li Bai's poem in semi-cursive script) dated 1905
hanging scroll, ink on paper,
66.3 cm x 27.1 cm
Gift of James Hayes 2003
255.2003

A modernising high-ranking official of the late Qing dynasty, Duanfang was one of five special commissioners to travel in Western countries to observe the forms of government in 1906. He was also a noted calligrapher, a collector and a connoisseur of antiquities. The lyrical content in this scroll was drawn from the last two lines of a poem by the great Tang dynasty poet Li Bai (701–762), *Waterfall at Mout Lu.* The full poem reads:

Sunlight flows on the Incense-Burner Peak, sparkling a purple haze,
From far to see, the river hangs high on the cliff.
Vaulting down for three thousand feet, It's like the Milky Way tumbling from the Nine Heavens.

THE SCHOLAR'S STUDIO

The trend for literati scholars to pursue a contemplative life in their studios reached a new high during the Ming and Qing dynasties. These scholars paid special attention to their writing materials, the tasteful decorative objects on their desks and to the atmosphere of their studios. The tools of calligraphy and painting – the paper, the brush, the ink and the inkstone – were commonly referred to as the 'Four Treasures'. Close attention was given to all items associated with calligraphy and painting and to pieces that would enhance the studio ambience. Accordingly, items such as brush rests, brush pots, waterdroppers, waterpots, censers and screens were chosen with discernment.

This social phenomenon in turn fuelled the production of studio objects made of jade (or other precious stones), bamboo or wood, animal horn and metal. Jade symbolised Confucian virtue, which echoed the enduring spirit of the literati. The external purity and glow of jade coincided with the subtlety and contemplative beauty sought by the literati, and therefore was one of the most adapted materials.

In such an atmosphere, the objects for the literati's daily use in the studio were carefully selected and assessed in terms of their individuality, rarity, antiquity and even their tactile quality. A fine black inkstone, which once belonged to the artist Wang Zhen (page 161), attests to this aesthetic.

Apart from poems, the most common decorative motifs found on objects in the scholar's studio are landscapes, flowers-and-birds and images of celebrities such as the Seven Worthies of the Bamboo Grove, a group of learned men of the 3rd century who, disgusted by political affairs and the strain of duty, retreated from society to indulge themselves in alcohol, music and literary activities in a bamboo grove. All of these elements were necessary for a creative atmosphere, and could most appropriately evoke the literati sentiment and love of nature.

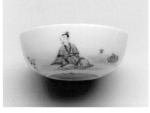

Jiangxi province
Ming dynasty, Wanli (1573–1619)
mark and period
**Jingdezhen ware brush rest in the
form of mountains**
porcelain with underglaze blue decoration,
13 x 17.7 x 4 cm
Purchased 1988 (ex the collection of
Mrs E Seligman and Montague L Meyer)
300.1988

Jiangxi province
Qing dynasty, Kangxi (1622–1722)
mark and period
**Jingdezhen ware chicken coop
water pot**
soft-paste porcelain, 9.1 x 12.6 cm
Gift of Mr J Hepburn Myrtle 1994
348.1994

Fujian province
Qing dynasty, Kangxi period (1622–1722)
**Dehua ware brush rest moulded in the
form of a dragon among rocks**
porcelain (*blanc de chine*), 5.3 x 10.5 x 4.2 cm
Purchased 1987
352.1987

The brush rest, modelled in the form of a
bifid-tailed dragon climbing out of the sea
onto a rock, evokes the sacred Isles of the
Blest in the Eastern Sea, where immortals
reside, as well as the fungus of immortality
(*lingzhi*), some of which can be seen
growing out of the rocks here. The
contorted rocks are full of energy (*qi*) while
their voids are symbolic of the female *yin*
that balances the male *yang* of the solid
form. A small piece such as this serves
doubly as a pleasure to handle because of
its tactile quality, while also acting as a
piece for contemplation on the forces of
the universe.

Qing dynasty, Kangxi (1622–1722)
mark and period
Jingdezhen ware brush washer
porcelain with pale celadon glaze over relief
decoration, 7.3 x 7.9 cm
Purchased 1988
303.1988

Qing dynasty (1644–1912)
**Jingdezhen ware wine cup decorated
with figure of Li Bai**
late 1600s – early 1700s
porcelain with *famille verte* decoration, six-
character Chenghua mark on base, 2.7 x 7.3 cm
Gift from the J Hepburn Myrtle collection 2000
187.2000

Shown here with his wine cup and pot,
Li Bai (701–762) was the foremost
romantic poet in the Tang Dynasty. Li's
political ambition was foiled, so he turned
to drinking and writing to drown his
sorrows, producing 'a hundred poems
per gallon of liquor.'

Qing dynasty (1644–1912)
Brush pot late 1700s – mid 1800s
porcelain with yellow/brown relief decoration,
12.1 x 6.9 cm
Gift of Laurence G Harrison 1977
344.1977

The yellow/brown glaze simulates carved
bamboo. Such technical conceits, where
one material was made to imitate another,
were popular from the 1700s. The high-
relief carved decoration depicts a
gentleman with a long beard in official
robe and cap, reclining against a flat-
topped rock, upon which are a cup, a
book and a vase. A young servant is seen
squatting in front of him, ladling wine from
a jar. Another servant stands to the back,
holding a wine flask. The scene represents
the enduring pleasure enjoyed by an
official scholar communing with nature
and indulging in literary creation.

Qing dynasty, Daoguang (1821–1850)
mark and period
**Jingdezhen ware inkwell for a
scholar's desk**
porcelain with yellowish, olive green 'tea dust'
glaze, 3.1 x 6.6 x 9.5 cm
Gift of Mr J Hepburn Myrtle 1989
246.1989

Inkstone c1900
stone, 33.3 x 20.3 cm
Purchased 1989
59.1989

This unusually large, fine, black inkstone
has the added interest of the inscriptions
on it and the provenance they imply.
It is incised with an image of a kneeling
Buddhist monk, which, the inscription
suggests, is a self-portrait by the noted
Buddhist and artist Wang Zhen (1867–
1938), and a poem by him which reads:

*In my previous life I was a monk.
Suddenly I came down to this human
world,
The fragrant incense is not smoking, but
already flowers appear in my vision,
where can I find the essence of Chan
[Buddhism].*

It is signed 'white dragon hermit' and
dated to 1912. The same inkstone also
has two poems inscribed by Wu
Changshuo (1844–1927), the principal
one, on the face of the stone and adjacent
to Wang's is richly enigmatic:

*Jin Shoumen [Jin Nong] once said
I am in my heart a monk eating congxi
[rice gruel]
Now I am going to use this title to give to
you.
How about that?*

Another inscription by Wu, on the side of
the stone, states that it was carved by
Shen Shiyou (1857–1917), a noted
collector and inkstone carver who often
worked with him.

THE SHANGHAI SCHOOL
AND MODERN PAINTING

The vast, pulsating conurbation that is Shanghai wears its history on its proverbial sleeve. Shanghai is today a place of extraordinary human activity, pace, tension and confrontation, a cosmopolitan mercantile melting pot that provokes originality in the arts, just as it was in its early heyday in the mid 1800s, when the so-called Shanghai school of painting emerged. Sometimes referred to in a slightly deprecating way as the Haipai, literally 'sea school', the Shanghai school takes its name from the obvious fact that its central protaganists congregated in and around the city.

Shanghai was a law unto itself and it is little surprise that things there should be different. And so it was with painting, where the great and enduring theme in Chinese painting traditions – the landscape – was of less significance. Following the great masters of early Qing orthodoxy, the landscape theme continued to be central to Chinese painting traditions of the 1800s and even the 1900s, but not to the Shanghai artists. And yet, as it turned out, the Shanghai school was the most influential school of Chinese painting in the 1800s and the one above all others that fostered the transmission of Chinese painting into the modern era.

Bird-and-flower themes, and to a lesser extent animals, vegetables and other of nature's more humble creations, were the favoured subjects of the Shanghai and related school painters. Their paintings were to a large extent 'market driven', a response to the new

urban rich who wanted paintings that were bold, striking, enjoyable and easy to comprehend. This new urban mercantile class, a hitherto unknown phenonomen in China, wanted an art more in keeping with the pace and colour of modernity; they wanted 'feathers and fur', not landscapes, bamboo and images rich in esoteric symbolism. Shanghai school painting is, above all, about the art and opportunity of painting, and the expression of personality and individuality.

The history of painting in China is one of evolution, with schools of orthodoxy balanced by individualist tendencies, and it was of course the latter that initiated progress and change. But it was not until the 1700s that any kind of commercial pragmatism exerted an influence. For the most part, until then the evolution of painting in China had been determined and inspired by history and tradition, political attitudes and sensitivities, not by economic factors or by urban energies and dynamics. Probably the first instance of that was the emergence in the early to mid 1700s of the city of Yangzhou as an extraordinarily thriving commercial city, largely a consequence of its role as a centre of the salt monopoly. The wealth generated by essentially mercantile activities produced a new breed of cultural patron, not tied to past or established traditions and values. They sought an art that was new, lively, anti-orthodox but not so revolutionary as to be beyond the mores of the time. Thus it was that the

group of artists known as the Yangzhou Eccentrics emerged and produced individualist and generally light-hearted works characterised by qualities of novelty, playfulness, humour and lightness of touch – in fact a range of moods and sentiments which were the very antithesis of the aloofness and restraint of the literati style. Colour too became a significant ingredient of this new, fresh and commercially successful art.

It was this innovative group that bore similarities to, and indeed was a source of inspiration for, the Shanghai artists a century or so later, and thus upon 20th-century styles and directions. There were also similarities in the circumstances of business and merchant patronage and a common interest in subjects other than the dominant landscape theme.

The Shanghai school is not a definitive style, but an evolving one. Its origins in the mid 1800s were well-mannered and restrained, developing into the more varied and widespread movement towards the end of the century. However, one indelible quality of the school is that despite its more individualist approach it remained very much within the great tradition of Chinese painting. This individualism was expressed particularly in subject matter through the selection of those 'fragments of nature' and to a lesser extent the human figure, and in technique through a more expressive use of traditional brush and ink.

Regarded as the 'founder' of the Shanghai school, Ren Bonian is a perfect example of scholarly restraint in the literati tradition combined with the promise of freedom in innovation and new attitudes. His 1893 *Figure in a boat under a wintry tree* (page 166) is a good example of how the Shanghai school painters may be regarded as a revitalised literati in their use of subjects so familiar to long-established values and styles but with a more contemporary flavour of self-expression and individualist brushwork. For all their innovation and artistic imagination, the Shanghai artists were nonetheless highly commercial and that too was certainly a sign of things to come, for in the 20th century painters in China survived not through establishment or courtly concurrence or patronage, or even less so as romantic or religious hermits, but on commercial activity and the sale of works in a broadening and secular market. Interestingly Ren's spirited brushwork is echoed in the styles of many much later 20th-century artists also represented in the gallery's collection.

Another artist central to the story of the Shanghai school is Wu Changshuo. Famed equally for his calligraphy, seal-carving and poetry, Wu is represented in the collection by a scroll of consummate fulfilment and typical directness. Wu's distinguished and energetic brushwork style is amply illustrated in the complex designs of the branches and stems,

punctuated by the colourful fruit, all set against the void of unblemished paper. There are no distractions, just the graphic drama of the composition. The scroll (page 166) is characteristically accompanied by a lengthy poem in Wu's own hand.

Of the Shanghai school figure painters, none is more engaging than Wu Changshuo's most distinguished pupil, Wang Zhen. His endearing and robust image of the Buddhist deity Bodhidharma, titled *Nine years facing the wall* (page 168), is a testament to his imaginative combination of tradition and modernity. It is also a celebration of the 'amateur' in the literati tradition for Wang Zhen took to painting relatively late in life having previously been a successful and wealthy Shanghai businessman. Wang was known initially for his bird-and-flower subjects but is now remembered as the ideal scholar-gentleman: philanthropist, Buddhist, poet, painter (especially of Buddhist subjects) and calligrapher. Wang Zhen appears in two further works in the collection, but in less usual circumstances: the first is a fine black inkstone incised with an image of a kneeling Buddhist monk (page 161), and the other is an inscription by him a landscape hanging scroll by Fang Shishu (1692–1751) which is dated in Fang's colophon to 1735 (page 154).

The continuing life of the Shanghai school, albeit in a more diffuse form, is illustrated in the work of a number of more recent Shanghai artists, including

Guan Liang, renowned for his figures taken from the Beijing Opera and folk legends, the landscape artist Lu Yanshao and Zhu Qizhan. The influence of the Shanghai school on modern Chinese art is notably demonstrated in the style of the southern Lingan (meaning 'south of the ranges') school which is again characterised by its bird-and-flower paintings of vivid colour and expressive energetic brushwork, such as the work of Guan Shanyue. Yet probably of even greater significance was the influence of the Shanghai artists on their Beijing counterparts in the later 19th and early 20th centuries.

There is little doubt that Qi Baishi is regarded as the greatest 20th-century Chinese painter in the traditional manner. His debt to the innovations and inspirations of the masters of the Shanghai school is similarly beyond dispute. The remarkable energy and invention of his brushwork, his regard for tradition but disregard for convention, the colour and sheer delight in his selection of the most humble of subjects, inspire in Qi's work an endless and spontaneous sense of exuberance and pleasure. Two scrolls in the collection, *Gourds on a trellis* (dated slightly confusingly in the colophon to the *yiyou* year of 1945 and yet that same inscription is signed 'Baishi at the age eighty-three years', a date that would correspond to 1947) and a more sombre scroll of *Pumpkins* painted with rich and mellifluous dark colours, are splendid examples of his

work (page 169). Very much in the Qi Baishi, and thus the ultimately the Shanghai, tradition are a number of 20th-century artists working within the ever-evolving spirit of the Chinese brush-and-ink style and yet continuing to find new opportunities and a distinctive modernity. Among the many artists represented in the collection and broadly within the continuing and evolving traditions of the Shanghai school are Chen Hengke, Cui Zifan and Ya Ming.

While these three definitive Shanghai, Beijing and Lingnan schools of new 'traditional' painting styles did more than most to define modern Chinese painting, there were many other forces at work. The classical restraint of the landscape literati tradition is shown in the work of Huang Binhong, Wu Hufan and the more recent and often humorous innovations of the Nanjing artist Xu Lele. The new and often eccentric diversions in figure painting are illustrated in the work of artists such as the Beijing painter Nie Ou, whose often dark ink and emotionally charged images bring a new sense of reality and contrast mightily with the very different figurative images of the playful Ding Yangyong or the sheer eccentricity of Huang Yonghou. In recent decades innovation in Chinese painting styles has been rife with artists seeking to engage with Western ideas of volume and modelling, for example Xu Beihong and Lin Fengmian, while others continue to explore the opportunities of the traditional forms of brush and ink and yet produce irrevocably contemporary works, like Wu Zuoren, who is renowned for his images of camels, and those of the contemporary Beijing artist He Jianguo.

Yet even the multitude of developments and diversions in Chinese painting in the 20th century up to the mid 1980s is overshadowed by what has subsequently occurred. The visions and horizons of Chinese artists today are no longer constrained by location; they have joined the artistic diaspora and work around the world in styles which reflect a global interest while retaining a spirit of the Chinese aesthetic. The seductive minimalism of Zhang Xiaogang's figures and faces, Yin Xiuzhen's didactic installations and Guan Wei's evocative and often humorous and graphic observations of human foibles and frailties are examples of the gregarious and innovative spirit of China's contemporary artists.

Ren Bonian (1840–96)
Figure in a boat under a wintry tree
dated 1893
hanging scroll, ink and colour on paper,
114.3 x 48.2 cm
Purchased 1988
395.1988

Orphaned in his early teens, Ren Bonian (also know as Ren Yi) was apprenticed to a fan shop in Shanghai. Here he learnt to paint and to copy the work of the then well-known and established artist Ren Xiung, and subsequently became his pupil. Ren Bonian's figure paintings are distinguished by dramatic and accented

brushstrokes. His inherent eloquence with brush and ink is well illustrated in the variable and expressive strokes of the tree, swift dashes of ink that define the wintry branches and the moody strokes that define the foreground rocks. He gained his fame as a portrait and figure painter but is equally known for his bird and flower subjects. This example is fully characteristic of his style: eloquent, sparse, delicate, with the brushstrokes echoing against timeless space of the background. The inscription, written by Ren Bonian, reads: 'Painted by Ren Yi Bonian in his studio in Shanghai in the third month of the *guizi* year [1893] of Guangxu reign.'

Wu Changshuo (1844–1927)
Loquats dated 1918
hanging scroll, ink and colour on paper,
181.5 x 82 cm
Purchased 1987
460.1987

Wu Changshuo was a poet and a calligrapher before he became a painter and it was his association with Ren Bonian that inspired him to become an artist. Wu subsequently became one of the leading figures of the Shanghai school, renowned for the directness,

colour and sense of spontaneity of his work. This scroll typifies Wu's energetic style distinguished by a graphic bravura in both the painting and the calligraphy. Having earlier studied calligraphy and ancient epigraphy Wu had a special appreciation of the opportunities of calligraphy and this is well demonstrated in his wonderful and expressive brushwork. The subject matter of the mature and ripening loquats combined with the sheer energy of the brushwork echo a sense of lively regeneration in the artist, who painted this scroll in his 75th year. The poem, also written by Wu, reads:

During the May 5th festival,
the good food ripens with the warm wind,
though its colour is like yellow gold
that hardly relieves poverty.
Placed with pomegranate flowers on the table for appreciation.
In the wuwu year four days before the ninth day of September,
a guest in the Qu Zhi Sui Yuan studio,
Wu Changshuo at the age of seventy-five.
Hanging on the wall,
Resembling Li Futang's old brushwork.
Written by a Fu-Daoist at Chan Bi Xian studio.

Wang Zhen (1867–1938)
Nine years facing the wall
hanging scroll, ink and colour on paper,
148.3 x 80.5 cm
Purchased 1989
338.1989

Wang Zhen was an 'amateur' scholar-artist who took to painting relatively late in life having previously been a successful and wealthy Shanghai businessman. This endearing and robust image of the Buddhist deity Bodhidharma, the chief patriarch of Chan (or Zen) Buddhism, reveals the imaginative and energetic combination of tradition and modernity in later 19th and early 20th century Chinese painting. According to legend, Bodhidharma achieved Enlightenment after spending nine years staring at a blank wall. This empathy with the Buddhist ideal is alluded to in the inscription on the right by the well-known Beijing intellectual of the time, Cai Yuanpei. The scroll is signed 'Bailong shanren' (white dragon hermit) and the poem, by Wang, is an ode to Bodhidharma:

Nine years facing the wall,
Shadow impressed on stone;
To move is not so good
As it is to be stationary.

Qi Baishi (1863–1957)
Pumpkins
hanging scroll, ink and colour on paper,
132 x 33.5 cm
Anonymous gift 2000 © Qi Baishi Estate
126.2000

Qi Baishi is the quintessential master of modern Chinese painting. His work embodies the qualities of freshness, colour and audacious brushwork that were the hallmarks of Chinese painting in the traditional manner around the turn of the 19th and 20th centuries. Born in Hunan province, Qi was plagued by illness in his youth and learnt carpentry in an attempt to improve his condition. Although always interested in painting, it was not until his late 30s that Qi began to formally study painting and poetry, initially with the great scholar Wang Xiangyi. As his career progressed Qi became the most established Chinese artist of the 20th century. Later in life, and following the foundation of the People's Republic, he was recognised in a number of positions and honours, including his 1953 appointment as 'People's Artist'. He was always the master of the *xieyi* (spontaneous brushwork) manner and in this painting demonstrates his delight in his subject and the experience of playing with brush, ink and colour.

The inscription reads: 'On working in the garden, I pulled out weeds and cut off wilted flowers. The newly planted vine was not thick enough to cover the fence, so I filled the empty space with autumn melons. In so doing I lamented the hardships of life, and the struggle for food. Baishi.'

The scroll also bears the seal of the distinguished artist and collector C C Wang to whom this painting once belonged.

Huang Binhong (1864–1955)
Landscape dated 1945
hanging scroll, ink and slight colour on paper,
67.6 x 38.2 cm
Purchased 1987 © Huang Binhong Estate
479.1987

Wu Hufan (1894–1968)
Landscape dated 1938
hanging scroll, ink and colour on paper,
76.5 x 30.7 cm
Purchased 1984 © Wu Hufan Estate
57.1984

Acknowledged as a master of the traditional style of landscape painting, Wu Hufan nonetheless brought a refreshing sense of colour to his often meticulous evocations of nature. Examples such as this remain firmly in the tradition with the clearly defined foreground, middle ground and the far distance hinted at in the soft colour washes of remote mountain peaks. The modulation of the rocks and mountains with abbreviated brushstrokes and the careful definition of the trees and leaves are reminiscent of the literati landscapes of the late Ming and early Qing dynasties, but Wu's innovative colours bring a sense of modernity to that traditional style. A native of Suzhou, Wu spent his early years in the Shanghai region and following the establishment of the People's Republic in 1949 he taught at the Shanghai Painting Academy. In the inscription Wu acknowledges the heritage of his own painting style: 'Dong Qichang (1555–1636) once copied the "boneless style" landscapes of the great Northern dynasties masters Zhang Shengyou and Yang Sheng. This method was lost in the Song and Yuan dynasties but Dong Qichang revitalized their secret. After him Ha Yan sometimes also did paintings in this manner. Dated *wuyin* year [1938], signed Wu Hufan.' The small colophon on the upper left, which was evidently written late reads: 'In the autumn of this year Mr. Pei Lin showed me this painting and I inscribed it for him.'

One of the last in the great tradition of literati landscape painters, Huang Binhong was born into a family with established artistic and literary traditions in Anhui province. From the age of ten he learnt the arts of painting and seal engraving and, in true literati tradition, in his teenage years he began to collect Yuan and Ming dynasty paintings. Having moved to Shanghai at the beginning of the 20th century, he edited an encyclopaedia of writings on the fine arts. Later he became head of the Zhejiang Academy of Arts in Hangzhou, where he spent the remainder of his life.

Assuming such teaching and academic roles was not uncommon for painters of Huang's eminence. His style was deeply influenced by the aestheticism and purity of the literati tradition and, as in this painting, he delighted in the use of brush and ink and used colour most sparingly. The inscription states that the painting is dedicated to a Mr Qin Zhi; it is signed Huang Binhong in his 81st year (1945).

Xu Beihong (1895–1953)
Galloping horse dated 1944
hanging scroll, ink and light colour on paper,
61.0 x 49.5 cm
Purchased 1988
394.1988

Few modern Chinese artists have achieved such renown as Xu Beihong. Famed not only for his prodigious output but also for his gregarious styles, he worked in the European manner in oils, infusing his Chinese brushwork with moments of the Western aesthetic of definition through light and shade. He became immensely popular and widely known with his series of ink paintings of ebullient horses, of which this is a prime example. The painting is dated to the *jiashen* year (1944).

After an unusually international life, Xu Beihong finally settled in Beijing in 1946 as principal of the Beijing College of the Arts and then from 1949 as head of the Central Arts Academy. A memorial museum, devoted to Xu's life and work is located in Beijing.

Wu Zuoren (1908–97)
Damo – great desert dated 1977
hanging scroll, ink on paper, 69.8 x 45.7 cm
Gift of Graham Fraser 1993 © Wu Zoren Estate
591.1993

The work of Wu Zuoren exemplifies the way in which the traditional brush-and-ink technique of Chinese painting can be transformed into an entirely modern idiom. Wu studied with another of the great modern masters of Chinese painting, Xu Beihong, and then from 1930 to 1935 he studied and worked in France and Belgium. His distinctive use of broad wet brushstrokes in the *mogu hua,* or 'boneless' style, that is one worked in brush washes of ink rather than brush lines, hints at the Western styles that he would have absorbed while in Europe, like his mentor Xu Beihong. Wu is particularly renowned for his appealing images of camels, yaks, oxen and pandas and for his evocations of the Gobi desert.

Zhu Qizhan (1891–1996)
Everlasting celebration dated 1963
hanging scroll, ink and colour on paper,
137 x 68 cm
Purchased with funds provide by Goldie Sternberg
1985 © Zhu Qizhan Estate
397.1985

Born in Jiangsu province in southern China, Zhu Qizhan was always closely associated with Shanghai. He was professor at the Shanghai Academy of Fine Arts and also served as head of the city's Xinhua Art College. He lived to a remarkable age and his 100th birthday in 1990 was celebrated with major exhibitions of his work in China and Hong Kong. Zhu is best known for his vibrant and expressive paintings of flowers, plants and fruit. Particularly characteristic is the spontaneous – even playful – and exuberant brushwork employing broad washes of ink and colour, full wet strokes and attenuated dry brushstrokes. Such variety in the brushwork is the hallmark of Zhu's style. The inscription on this scroll states that it was painted in the autumn of the *guimao* year (1963) in the *Meihua caotang* (plum blossom thatched studio) in Shanghai.

Cui Zifan (b1915)
Lotus dated 1981
hanging scroll, ink and colour on paper,
69 x 34 cm
Purchased 1985 © Cui Zifan
398.1985

Cui Zifan was born in Shandong province but has spent most of his creative life in Beijing. Originally he studied the works of the great 17th-century individualist painter Zhu Da and was later influenced by the free brushwork and vibrant colours of Wu Changshuo and Qi Baishi. Cui's work continues in the manner of those two mentors. The bold, expressive and dramatic contrast of black ink and colour is a consistent theme in his work. The painting is signed 'Zifan' and dated to the *xinyu* year [1981].

Lu Yanshao (1909–93)
Landscape of Liuzhou dated 1985
handscroll, ink and colour on paper,
45.7 x 209.6 cm
Gift of Mr Lee Teck-Chiow 2000
© Lu Yanshao Estate
125.2000

Born in Shanghai, Lu Yanshao is acknowledged as one of the major and most innovative landscape painters of 20th-century China. Before joining the Zhejiang Academy of Fine Arts in 1962 he was widely recognised as a distinguished artist and seal carver. His style is characterised by the tremulous energy in his landscapes as though the air, water, rocks and mountains are in constant and often uncertain motion. They convey the contradictory effects of stability, in the representation of nature and the landscape, and uncertainty, in the deliberately nervous brushwork. The long inscription at the end of the scroll states that the painting was inspired by the writings of the Tang dynasty official Liu Zizhou (Liu Zongyuan) who, in the reign of the Emperor Xianzang (806–20), had been banished to Liu county following his involvement in a failed political reform movement. The inscription reads: 'Liu Zizhou (also named Zongyuan) had been banished to Liu County by the Tang Court.

Amid the mountains and streams Liu wrote his famous prose, now considered to be the highest among all. Han Changli [768–824: Tang dynasty scholar] made a critique which highly praised Liu's prose. Now I, Lu Yanshao, visited Liu County and my painting is inspired by the scenery and the historical accounts made by Han Changli. The sixth month of the *yichou* year [1985], Lu Yanshao at Xizi Lake.'

Ding Yangyong (1902–78)
The Eight Immortals dated 1978
hanging scroll, ink and colour on paper,
141.5 x 69.6 cm
Purchased 2000 © Ding Yangyong Estate
231.2000

Born in Guangdong province, Ding studied Western art at the Tokyo School of Fine Arts, where he was influenced by the colourful style of the Fauves, and Matisse in particular. In 1925 he returned to China, where he played a significant role in rejuvenating traditional styles with the colour and spontaneity of contemporary Western art. In 1949 he moved to Hong Kong and founded the Fine Arts Department of the Arts College in 1957. This lively scroll depicting the Eight Daoist Immortals is typical of Ding's individual and eccentric idiom, with its caricature figurative style, effervescent colours and the so-called quality of *zhuo* or 'deliberate clumsiness'. The inscription

describes the Eight Immortals and reads: 'Zhang Guolao was riding backwards on his mule; Lan Caihe had a childish look; Lu Dongbin learnt the secret of Daoism; the great Han dynasty general Zhongli Quan had an erudite expression; Cao Guoqiu was a relative of the Imperial family; Li Tieguai was grotesque and crippled; Han Xiangzi's flute music resounded among the clouds; He Xiangu was a fair lady. Painted by Ding Yangyong in the *wuwu* year [1978].'

He Jianguo (b1953)
Portrait of Chen Lang dated 1985
hanging scroll, ink and colour on paper
140 x 80 cm
Purchased 1993 © He Jianguo
325.1993

The idiosyncratic and self-taught Beijing artist He Jianguo has brought both new life and new opportunity to the great tradition of Chinese brush and ink painting. A fan of Western artists such as Matisse, Picasso, Cezanne and Kandinsky, He Jianguo seeks to instill his own work with the breadth and opportunity of those Western artists whose work he so admires. His brushwork and sense of composition are both free and novel in the Chinese experience. The inscription states that this scroll was 'painted by He Jianguo in 1985 on the occasion of [his friend] Mr. Chen's sixtieth birthday'.

Nie Ou (b1948)
Zhuyue mountain after rain dated 1986
hanging scroll, ink on paper, 143 x 34 cm
Purchased 1987 © Nie Ou
539.1987

The distinguished artist Nie Ou was born
in Liaoning province in northeast China.
By the age of 12 she excelled in the basic
techniques of drawing, Western oil
painting and later in woodcuts. In spite
of the deprivations during the Cultural
Revolution, she found lasting inspiration
in the countryside and developed her
distinctive, contemporary and spacious
style of ink painting.

Xu Lele (b1955)
Enjoying summer dated 1994
hanging scroll, ink and colour on paper,
127 x 33 cm
Purchased 1997 © Xu Lele
364.1997

Xu Lele brings the great tradition of
literati painting in China into a humorous,
almost satirical, contemporary idiom. The
composition is drawn from the vocabulary
of Ming and Qing dynasty court and
literati painting styles, and yet it evokes a
sense of the modern in its colour, humour
and gentle satire.

Li Qun (b1912)
Drinking 1940
woodcut, 19.2 x 13.8 cm
Purchased 1995 © Li Qun
199.1995

Wang Qi (b1918)
Stone workers 1945
woodcut, 33.5 x 25.8 cm
Purchased 1996 © Wang Qi
226.1996

Yan Han (b1916)
Electing leaders by casting beans 1947
woodcut, 29 x 37 cm
Gift of the artist 1995 © Yan Han
224.1996

During the 1930s and 1940s in China, social turmoil and civil war fuelled a revitalised woodcut movement influenced by the potent prints of Western artists such as Käthe Kollwitz. These new works graphically convey feelings of suffering and struggle.

Li Qun and Wang Qi were seminal figures in the Chinese revolutionary woodcut movement promoted by leading Chinese writer Lu Xun as a vehicle for articulating the people's revolution from the late 1920s through to the establishment of the People's Republic in 1949. *Drinking* and *Stone workers* are classic images of this movement. The latter is an excellent example of one of the subjects of the revolutionary genre in prints executed during the war against Japan (1937–45).

Su Xinping (b1960)
Dialogue 1989
lithograph, 46 x 61.8 cm
Gift of Ruth Burgess 1996 © Su Xinping
297.1996

The artist is a skilled printmaker from Inner
Mongolia whose still, eerily lit tableau
potently evokes a tense and alienating
world.

Fang Lijun (b1963)
Pencil drawing no 2 1988
pencil on paper, 54.7 x 79 cm
Purchased 1993 © Fang Lijun
327.1993

Fang Lijun (b1963)
Pencil drawing no 3 1988
pencil on paper, 54.8 x 79.1 cm
Purchased 1993 © Fang Lijun
328.1993

Academic realism has been taught at
Chinese art academies since the 1940s
and continues to be a main technique
influenced by classical European art and
individual artists such as the American
painter Andrew Wyeth. While some of the
artists of the first two post-revolution
generations depicted the harsh realities of
rural poverty and misery with a humane
concern, there emerged a third, more
despairing generation of artists. Fang Lijun
epitomises the generation that adopted a
kind of 'rogue cynicism' which reflected
their acute feeling of the meaninglessness
and hopelessness of their own lives and
society. These drawing were among those
the artist prepared for his graduation
assignment at the Central Academy of
Fine Arts in Beijing.

Zhang Xiaogang (b1958)
Comrade 2001
oil on canvas, 200 x 260 cm
Purchased 2002 © Zhang Xiaogang
280.2002

There is in Zhang's work a disturbing sense of detachment. The cool, impersonal face of the baby (beautiful, soft, oddly uniform though it is) seems to represent an ideal that is ambiguous in its obvious, almost flagrant, confrontation with the viewer. Yet the face remains unapproachable and unattainable. With a subtle sleekness Zhang expresses so many of the dilemmas facing modern China: the urgent quest for engagement with the world without prejudice to its own values and traditions, the tension between public and private, between collective good and private ambition, between self – so strongly illustrated in this image – and society. With its limpid eyes and hint of happy impertinence, this strangely mature baby infers the contradictory senses of confidence and vulnerability. Zhang Xiaogang, who teaches at the Academy of Fine Arts in Chengdu, Sichuan province, represents, in both his style and broader social and human concerns, a gregarious and imaginative new spirit in Chinese painting.

Guan Wei (China/Australia, b1957)
(detail) Revisionary 1998
26 panels, synthetic polymer paint on canvas,
21 panels 120 x 50 cm, 5 panels 60 x 45 cm
Purchased with funds provided by the Rudy
Komon Memorial Fund 1999 © Guan Wei
173.1999.a-z

Having moved from Beijing to Australia in 1989, Guan Wei retains a strong sense of guidance from his Chinese heritage but having made that move inevitably feels less bound by it. There is a fresh spirit of freedom in his work that reveals itself in humour, whimsy and in the playful but pertinent allusions to his Chinese heritage. Nonetheless, tucked away in the fancy and apparent whimsy of his work are moments of quietly barbed remonstration and demonstration which reveal a more serious intent. This large and complex work explores many of Guan's recurring themes: in particular the general well-being of humanity and the sheer survival of the earth. The composition loosely suggests the Last Judgement with the heavenly realms shown in the upper panels and the earthly realms in the lower. However, his gods, angels and demons have been drawn from neither east nor west and appear, characteristically, as vulnerable naked and frolicking figures of no fixed identity.

Liu Xiao Xian (China/Australia, b1963)
Our gods 2000
type C photographs, 18 panels,
100 x 100 cm each
D G Wilson Bequest Fund 2000 © Liu Xiao Xian
168.2000.a-r

In this subtle and insightful work, each larger-than-life image proves on close inspection to be composed of digitally produced images of the other: Christ is created from tiny figures of Buddha and the Buddha from tiny images of Christ. There are 22 500 smaller figures in each large figure. The Buddha is in fact the so-called 'Laughing Buddha', a historical figure called Budai who also became synonymous with the Future Buddha Maitreya. Budai was an eccentric pot-bellied Chinese monk easily recognisable by his enormous smile and the large cloth bag he always carried. Budai was revered as an enlightened being, detached from the cares that bind the rest of us. He became associated with Maitreya because of his supramundane character and because of a famous poem he wrote on his deathbed that implied that he was Maitreya in disguise.

In Chinese folklore, he became a symbol of good luck and prosperity. The artist Liu Xiao Xian was born in China and emigrated to Australia in the 1980s.

KOREA

Known popularly as the 'Hermit Kingdom', Korea is represented in the collection by its most celebrated artform: the extraordinarily beautiful and skilfully made celadons of the famous Koryo dynasty (918–1392), created under the patronage of a court devoted to Buddhism.

Korea's destiny has been shaped by its geographical position. Contained on a peninsula on the northeastern part of the Chinese continent, it has been subject to influences from the north Asiatic cultures of Manchuria and Siberia, as well as from China. Its religious heritage reflects its links with these cultures, and in Korean society today elements of animism, shamanism and ancestor worship can be found together with Buddhism and Confucianism. Buddhism reached Korea from China in the 4th century and was successfully adopted as the state religion by the so-called Three Kingdoms which comprised Korea at that time: Koguryo, the largest kingdom, established in the north in 37 BCE, and its southern neighbours Paekche and Silla. By alliance with Tang China, Silla expanded to unify the peninsula and under Unified Silla (668–936) Buddhism persisted as the state religion while Confucianism, the teachings of the Chinese philosopher Confucius (551–479 BCE), was adopted for education and administration.

The succeeding Koryo dynasty maintained Buddhism as the state religion while the civil service remained in the hands of a Confucian-educated hereditary administrative elite (*yangban*, literally 'two categories', the military and civil officials). The Koryo aristocracy had close contact with the court of Song dynasty China and during the 1100s, a time of peace and prosperity, Korean arts reached an unrivalled level of refinement. It is a sad fact that due to Korea's turbulent history so little of this magnificent heritage survives. The Mongols conquered Korea in 1259, while the Choson dynasty (1392–1910) incurred the Japanese invasions of 1592 and 1597 (sometimes called the 'ceramic wars' because so many Korean potters were forcibly taken to Japan to develop its ceramic industry) and the Manchu invasions of 1627 and 1637–39. By the time of the Choson dynasty, corruption and degeneration within the Buddhist establishment had caused Buddhism to lose its position as the official state doctrine. The dominant Confucian policies of Choson imparted a different character to the culture compared with Koryo culture. This is reflected in the ceramics, which tend to be sturdy, austere and minimally decorated.

In the aftermath of Japanese rule from 1910–45 and the Korean War of 1950–55, Korea split into the Democratic Republic of Korea in the north, and the Republic of Korea in the south. The contemporary scene in the south is lively, with both the invigoration of traditions and engagement with new international forms.

Silla period (57 BCE – 668 CE)
Two jars 600s
left: grey stoneware, 10.5 x 11 cm (mouth diameter)
right: grey stoneware with stamped decoration, 10.7 cm
Purchased 1986, 1983
381.1986, 4.1983

Deposited in large quantities in tombs along with armour, agricultural implements and ceremonial jewellery, Silla ceramics survive in significant numbers. Tomb ceramics range from large storage jars and ceremonial vessels for fertility and harvest rites, to household pieces such as these. The use of impressed and incised decoration into a grey body is characteristic of Silla decoration.

Koryo period (918–1392)
Mirror with design of two birds
bronze, 14 cm (diameter)
Gift of J A and H D Sperling 1999
161.1999

Koryo period (918–1392)
Dish with incised design of two birds
celadon, 4.9 x 16.9 cm
Gift of Graham E Fraser 1986
174.1986

Koryo period (918–1392)
Bowl
celadon, 7.5 x 15.8 cm
Gift of Mr J Hepburn Myrtle 1993
339.1993

Koryo period (918–1392)
Cupstand with hexagonally scalloped flange
celadon with inlaid decoration of eight flowers, 6.5 x 13.7 cm
Gift of Dr Peter Elliott 1998
232.1998

Towards the mid 1100s an important innovation took place in the decoration of Koryo celadons. This was the use of an inlay technique known to Koreans as *sanggam*. The decoration is carved or incised into the unglazed body and inlaid with white or black slip, before glazing. Delicate floral decoration as seen on this cupstand is typical of *sanggam* designs, which catered to the refined tastes of the Koryo aristocracy.

Koryo period (918–1392)
Cupstand with five-petal flange
celadon, 6 x 14.5 cm
Gift of Mr J Hepburn Myrtle 1989
253.1989

In this piece the combination of the naturalistically inspired lotus petal form with the abstract qualities of the glaze and texture has produced an object of the highest artistry and sophistication. The sinuous outlines of the five sections define the lotus leaves on which the cup would rest when making an offering. Produced for use in Buddhist temples as well as the court, Koryo celadons are distinguished by their understated forms and soft beauty of colour. Like the majority of the Koryo celadon repertoire, the cupstand derives from Song dynasty Chinese prototypes: wares distinguished by their simple and refined forms and the exquisite

lustre of their glazes. With its five-petal flange, this is an unusual piece: most Koryo celadons of this type have six petals. The unusual shape harks back to the silver and lacquer types of Tang dynasty China (8th century), which combined the offering cup and separated stand into a single unit. The ceramic version was refined in the Song dynasty, most especially by potters at the rarefied imperial Ru ware kilns in Henan province.

Choson dynasty (1392–1910)
Jar 1800s
stoneware, 11.7 x 16.7 cm
Purchased 1989
283.1989

This jar, thought to be from Hwaeryeong in North Korea, came from the collection of Australian artist Margaret Preston. Preston visited Peking, Seoul and Japan in 1934, one of the first Australian artists to do so. A paper label on the base reads 'Korean/got from/Seoul'.

Choson dynasty
Four waterdroppers
Gifts of Mr J Hepburn Myrtle 1993

The simple waterdropper, essential to calligraphy writing and painting, is a form the Korean potters made their own. An amazingly varied number of designs and forms were produced, from small pieces such as these to those requiring two hands to lift. Confucianism was the official state doctrine in the Choson dynasty, resulting in an educated class of scholars, known as *sonbi*, who did not yet hold official positions. Waterdroppers such as these were an essential accoutrement of *sonbi* culture.

clockwise from top left:
Moulded in the form of a fish
porcelain decorated in monochrone blue glaze,
1.7 x 8.5 cm
341.1993

'Doughnut' form
porcelain with copper red monochrome glaze,
3.7 x 8.7 cm
343.1993

Peach form
porcelain decorated with underglaze blue and red,
4.7 cm
344.1993

Square with landscape scene
porcelain decorated in underglaze blue,
3.3 x 6.4 x 6.5 cm
342.1993

Yoon Kwang-cho (b1946)
Punch'ong ware jar c1990
stoneware with slip decoration, 39 x 31 cm
Purchased with the assistance of an anonymous
donor 1992 © Yoon Kwang-cho
198.1992

Yoon has incised the text of a Buddhist
sutra on nothingness into this jar. Yoon's
work is praised for its individuality and for
its imaginative revival of the austerely
beautiful aesthetic of the uniquely Korean
punch'ong ceramics of the 1400s and
1500s. The rough spareness and honesty
of *punch'ong* ware endeared it to
discerning connoisseurs such as the tea
masters of Japan. Literally translated,
punch'ong means 'powder green', a
reference to the transparent glaze applied
at the end of the creation process. By the
Japanese invasions of 1592, *punch'ong*
wares were in decline, to be replaced
among the Korean upper classes by white
porcelain. Revitalising and modernising
this lost tradition, Yoon makes his vessels
by coiling as this gives him greater
freedom. He then beats and scratches the
surface, then applies a coating of brushed
white slip. As a Buddhist, Yoon believes
that the painstaking effort required to
produce a pot is yet another form of
disciplined asceticism.

Nam June Paik (Korea/USA b1932)
Buddha game 1991
antique television set covered in pages from a
printed book, two gold leaf wooden Buddhas,
neon, antennae, three Sony Watchmans, two
Sony 8-inch televisions KV8AD10, Sony laser disc
player, original laser disc, Stancore 350 1989;
147.3 x 92.7 x 59.7 cm
Purchased 2002 © Nam June Paik
10.2002

This work combines many of the
persistent themes found in the work of
Paik, who has been an international
pioneer of video installation and the
integration of new technologies with
spiritual issues. This work is presented as
an old television set – the vehicle used by
so many to mediate everyday existence. It
is covered with pages of printed text, the
previous vehicle of mass communication.
Within the set are two seated Buddhas,
each holding a Playstation module and
viewing a speeding abstraction – a
psychedelic, hallucinatory vision, a 21st-
century imaging of Nirvana?

JAPAN

THE ART OF BUDDHISM AND OTHER WORLDS

Before the introduction of Buddhism to Japan, the native religion of Shinto ('the way of the *kami* or gods) as well as various folk beliefs were practised. The arrival of Buddhism from the mainland in the mid 500s CE gave a strong stimulus to the pursuit and learning of things Chinese, including the system of writing. By the end of the 6th century Buddhism had gained a firm and permanent foothold thereby enabling the faith to quietly grow and complement, rather than challenge, the native Shinto tradition. Certainly by the time the gallery's sublime and serene wood sculpture of Amida Buddha, the Buddha of the Western Paradise, was carved in the 1100s Buddhism was confidently part of the Japanese way of life with a background of centuries of evolution and established traditions of many sects and temples (many of which still stand to this day), particularly in the Nara-Kyoto region. Esoteric Buddhist sects such as those of Shingon and Tendai grew, as did the popular Pure Land Sect and Zen Buddhism, with the golden age of Buddhism in Japan extending through to the 1500s.

The essential teachings of the Mahayana school of Buddhism introduced to Japan are contained within the Lotus Sutra, which includes the doctrines of the transcendental nature of the Buddha, as well as his complete teachings. All sects recognise the importance of the Lotus Sutra, which was a great source of inspiration to Buddhist practitioners and artists.

PURE LAND BUDDHISM

The art of the Pure Land sect of Buddhism in Japan is represented in the gallery's collection by three significant pieces, all images of Amida (Sanskrit: Amitabha, 'the lord of vast light'), the Buddha who presides over the Western Paradise of Sukhavati. This school of Buddhism became extremely popular in Japan from the 11th century, in line with a prevalent belief that the Age of the Decline of the Dharma (in Japanese, Mappo) had begun, a belief reinforced by the turbulent despair caused by war and natural disasters at that time. This belief held that the power of Buddha and his control of affairs on earth would cease in 1052. The Pure Land sect, which taught that invocation of Amida's name would be enough to ensure rebirth in the Western Paradise, understandably gained widespread popularity, and images of Amida were commissioned in large numbers.

Because of the belief that commissioning an image of the Buddha accrued one merit, not only sculptures and paintings were commissioned but also countless numbers of blockprinted images, some of which were then placed within a sculpture (the gallery has a small woodblock fragment of one such sheet, but because of its fragility and rarity it is seldom on display). Just as it was believed that merit was acquired in direct proportion to the number of images produced, so it was believed that merit was

doubled by producing printed images and then placing them inside a sculptural image.

The earliest significant painting in the gallery's Japanese collection is Buddhist: a large and beautifully painted depiction of the Western Paradise of Amida. The painting is a mandala, a diagram of a sacred cosmic space. This particular form of mandala is known as a Taima mandala after the Taima-dera, a temple in Nara where, according to tradition, the first representation of the magnificent paradise was woven from threads made from lotus stalks. This extraordinarily complex representation of paradise is one of the masterpieces of the collection, the glowing details and narratives of which cannot be given justice in photographic reproduction.

ZEN BUDDHISM

Zen Buddhism has become synonymous with Japan, although it originated, like so much in Japan, in China. Zen literally means 'meditation', and in the search for Enlightenment (*satori*), it was the mediating teacher-monk who was important in guiding his student on the path to Enlightenment. While Zen teaching decried the use of religious images, portraits were acceptable, and the Zen repertoire is distinguished by portraits of teachers (presented as graduation 'diplomas') and those Zen eccentrics who epitomised the professed Zen indifference, even disdain, for the rules of society.

Japanese monks who had been studying the teachings of the Chan (Zen) sect in China returned to Japan to found the two main lines of the Rinzai and Soto sects in 1191 and 1227. From the Kamakura period (1185–1332), under the patronage of the ruling samurai elite, Zen became the dominant cultural influence for some centuries. Through their frequent journeys to China, Zen monks were the principal agents for the transmission of Chinese ideas and fashions back to Japan. Zen temples became major centres of Chinese learning and art, with enormous holdings still today.

While the influence of Zen had waned by the 1500s, a resurgence occurred when the Obaku sect, led by monks fleeing China as the Ming dynasty collapsed, came to prominence. Understandably, many Zen monks, with their knowledge of Chinese culture and their commitment to teaching, were great calligraphers. This can be seen in the Buddhist couplet by Etsuzan Doshu (page 194), the seventh abbot of the chief temple of the Obaku sect.

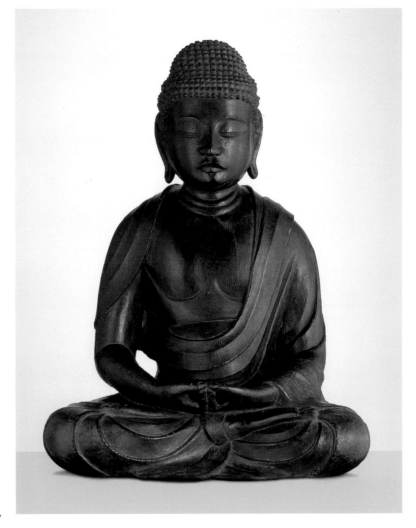

Heian period (794–1185)
Images of the Amida Buddha
woodblock print, 13.4 x 10.2 cm
Gift of Prof T Mori 1962
DO24.1962

Printed on extremely thin mulberry paper, this fragment of seven images and two part-images reportedly comes from Joruriji, a temple east of Nara. Several sheets were found inside a sculpture. These particular representations of Amida are the oldest-known woodblock prints of holy images still existing, and other specimens of sheets of Amida figures found at Joruriji are classified as National Treasures.

The Joruriji temple was founded in 1047 as a dedication to the Medicine Buddha Yakushi but was converted to a place of worship for Amida in the early 1100s. The Amida Buddha images sit in the full lotus position on lotus leaves. Their hands are in the gesture (*mudra*) of concentration. It was believed that the more images one produced or paid to have produced, the more blessings one accrued. This led to the production of sheets with the same image printed (or stamped) in repetitive rows.

Heian period (794–1185)
Seated figure of Amida 1000s–1100s
nutmeg wood with black lacquer and some gilding, 53.5 cm
Purchased with assistance from the W H Nolan Bequest 1984
119.1984

This sculpture of Amida echoes the qualities of formality and spiritual serenity characteristic of the Buddhist art of Japan. Carved from a hard, dense nutmeg wood – with that inherent sensitivity to the nature of the material so identified with Japanese artists – the image emanates an aura of reassurance and spiritual certainty not commensurate with its modest scale. Amida's hands are held in the gesture (*mudra*) of meditation.

Kamakura period (1185–1332)
Taima mandala early 1300s
hanging scroll, ink and colour with gold on silk,
146 x 138 cm
Art Gallery of New South Wales Foundation
Purchase 1991
369.1991

Here a glowing figure of Amida sits in the centre, flanked by the bodhisattvas Kannon and Seishi, who respectively embody Amida's compassion and wisdom. They are surrounded by golden pavilions and over 500 living beings, including other Buddhas, bodhisattvas, disciples, monks, men and women. The painting is a lyrical and enticing evocation of the Pure Land as described in the sutras, which conjure images of magical realms of precious-gem trees, lotus-covered lakes of jewel water, and myriad, golden pavilions filled with celestial musicians. The border panels illustrate the contents of one of the principal Pure Land sutras. The 11 panels on the left, to be read from the bottom up, are sequential vignettes of a Buddhist parable that tells the story of a royal family whose king and queen sought solace in the Buddha after being imprisoned and threatened with death by their son, who had been corrupted by an evil monk. The anxious

prayers of the queen brought first disciples of the Buddha Shakyamuni and then Shakyamuni himself within a halo of golden light. His glow illuminated the realms of the afterlife and the pure lands of the ten directions. At the queen's request the Buddha describes 16 meditations to ensure rebirth in this Land of Supreme Happiness ruled by Amida Buddha. The first 13 of these are illustrated in the panels on the right, reading from the top down. The illustrations in the lower border depict the last three of the 16 meditations described in the sutra. Viewers too can follow this path to enter the blissful paradise floating before them.

Etsuzan Doshu (1629–1709)
Calligraphy
pair of hanging scrolls, ink on paper,
136.5 x 30.4 cm each
Gift of Klaus Naumann 2003
42.2003.a-b

Etsuzan Doshu was the seventh abbot of
Manpuku-ji, the temple of the Obaku sect
of Chinese monks who emigrated after
the fall of the Ming dynasty in 1644. The
temple became the temple for Chinese
studies in the Edo period. The calligraphy
reads: 'The cloud of the [Buddhist] Law
reaches the pinnacle' (right) and 'Buddhist
wisdom lights the world' (left).

Jiun Sonja (1718–1804)
Calligraphy
hanging scroll, ink on paper, 124.7 x 26 cm
David Wilson Bequest Fund 1998
249.1998

One of the later masters of Japanese
calligraphy, Jiun was initiated into Esoteric
Buddhism and spent two years studying
in Kyoto with a Confucian scholar before
starting his studies of Zen Buddhism.
He went on to establish his own school
of Buddhism, the Ritsu sect, eventually
retiring to a mountain retreat where he
spent the last three decades of his life.
There he executed a vast number of

calligraphies and gained respect as one
of Japan's most revered Buddhists.
These five characters, written in Jiun's
characteristic bold, blocky style, are the
first line of a couplet from the Lotus Sutra
which, roughly paraphrased, declares that
all things exist in the Absolute.

Sakai Hoitsu (1761–1828)
Portrait of Abbot Zetsugai c1803
hanging scroll, ink and colour on silk,
102.1 x 51.2 cm
Purchased 1983
270.1983

Portraits such as this, termed *chinso* and customarily presented to a pupil once it was considered he or she had achieved Enlightenment, have a long tradition in Zen Buddhism. They were the tangible artistic expression of the deeply personal relationship between teacher and pupil, which is characteristic of the Zen sect. The standard pose for Zen portraits is the full-length seated posture, with shoes on a stool in front and the sitter holding one of the accoutrements of a Zen master, such as the fly whisk seen here. Abbot Zetsugai was the 241st abbot of the Kyoto temple Myoshin-ji. He died in 1713, so it is likely that Hoitsu painted this version after an original that had been damaged, perhaps by fire – a constant threat in earthquake-prone Japan. The signature and seal suggest that this painting was done when Hoitsu was aged between 41 and 44.

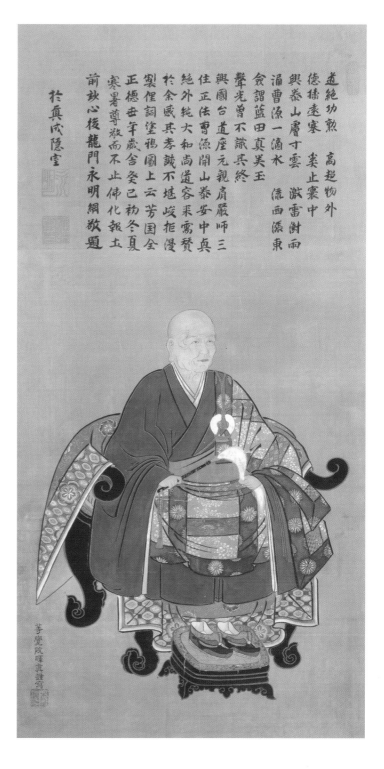

OTHER WORLDS

According to Shinto belief, there are eight million gods (*kami*) that govern every aspect of people's lives from natural forces to the acquisition of skills. In ancient times the priest, who communicated with the gods and mediated between them and the humans, was given the power to rule. Conducting rituals was his major role: the word *matsuri* and its verb form *matsuru* mean 'festivals' as well as 'to worship'. They are also used to mean 'to govern', reminiscent of the time when the shaman-ruler controlled both religious and secular matters.

One of the characteristics of Shinto belief is its anthropomorphic view of the world. Artists and poets have conjured fanciful images of natural objects as if they have human emotions. This belief in the existence of *kami* in all beings and objects continued after the introduction of Buddhism in the 6th century and remains in various forms to the present day (as seen here in the *Night procession of 100 goblins* scroll).

Itaya Hiroharu (active c1820s)
(detail) Night procession of 100 goblins
c1820
handscroll, ink and colour on paper,
29.5 x 600 cm
Purchased with funds provided by the Asian Collection Benefactors' Program 1995
125.1995

A humorous yet revealing image of anthropomorphic beliefs, this scroll depicts a medley of 'object-goblins'– kitchen utensils, musical instruments and the like. Recent scholarship explains that, according to old Japanese belief, objects that reached 100 years acquire a spirit. One surviving narrative scroll from the Muromachi period tells how used objects, discarded during the spring-cleaning of a temple, turned into demons and wreaked havoc on the village until a Buddhist monk quelled them and eventually turned them into good Buddhists. This scroll is one of many existing versions of the subject. As a pictorial representation, the scroll can be seen as part of the Japanese caricatural cartoon tradition that continues today as *manga*.

Okumura Masanobu (1686–1764)
Shoki the demon queller c1705
woodcut with hand-applied lacquer and washes
of ink, 55.7 x 24.2 cm
Purchased 1993
338.1993

Kawanabe Kyosai (1831–89)
Ogre chanting Buddhist prayer 1864
colour woodcut, 35.8 x 25.2 cm
Purchased with funds provided by the Asian
Collection Benefactors' Program 2000
132.2000

Shoki the demon queller is a good
example of a Chinese import into the vast
pantheon of Japanese gods and spirits.
Legend has it that the Tang emperor Xuan
Zung was healed from his illness by Shoki
(Chinese name Zhongkuei), who appeared
in his dream. In the dream Shoki said that
he had been an unsuccessful candidate of
the official examinations, but found his
talent in quelling demons. In Japan, the
image of Shoki is most conspicuous on
Boy's Day, when people pray for the well-
being of their male offspring.

Well known in the West for his humorous
as well as serious paintings, drawings and
prints, Kyosai was born in a low-ranking
samurai family. He initially studied Kano
school painting, then *nanga* and *ukiyo-e*
styles. A master of drawings and dynamic
composition, he taught Josiah Condor
(1852–1920), a British architect who
worked in Japan. Kyosai's anti-
authoritarian spirit found many targets for
satirical prints and cartoons.

Ogres, or *oni*, alongside animals and
ghosts, were his favourite subjects. This
image, his version of the popular folk
painting called *Otsu-e* (painting of the

Otsu region), depicts a hairy *oni* dressed
in the robes of a Buddhist itinerant priest
with a gong around his neck, a striker in
one hand, and a Buddhist subscription list
(*hogacho*) in the other. He is apparently
reciting *nembutsu*, a chant believed by
some Buddhists to help one attain
salvation in a Buddhist paradise.

THE AESTHETIC OF TRANSIENCE

The strong Chinese influence that came into Japanese culture with Buddhism persisted through the Nara period (646–794) and into the succeeding Heian period (794–1185). With the encroaching collapse of the Tang dynasty in China, Japan terminated official relations after the mission of 838 and evolved what was to become the classical culture of Japan at the imperial court in Heian (the old name for Kyoto). The courtiers of this highly literate culture created poems and tales charged with emotional intensity, subtle moods and an acute awareness of the beauty and transience of nature and life. Their poetry and literature, of which the *Tales of Ise* and the famous *Tale of Genji* written about 1000 CE are ultimate expressions, were an endless source of inspiration to artists through succeeding centuries.

Calligraphy was an important part of the Chinese legacy for which Japan has always maintained such respect. Japanese language had no writing system before the adoption of Chinese characters. Two styles of phonetic script (*kana*) were developed from the Chinese characters in the early Heian period to be used in combination with the characters. Japanese calligraphy is distinct from other East Asian forms in its additional dimension of *kana* calligraphy, which is sometimes written with extreme freedom and visual inventiveness. This art was largely initiated by the women, while the men wrote mostly in the Chinese style. The complex interaction of the content and artistic merit of writing is one the Japanese continue to enjoy today. Before the modern age, all educated people in Japan were expected to compose poems at private or social occasions. In other words, a verse-reading and writing public existed both as participants and as recipients of poetry throughout history.

In the Japanese aesthetic that emerged in the Heian period, the changes of the seasons were used as metaphors for the emotions; this aesthetic has guided succeeding generations for over a thousand years to add layered meanings to various facets of nature. Crucial to this 'communication with nature' is the awareness that all natural beings are impermanent: thus the signs of the waxing and waning of each season provide the poet with a rich array of subjects to express his or her joy, irritation, sadness and happiness. This sensitivity to the poignant transience of all things was the basis for the uniquely Japanese aesthetic of *mono no aware* (literally 'the sadness of things') which underpins the culture. In expressing this through the transmission of the seasons, the most potent symbols are the cherry blossom and the autumn maple, which are often combined in artworks. Cherry blossoms flower before the young leaves appear. They also open at once, turning the whole tree into a clump of pale pink cloud, only to fall within a week or so. A Heian period poet sang:

On a sunny, balmy spring day
How restlessly do cherry blossoms scatter!
(Ki (no) Tomonori, late 800s/early 900s)

In the Japanese mind, the cherry blossom has a special place. The purity of its colour and its grace in accepting its fate (rather than lingering on the branch after passing its prime) are qualities that make it also an ethical symbol: the opening sentence of *Bushido: the way of the samurai* by Nitobe Inazo reads: 'Chivalry is a flower no less indigenous to the soil of Japan than its emblem, the cherry blossom … It is still a living object of power and beauty among us.' At the other end of the moral scale, the cherry blossom has also provided an excuse for revelling at 'cherry-viewing parties' practised by all levels of society. Perhaps the secret to its popularity lies in its versatility in adapting itself to all facets of Japanese life – from severe ethical codes to poetic inspiration and bacchanalia.

For centuries successive writers have discussed the appreciation of the seasons. In his famous passage in *Essays in idleness* (c1330) Yoshida Kenko, one of Japan's most influential writers, points out the folly of seeing cherry blossoms and the autumn moon only in their prime. Instead, he says, one should appreciate the bursting buds, scattered petals in the garden or the full moon behind the clouds. The combination of literary allusion, seasonal references and this aesthetic appreciation of transience is exemplified beautifully in the pair of screens *Plain of Musashi* (page 204), where the moon – a symbol of autumn, the season when the moon seems brightest due to the drier air – is depicted through the grass.

Otagaki Rengetsu (1791–1875)
Calligraphy (poem)
hanging scroll, ink on paper, 29.4 x 41 cm
Purchased 1994
19.1994

Born into a samurai family, Rengetsu
became a Buddhist nun after her husband
and children died. She adopted the name
Rengetsu, meaning 'lotus moon', and
became best known for her tasteful
inscriptions of her poems on ceramics
such as bowls and teapots. This poem
reads:

The evening is fragrant with plum
blossoms
Oh, this fragrance!
It penetrates the black sleeves of my nun's
habit
Even though I have renounced the world,
I enjoy dressing myself in this aromatic
midnight scent.

Hokusai pupils
The Six Immortal Poets c1830
hanging scroll, ink and colour on weathered paper,
94 x 28.5 cm
Purchased 1983
204.1983

In the poetry tradition, some outstanding
poets have been worshipped as
'immortals'. The most popular groupings
are the Six Immortal Poets and the Thirty-
Six Immortal Poets. Both are popularly
portrayed in paintings and other arts. The
painting is an example of the collaborative
works so popular with artists and poets
and so often created at literary and artistic
gatherings. Six artists drew the portraits
and the literary scholar Rokujuen
contributed a comic poem:

In the Kokin Preface
You can hear the sound
The Six Poets made
When their heads
Cracked together.

'Kokin' refers to a 10th-century poetry
anthology which names the six poets as
'famous poets of recent times'.

Arakawa Takeo (b1913)
Bowl with design of cherry blossoms and maple leaves
stoneware with overglaze enamel, 8.8 x 26.6 cm
Gift of Rev Muneharu Kurozumi 1981
278.1981

When cherry blossoms and autumn maples are combined as a motif, it is called 'cloud and brocade', referring to the cherry blossoms of Mount Yoshino and the maple leaves floating in Tatsuta River respectively. The poetic metaphors were originally made by the 7th-century court poet Kakinomoto (no) Hitomaro, who was described as a saint of poetry in the 10th-century *Kokinshu*, an anthology of ancient and contemporary poems.

Arakawa Takeo is the first son of Arakawa Toyozo (1894–1985), who was instrumental in rediscovering the Momoyama period kiln sites that produced Shino ware, and succeeded in recreating the characteristic luscious Shino glaze, the technique for which had been forgotten. Arakawa continues his father's passion for various traditional styles of tea wares.

Rinpa school
Edo period (1615–1868)
Flowers of the four seasons 1600s
pair of six-fold screens, ink, colour and sprinkled gold on paper, 154.5 x 348 cm each
Purchased 1989
282.1989.a-b

Paintings of flowers of the Four Seasons embody the Japanese veneration for transience. The first grouping of flowers on the extreme right is a cluster containing the pine, bamboo, plum blossom and cherry blossom. In Japan, as in China, the flowers most esteemed are those endeared by custom and tradition and cherished as harbingers of the seasons. The flower with the richest poetic and pictorial association is the plum blossom, the first spring flower to appear, coincidental with the lunar New Year and a symbol of regeneration and harmony in the universe. The plum blossom also symbolises the ideals of the scholarly recluse, and a spray of plum blossom was always held by the great statesman Sugawara Michizane, the patron saint of literature. Both the plum and cherry blossom symbolise the transience of beauty and worldly pleasures.

Because the cherry blossom blooms for a shorter period, it was more precious to the Japanese, who consider impermanence a prerequisite for beauty. Indeed, the very choice of flowers whose beauty is so fragile and transient as a subject for painting reiterates this Japanese veneration for the ephemeral. The centre of the top screen is dominated by peonies, here a symbol of spring and a perfect foil to the chrysanthemums, which are the central focus of the screen below. Chrysanthemums flower in autumn and they too, like the plum blossom, are redolent with poetic associations. The selection of flowers represents the 12 months, as well as the four seasons. The final panel – the left panel of the bottom screen – contains narcissus. Since it blooms in the bitter cold of the New Year season, the narcissus shares with the plum blossom the virtues of purity and perseverance, and hence by placing it last on the screens, the artist has brought the viewer full circle to the beginning and reiterated the continuity of the seasons. The Oriental concept of time as cyclical not linear is thus evident, and the screens are an affirmation of harmony and order within nature.

Anonymous
Edo period (1615–1868)
Plain of Musashi late 1600s – early 1700s
pair of six-fold screens, ink, colour and gold on
paper, 156 x 360 cm each
Purchased 2000
143.2000.a-b

Musashi is an old name for the land that includes Edo (Tokyo) and expands northwest. The plain is the largest flat expanse in an otherwise mountainous Japanese landscape. Its serene beauty was first mentioned in the poetry of the Heian period, and there is a famous scene, familiar to all Japanese, in the *Tales of Ise,* where two fleeing lovers conceal themselves in the tall grasses. The scene is redolent with the classic emotion of *sabi,* desolate or lonely: the reason it was much feted by poets, writers and painters.

In the first of these screens, the motif of the moon seen through the grass relates to a poem by Minamoto Michikata (1189–1238):

On the Musashi plain
There is no mountain
Behind which the moon disappears
It rises and sinks among the grass.

In the second, Mount Fuji appears in the distance, set apart from the Musashi plains. Not only does the painting comply with the established category of 'paintings of the seasons' (*shiki-e),* it also falls into the category of 'pictures of famous places' *(meisho-e),* places with a number of poetic associations.

The use of colour, the subject and the emphasis on the seasons place this painting firmly in the category of *Yamato-e* ('Japanese pictures'), as opposed to the Chinese-style paintings (*kanga*).

THE WORLD OF SAMURAI CULTURE

The samurai class originated as the private guards of the aristocrats who lived in the capital Kyoto. In the 12th century, through a series of civil wars, the samurai supplanted the court aristocracy and emerged as rulers of Japan. In 1192, Minamoto Yoritomo was granted the title of the Barbarian-Conquering General (Seii tai Shogun or 'shogun' for short) by the emperor and established the first shogunate government in Kamakura (southwest of present-day Tokyo). From that time until 1868 Japan had three successive shogunate governments: the Minamoto/Hojo clans (1192–1333) based in Kamakura, the Ashikaga clan (1338–1573) in Kyoto and the Tokugawa clan (1603–1868) in Edo, each preceded by a period of civil war. Between the Ashikaga and Tokugawa shogunates was a brief but culturally significant period called Momoyama (1568–1615), marked by a schismatic shift in taste from a Zen-dominated aesthetic to a more broadly based secular one that was to dominate Edo period taste. In 1868 the Tokugawa shogunate surrendered its power to the newly established Meiji government headed by the emperor, thus ending the 700-year-rule of the warrior class.

For the military man, loyalty and honour were the central values of life – values that transcended death. Instead of the ritual-laden esoteric Buddhism of the aristocracy, his ideology was supported by the combination of Zen Buddhism and Confucianism: Zen provided personal discipline and non-attachment to the things of this world, while Confucianism taught that loyalty to one's lord and obligation to one's family took priority over individual concerns.

The samurai elite vigorously promoted Zen Buddhism and Zen priests journeying to China became agents for the transmission of Chinese ideas and culture to Japan. Consequently, in art the pure-ink painting (*suibokuga*) traditions of China that flourished from the Song to early Ming dynasties soon dominated Japanese art. Sesshu Toyo (1420–1506), considered the greatest *suibokuga* master, is revered for mastering ink painting in China and on his return establishing it as a distinctly Japanese art form. Sesshu, who painted as an artistic as well as spiritual endeavour, had many students and followers including the Unkoku school of painters. The Chinese-inspired landscape (pages 208–9) was painted by Unkoku Toeki in the style of Sesshu. Toeki claims a direct lineage of Sesshu by signing the painting 'Sesshu IV Unkoku Toeki'.

KANO SCHOOL

The *suibokuga* style of painting practised by Zen priest-monks was so popular it was adopted by secular artists, most notably those of the Kano school. The founder of the Kano school, and the first official artist appointed to the Ashikaga shogunate was Kano

Masanobu (1434–1530). The extensive and long-lasting Kano school of professional painters who lived on commissions from their warrior patrons was to extend well into the Edo period. Apart from using the ink-painting style, Kano artists chose masculine subjects and symbols of power such as the dragon and tiger, in response to their patrons' taste (for example the 17th-century pair of screens by Kano Tan'yu, page 213). Early samurai taste in painting is also seen in the gallery's rare Muromachi period painting *Tartars hunting* (page 212), a Chinese subject depicting a 'barbarian' hunting scene and the earliest screen painting in the collection.

TASTE FOR CHINESE OBJECTS

During the Muromachi period (1392–1568), tea drinking was established as part of the official protocols of the shogunate. For such formal occasions, only objects of Chinese origin or those made in a Chinese style were deemed appropriate (illustrated on page 210 are examples of Chinese objects appreciated by Japanese tea practitioners and connoisseurs).

A group of specialists was employed to select objects and decorate the reception room (*zashiki*) for the shogun. Like tea drinking itself, formal *zashiki* decoration was adopted from the Zen temple. The so-called 'three sacred objects' (*mitsu-gusoku*) – a censer, a pair of candleholders and a flower vase – used to decorate the temple altar were incorporated into an alcove in the *zashiki*. The specialists institutionalised *zashiki* decoration in a catalogue that was the first Japanese written commentary on art objects. Although they rated Chinese objects above Japanese ones because they were technically superior, their artistic valuation was not influenced by Chinese standards. For example, they gave Song ink painter Mu Qi the highest ranking despite the fact that he was considered a mediocre painter in China.

The Tokugawa shogunate maintained this Muromachi protocol and the Kano school as the official painters of the shogunate, and Kano artists continued to produce paintings for the *zashiki*.

Unkoku Toeki (1591–1644)
Landscape
pair of six-fold screens, ink and gold wash on
paper, 155 x 352 cm each
Purchased with funds provided by Kenneth Myer
1985
166.1985.a-b

By the 1400s panoramic landscape screens in the *suibokuga* style were an established and popular genre. The Japanese *suibokuga* artists adopted Chinese styles, motifs, compositions and subjects but since they were unfamiliar with Chinese scenery, their landscapes often assumed an imaginary quality. Here Toeki combines the gentle rolling hills native to Japan with the soaring, ragged peaks typical of China. With its high, dense land formation either side of an expansive misty lake and use of atmospheric perspective, the composition is typical of the *suibokuga* landscape tradition.

Toeki's screens recall earlier depictions of the popular Chinese theme of the Eight Views of the Xiao Xiang rivers (in modern Hunan province in the southern part of China). The themes had inspired many Chinese poets and painters and from the 1300s Japanese painters as well. A formula evolved where each of the Eight Views was identified by a set poetic title such as 'Returning sail off distant shore' or 'Wild geese descending to sandbar': Toeki's response to these themes form vignettes within his overall composition. His figures of gentleman scholars have also evolved from Chinese prototypes. Gentlemen scholars were an influential class in Confucian China but one that did not exist in Japan. The two figures on the left are scholars, followed by their servant who carries their zither. Other figures can be seen within the pavilions conversing and reading, activities associated with the ideal of the cultivated gentleman.

CHINA, Zhejiang province
Ming dynasty (1368–1644)
Longquan ware tablestand
celadon with relief decoration,
12.5 x 11.4 x 4.5 cm
Gift of Laurence G Harrison 1990
101.1990

The wooden box in which this piece is stored (according to the Japanese custom), indicates that it was once in the possession of the Kyoto Zen temple of Tenryu-ji, which was ranked first among the major Zen temples in Kyoto during the Muromachi period (1392–1568). Modelled on a wooden prototype with a pair of incense holders attached, the tablestand would have been produced for the local Chinese market and have been brought back to Japan by a Zen monk. Zen monks played a significant role in the import of Chinese culture to Japan.

CHINA, Ming dynasty (1368–1644)
Covered box decorated with lychee sprays late 1500s
carved cinnabar lacquer with black lacquer interior,
3.6 x 7 cm overall
Purchased 1989
339.1989

The wooden body of this box has been covered in many layers of red lacquer and the design carved in relief. The technique has been used in China for centuries, while this particular shape derives from ceramic seal-paste containers. This box was purchased in Japan by a private collector, and thus is included here as an example of 'creative adaptation' (*mitate*) by Japanese tea practitioners who would have used it as an incense box (*kogo*) to contain the slithers of imported fragrant wood used to scent a room.

CHINA, Fujian province
Song dynasty (960–1279)
Jian ware tea bowl
stoneware with *tenmoku* glaze and silver rim,
6.9 x 12.4 cm
Purchased 1965
EC4.1965

Jian ware tea bowls were used as everyday utensils in the Chinese Chan (Zen) monasteries. They were brought back to Japan by Japanese monks who had studied there, and their simple forms and dark, lustrous glazes, called *tenmoku*, greatly appealed to Japanese taste. A Jian ware tea bowl is characterised by steeply sloping walls, a small unglazed foot, and a mouth that slightly narrows just below the rim. Due to the small foot, the bowl is traditionally placed on a stand. In this bowl, the thick lustrous blue-black glaze has run down from the rim leaving a pattern of fine lines, which are called 'hare's fur' in China and *nogime* (needle-like tips of grain husks) in Japan.

Japanese tea practitioners also appreciated the lustre that developed with use, and even stains and repairs. Exceptional pieces were given names and became hereditary treasures.

Edo period (1615–1868)
No robe with design of flowers of the four seasons 1800s
karaori silk brocade of silk, gold metallic thread supplementary wefts in a silk twill ground,
152.5 x 144 cm
Purchased 2002
321.2002

No performance, perfected during the Muromachi period, was an integral part of the samurai culture. Originating in the comedy plays performed at temples, No developed into an intense expression of personal emotion that transcends life and death. The protagonists are the spirits of dead people or features of the natural world, for example, a cherry tree: they appear on stage to tell their concerns and to be appeased. A No play is always a one-off performance as an offering to the gods or entertainment for honoured guests. Being exclusive to the samurai class (in contrast to the later Kabuki theatre that arose in response to the taste of Edo period townspeople), its costumes were made with the best available materials and techniques.

The most gorgeous and resplendent No costumes are the *karaori* robes, which are the centrepiece of a performance. The term *karaori* (literally 'Chinese weaving') refers to the intricately woven figured brocades which produce a stiff and heavy garment. The bulk and stately style of the robe is well suited to the considered pace of a No performance. The design of a *karaori* is based on the contrast between a ground pattern (*jimon*), usually geometrical, and a surface pattern (*uwamon*), often floral.

Anonymous
Late Muromachi/early Momoyama period
Tartars hunting 1500s
single six-fold screen, ink and colour on paper,
141.0 x 337.7 cm
Gift of Paul Haefliger 1982
220.1982

The king and his entourage look on from
the upper left of the screen as the
Xiongnu Tartars hunt a variety of birds and
animals. The screen is unusual in that its
style is different from both the native
Japanese style and the Chinese style: it
may have been created by a provincial
artist or even an itinerant Chinese artist.
Certainly the screen would have appealed
to Momoyama warrior taste, rather than
the more sedentary taste of Edo samurai.
The composition has been altered, with a
part missing between the central two
panels. Nevertheless, the artist's masterly
brushstroke gives a lively sense of
movement, particularly to the men
engaged in hunting as well as their horses
and animals. Careful attention is given
also to the surrounding trees, hills and
rocks. Screens of this subject are known
as Hokuteki, or 'Northern Barbarian', and
are not as common as depictions of
Namban, or 'Southern Barbarians'.

Kano Tan'yu (1602–74)
Dragon and tiger c1640s
pair of six-fold screens, ink on paper,
133.7 x 352 cm each
Purchased with funds provided by Kenneth Myer
1990
106.1990a-b

Masculine subjects and symbols of power
such as the dragon and tiger were popular
painting themes among the warrior
patrons of 17th-century Japan.

Anonymous
Edo period (1615–1868)
Views in and around Kyoto (Rakuchu rakugai zu) c1660
pair of six-fold screens, ink, colour and gold on paper, 136.5 x 383.5 cm each
Purchased with funds donated by Kenneth Myer 1980
7.1980.1-2

The 1500s witnessed the rebuilding of Kyoto after a long period of civil strife during which the city was almost destroyed. A resurgence of pride and love for Kyoto resulted in the development of paintings portraying the city in meticulous detail. The panoramic view of Kyoto on these screens looks eastwards across the Kamo River towards the Higashiyama

hills. It is an accurate map of Kyoto: the lower section of each screen below the Kamo River is *rakuchu* ('within the city'), above the river is *rakugai* ('without the city'). The top screen portrays Kyoto south of Shijo (Fourth Avenue) and the bottom screen portrays Kyoto north of Shijo.

Reading the top screen from right to left, the Great Buddha Hall, first built in 1589, is represented in great detail from its double tiled roof and intricate bracket system to the large gilt image of the seated Buddha within. To the right is the Sanjusangendo, an unusually long reliquary hall which during the Edo period was famous for the *toshiya* archery contests held on its long verandah. The most significant buildings on the bottom

screen are the imperial residences built in traditional court residential style. Above these buildings the various temples nestling in the far hills are each identified by a small label pasted onto the screen – a device which reinforces the architectural and historical importance of the screens.

The unknown artist was probably a town-painter (*machi-eshi*), typical of a large number of independent artists who set up their own studios and owed no allegiance to a specific school of painting.

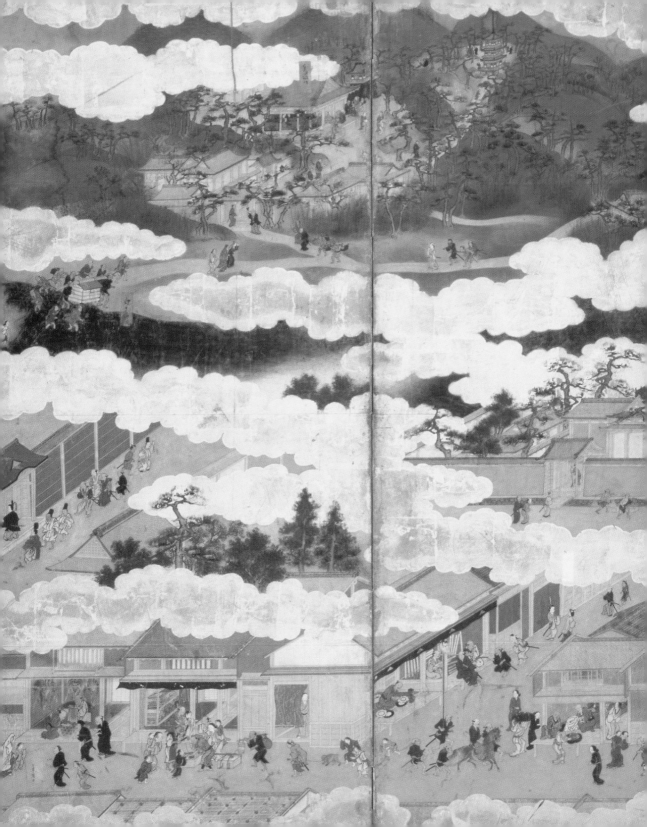

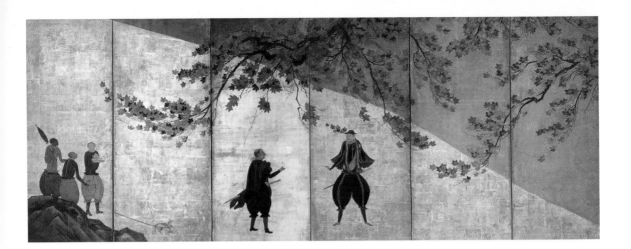

Kano school
The arrival of the Portuguese
late 1500s – early 1600s
single six-fold screen, ink, colour and gold on
paper, 152 x 369 cm
Purchased 1996
301.1996

The scene depicts a captain-major with his retinue; the relative importance of the figures is denoted by their size. They are dressed in the clothing worn by the Portuguese only in Southeast Asia. The Moorish, Chinese and Goanese servants chronicle three previous trading relationships that the Portuguese had established in their mercantile empire. The setting is distinctly Japanese. Set in the autumn during the maple viewing (*momiji*) season, the main figure holds a branch of leaves. The composition is boldly dissected using silver to depict water in the upper right portion and gold leaf to depict the remaining areas of land. The style is of the Momoyama to early Edo period, when Kano artists revolutionised painting by combining Chinese ink painting with the Japanese native *Yamato-e* style, enhanced with a new emphasis on the decorative. Screens depicting the Portuguese fit into the generic of 'Namban', literally 'Southern Barbarian', a term used to describe the political, artistic, academic and economic exchange between the West and Japan.

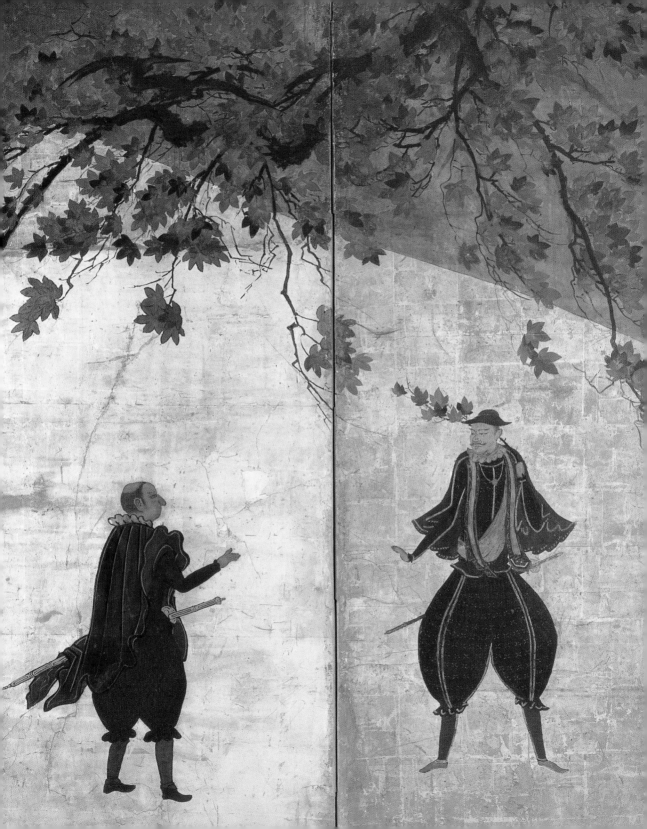

Kano Eino (1631–97)
Pine, bamboo and plum
pair of six-fold screens, colour and gold on paper,
167 x 359.5 cm each
Art Gallery of New South Wales Foundation
Purchase 1994
638.1994.a-b

The 'golden age' of Japanese screen painting occurred in the 1600s in Kyoto, when these brilliantly realised screens were painted by Kano Eino, third generation head of the Kyoto Kano school. The style had emerged in the confidently flamboyant Momoyama period (1568–1615) as the brash and newly emergent samurai elite sought an ostentatious display of their own power and wealth. It was their patronage that created for the first time lavish screens of gold background decorated with symbols of power such as bamboo and cypress.

The new style, expressed most beautifully by artists of the Kano school in the late 1500s and 1600s, was an intuitive distillation of the dialectic that has driven Japanese culture: its accepting/rejecting relationship with China. This dialectic (which the Japanese call *wakan*, 'China/Japan') was based on a series of opposites: monochrome/colour, emotion/restraint, abstraction/naturalism. The dialectic is epitomised in these screens: the bold, vigorous and rich brushstroke of Chinese painting displayed in the rhythmic sweep of the lichen-covered cypress trunks and the sharp lines of the rock faces, combined with the clear, bright colours and attentive recording of nature that is the native inheritance of the

Japanese artist. The delicate, elegant handling of the dandelions and lilies on the top screen exemplifies the native Japanese sensitivity to nature.

The screens also realise this dialectic symbolically: the cypress was a favoured symbol of the samurai to express their dominance and power, while the pierced rock formation on the bottom screen is a classic Chinese Daoist interpretation of the *yin* and *yang*, void and form. The pampas grass with its trimming of autumnal frost (in reality a movingly beautiful sight) is a favourite Japanese subject for painters and poets. The combination of the pine, bamboo and plum blossom on the extreme left originated in 13th-century China and became one of the most popular depictions in Chinese art. Termed the 'Three Friends of the Cold Season', the trio is laden with symbolism: the pine exemplifies steadfastness and courage, the bamboo uprightness and the plum blossom, purity. The pheasant, often synonymous with the phoenix, is a Chinese emblem of beauty and good fortune, while in Japan the pheasant was the prey in the samurai's beloved sport of falconry. The strong interest in plants such as camellias that arose in the mid 1600s is also reflected in this work.

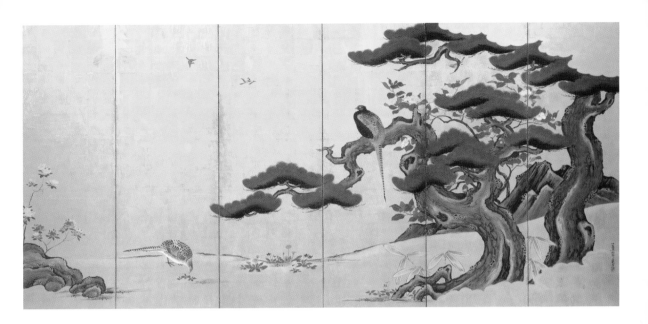

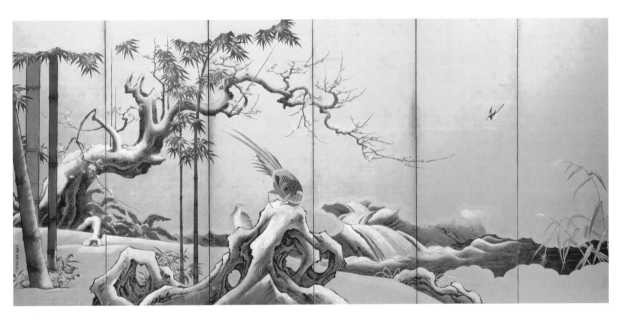

LACQUERWARE

The rigid class system of pre-modern Japan ensured the supply of quality metalwork, lacquerware, ceramics, woodcarving and other goods required by the ruling class. While a craftsman's living was secured by his patrons, he was required to ensure that his skills be continued by his son or an appropriate student. The towel stand and the writing box (containing inkstone, waterdropper and brushes) are good examples of everyday objects made with the elegant *maki-e* lacquer technique.

Edo period (1615–1868)
Towel stand with design of peacock feather pattern late 1700s – early 1800s
lacquer and gold on wood (*maki-e*) with metal mounts, 65.5 x 33.2 cm
Gift of Mrs Ella Bodor 1994
645.1994

Edo period (1615–1868)
Inkstone case with design of pine tree and citrus 1600s
lacquer and gold on wood (*maki-e*), 4.2 x 33 x 23.1 cm
Gift of Klaus Naumann 1989
346.1989

The inkstone case (*suzuribako*) is designed to store writing utensils – inkstone, inkstick, waterdropper and brushes.

Edo period (1615–1868)
Covered box 1700s
lacquer on wood (*maki-e*), 13.5 x 22.7 x 14.6 cm
Purchased 1988
363.1988

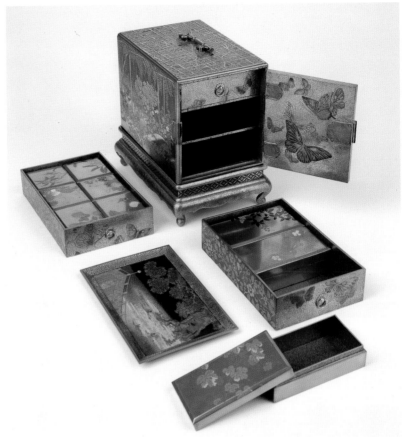

Edo period (1615–1868)
Incense box 1800s
lacquer and gold on wood (*maki-e*), mother-of-pearl inlay, 17.8 x 18.9 x 12.8 cm overall
Purchased 1988
305.1988

Incense played a significant part in the culture of the aristocracy and was adopted by the samurai class. Fragrant woods were imported at great expense from Southeast Asia, where they had been buried for many years to 'mature'. This box was made to store different types of incense for the incense game, in which participants are challenged to tell the different types of incense, each named with a poetic reference. Intricately decorated with various lacquer techniques, it features a profusion of flowers of the four seasons in a three-dimensional setting with the top as a trellis covered with wisteria.

SWORD ACCESSORIES

By the time these pieces were made in the Edo period (1615–1868), members of the warrior class were engaged more in administrative work than in combat. The sword and its accessories had become more symbols of status than weapons of war.

Tsuba with pierced design of man reading and bull sitting next to him in the rocks

copper alloy with gold inlay, 6.9 x 6.6 cm
Gift of George Sherren Johnston 1996
440.1996

Kashira with design of Hotei

copper alloy with copper and gold inlay,
3.2 x 1.5 cm
Gift of George Sherren Johnston 1996
427.1996

Tsuba for wakizashi with pierced design of boy with scroll

copper alloy, 5.7 x 4.5 cm
Gift of George Sherren Johnston 1996
432.1996

Menuki in the shape of armour sleeve and strings

copper alloy with gold inlay, 1.5 x 4.3 cm
Gift of George Sherren Johnston 1996
428.1996

Tsuba with design of bat and cobweb

copper alloy, 7.5 x 7 cm
Gift of George Sherren Johnston 1996
434.1996

NETSUKE

Traditional Japanese clothes do not have pockets. Some objects such as multipurpose tissues or fans were carried in the bosom (between the front collars) while others, like *inro* (men's medicine containers) and tobacco pouches, were hung from the waist by a cord which was slipped under the *obi* (a sash worn around the waist) with a netsuke (toggle) at the other end to stop it from falling. These were fashion statements as well as practical objects, and are often beautiful works of art. *Netsuke,* usually made of wood or ivory/staghorn, represent a wide range of subjects – animal, mythical, exotic, humorous and erotic – and were eagerly collected in the West. The functional hole distinguishes a *netsuke* from ornamental carved objects.

top row:

Netsuke in the form of a Mongolian archer
ivory, 10.6 cm
Bequest of Henry Albert Nathan 1941
7159.40

Netsuke in the form of sennin (mountain recluse) holding his hair and a staff
wood, 9.6 x 3.7 x 2.7 cm
Gift of G F Williams 1995
51.2002

Netsuke in the form of ashinaga ('the long legs') carrying tenaga ('the long arms') who is holding an octopus
wood, 11.9 x 3.0 x 4.2 cm
Gift of G F Williams 1995
38.2002

middle row:

Netsuke in the form of a fox disguised as a woman dancing
wood, 7.1 x 4.2 x 1.3 cm
Gift of G F Williams 1995
40.2002

Netsuke in the form of a standing Daruma
ivory, 6.9 x 2.7 x 1.9 cm
Gift of G F Williams 1995
60.2002

Netsuke in the form of a badger carrying a sake bottle
staghorn, 4.9 x 2.2 x 2.5 cm
Gift of G F Williams 1995
59.2002

bottom row:

Netsuke in the form of a toad
wood, 3.2 x 4.2 x 4.8 cm
Gift of G F Williams 1995
41.2002

Netsuke in the form of a seated skeleton hitting mokugyo (Buddhist bell)
wood, 3.4 x 2.6 x 3.3 cm
Gift of G F Williams 1995
45.2002

Netsuke in the form of a cucumber with wasp
staghorn, 2.4 x 13.9 x 2.2 cm
Gift of G F Williams 1995
35.2002

TEA

The tea ceremony (*cha-no-yu*, literally 'hot water for tea') and the broader philosophical and aesthetic context against which it is practised (Chado, the way of tea) have been central to Japanese culture since the 1500s. The tea ceremony creates an environment that encourages the participant to sharpen his or her aesthetic sensitivity to an object, to see beyond its appearance and usage and to 'appropriate' the object into a new context. To cite an example famous among tea masters: to look into a Korean Ido ware rice bowl containing a small amount of green tea is like peering down a bottomless well. The object's ability to evoke such deep sensations and to engage the viewer's imagination have been recognised by generations of respected tea practitioners who have bestowed on the Ido tea bowl 'status' (*kaku*), a crucial concept in object appreciation associated with the tea ceremony. Selected tea ceremony objects are also valued as material evidence of the taste of revered connoisseurs and for their provenance and associated anecdotes. Although various arts are integral to the tea ceremony, undeniably it is ceramics which take the greatest precedence.

The custom of tea drinking was first brought from Tang dynasty China to Japan at the beginning of the 9th century. In this early tea, the leaves were steamed, pounded and compressed into cakes, then dried for storage. To prepare for drinking, the cake was roasted and pounded into powder before being boiled. This type of tea was taken among a limited number of aristocrats and Buddhist priests. The new preparation method – to dry the tea leaves, pound them into powder then pour on hot water – is said to have been brought to Japan by the monk Yosai in the 1100s together with Zen teachings and tea seeds from his second visit to China. At the temple tea was taken to keep the monks awake during their training. The Kamakura shogunate (1185–1332) patronised Zen temples and this helped the tea drinking practice spread among the samurai class. As the variety of tea increased, the 'tea game' appeared – a game in which the participants would taste different types of tea and try to identify their correct origins.

WABI TEA

From the late 1400s to the 1500s, when Japan went through the Warring States period, the established values and hierarchy of the Muromachi samurai-court were challenged and overturned together with its rulers. Freer and more creative tea was practised among the regional lords, while concurrently a contemplative style of tea – *wabi* tea – emerged. *Wabi* means 'poverty and simplicity' or 'austerity' and the *wabi* aesthetic seeks to achieve the Zen ideal by focusing on the immediacy of the 'here and now' to appreciate a special moment in the transient world.

The *wabi* tea was developed by a new breed of tea practitioners who emerged among wealthy commoners. Their creative imagination saw 'the extraordinary in the ordinary' and used Korean or locally produced vessels in preference to more imposing Chinese objects. In the Momoyama period (1568–1615), the tea master Sen (no) Rikyu took this sombre aesthetic to the extreme by reducing decoration to the bare minimum as the ultimate complement to the richness and abundance of the samurai tea. Rikyu also began using bamboo for vases as well as commissioning utensils to his taste instead of always selecting from existing objects. The black 'raku' bowl (page 227), with its cylindrical body and colour, was made in the style which Rikyu originally conceived and instructed his potter to make.

The different aesthetics of samurai and *wabi* tea can be clearly observed in the contrast between a Ming dynasty celadon vase (for example the Longquan ware vase pictured page 226) and a Japanese Bizen ware vase, while their overlap in taste is seen in the acceptance of similar types of stoneware tea caddies. The *wabi* aesthetic, however, was not the opposite of samurai tea taste but rather the complement: to express the notion of 'poverty and simplicity' was a privilege of the rich and powerful. The underlying concept for both aesthetics was *suki*, which can be loosely translated as 'personal and creative taste'. *Suki*

also applies to poetry or lifestyle in general, and the perception of the 'moment' in the transient world was essential to its expression.

Today the tea ceremony is practised by many Japanese people and the demand for the utensils remains strong. Contemporary potters continue to produce tea utensils in new and traditional styles. Some techniques and materials of Momoyama period ceramics, such as the Shino glaze, had been lost during the Edo period, but in the 1920s and 1930s potters began searching for old kiln sites to revive. As the *wabi* tea is very popular, works are made in traditional styles such Mino, while other potters introduce a modern aesthetic as seen overleaf in Suzuki Osamu's incense box (along with flowers, incense is an important element of the tea ceremony).

CHINA, Ming dynasty (1368–1644)
Longquan ware vase
celadon, 22.7 x 9.5 cm
Gift of Dr John Yu & Dr George Soutter 2001
29.2001

The three pieces on this page demonstrate the Japanese taste for Chinese objects associated with the tea ceremony (while the pieces on the opposite page reflect the more contemplative and austere *wabi* taste). The type of celadon vase pictured here became popular during the 1100s and 1200s, and is found more frequently in Longquan ware than any other. Such vases were produced continuously during the Ming period and are still popular among Japanese tea practitioners.

CHINA, Ming dynasty
Tea bowl mid 1500s
porcelain with underglaze blue, overglaze enamel and gold
6.3 x 11.8 cm
Gift of Mr J Hepburn Myrtle 1984
63.1984

This bowl is decorated with *kinrande* (gold brocade), a style of Ming Jingdezhen porcelain decorated with overglaze enamels and gold favoured by the Japanese. Another feature of this style is the *akadama,* or 'red dot pattern'. These techniques and designs were incorporated into Japanese porcelain from the late 1600s.

CHINA, Ming dynasty
Mukozuke bowl early 1600s
porcelain with underglaze blue, 9.4 x 10 cm
Gift of Mr J Hepburn Myrtle 1989
245.1989

Mukozuke refers to a specific dish used in the meal served in the tea ceremony, and placed centre back on the tray in front of each guest. In the 1620s local Jingdezhen kilns began to make various utensils for the Japanese markets, and this bowl is a good example. The rim is shaped like a lotus flower with a design of lotus petals and floral spray. The Japanese have called this imported ware *ko-sometsuke* (old blue-and-white). One of the characteristics of *ko-sometsuke* is the series of small holes in the glaze, particularly along the rim, where the glaze has pulled away from the body during firing. Japanese tea practitioners greatly appreciate these defects, fondly calling them 'insect eaten' (*mushikui*).

Kikko Jusoken (b1948)
Black raku tea bowl 1997
earthenware with black raku glaze, 8.7 x 12 cm
Gift of Rev Muneharu Kurozumi 1999
© Kikko Jusoken
160.1999

Raku tea bowls are hand-shaped rather than thrown, and the rim is slightly narrowed. They were first made by a Momoyama period potter called Chojiro under the instruction of the influential tea master Sen (no) Rikyu in the late 1500s. Kikko Jusoken is an eighth-generation Osaka potter and is an official tea bowl maker for the Urasenke and Onotesenke, the two largest tea ceremony schools in Japan.

Sakata Deika (b1915)
Hagi ware tea bowl
stoneware with ash glaze, 8.6 x 15.5 cm
Gift of Rev Muneharu Kurozumi 1984
© Sakata Deika
248.1984

Kato Shuntai (1802–77)
Tea bowl
stoneware with Shino-type glaze, 7.3 x 11 cm
Gift of Mr F Storch 1987
442.1987

Suzuki Osamu (1926–2001)
Incense box *Egg and wave*
celadon, 7.8 x 9.4 cm overall
Gift of Rev Muneharu Kurozumi 1989
© Suzuki Osamu Estate
62.1992

Yamamoto Tosho (1906–92)
Bizen ware tea caddy *Ocean*
stoneware, 7.5 x 9.5 cm
Gift of Rev Muneharu Kurozumi 1981
© Yamamoto Tosho Estate
312.1981

EDO PAINTING SCHOOLS

In the Edo period (1615–1868), the government adopted a strict isolationist policy whereby no Japanese person was allowed to leave the country and foreign contact was restricted to a few Chinese and Dutch traders at the one port of Nagasaki. This nurtured the development of a sophisticated, introverted culture that fed deeply on its own heritage. The Tokugawa shogunate (*bakufu*) ruled from the newly created capital of Edo (present-day Tokyo) and to ensure control over other feudal lords (*daimyo*) demanded that the lord of each clan fief around the country maintain a residence in Edo and reside there in alternate years. The samurai (warrior) culture flourished in Edo, although from the 1700s commoners began to form their own culture. In Kyoto – home of the imperial court and its culture as well as the Muromachi shoguns and many Buddhist temples – tradition prevailed.

During the Edo period, the members of the samurai class were no longer engaged in battle. Their main duties were administrative work within the shogunate government or the feudal fief; they became essentially bureaucrats. Maintaining the status quo became the primary focus of their neo-Confucian ethics and the official art reflected this. The Kano school became an academic establishment which placed primary value on training painters in skills rather than the development of individual talent. It was inevitable that the school lost the vigour of its founders, whose art reflected the more dynamic spirit of the previous era.

The prevailing peace, on the other hand, created learning opportunities for the greater part of the population. Increased agricultural production and commerce allowed commoners in large cities to provide their children with basic education, while new ideas from China and the West were brought into Nagasaki, where scholars from various regions came to study before returning to their homelands. As a result, new knowledge found its way around Japan, rather than centring in Edo and Kyoto.

Against this background, new styles of painting emerged outside the academic Kano school. One of the famous rebels of the Kano school in the early Edo period was Kusumi Morikage, a student of the celebrated master Kano Tan'yu (see pages 231 and 213). Morikage chose a new direction by depicting the lives of real people in rural Japan rather than following the conventions derived from Chinese traditions.

RINPA

An important school that had emerged in the culturally significant Momoyama period (1568–1615) in Kyoto, home of the classical arts, was Rinpa. Patronised by wealthy Kyoto merchants, the new style fused and developed indigenous traditions of the past. The style was pioneered by Hon'ami Koetsu and

extended by Tawaraya Sotatsu and Ogata Korin. The name of this school derives from the 'Rin' of Korin and *ga* meaning school. The school drew on the decorative elements of past styles, such as the native Tosa school, to create a style that spanned all the arts with works of stunning simplicity and abstraction of motifs. The school has been a constant source of inspiration to artists, and is the quintessential expression of the Japanese sense of design. Its design principles have impacted on paintings, lacquer, ceramics and virtually all media.

NATURALISM

Maruyama Okyo was an influential advocate of naturalism in painting. A Kyoto artist, Okyo enjoyed the patronage of temples, rich merchants and the imperial court, which still resided in Kyoto although political power was with the shogun in Edo. His studio was large, his art was popular and his pupils were many. His art appealed to the middle class of Kyoto which until Okyo's time had lacked an art identifiably its own. Okyo advocated drawing from nature; an example of this was that he taught his students to 'see a dog in a monkey': the head of the monkey, which had traditionally been drawn in human-like form, was in fact closer to a dog's in structure than to a human's. The revolutionary aspect of his approach was rejecting the conventional 'school' system in which a style was handed down by way of the students copying their master's works. Okyo's naturalism made his followers most open to Western influences in the 1800s.

ECCENTRICS

Nagasawa Rosetsu was a talented pupil of Okyo's but was expelled by his master reputedly for abrasive behaviour. Starting from the naturalism he learned from Okyo, Rosetsu became a versatile individualist, particularly acclaimed for his extravagantly energetic and unconventional ink paintings (page 236). He is considered one of the three eccentric painters of the 1700s, the others being Soga Shohaku (represented in the collection with a characteristic large figure painting also pictured on page 236) and Ito Jakuchu. Rosetsu toured the country fulfilling painting commissions for Zen temples.

NANGA

Nanga, literally 'southern style painting', is also called *bunjinga*, 'literary men's painting', after the term used for its Chinese prototype. The term 'southern painting' derived from a Chinese theory of painting which distinguished two traditions: a highly coloured, conservative 'northern' style which was practised by professional artists, and a personal, intuitive 'southern' style which expressed the artists' inner feelings. Like their Chinese model, the Japanese *nanga* artists

opposed the academic Kano style and sought to express their sympathy with the Chinese literati ideals of retreating into nature and conveying personal responses to nature. But unlike their Chinese equivalents who were part of a wealthy, Confucian-educated, bureaucratic elite who could dismiss the need to sell paintings, Japanese scholar artists came from diverse backgrounds – samurai, merchant and plebeian – and were often professional painters who worked in a codified decorative style as well as the *nanga* style.

While most *nanga* artists worked in the Kyoto/Osaka region where they had a support base among its temples and merchants, Tani Buncho was a member of the samurai elite in Edo. Here he was closely associated with Matsudaira Sadanobu, chief advisor to the shogun. With this advantageous connection and his exceptional talent, Buncho became instrumental in spreading *nanga* in Edo.

For the dilettante of the Edo period, poetry and calligraphy, as well as the tea ceremony, were also important accomplishments. As part of Chinese studies men of letters familiarised themselves with Chinese poems, as seen in the calligraphy by Ichikawa Beian, one of the Three Masters of Calligraphy in the late Edo period (page 238).

The gallery has a strong collection of *nanga* paintings, including a number of works by important artists such as Ike-no Taiga, one of the two master painters credited with founding Japanese *nanga*.

SHIJO SCHOOL

Patronised by the wealthy commoners of Kyoto, the Shijo school developed out of a combination of the naturalism of the Maruyama school and the lyricism of the *nanga* style. Shijo means 'Fourth Avenue' and was the name of the street in Kyoto where the school's master Matsumura Gekkei (Go Shun) lived. The school originated in Kyoto but was spread to Edo by Watanabe Nangaku, who taught Suzuki Nanrei there. Other Shijo artists represented in the gallery's collection are Onishi Chinnen, Kishi Chikudo and Kono Bairei.

Kusumi Morikage (c1620–90)
Rural landscape with horses and bulls
1600s
pair of six-fold screens, ink and gold wash on
paper, 152 x 346.6 cm each
Purchased with funds provided by Kenneth Myer
1984
246.1984.a-b

This Arcadian landscape has horses and
bulls as the main subject; humans and
their activities seem to take a secondary
role. The top screen is dominated by the
freely roaming, gambolling horses. The
season moves from spring on the right
with the blossoming plum tree to a
summery scene of a mare and her colt in
a stream. The bottom screen shows bulls
working or playing while the village lads
frolic in the landscape. The season shifts

from autumn, with farmers carrying
harvest, to the snowy winter. Morikage
was expelled from the Kano school later
in his life and moved from Edo to Kaga
(present-day Ishikawa) ruled by the Maeda
clan.

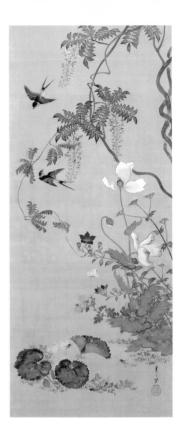

Kamisaka Sekka (1866–1942)
Momoyo-gusa (the world of things)
1909
illustrated books, colour woodcut,
29.7 x 22.2 cm leaf
top: Six Immortal Poets
above: Kikujido
Purchased with the assistance of the Sidney Myer
Fund 1991
176.1991.3.g, 176.1991.2.l

Kamisaka Sekka, a Kyoto artist, was instrumental in reforming the anachronistic craft designs of his day. While others tried to adopt the European art nouveau style in ceramics, lacquerware and textiles, Kamisaka worked with craftspeople, providing them with his Rinpa-inspired designs. His three-volume illustrated book *Momoyo-gusa* (the world of things), published in 1909, is an important example of the early 20th-century adaptation of Rinpa-style designs. Reproduced in woodblock prints,

Kamisaka's images freshly reinterpret classical subjects using the 'wash' technique characteristic of the school.

Kikujido (child of the benevolent chrysanthemum) is a figure from Chinese legend. A page boy at the time of the ancient dynasty of Western Zhou, he was banished from court and sent into exile, where he drank from a stream in which chrysanthemum flowers had been soaked and obtained immortality. The story was a popular theme for painting and craftworks and was made into a No play.

Suzuki Kiitsu (1796–1858)
Birds and flowers c1855
hanging scroll, colour on silk, 127 x 55.4 cm
Purchased 1983
205.1983

In this painting flowers of all seasons such as wisteria (spring), poppies (summer), bush clover and bellflower (autumn) are combined as if to celebrate a timeless world of flowers. Yet one cannot miss the loss of petals on the poppy which holds the centre of the painting – an unmistakable sign of impermanence. It is this awareness, subtly expressed in works of art, that resonates in the mind of the cultivated Japanese. Kiitsu, a later Rinpa school artist, has used a characteristic Rinpa technique of dropping colour onto another while still wet to create a suffused effect, known as *tarashikomi*.

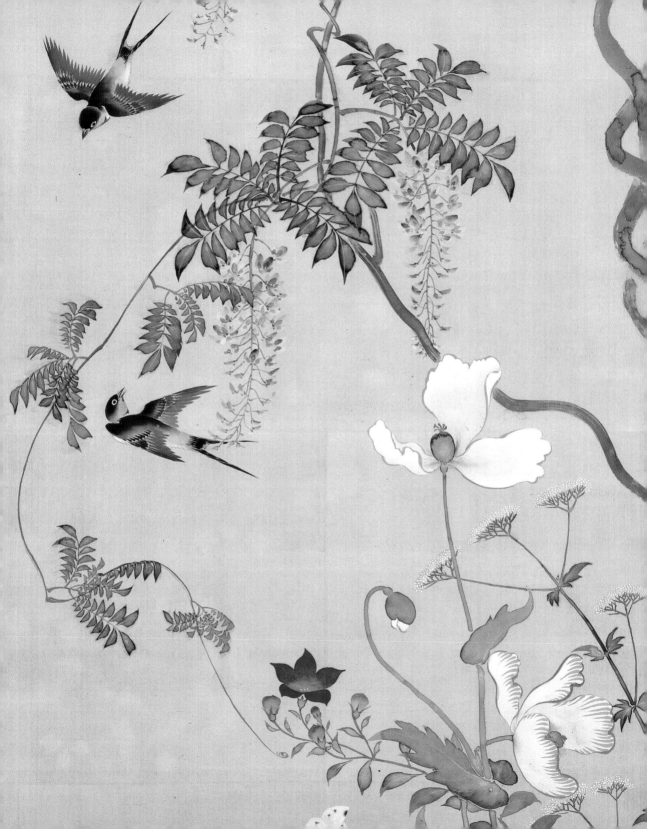

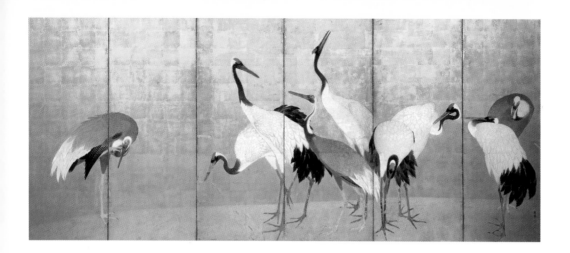

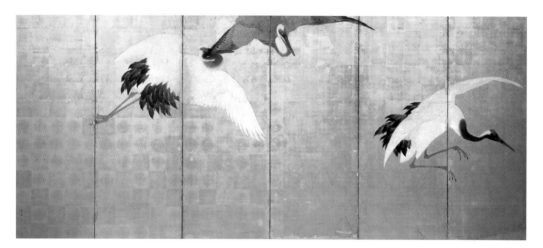

Maruyama Okyo (1733–95)
Cranes 1700s
pair of six-fold screens, colour and gold leaf on
paper, 153 x 357 cm each
Purchased with assistance from the Japanese
Society of Sydney, the Japan Chamber of
Commerce and The Sidney Myer Charity Trust
1981
109.1981.a-b

This stunning example of Japanese
screen design shows Okyo's expressive
power as well as his meticulous
observation of cranes and their behaviour.
The artist is attuned to the subtle
relationship among the adult and juvenile
birds that congregate in the top screen. In
contrast, in the bottom screen he captures
the dynamic movements of three cranes
that are about to land to join the others.
The artist's power of observation can be
seen in details such as the half-closed eye
of the resting adult crane on the far right,
and the crane stretching his neck
skywards.

Soga Shohaku (1703–81)
The poet Rinnasei c1770s
hanging scroll, ink on paper, 130 x 49.5 cm
Gift of the Japanese Ministry of Foreign Affairs
1963
EP6.1963

Shohaku often took his subjects from Chinese mythology, with a noted preference for recluses, eccentrics and such well-known figures as the Daoist Eight Immortals. Here he has chosen the Chinese poet Lin Hexing (in Japanese, Rinnasei) who, although described as a poet, did not want to leave his poems to posterity and hence never committed them to paper. The poet has his back to the viewer, absorbed in his own musings. His unkempt hair and beard, and plain, voluminous robes – realised in the assured, scratchy brushstroke typical of Shohaku's style – emphasise the poet's indifference to accepted standards of appearance and behaviour. Together with Nagasawa Rosetsu and Ito Jakuchu, Shohaku is considered one of the three 'eccentrics' of 18th-century painting who refused to belong to one of the large studios.

Nagasawa Rosetsu (1754–99)
Kanzan and Jittoku 1780s
hanging scroll, ink on paper, 156 x 82.3 cm
Purchased 1985
338.1985

Kanzan and Jittoku (in Chinese, Han Shan and Shi De) were two monks who lived on Mount Tiantai in Tang dynasty China (618–906). Kanzan, in the true Zen manner, was a hermit-poet who befriended Jittoku, a kitchen-hand in the nearby Guoqing temple. Jittoku would give his friend leftover food from the temple and in return Kanzan would read his humble colleague his poems. Here Jittoku, holding a bamboo pail, scrutinises his friend's poem with studied concentration, while Kanzan's expression is one of shy anticipation. This eccentric pair is one of the most popular subjects among Zen painters. The artist Rosetsu, admired as one of the great ink painters of the Edo period, travelled around many Zen temples fulfilling commissions for hanging scrolls, screens and wall paintings.

Ike-no Taiga (1723–76)
Taigado Gafu 1804
folded book, 32 leaves, 24 prints, colour woodcut,
29.8 x 19.1 cm
Purchased 1983
269.1983.a-ff

Taiga came from a commoner's family and lost his father when he was four. From an early age he showed talent in Chinese studies at Manpukuji temple, built in 1669 as the main temple of the Chinese Obaku sect of Zen Buddhism and a mecca for Chinese studies throughout the Edo period. Japanese artists developed the Chinese literati style largely by studying paintings and woodblock-printed books such as the famous *Mustard seed garden manual of painting*, originally published in China (1679/1701) and brought to Japan in the following decades. Following this example, Taiga published his own manual, from which these prints are taken, and inspired a following of many artists.

Ichikawa Beian (1779–1858)
Calligraphy (Chinese style poem) 1800s
hanging scroll, ink on paper, 131 x 46 cm
Gift of Klaus Naumann 1998
280.1998

The son of a government-employed calligrapher, Beian excelled in the 'scribe's style' and 'square style' of calligraphy. He is said to have possessed over 5000 examples of Chinese painting and calligraphy from the Ming and Qing periods. This Chinese poem is by a Song dynasty poet called Zhang Ci. It can be translated as:

The scent of happiness fills the pavilion; Spring shows itself in a grove of pine trees and bamboo.

Takahashi Sohei (1802–33)
Bamboo grove 1828
hanging scroll, ink on silk, 113 x 49 cm
Gift of the Japanese Ministry of Foreign Affairs 1963
EP8.1963

Bamboo was an evocative subject for a *nanga* artist, as literati tradition had long used it to symbolise strength and nobility of spirit. Here the skilful variation in ink tone suggests a rustling breeze and evokes the intimacy and quiet of a small bamboo grove. According to the inscription, Sohei is emulating the late Ming artist Wang Jianzhang (see page 148), many of whose paintings are preserved in Japan.

Tani Buncho (1763–1840)
Early summer mountains in the rain
1826
hanging scroll, ink and colour on paper,
174 x 96 cm
Purchased with funds provided by Kenneth Myer
1987
461.1987

Buncho is one of the great masters of
Japanese *suiboku* painting. He studied
and adopted many different painting
styles, both Japanese and Chinese, but
particularly the Chinese academic style.
This painting, however, is a good example
of his *nanga* style, which he executed
with short brushstrokes in various shades
of ink and almost entirely without outline:
imposing mountains stand with their
peaks above the clouds in warm, misty
air. In the foreground a lone fisherman
is walking towards the houses nestled
in the woods at the foot of the mountain.
Buncho's mastery of expression is fully
demonstrated here in the fine balance
between grandeur and intimacy –
powerful nature and insignificant yet
comforting human surroundings.

Yamamoto Baiitsu (1783–1856)
Birds and flowers of the four seasons
1847
pair of six-fold screens, ink and colour on paper,
160 x 363.2 cm each
Purchased 1982
236.1982.a-b

When the four seasons appear in a screen painting, there is usually a narrative of the 'passing of time' starting from the right and progressing to the left. In this pair of screens time moves from the daphne and wild orchid of spring at the right end through to the presiding peony, then the lotus of summer, a clump of autumn flowers including chrysanthemum and bush clover and bypassing winter to the

sacred bamboo and daffodils of the early spring. Baiitsu was a *nanga* painter who had studied Chinese painting styles and techniques of the Ming and Qing dynasties.

Go Shun (1752–1811)
Fisherman returning home c1785
hanging scroll, ink and colour on silk,
110 x 33 cm
Purchased under the terms of the Florence Turner
Blake Bequest 1984
281.1984

Go Shun (Matsumura Gekkei) first studied
painting under the great *nanga* master
Yosa Buson (1716–83). After Buson's
death, he joined Maruyama Okyo and
adopted Okyo's naturalist style, eventually
establishing the Shijo Maruyama school.
This painting, however, was executed
before his move to naturalism. It is
considered to be from his mature phase,
produced during his sojourn from 1781 to
1786 at Ikeda in Osaka, where he was
recovering from the shock of losing his
wife and father. The figure of a fisherman,
drawn disproportionately large in relation
to the lyrical landscape, and the two
ducks in water capture the rural tranquility.

Kono Bairei (1844–95)
(detail) Trip to Lake Biwa 1873
handscroll, ink and light colour on paper,
20 x 706.5 cm
Gift of the Bodor family on the occasion of the
opening of the new Asian Gallery 1987
586.1987

Tsubaki Chinzan (1801–54)
Two fragrant katsura 1847
hanging scroll, ink and colour on paper,
142 x 46 cm
Purchased 1986
97.1986

Chinzan, a samurai, took up painting to augment his income, studying under Tani Buncho. He concentrated on bird and flower painting (*kachoga*), absorbing elements of Chinese 18th-century bird and flower painting then popular among some Japanese artists. This painting is handled with the delicate and sensitive touch so typical of Chinzan, who has used the 'boneless' technique in which the colour creates its own outlines and is not confined by black ink contours.

Kishi Chikudo (1826–97)
Bottle gourd and sickle moon 1800s
hanging scroll, ink and colour on paper,
99.8 x 34.1 cm
Purchased 1981
7.1981

THE FLOATING WORLD

Away from Kyoto in the new urban centre of Edo, a diversity of artistic traditions arose from 1615 under the patronage of a newly affluent merchant class. These merchants had grown rich on profits made as Japan shifted from an agricultural economy, where rice was the medium of exchange, to a money economy. Edo art was overwhelmingly secular in nature, partly because of the government's suppression of Buddhist establishments, which in the past had been major patrons of arts. The culture created by the newly affluent class of townsmen (*chonin*) in the Edo period was so distinctive and pervasive that the word *ukiyo* was adopted to describe it – the term was originally used in Buddhist texts to refer to the transient and ultimately sadly irrelevant nature of the pleasures enjoyed in this life. *Ukiyo* culture, in Edo centred in the licensed entertainment district of Yoshiwara (or 'Nightless City'), affected literature, music, theatre and art. The art of this 'floating world', called *ukiyo-e*, literally 'pictures of the floating world', had two principal subjects: the courtesans of the pleasure quarters and Kabuki actors. A small early *ukiyo-e* screen in the gallery's collection graphically portrays the interior of one of the pleasure quarters.

The depiction of courtesans was a special category of painting termed *bijin-ga*, literally 'paintings of beautiful women'. *Bijin-ga* were symbols of a feminine ideal: in *bijin-ga* a woman's personality was conveyed not through individual facial expression but by pose, gesture and the choice and colour of her kimono. The gallery has several fine examples of *bijin-ga*, such as Kaigetsudo Anchi's elegant portrayal of a statuesque beauty against a blank ground, her graceful saunter defined by thick, rhythmic lines, and her fashionable hairstyle and luxurious layering of robes identifying her as an expensive sophisticate (page 246). Yoshiwara courtesans were noted for their expensive silks, their panache and style, and were feted for their *hari* (dash, élan, independent spirit). Comparing this image with the portrayal of an *onnagata* (a female impersonator of the Kabuki theatre) by Miyagawa Choshun (page 247), another seminal early master of *ukiyo-e,* one can see how well established was the *bijin* ideal, and how closely connected were the worlds of the Yoshiwara and Kabuki. Choshun was a leading chronicler of the lifestyle and values of the new class of townsmen, and one of the first artists to depict the people and activities important to this culture.

Kabuki theatre developed in the Edo period in response to the demand by the merchant class for a popular theatre more accessible and relevant to them than the classic No theatre patronised by the upper classes. Like the Yoshiwara, the world of Kabuki had its own rituals and conventions. Restricted to three officially sanctioned theatres, the annual season commenced in the 11th month, when the theatres

published their actors and plays for the coming year. The theatre was a constant source of anxiety to the *bakufu* (shogunate) who regarded it as disruptive and viewed the popularity of the actors as a potentially subversive element in society.

THE UKIYO-E PRINT

Such was the demand for portraits of favourite actors at particular performances, as well as for the most glamorous courtesans, that painters could not fulfil the orders. Nor could the ordinary townsperson afford a painting. Fortunately techniques of printing improved from black outlines alone to handcoloured images (using vegetable colours), and then to blockprinting with an increasing number of colours. The creation of the full-colour print (*nishiki-e*) was made possible with the invention of a system of registration that enabled the alignment of blocks of different colour areas so they could be printed with no overlapping of boundaries. The artist Suzuki Harunobu, represented in the gallery's collection by two prints, is traditionally acknowledged for this invention in 1764–65.

Credit for the creation of a fine print was due not only the artist who did the initial drawing (and whose name appears on the print), but also to the blockcutter who took the artist's drawing, pasted it face down onto a hardwood block, and then carved away the portions of the block that were not to be printed,

leaving only the fine outlines of the original sketch in relief (the original drawing was of course destroyed in this process). Next the printer produced the print by inking the block, laying fine absorbent mulberry paper on it and rubbing the back of the paper by hand with a hard, round pad called a *baren*. The publisher was responsible for the overall quality, quantity and distribution. The standard format for a print is the *oban* that measures 38 x 25 cm; occasionally three or five *oban* prints abut to produce a continuous narrative. Clients could purchase either part of the narrative or the whole, depending on their taste and wallet.

The 1780s and 1790s are acknowledged as the golden years for *ukiyo* culture. It was during this period that great artists such as Torii Kiyonaga and Kitagawa Utamaro created some of their classic images. The work of the prolific artist Kunisada of the Utagawa school (the gallery has some 35 of his prints) exemplifies the vibrant colours and intense designs of later prints. The tradition of prints of Kabuki actors in particular performances has been continued in most recent times by the artist Kokei, and looks set to continue, albeit the Edo tradition of portraits of courtesans may have come to an end.

For a collector, a print's value is gauged by many factors: not only the innovation, imagination and empathy with which the image and composition have

been created but also the quality and freshness of the colour, the sharpness of the printing and accuracy of alignment of the blocks used for each colour. Since prints are affected by exposure to dust and light, condition is an important factor, as well as the rarity of the particular design.

Always on display in the Art Gallery of New South Wales is a selection from the gallery's extensive holdings of Japanese prints. Through the collection can be traced much of the technical history of *ukiyo-e* prints, as well as many aspects of the society and culture of the times. For example, distinctive differences in the portrayal of women can be tracked from the gracious, anonymous ideals of the early 1700s through to the more realistic, personalised depictions of 19th-century women. There are images of Kabuki performances, listing actors and plays, and portraits of famous courtesans.

Kaigetsudo Anchi (active 1700–16)
Beauty (*bijin*)
hanging scroll, ink and colour on paper,
107 x 46 cm
Bequest of Kenneth Myer 1993
595.1993

Miyagawa Choshun (1683–1753)
Portrait of an onnagata 1713
hanging scroll, ink and colour on paper,
110 x 53 cm
Art Gallery of New South Wales Foundation
Purchase 1987
583.1987

Choshun was esteemed for his portrayal
of ideal figures of the urban culture. The
small cap snugly fitting the head of this
figure indicates he is an *onnagata* (female
impersonator) of the Kabuki theatre. The
onnagata was a highly skilled category of
Kabuki actor who, through deportment,
mannerism and dress, could convey every
nuance of femininity.

This painting may be a rare and hence
important portrait of a central figure in the
history of *onnagata*: the talented
Yoshizawa Ayame (1673–1729) who is
also important for articulating the
philosophy of his craft in a series of
opinions recorded by a contemporary
actor-playwright. Yoshizawa's *mon*, or
heraldic crest (a paulownia leaf within a
circle), appears as the motif on the hairpin
worn by this figure. His identity as
Yoshizawa is also supported by the fact
that the Kyoto-based actor only visited
Edo for one year in 1713, and Choshun's
signature on this painting is one he used
only in 1713 and 1714.

Nishikawa Sukenobu (1671–1750)
Girl with koto after c1717
woodblock print, 26.2 x 17.9 cm
Purchased 1930
4349

Sukenobu was a leading Kyoto master who turned from classical subjects to the depiction of contemporary life. This image is a fine example of a *sumizuri-e* (ink print), the basis of all prints.

Suzuki Harunobu (1725–70)
Lovers in an eggplant field
colour woodblock print, 28.2 x 21 cm
Purchased 1930
4350

Harunobu was one of the geniuses of *ukiyo-e*. He is famous not only for the invention of the full-colour print, but also for the creation of images of sweet young beauties, as opposed to the sophisticates of the entertainment district.

Katsukawa Shunko (1743–1812)
Onnagata Nakamura Noshio dancing in the role of a fox-girl 1780s
colour woodblock print, 29.2 x 14.8 cm
Purchased 1930
4351

In Japanese folklore, the fox is a cunning animal that can assume human form. Here he takes the form of a woman, his hand curled like a forepaw – a clue to the disguise. The small cap worn on the forehead was standard headgear for *onnagata*. The scene is heavily autumnal, with maple leaves above and the actor carrying chrysanthemums. Shunko was first among the pupils devoted to the theatre of leading *ukiyo-e* artist Katsukawa Shunsho (1726–93), founder of the important Katsukawa school.

Isoda Koryusai (active 1760s–80s)
**New Year's kimono patterns for oiran:
Kisakata of Onishi-ya** c1780
colour woodblock print, 38 x 26.1 cm
Purchased 1930
4353

The elegant courtesan (*oiran)* is shown
writing, presumably a poem or witty
exchange with a suitor. Beside her are her
two assistants and an inkbox with all its
contents on the floor. The print belongs to
a series comprising over 110 prints,
published in the mid 1770s to the early
1780s, each to show a new kimono
pattern. Sample patterns for kimono were
conventionally printed in the flat kimono
shape, but in this series, popular
courtesans are dressed in the new
patterns. Her robe is decorated with pine
needles and a set of the symbols that
denote a chapter of the classic *Tale of
Genji.*

Kitagawa Utamaro (1753–1806)
The coquettish woman
from the series 'Variations of blooms
according to their speech' 1802
colour woodblock print, 37.2 x 27.3 cm
Purchased 1930
4368

Utamaro dominated *ukiyo-e* of the 1790s.
The master of the female psychological
portrait, he captured every nuance of his
subjects' sensual persona. One of
Utamaro's innovations was the 'large
head' print (*okubi-e*), where the focus was
on the face and upper body, thus allowing
the viewer to relate to the individuality of
the person portrayed.

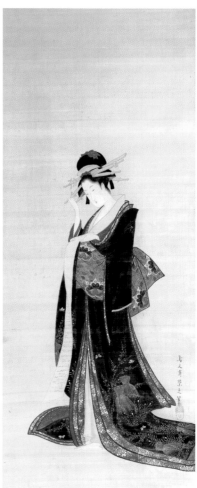

Hosoda Eishi (1756–1829)
The fifth month
from the series 'Five festivals à la mode'
colour woodblock print, 37.7 x 24.2 cm
Purchased 1961
DO2.1961

Hosoda Eishi (1756–1829)
Standing beauty reading a letter c1814
hanging scroll, ink and colour on silk,
85 x 34.5 cm
Purchased 2002
155.2002

Hosoda Eishi was one of the 'three great masters of beautiful women' (together with Kitagawa Utamaro and Torii Kiyonaga) at the height of *ukiyo-e* print tradition (late 1700s – early 1800s). Eishi was a high-ranking samurai who initially studied painting under a Kano school master. He then served the 10th shogun Ieharu (1737–86) for three years during which time he was also his painting companion. However, Eishi retired from service and began painting in the *ukiyo-e* style. He was adept in his brushwork, and produced many quality *nikuhitsu* (*ukiyo e* paintings as distinct from prints) on which he is said to have concentrated in later life. The elegant courtesan (right), dressed in full finery against a completely blank ground, wears a robe decorated with autumn motifs such as bushclover (*hagi*), a chrysanthemum-scattered bright red underrobe, and a more formally designed red *obi* (sash) decorated with butterflies against a wave patterned ground. The elaborate hairstyle with numerous hairpins was the latest fashion. The lady is totally absorbed in her letter, playing with a comb as she puzzles over its contents.

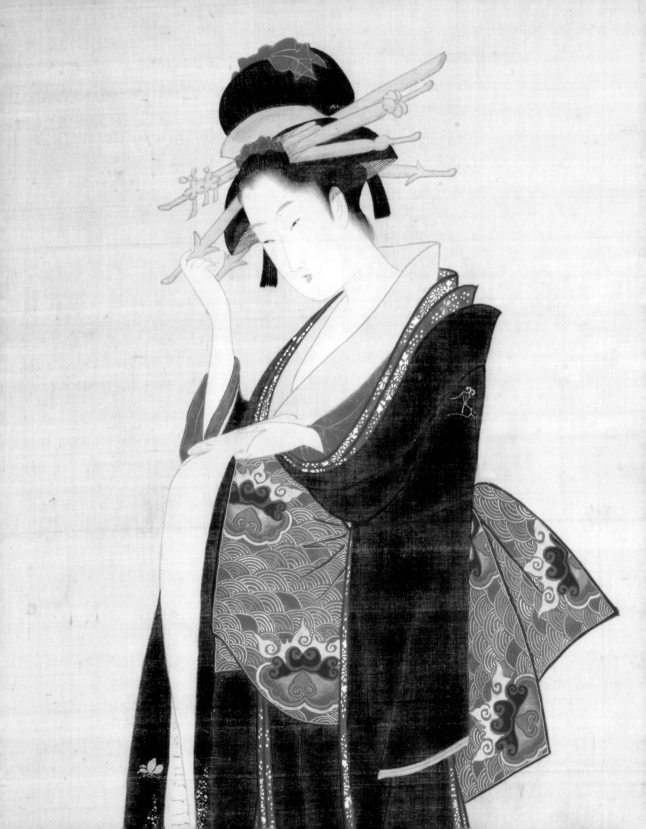

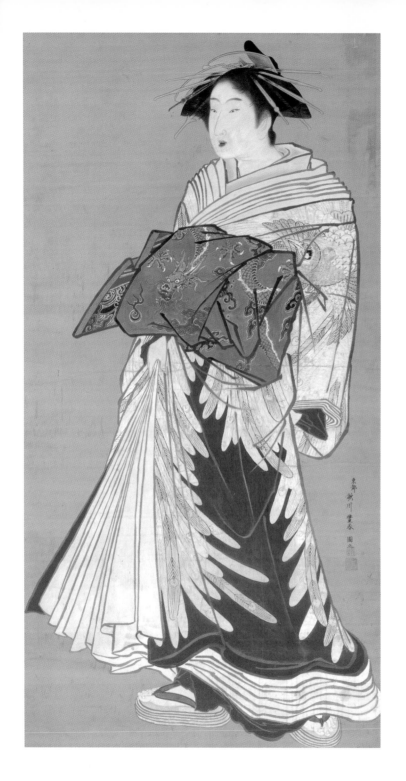

Utagawa Toyoharu (1735–1814)
Portrait of a standing courtesan 1780s
hanging scroll, ink and colour on silk,
161.5 x 84.2 cm
Purchased with funds donated by Mr Kenneth
Myer 1990
104.1990

Toyoharu was the founder of the Utagawa
school, a school of *ukiyo-e* that was to
dominate the late 1700s into the 1800s.
As with many *ukiyo-e* masters,
biographical details on him are scant.
He produced many prints, pioneering
the use of perspective in his landscape
prints. In the 1780s he turned to paintings
of courtesans of which this is an
extraordinary example. The subject is a
high-class courtesan, yet its unusual scale
would indicate it was created for a special
patron or teahouse proprietor who avidly
admired the girl. She is sumptuously
dressed in between-season robes, boldly
decorated with the classic pairing of
phoenix and dragon. The distinctive
hairdo with its wide side flanges and
many combs and ornamental hairpins
dates the work to the 1780s, when such
hairstyles were the vogue.

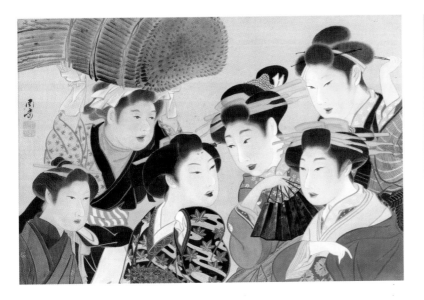

Watanabe Nangaku (1767–1813)
Portraits of six women
hanging scroll, ink and colour on silk,
44.3 x 66 cm
Purchased 1980
121.1980

Watanabe Nangaku was one of Okyo's ten most noted pupils. Okyo and his large studio fulfilled many commissions for *bijin-ga* (paintings of beautiful women), professional-style paintings that were the Kyoto equivalent of Edo *ukiyo-e* paintings and would have been commissioned by the Kyoto equivalent of the Edo townspeople. Nangaku was also significant for initiating Edo artists into the Kyoto-based Maruyama school while on a three-year sojourn there.

Compositions of six female portraits are uncommon, and while an Edo artist may have done it as a *mitate* (parody) on the classical theme of the Six Immortal Poets (*Rokkasen*), Nangaku has treated his work as a group portrait. The women are believed to include two courtesans from Shimabara, Kyoto's entertainment district, the mother of painter Ike Taiga (lower left), and a peasant from the Ohara village, which provided Kyoto with brushwood for winter fires.

Katsukawa Shun'ei (1762–1819)
Beauty *(bijin)*
hanging scroll, ink and colour on silk, 84 x 33 cm
Purchased 1985
339.1985

A courtesan, twenty-seven years old,
Laments the ten years spent
on the bitter ocean,
Looking back,
Her life appears a mirage
Now she is leaving the quarter.

This is an unusually poignant and personal depiction of a courtesan. The poem, written by the satirical poet and writer of popular fiction Ota Nampo (1749–1823), tells of her plight as she contemplates her future now that her ten-year contract has expired and she must find another livelihood. Shun'ei created many beautiful prints, but his paintings are rare.

Utagawa Kunisada I (1786–1864)
Yoshiwara and Kanbara: a female Daruma
from the series 'Eastern seaboard highway'
colour woodblock print, 35.4 x 24.6 cm
Purchased 1995
211.1995

Utagawa Kunisada I (1786–1864)
Mitate variety of darkness: evening darkness
colour woodblock print, 35.5 x 24.6 cm
Purchased 1995
210.1995

Utagawa Kunisada I (1786–1864)
Contemporary tales of three villains
1860
colour woodblock print, 35 x 24.3 cm
Bequest of Kenneth Myer 1993
598.1993

Kunisada (Toyokuni III) was a prolific artist of the late *ukiyo-e* school. Bodhidharma, or Daruma in Japanese, was the legendary founder of Zen Buddhism, easily recognised by the characteristic red robe that covered his body and head. In the deliciously irreverent and witty style of *ukiyo* culture, images of courtesans dressed as Daruma appeared, drawing parallels between the austerities Bodhidharma endured during the nine years he meditated in front of a wall to obtain Enlightenment, and the trials of a courtesan who was contracted to a brothel for ten years.

Utagawa Kunisada I (1786–1864)
Kaomachi of Tama-ya
colour woodblock print, 37.5 x 26.7 cm
Purchased 1930
4358

This print is technically unusual in being
printed only in tones of blue. Its subject
Kaomachi was a famous courtesan of the
teahouse called Tama-ya.

Utagawa Kuniyoshi (1797–1861)
**Brave men in Hakkenden: Inuta
Kobungo** 1847–52
colour woodblock print, 35 x 23.2
Gift of Dr Roderick Bain 1997
169.1997

Kuniyoshi established his reputation with
his pictures of historical heroes.

Ando/Utagawa Hiroshige (1797–1858)
Sekiya and Suijin woods 1857
from the series 'One hundred famous
places of Edo' 1856–58
colour woodcut, 34 x 22.5 cm
Publisher: Eikichi Uoya
Purchased 1961
DO13.1961

The last major artist of the *ukiyo-e* school,
Hiroshige is most famous for his series of
landscape prints. This print typifies the
sensitivity to nature and originality of
composition for which he is famous.

Masami Teraoka (b1936)
31 flavours invading Japan: French vanilla IV 1979
65 colour screenprints, AP II, 28 x 139.5 cm
Gift of the Thea Proctor Memorial Fund 1989
© Masami Teraoka
343.1989

Masami Teraoka draws on his unique blend of Japanese/American heritage to comment on contemporary society. Teraoka moved to Los Angeles in 1961 and made his reputation through his witty prints which, drawing stylistically on traditional *ukiyo-e* prints, satirise contemporary lifestyles. His sophisticated works warrant close study, so rich are they in wit, nuance (often salacious and erotic) and visual and verbal puns. The print *31 flavours invading Japan* perfectly exemplifies his style. The title is a reference to the marketing onslaught of the American firm Baskin-Robbins on the Japanese consumer market. In a successful attempt to get Japanese eating icecream cones, brightly coloured stalls offering '31 flavours' sprang up all around Tokyo. The main figure resembles a typical *ukiyo-e* courtesan, particularly those by Utagawa Kunisada (1786–1864). The courtesan, over-adorned with hair combs, holds a melting icecream cone while reaching for napkins, a modern version of a favourite 19th-century erotic convention.

Tsuruya Kokei (b1946)
Two onnagata c1980
colour woodcut, 39.7 x 24.9 cm
Purchased 1984 © Tsuruya Kokei
83.1984

Kokei has revived the *ukiyo-e* tradition of depicting individual actors in specific performances. He does his own drawing, blockcutting and printing, unlike in traditional practice where the artist did only the drawing. While consistent with the conventions of *ukiyo-e*, the prints have a compelling power and a certain malevolence that generates an unease at odds with the purely visual pleasure of traditional *ukiyo-e* prints.

CERAMICS

The production of ceramics in Japan began around 10 000 BCE, making Japan one of the oldest pottery-producing cultures in the world. The earliest pottery is called *jomon*, or 'cord pattern', from one of its typical patterns created by pressing cords on the soft clay surface. The Jomon period was followed by the appearance of the distinctive Yayoi pottery in the 3rd century BCE. In its simplicity of shape and serene balance, Yayoi pottery showed a complete break in aesthetic from the Jomon style. The ceremonial jar (page 261) in the gallery's collection is a good example of Yayoi pottery from western Japan.

In the 5th century, new high-temperature firing techniques were introduced from the Korean peninsula, and pieces similar in colour and shape to Korean Silla pottery were produced in Japan. When the official trade missions to Tang China began in 630 and the fleets brought in large quantities of Chinese ceramics, kilns in central Japan aspired to copy their mainland prototypes. By the mid 1200s kilns were established in central Japan, some of which have continued production until today: they are the so-called 'Six Old Kilns' – Seto (Sanage), Tokoname, Bizen, Shigaraki, Echigo and Tanba. The two Shigaraki jars in the gallery's collection (page 261) are fine examples of the practical wares produced in the old kilns, the rustic beauty of which was first admired by the 16th-century tea masters.

With the rising demand for ceramics associated with the tea ceremony, feudal lords were keen to develop a ceramic industry in their fiefs. They took advantage of the ruler Toyotomi Hideyoshi's invasions of Korea (1592 and 1598) and brought Korean potters into their fiefs. The resulting introduction of their advanced skills opened a new chapter in the history of Japanese ceramics.

ARITA
One of the most significant achievements of the Korean potters settled in the fief of Saga in the southern island of Kyushu at Arita, was the discovery of porcelain clay in the 1610s. The earliest Arita ware porcelain was decorated with underglaze blue but the more technically demanding overglaze enamel technique was soon learnt. These earliest porcelain wares were sold to domestic markets as substitutes for Chinese imported wares, although some were exported overseas. Arita ware porcelain is also commonly called 'Imari' or 'Imari ware' after the name of the port from which it was transported. Apart from Imari, the other main types of Japanese porcelain are Kakiemon, Kutani and Nabeshima.

JAPANESE EXPORT CERAMICS
From the 1600s Japan had a thriving export market with Southeast Asia, sending out underglaze and

polychrome porcelains as well as greenwares made in imitation of Chinese Longquan celadons. The greenwares, large dishes with carved floral decorations, were much admired in Indonesia, where Chinese greenwares of the Yuan and early Ming dynasties had been collected and kept as valuable heirlooms for centuries.

Japanese porcelains were also exported to Europe through the Dutch East India Company (VOC). When Dutch trade with China came to a standstill the company turned to Japan, where in 1641 it had been permitted to establish a 'factory' on Dejima Island in the bay of Nagasaki. Initially the VOC commissioned copies of popular Chinese porcelains which were shipped from the factories of Arita via the port of Imari. Imari wares were the most commonly exported, whether blue-and-white plates decorated in the Chinese Kraak style, or brocade wares. The VOC's Japan trade only lasted about a quarter of a century, after which the Chinese trade was resumed.

The large charger and shaving bowl are examples of the brocade-style export ware (page 264), which in the 1800s was maintained by the Satsuma kilns that produced pieces for both the local and foreign markets.

Like many countries around the globe, Japan participated enthusiastically in the great international trade fairs that became such hallmarks of progress and prosperity during the second half of the 19th century after the overwhelming success of the Crystal Palace exhibition in London in 1851. Japan participated in the 1879 International Exhibition held in Sydney in the grand, purpose-built Garden Palace in what is now the Botanic Gardens. After the event, the Japanese government donated several ceramics and bronzes to the Art Gallery, one of which is illustrated.

KAKIEMON

The Kakiemon style overglaze enamel porcelain, well known in the West, was developed from the 1670s for the upper end of the European market. However, the soft white clay was difficult to fire: the yield rate was bad, and as overseas demand dwindled in the late Edo period, the quality and quantity of production of Kakiemon-style porcelain dropped. Among the gallery's examples is a vigorously painted plate with a design of dragon and tiger that is a very fine example from the high point of the Kakiemon style (page 262).

SATSUMA

Among the generals who brought Korean potters back to Japan with the retreat of 1698 was Lord Shimazu of Satsuma in southern Kyushu. The settled Korean potters produced two distinct styles of ceramics: one was a white-bodied stoneware for the exclusive use of the ruling class and the other a dark earthenware for

ordinary people. When gold mines were discovered in Shimazu's fief land, gold was extensively applied to decorate the whiteware. Delicate designs were adopted from the Kyoto style. During the Meiji period, the whiteware, known as Satsuma ware, became popular at international expositions, and as the demand for it grew, other areas in Japan began to produce ceramics in this style (their products also became known as Satsuma ware). An example in the gallery's collection (pictured page 267) is the vase made in Kyoto by Kinkozan. While some Satsuma ware was produced for the local market, most found its way overseas.

Fine examples in the gallery's collection of pieces made for Japanese consumption include a large jar dated to 1805 and a small piece persuasively modelled as a bamboo cricket cage wrapped in a richly decorated cloth (page 267).

NABESHIMA WARE
One type of porcelain was never meant for export; Nabeshima ware was produced exclusively for use by the lord of Saga and his household and as presentation pieces. After the Meiji Restoration, when potters lost the clan patronage and had to move in search of work, the style spread. The gallery's Hirado ware plate in Nabeshima style (page 262) was possibly made by one such potter and could have been decorated by a member of Imaizumi family, who for generations have

been the traditional makers of Nabeshima ware. The gallery has a contemporary piece by Imaizumi Imaemon XIII, who in 1976 was designated an Important Intangible Cultural Asset.

MODERN CERAMICS
From the early 20th century, handmade Japanese ceramics have diverged in two distinct currents. One was the continuation and revival of distinctly regional ceramics. Some Momoyama-period kilns (such as those for Shino ware) had fallen out of favour during the Edo period and disappeared, but their re-appreciation prompted the search for old kiln and clay sites to revive production. Strong demand from tea practitioners and ceramic lovers supported this revival of regional wares. The gallery's collection contains a variety of these traditional wares.

The other modern current is 'creative' ceramics. From the early 20th century the modern concept of individualism encouraged many young artists to take up ceramics as a medium of self-expression. Some had been born into families of potters but others studied the necessary skills at school. Often inspired by European modernist trends, the new generation of potters broke free from conventional techniques and forms.

In more recent years this diversity has continued, ranging from conventional forms such as Ono Hakuko's

golden vase, Shiga Shigeo's white vase, Tsukuda Masahiko's jar and Yasuhara Kimei's vase to Ito Keiji's sculptural piece and Araki Takako's contemplative *Stone bible* (see page 269).

A large part of the gallery's contemporary Japanese ceramics collection has been generously donated by the Reverend Muneharu Kurozumi, chief patriarch of the Kurozumi sect of Shinto, based in Okayama (old Bizen), and Norman Sparnon (1913–95), the founder of the Sogetsu ikebana school in Australia.

Jomon period (c6000–200 BCE)
Jar
earthenware, 22 x 19 cm
Purchased 1977
363.1977

With its restrained decoration, this small jar is the earliest example of Japanese pottery in the collection. Its 'cord pattern', over-incised by wider lines, is typical of pottery made in the Kanto district (present-day Tokyo and environs) during the mid to late Jomon period. The patterns in Jomon pottery are thought to have meaning rather than being purely decorative, but their meanings are not known today. This type of jar was used to cook food, most likely half-buried in a fire, with the lugs functioning as handles.

Northern Kyushu
Yayoi period (c200 BCE – c250 CE)
Ceremonial jar c100 CE
earthenware, 34.4 x 32 cm
Purchased with funds provided by Kenneth Myer
1986
24.1986

Muromachi period (1392–1568)
Shigaraki ware storage jar 1400s
stoneware with natural ash glaze, 53 x 39 cm
Gift of Norman Sparnon 1989
86.1989

Muromachi period (1392–1568)
**Shigaraki ware wide-mouthed
jar *kame*** 1500s
stoneware with natural ash glaze, 60 x 38 cm
Purchased 1985
213.1985

Edo period (1615–1868)
Arita ware Kakiemon style octagonal bowl late 1600s
porcelain with overglaze enamel, 8.6 x 18.1 cm
Gift of Graham E Fraser 1986
172.1986

Meiji period (1868–1912)
Hirado ware plate with chestnut design 1800s
porcelain with underglaze blue decoration,
6 x 22.5 cm
Purchased 1995
215.1995

Edo period (1615–1868)
Arita ware Kakiemon style dish with tiger and dragon design c1670–90
porcelain with overglaze enamel, 3.5 x 18.3 cm
Purchased 1983
206.1983

KAKIEMON WARE

The Kakiemon style overglaze enamel porcelain was developed from the 1670s for the upper end of the European market. Its milky-white ground (known as *nigoshide*) accentuated the coloured enamels and allowed a sparer style more attuned to Japanese taste. Tradition has it that Kakiemon is the name of the enameller who perfected the style's distinctive red persimmon (*kaki)* colour.

Characteristically for Kakiemon, the design on this dish is Chinese (a tiger and dragon) executed in vibrant enamel colours, while the body is a warm, rich white against which the motifs are delicately and sparsely placed. Typical too of Kakiemon is the rust-red coating on the rim.

In Europe a passion developed for Kakiemon porcelain, where it was first copied by Meissen and later in England by the Chelsea, Bow and Worcester factories. In fact, before its acquisition by the gallery, this piece had mistakenly been exhibited as Chelsea.

KO-KUTANI AND KUTANI WARES

Ko-Kutani (Old Kutani) wares, a distinct category of 17th-century Japanese porcelain, are easily recognisable by their bold use of strong, dark enamels. They were initially thought to have been produced in kilns in the old Kaga region (present-day Ishikawa prefecture). Current thinking however is that 'Ko-Kutani' should be used as a stylistic rather than geographic descriptor, and that the wares were produced at Arita. Regardless of where the kilns were, Ko-Kutani wares seem only to have been made in the mid 1600s. The style was revived in the 1800s and was referred to as 'Kutani' to distinguish it from the earlier pieces. With their distinctive gilt-on-red backgrounds, Kutani style wares were developed and exported in huge quantities to the West.

Edo period (1615–1868)
Arita ware Ko-Kutani style bottle with design of landscape and flowering plants c1650–60
porcelain with overglaze enamel, 20.1 x 8.9 cm
Purchased 1979
212.1979

The four different scenes on the sides of this enamelled porcelain bottle are Chinese in style. Many fine examples of this type were handed down in the old Kaga region (present-day Ishikawa prefecture on the Japan Sea) ruled by the Maeda clan, and were thought to have been produced in its local kilns during the latter half of the 1600s. The firing cracks in this piece have been obviously repaired with gold lacquer. Unlike the Chinese, whose inclination is to discard faulty pieces, the Japanese revel in such faults

as symbols of the uncertainty of fate and humanity's inability to control the element of fire even within a kiln. This jar is from the Englishman Richard de la Mare's collection of Japanese ceramics, which in its day was considered one of the finest outside Japan.

Kanzan Denshichi (1821–90)
Kutani ware vase
porcelain enamel and gilt decoration,
24.8 x 14 cm
Gift of the Japanese commissioners at the
International Exhibition 1881
2465

Edo period (1615–1868)
Arita ware charger 1800s
porcelain with underglaze blue, overglaze enamel
and gold, 8.2 x 59 cm
Gift of Prof R Clough 1985
179.1985

Although in Japan the term Imari ware
designates both blue-and-white and
enamel decorated wares, in the West the
term has generally referred to porcelains
densely decorated in enamels, such as
this. In the centre it features a design of
phoenix and flowering plants, with a
flower and animal pattern around it. The
large shallow shape of a charger made it
well suited to pictorial decoration. Most
dishes were hung on the wall rather than
used.

Edo period (1615–1868)
Arita ware shaving dish
late 1600s – early 1700s
porcelain with underglaze blue, overglaze enamel
and gold, 6.2 x 27 cm
Purchased 2000
560.2000

When the Dutch East India Company
turned to Japanese suppliers in the 1600s
to replace their Chinese sources, it
commissioned many purely European
shapes. This piece is an obvious example,
such wares not being used by the
Japanese. It is decorated in the 'brocade
style', with the application of gold which
was an innovation of the sumptuous
Genroku era (1688–1704).

Edo period (1615–1868)
Arita ware covered jar 1700s
porcelain with overglaze enamel and gilding,
59.5 cm
J S Watkins Bequest Fund 1984
151.1984

Among the gallery's export Imari wares,
this large covered jar is unusual in being
decorated only in red and gilt. The scale
of a piece such as this (as well as the
large charger at left) would be an
anathema to Japanese taste yet well
suited to the decoration of an English
Victorian country house.

Edo period, Tenpo era (1830–44)
Arita ware rectangular plate decorated with a map of Japan and neighbouring islands
porcelain with underglaze blue,
5.6 x 32.4 x 29 cm
Purchased 1981
154.1981

In the vast repertoire of Imari shapes and designs, map plates are an interesting and unusual diversion that appear only in the 1800s, when the Edo period was ending. They are an obvious reflection of the nationalistic feeling engendered by fear of the foreign ships then arriving at Japanese ports and demanding an end to Japan's policy of seclusion. The insularity of Japan at the time is reflected in the names of foreign countries – while all the provinces of Japan are named, other countries are labelled with titles such as 'country of the little people'.

Edo period (1615–1868)
Arita ware multi-lobed sake bottle with design of tiger late 1700s – early 1800s
porcelain with underglaze blue, 33 x 20.5 cm
Gift of Sogetsu Ikebana Friends in memory of Norman Sparnon AO 1997
428.1997

Kinkozan Sobee VII (1866–1927)
Vase with design of birds and flowers
1800s
stoneware with overglaze enamel and gold,
30.6 x 13.5 cm
Bequest of Alan Renshaw 1975
292.1975

The Kinkozan was a family of Kyoto
potters established during the Edo period.
In the Meiji period Kinkozan Sobee VI
began using the Satsuma ware technique.
His son Kinkozan VII continued this work,
actively exploring new designs for export
ware and participating in international
exhibitions.

Meiji period (1868–1912)
Satsuma ware cricket cage c1900
stoneware with overglaze enamel and gold,
17.8 x 11 cm
Gift of Charles Binnie 1939
4076.a-b

This fine example of Satsuma ware was
produced in Yokohama by a company
begun by Hodota Takichi, formerly a tea
merchant. The piece is signed
'Masanobu', possibly the decorator. With
the Meiji Satsuma ware, the base was
often made in Kagoshima, the traditional
Satsuma ware region, and sent to various
areas to be decorated. Some pieces
found their way to the domestic market,
but most were made for export.

THE MINGEI STYLE

The Mingei movement was a Western-inspired craft movement, distinguished by its appreciation of, and inspiration from, European and Japanese folk crafts. Its most representative artist is perhaps Hamada Shoji. In 1920 Hamada accompanied the British potter Bernard Leach (who had studied pottery in Japan) to England. After Hamada returned to Japan in 1924, the two potters kept in touch, visiting and holding exhibitions together. Their works were largely inspired by English slipware and other folk pottery, and were given a theoretical support by Yanagi Soetsu (1889–1961), a religious philosopher who claimed that the supreme beauty of craft was found in pieces made by anonymous craftspeople for use by ordinary people. The theory, rather ironically promoted by works of prominent artists such as Hamada and Leach (who published Yanagi's theory under the title *The unknown craftsman*), was embraced by many craftspeople. In Japan, the style has been continued by potters such as Kawai Takeichi and Shimaoka Tatsuzo.

Hamada Shoji (1894–1978)
Square jar c1964
stoneware with white ash glaze, 20.3 x 16.8 cm
Purchased 1965 © Hamada Shoji Estate
EC6.1965

Hamada Shoji (1894–1978)
Vase c1967
stoneware, press moulded and cut,
23 x 16 cm
Gift of Mrs J Higgs in memory of her husband Arthur 1992 © Hamada Shoji Estate
197.1992

Kawai Takeichi (1908–89)
Square dish c1961
stoneware, 4.7 x 32.5 x 32.5 cm
Purchased 1964 © Kawai Takeichi Estate
EC3.1964

Shimaoka Tatsuzo (b1919)
Flat vase with cord pattern design
stoneware with slip inlay, 21.3 x 16.4 cm
Gift of Klaus Naumann 1984
© Shimaoka Tatsuko
59.1984

Shiga Shigeo (b1928)
Round pot with white magnesium glaze
1975
stoneware, 20 x 23.5 cm
Gift of the artist 1997 © Shiga Shigeo
260.1997

Having studied ceramics in his native
Niigata under Saito Saburo then under
Kawai Takeichi in Kyoto, Shiga Shigeo
came to Australia and spent 13 years in
New South Wales between 1963 and
1979. He first taught at the pioneering
Sturt Craft Workshops in Mittagong, and
later set up a kiln in the Sydney suburb of
Terrey Hills. During his years in Australia,
Shiga formed a strong relationship with
Australian potters, and his influence on
Australian ceramics in technique and style
has been significant. Most of the ceramics
illustrated in the book *Shiga the potter* are
in the collection of the Art Gallery of New
South Wales.

Ito Keiji (b1935)
Message of peace 1983
stoneware, 20 x 35 x 26 cm
Gift of Rev Muneharu Kurozumi 1984
© Ito Keiji
250.1984

Araki Takako (b1921)
Stone bible 1983
stoneware, 15 x 23 x 16 cm
Gift of Rev Muneharu Kurozumi 1984
© Araki Takako
249.1984

SODEISHA

Despite the technical restrictions imposed by the material and production process, postwar Japanese ceramics have ventured into ever-expanding expressions. Sodeisha, a group of avant-garde ceramic artists, was founded in 1948 by Yagi Kazuo, Suzuki Osamu and Yamada Hikaru. Sodeisha liberated Japanese ceramics from forms that were associated with uses such as vases. It did so by creating abstract objects, to which the term 'object ware' was given, and thus opened up endless possibilities for ceramic artists in the following decades. Suzuki Osamu and Yamada Hikaru were two of the three founding members.

Suzuki Osamu (1926–2001)
Black glaze square jar c1950–60
stoneware with *tenmoku* glaze, 23 x 13 cm
Gift of Norman Sparnon 1988
© Suzuki Osamu Estate
416.1988

Yasuhara Kimei (1906–80)
White slip flower vase
stoneware, 63.5 x 22.5 cm
Gift of Norman Sparnon 1988
© Yasuhara Kimei
405.1998

Yasuhara Kimei based his activities in the government-sponsored annual exhibition. Characterised by their abstract and geometric designs, Yasuhara's works from the 1930s were noticed by Teshigahara Sofu, the founder of the abstract Sogetsu School of Ikebana (Teshigahara was searching for potters who could make vases suitable for his free-style flower arrangements).

IKEBANA

The notion of impermanence is intrinsic to the art of ikebana, the Japanese art of flower arrangement. Developed from the formal altar decoration of the Buddhist temple, ikebana became an independent art form. In 1988 the gallery acquired a number of vases donated by Norman Sparnon, who had brought the innovative Sogetsu School of Ikebana to Australia, and was awarded the Order of the Rising Sun by the Japanese government in recognition of his talent and contribution. As an active ikebana practitioner, Sparnon had studied under Teshigahara and worked with a number of potters including Suzuki and Yasuhara. The two illustrated Ikebana displays (above) are examples of their collaboration.

Suzuki Osamu (1926–2001)
Clay figure: stepping out 1973
stoneware, 59.5 x 30.5 cm
Gift of Rev Muneharu Kurozumi 1981
© Suzuki Osamu Estate
306.1981

In much of his 'object' work, Suzuki was
inspired by prehistoric clay figures as
shown in this piece. His main concern
here is the handling of the surface plane
and the texture of the form, resulting in a
fine combination of the solid mass of the
clay, the delicate movement in the form
and warmth of the colour and texture.

Yamada Hikaru (1924–2001)
Black ceramic screen
stoneware with black glaze, 54.4 x 28 x 13.5 cm
Gift of Rev Muneharu Kurozumi 1981
© Yamada Hikaru Estate
311.1981

A NEW DICHOTOMY

The arrival of American Commodore Matthew Perry and his squadron of 'black ships' in 1853 marked a turning point in Japanese history. With the signing of a Treaty of Friendship between Japan and the United States the following year, Japan took its first step towards ending its policies of seclusion that had been in place for more than 200 years. Other changes were brewing within Japanese political circles as loyalists, advocating the restitution of imperial rule, gained more power. The loyalists eventually overthrew the Tokugawa shogunate, thus instigating the Meiji Restoration, named after Emperor Meiji (1852–1912). The new leaders, a mix of enlightened samurai and Kyoto courtiers, looked to the future and embarked on a course of modernisation and the pursuit of Western 'civilisation and enlightenment' that impacted across all spheres of Japanese government, society and culture.

In the aftermath of the 1868 Meiji Restoration two events were to profoundly affect the future of Japanese art: the introduction of oil painting and changes to the traditional system of patronage. Oil painting, with its principles of linear perspective and chiaroscuro, was first taught in Japan by the Italian painter Antonio Fontanesi at the government school founded in 1876 specifically for the purpose of teaching the techniques of Western art. Within a few decades, the old dichotomy of Chinese and Japanese styles of painting, based on stylistic difference, was replaced by a new dichotomy of Western-style painting (*yoga*) versus Japanese-style painting (*nihonga*), based on the difference in medium. Various existing schools, including the Chinese-inspired *nanga* painting, were gathered together under the singular category of *nihonga*. The gallery's holding of modern Japanese painting is still small but contains good examples of different developments in *nihonga*. Suzuki Shonen and Kawabata Gyokusho, both from Kyoto, a long-time rival of Edo/Tokyo in all aspects of the arts, sought to infuse tradition with modernity in their *nihonga*.

In the pursuit of modernity, many artists, particularly *yoga* ones, were resident in large numbers in London, Paris and Berlin, especially in the 1920s and early 1930s. While as yet the gallery contains no paintings by any of these *yoga* artists, it does contain prints by three of its major artists: Asai Chu, Yasui Sotaro, one of the most prominent modern oil painters in Japan, and Fujita Tsuguji, the best known in the West.

With such radical steps as the dissolution of the samurai class, the social reforms initiated by the new Meiji government overturned the system of patronage that had been in place for centuries. Painters of the ruling classes – the Kano and Tosa/Sumiyoshi schools – now had to seek work elsewhere. During the last three decades of the 19th century, government-sponsored

domestic and international expositions and newly established art schools provided new forums for artists. A government-sponsored art exhibition (first called Bunten) was permanently established in 1907 as an annual national exhibition. From the start, the exhibition enjoyed an enormous influence over the Japanese art world: to be hung at this national exhibition was considered a prestigious debut for an artist. It soon consolidated its status as the Japanese art academy.

But from around 1910, Bunten's conservatism became a target of criticism by a generation of young artists who felt that a new art was needed to reflect the changing social reality and concerns. The *yoga* artists were the first to rebel, setting up a separate exhibition in 1912, while in *nihonga* circles radical young painters of Kyoto formed the Association for Creation of National Painting (Kokuga Sosaku Kyokai or Kokugakai for short) in 1918. Despite the conservative tone of its name, works hung at its exhibitions clearly stated that the artists' concern was not classical idealism but 'reality', and the subjects depicted were 'real people' often in their working clothes. The sympathy for working-class people reflected the humanist ideals of the Taisho period (1912–26), when ideas of democracy and humanism permeated the society for the first time. Kainosho Tadaoto was a member of Kokugakai, and one who

perhaps took this realism further than anyone else, with his depictions of women often so sensual and melancholic that they bordered on the grotesque.

The passionate realism of the Taisho period was subdued and replaced by idealistic neoclassicism of the Showa period (1926–88), but the streams established through Meiji and into Showa remain integral to the contemporary art scene today.

Suzuki Shonen (1849–1918)
Pine trees
pair of six-fold screens, ink on gilded paper,
153 x 364 cm each
Purchased 2000
15.2000

Suzuki Shonen was a son and the best student of Suzuki Hyakunen (1825–91), who had established a style of his own without adhering to any existing schools. Shonen, a significant Kyoto painter and an influential teacher, was known for his uninhibited, powerful brushstrokes, which are certainly visible in these screens of one of his favourite subjects. If Kano

Eino's pine tree (page 219) is an expression of the aesthetic and taste of the feudal rulers, Shonen's pines embody the unfettered spirit of the progressive Meiji period.

Fujita Tsuguji (1886–1968)
Self-portrait with cat 1920s
etching, 32.6 x 24.5 cm
Purchased 1957 © Fujita Tsuguji Estate
9350

Yasui Sotaro (1888–1955)
Artist and a model 1934
colour woodcut, 39.7 x 27.8 cm
Purchased 1997 © Yasui Sotaru Estate
211.1997

Fujita most likely made this print in
Paris, where in the 1920s he enjoyed
unprecedented success as a Japanese
painter. He established a much-acclaimed
style of painting on a white surface with
black ink outlines inspired by traditional
Japanese painting, as seen in this etching.
While many Japanese artists spent time
in Paris, Fujita was the painter most fully
integrated into the Parisian art world,
living there from 1913 to 1929, and then
intermittently until his death. In Paris he
mixed with artists such as Modigliani and
Picasso, and served as a judge for the
salons. His fondness of cats was well
known, and they feature in many of his
works.

Kawabata Gyokusho (1842–1913)
Spring cherry blossoms and autumn maples
pair of two-fold screens, ink, colour and sprinkled gold on paper, 163.2 x 86 cm each
D G Wilson Bequest Fund 1997
419.1997.a-b

Kawabata Gyokusho, the son of a *maki-e* lacquer artist, was a student of the Maruyama school. In 1866 he moved to Tokyo, where he also studied oil painting from Takahashi Yuichi, the pioneer of Western-style painting. When the Tokyo School of Fine Arts was established, he was invited to teach the Maruyama school of painting. Kawabata's works usually reflect his skilful synthesis of the two traditions he had studied. This pair of screens epitomises his creative adaptability. While the details of the maple leaves and cherry blossoms indicate his dedication to the naturalistic representation of the Maruyama school, the flat, decorative treatment reflects a debt to the Rinpa school.

Kainosho Tadaoto (1894–1978)
Beauty looking back c1928
hanging scroll, ink, colour and gilt on paper,
60.3 x 39.5 cm
Purchased 1991 © Kainosho Tadaoto Estate
264.1991

Kainosho was a pivotal figure in the
nihonga circles of his period. His strange
figures of women were a challenge to the
established genre of *bijin* paintings, with
his later works distinguished by a deep
insight into the sitter's personality, as is
apparent here. The subject is a young
woman, Tokuko Maruoka, whom the artist
admired and often used as his model
around 1928–29. He depicted the model
as an individual rather than as a universal
beauty.

INDIVIDUALITY IN EARLY 20TH CENTURY WORKS ON PAPER

From the closing decades of the 1800s, the radical changes faced by Japan as it set out on a course of modernisation were reflected in two major trends in printmaking: the Creative Print (*sosaku hanga*) and the New Print (*shin hanga*) movements.

The artists of the Creative Print movement, mostly young Western-style painters and illustrators who were engrossed in the new idea that art was, first and foremost, 'self-expression', believed that the print could be a work of art in its own right. They insisted the artist had total control of all aspects of production. In the case of the woodcut, which remained the most popular medium, this meant that the artist should design, blockcut and print his or her own work.

The preoccupation with 'self-expression' among the early Creative Print artists is reflected pre-eminently in the works of Onchi Koshiro, Tanaka Kyokichi and Fujimori Shizuo, who created *Tsukuhae* (1914–15), the first magazine dedicated to prints and poetry. Of the three, Onchi remained at the forefront of modern Japanese graphic art: with *Bright hours* in 1915 he was the first Japanese artist to produce an abstract image.

The Japan Creative Print Association, formed in 1919, opened up opportunities for print artists to communicate to one another as well as exhibit their works. Printmaking thus spread from the major cities to various local towns, which began to produce their own print magazines, each with local flavour. Japanese printmaking also enriched itself through international experience: after World War I more information on Western art became available through the increased number of artists travelling to Europe and the wide availability of books. Works such as *Poet strolling* and *Road towards the hill* (page 282) by Fukasawa Sakuichi show how the artist experimented with marrying Western modernity with the texture of the woodcut.

Among the Creative Print artists in the 1930s and 1940s Munakata Shiko and Taninaka Yasunori stand out for their originality and uninhibited imagination. Munakata drew his inspiration from Japanese religions and the folk arts of his native Aomori at the northern end of the Japanese main island Honshu, as exemplified in *Night visit* from the series 'Story of the cormorant' (page 283). In contrast to Munakata, Taninaka was an artist of urban mythology, who created uneasy images depicting the dreams and paranoia of modern men and women. *Man exhaling butterfly* and *Mr Contemplation* (page 282) are two such works from the series 'Collection of poetic pictures' and are considered to be some of the artist's most characteristic works.

Like the Creative Print movement, the New Print movement was a reaction against the contemporary woodblock prints that were reproductions of paintings. Unlike the Creative Print movement, however, it

aimed at revitalising the *ukiyo-e* tradition for the modern era through high-quality prints of traditional *ukiyo-e* subjects – beauties, actors, birds, flowers and famous places. It was also a commercial venture: Watanabe Shozaburo, a publisher and *ukiyo-e* enthusiast who initiated the movement, knew that there was a market for such prints among foreign visitors and collectors. In 1914 he published the first print by designer/illustrator Hashiguchi Goyo, which was blockcut and printed by skilled specialists. After this first print Hashiguchi began producing prints on his own, so Watanabe turned to the young painter Ito Shinsui, who became one of Watanabe's most important artists. *Washing the hair* (page 285) is a well-known work among Ito's postwar prints, admired for its dynamic composition and refined sensuality. Over the years Watanabe engaged a number of other artists for his New Prints including Kawase Hasui, who was a major producer of landscape prints. *Snow in Shiba Park Tokyo* (page 284), depicting a traditional gate by a river, is a typical example of Kawase's work in the conventional and popular 'famous places' genre. Other publishers also began to create quality prints such as Kitano Tsunetomi's *Heron maiden*, the subject of which was a popular mythological figure (page 284).

Painters and illustrators also produced prints as artistic and commercial projects. Takehisa Yumeji, whose images of languid women, innocent children dotted with exotic Western icons enraptured women of all ages, was hailed as Japan's first modern designer/illustrator. *Autumn makeup* is an example of his designs, used on the front cover of the women's magazine *Fujin Gurafu* (ladies graphics). Some Western artists also produced woodblock prints taking advantage of Japan's rich graphic tradition with skilled professional blockcutters and printers. Paul Jacoulet arrived in Japan with his French parents when he was four and lived in Japan for the rest of his life. Jacoulet travelled to Korea, China, Mongolia and the Pacific islands before World War II. His prints (page 285) are characterised by a flatness (which he took from *ukiyo-e*) and richness of colour in which he delighted.

Onchi Koshiro (1891–1955)
Lyric I 1914
colour woodcut, 13.4 x 11.1 cm
Yasuko Myer Bequest Fund 2000
© Onchi Koshiro Estate
82.2000

This work is considered the first in the 'Lyric' series in which Onchi attempted to create 'poem-like images', that is, to express his inner joy, hope, sorrow and anger with colour and shape instead of words. He republished this print in the magazine *Kaze* in 1928 with the poem:

While gazing at a point
Focusing on a point,
The will shoots out to the sky,
A platinum wire springs out,
And tears run from the heart.

Onchi Koshiro (1891–1955)
A face 1914
colour woodcut, 14.7 x 11.1 cm
Yasuko Myer Bequest Fund 2000
© Onchi Koshiro Estate
83.2000

Like *Lyric I*, this is a good example of Onchi's earliest works, which embody Japanese modernism and poetic sensitivity within small yet striking images.

Onchi Koshiro (1891–1955)
Morning 1930
colour woodcut, 21 x 12.9 cm
Yasuko Myer Bequest Fund 1999
© Onchi Koshiro Estate
184.1999

Onchi worked in both figurative and abstract/semi-abstract images at the same time, as shown here. Impressions of this work were attached to the page in a coterie magazine *Sen* in 1930, accompanied by a poem on the opposite page also by the artist.

Fukazawa Sakuichi (1896–1946)
Poet strolling 1927–28
woodcut, 26.3 x 19.2 cm
Yasuko Myer Bequest Fund 2000
85.2000

Fukazawa Sakuichi (1896–1946)
Road towards the hill 1925
colour woodcut, 23.2 x 30.4 cm
Yasuko Myer Bequest Fund 2000
84.2000

Taninaka Yasunori (1897–1946)
Man exhaling butterfly 1933
colour woodcut, 16.1 x 19.9 cm
D G Wilson Bequest Fund 1999
14.1999

Taninaka Yasunori (1897–1946)
The universe (Mr Contemplation) 1933
colour woodcut, 17.3 x 23 cm
D G Wilson Bequest Fund 1999
15.1999

Munakata Shiko (1903–75)
Night visit 1960s (printed)
from the series 'Story of the cormorant'
1938
woodcut, 25.4 x 28 cm
Purchased 1968 © Munakata Shiko Estate
DO28.1968

When he made this series of 31 prints,
Munakata was inspired by the centuries-
old No play of the same title. This image
depicts the wife of a hunter, who,
unbeknown to her, has been condemned
to become a devil to atone for taking the
life of fellow creatures. The wife is shown
opening her door to a monk, the bearer of
the message and relics from her husband,
who can no longer return to her. Munakata
has eloquently captured this fleeting
moment in the wife's inquiring expression.
Most of the woodblocks of this 1938
series were lost. This is one of the few to
survive.

Munakata Shiko (1903–75)
Shell kind 1945 (later impression)
woodcut with hand colouring on verso,
45.1 x 32.4 cm
Purchased 1963 © Munakata Shiko Estate
DO22.1963

Kawase Hasui (1883–1957)
Snow in Shiba Park, Tokyo
colour woodcut, 24.1 x 36.5 cm
Purchased 1960 © Kawase Hasui Estate
DO2.1960

Shiba Park is one of Tokyo's 'famous
sites', making this print a good souvenir
for visitors. The seasonal reference of the
snow follows the *ukiyo-e* convention,
while the chiaroscuro and absence of
outline indicate the influence of
watercolour painting: a reassuring blend
of the traditional and the modern, with
richly overlaid colours creating subtlety
and depth.

Kitano Tsunetomi (1880–1947)
The heron maiden 1925
colour woodcut, 45.7 x 30 cm
Purchased 1987
354.1987

Ito Shinsui (1898–1972)
Washing the hair 1953
colour woodcut, 49.2 x 35.7 cm
Purchased with funds provided by Yasuko Myer
1988 © Ito Shinsui Estate
304.1988

Paul Jacoulet (France/Japan 1902–60)
Stars in the Gobi, Mongolia 1951
colour woodcut, 39.5 x 30 cm
Purchased 1992 © Paul Jacoulet,
Licensed by Viscopy, Sydney
196.1992

Paul Jacoulet moved to Japan with his
family when he was four and lived there
for the rest of his life. His prints are
characterised by a flatness (which he took
from *ukiyo-e*) and richness of colour. This
woodcut, produced in 1951 from a sketch
he made earlier, shows his forte in full.

CONTEMPORARY PRINTS

The devastating effects of World War II and massive social upheaval wrought under the Occupation had far-reaching effects on Japanese print artists. For artists, the breakdown of traditional training systems, the shortage of materials and the enforced poverty of so many Japanese were catalysts for changes in printmaking. Furthermore, as Japanese artists started travelling to the West (mainly America) to study, they were exposed to contemporary Western printmaking with its emphasis on technical variety and experimentation. From the 1950s these various factors coalesced to create a vibrant and innovative scene which placed Japanese print artists at the forefront of contemporary printmaking.

During the 1950s Japanese artists began submitting works to international biennales and it was the print that attracted most attention. Munakata Shiko enjoyed the spotlight outside Japan by winning grand prizes at Sao Paulo (1955) and Venice (1956). Although the woodcut remained the preferred medium of most artists, some favoured the cold lines of the copperplate print. Hasegawa Kiyoshi went to Paris in 1918, where he discovered the forgotten technique of mezzotint and revived it as a means of artistic expression. While remaining in France for the rest of his life, he assisted like-minded artists in the technique. Also working mostly in Paris, Hamaguchi Yozo was one several artists considered to have successfully fused the Western printmaking tradition with the Eastern sensitivity: his *Walnut* (page 288) is a typical example of his still life prints with a deeply contemplative, timeless quality. Hamada Chimei also became internationally recognised with a series of confronting images of his experiences as a soldier in China during the war.

While the prewar Japanese print was essentially narrative or poetic, from the 1960s many artists rejected literary content to pursue the image for its own sake. Naturally, this resulted in the proliferation of abstract expression. Sugai Kumi's *Purple* is an example by this important artist. International success by Japanese print artists stimulated printmaking education. The 1970s saw formal printmaking courses being set up at art universities, and as the print became recognised as an affordable original work of art, the market for prints boomed. Seeking delight in colour and texture, artists experimented in various techniques and their combinations of silkscreen, lithograph and etching opened up a greater range of expression. Ikeda Masuo, another winner of the Grand Prix at the 1966 Venice Biennale, emerged as an artist with a contemporary sensibility and personal flair, as seen in *Ladies on bicycles* (page 288).

Concurrently with international exposure and exchanges, an increasing number of Japanese print artists were based outside Japan, reinterpreting

Sugai Kumi (Japan/France, 1919–96)
Purple 1963
colour lithograph, 66.1 x 45.1 cm
Purchased 1967 © Sugai Kumi Estate
DO4.1967

traditional cultural icons and playing on the fusion of past and present with humour. In *Rainbow Hokusai*, one of the works with which he won the main prize at the Tokyo International Print Biennale in 1970, Ay-O successfully marries his obsession with 'rainbow' colours with a traditional icon – in this case Hokusai's erotic prints (page 289). With her voluptuous and carefree female figures, Oda Mayumi goes further back in history to ancient Western and Eastern mythologies (page 288).

As experiments continued to break new ground in technique and expression, various forms of contemporary art and printmaking began to encroach on each other's conventional territory, and the definition of 'the print' has become increasingly ambiguous.

Hamaguchi Yozo (1909–2000)
Walnut c1960
mezzotint, 29.8 x 44.4 cm
Purchased 1963 © Hamaguchi Yozo Estate
DO15.1963

Hamada Chimei (b1917)
A corner 1956
etching and aquatint, 22.2 x 14.9 cm
Purchased 1995 © Hamada Chimei
506.1995

Ikeda Masuo (1934–97)
Ladies on bicycles 1963
drypoint, 45.1 x 41.9 cm
Gift of Mr John Kaldor 1967
© Ikeda Masuo Estate
DO36.1967

Oda Mayumi (b1941)
Aphrodite
colour silkscreen, 80 x 56 cm
Gift of Michael Gleeson-White 1988
© Oda Mayumi
166.1988

Ay-O (b1931)
Rainbow Hokusai, position 'A' 1970
colour silkscreen, 90 x 135 cm
Purchased 1971 © Ay-O
127.1971

PHOTOGRAPHY

In early 20th-century Japan, photography was synonymous with all that was new and Western. In the 1890s and 1900s amateur photographers formed clubs in order to debate the merits of photography as art and to discuss their burgeoning pictorialist techniques. By the late 1920s the ideas of avant-garde photographers such as Man Ray and Laszlo Moholy-Nagy were being translated and published in Japanese photo journals in parallel with an increasing interest in Western modernism regardless of the medium. In 1931 the large scale avant-garde photographic exhibition *Film und Foto* was brought to Japan after touring Germany – this both enlarged and cemented the ideas associated with new ways of seeing and using the camera to represent modern life.

Yamawaki Iwao was one of the few Japanese to attend the Bauhaus at Dessau in Germany. His photographic output was small but highly influential and on his return to Japan he was able to demonstrate his understanding of Bauhaus principles and encourage a dialogue between European modernism and its Japanese adaptors and innovators. Making trips to Berlin, Moscow and Amsterdam, Yamawaki photographed important examples of modernist architecture. He used these to illustrate his essays published in Japanese architectural journals. In 1932 on his return to Japan, Yamawaki pursued architecture as a career, his photographic output dwindling though

he continued to document important designs such as the 1934 studio he created for artist Migishi Kotaro. In 1939, Yamawaki's spectacular photomontages (made in conjunction with Domon Ken) formed part of the Japanese section of the Hall of Nations at the New York World's Fair.

Recent photography in Japan shows a diversity similar to elsewhere in the industrialised world: for example, experiments in constructed photography which prevailed in the 1980s have been overtaken by experiments in analysis of the constructed self performed for the camera. Morimura Yasumasa, one of Japan's most influential artists, sprang to prominence in the West in the late 1980s. Born in Osaka in 1951, Morimura studied art in Kyoto, including under *Life* magazine photographer Ernest Sato. Morimura has stated that he is most interested in the relationship between 'to see' and 'to be seen', and that the latter – to be seen – and its implications, have largely been ignored. Through his work he is able to see himself in the role of others being seen through the camera. This complex set of visual relationships allows him to parade in a variety of guises. To some extent the work is narcissistic, even necrophiliac, though by using famous and familiar images as his source Morimura always maintains a point of connection with his audience – we remember that we have seen his work before. In the case of *Slaughter cabinet II* (page 294),

Morimura is potentially able to manipulate his audience into remembering Vietnam in a personal and individual way through the use of his own body, and thereby understanding our own involvement in any war.

The three photographs by Kon Michiko (page 293) are indicative of her practice, which now spans more than 20 years. Kon has a studio close to the Tsukiji fish market in central Tokyo and there she finds many of the objects she uses in her photographs. The artist works in isolation: placing accumulated objects in her room she waits till their sight, smell and tactility allows her to construct the image that she then photographs. Kon's photography is most closely aligned to surrealism yet harks back to the strange allegorical paintings of Guiseppi Arcimboldo, where people were depicted as composed of fruit or vegetables. Kon's darkly beautiful and disturbing images can also be aligned with Joel-Peter Witkin but they avoid that artist's explicit sexual connotations. Instead the work has a more delicate edge due to her finesse at composing and collaging her materials.

Yanagi Miwa's work depends on allowing her subjects to inhabit another kind of 'skin' so that a different view of reality can be understood: this is particularly important in Japan where feminism is in its infancy and, despite great changes in the status of women, many conform to entrenched social codes which are invariably confining and isolating. Yanagi was educated at Kyoto University of Fine Art, where she graduated in 1992. She first came to prominence with her photographs of Japanese elevator girls in the mid 1990s. This substantial series portrayed women within identifiable work locales (the shopping mall or department store) and from their perspective but as though it was after hours for their clients are never present. The tension in these works is in the slippage between what could be real or fantasy.

The two photographs by Sugimoto Hiroshi (page 295) were taken during his first visit to Australia in 1997, when he also photographed the State Theatre and the Hayden Orpheum in Sydney. Sugimoto has worked in series since he graduated from art school in Los Angeles in 1974 – initially dioramas (which eventually included waxworks) and cinemas. In 1980 he began to photograph seascapes. While Sugimoto has embarked on various subsets of these three subjects, and in 1995 photographed a representation of the divine (*Hall of 33 Bays*, which comprised 1001 statues of the thousand-armed Bodhisattva Kannon at Sanjusangendo, Kyoto), his earlier series are ongoing.

Yamawaki Iwao (1898–1987)
Untitled (portrait of a woman) 1930–32
gelatin silver photograph, 7.9 x 5.2 cm
Purchased with funds provided by the
Photography Collection Benefactors' Program
2001 © Yamawaki Iwao Estate
368.2001

Yamawaki Iwao (1898–1987)
Untitled (glass abstraction) 1930–32
gelatin silver photograph, 7.7 x 11 cm
Purchased with funds provided by the
Photography Collection Benefactors' Program
2001 © Yamawaki Iwao Estate
367.2001

These two photographs are typical of Yamawaki's work: his photographs of people (fellow Bauhaus students) – in this case *Untitled (portrait of woman)* – exhibit interesting variations of pose in common with other Bauhaus photographers. Unusual angles are used and shadows are incorporated creatively so that a spontaneous effect is achieved. *Untitled (glass abstraction)* is a classic Bauhaus experiment in terms of the placement of objects in order to provide an unusual perspective on the mundane or to show off a manufactured item in a new way.

Yamawaki (Fujita Iwao) was born in Nagasaki. From 1921–26 he studied architecture at the Tokyo School of Arts, where he first began to take photographs. Fascinated by the information and debates in publications about avant-garde practice and the activities of the Bauhaus, Yamawaki and his wife Michiko (whose family name he took) decided to move to Germany in 1930, where they studied initially under Wassily Kandinsky and Josef Albers. Yamawaki began with interior design and architecture, and then focused on photography under the tutelage of Walter Peterhans. He also developed an interest and practice in photomontage alongside fellow student Kurt Kranz, whom he invited to Japan after World War II.

Kon Michiko (b1955)
Lingerie of Udo 1995
gelatin silver photograph, ed 11/75,
51.1 x 40.8 cm
Purchased 1995 © Kon Michiko
206.1995

Kon Michiko (b1955)
Boots of shrimps 1992
gelatin silver photograph, ed 12/75,
51.1 x 41.3 cm
Purchased 1995 © Kon Michiko
205.1995

Kon Michiko (b1955)
Mackerel, hairtails and handbag 1992
gelatin silver photograph, ed 7/75,
52.3 x 41 cm
Purchased 1995 © Kon Michiko
207.1995

Through her work Kon plays with the nature of life and death, animate and inanimate, and it is this liminal aspect which evokes both fascination and disgust when we look at these photographs. There is also an element to the work which could be described as fey (we notice that the boot composed of shrimp has roses around its top and that one shrimp has fallen off, or not quite made it onto its elegant host). The slip hanging from the cheap wire coathanger is composed of plants, which resemble tiny limbs and feet. This animation of the undergarment invites feelings which are not appropriate to such an intimate article of clothing. The handbag, rather than being a useful receptacle, is decorated with hooks.

Michiko Kon was born in Kamakura, Kanagawa prefecture. She graduated from Sokei Art School in 1978 and then studied photography at the Tokyo Photographic College until 1980. In 1991 she was the recipient of the KIMURA Ihee Photography Award.

Morimura Yasumasa (b1951)
Slaughter cabinet II 1991
wood, lightbox, gelatin silver photograph, ed 3/3,
58 x 43 x 43 cm
Gift of the Young Friends Committee of the Art
Gallery Society of New South Wales 1996
© Morimura Yasumasa
506.1996

Produced in response to the 1990-91 Gulf
War, this is a rare example of Morimura
commenting directly on politics in his
work. *Slaughter cabinet II* recreates the
events depicted in the photographs of
American photojournalist Eddie Adams,
taking the action to downtown Osaka
where the artist lives. The work is small in
scale for Morimura; although he had
previously made 3-dimensional sculptural
pieces he had not made a work which
was so intimate. In addition, Morimura's
lightbox is set into a domestic Buddhist
shrine – the sort used in Japanese homes
to commemorate the dead. The Adams'
image has become, over time, a
monument to the brutality and suffering
in war. The Morimura work signifies
remembrance in a more personal sense
in relation to war.

Yanagi Miwa (b1967)
Hiroko
from the series 'My grandmothers' 2000
type C photograph, text, ed 3/7, 120 x 144 cm
(photograph), 30 x 36 cm (text)
Purchased with funds provided by Martin Browne,
Jo Braithwaite, Leon Rogan, Erin McCartin,
Patrick Flanagan, Michel Lemaitre, Erick Valls,
Annette Larkin, Chris Bruce, Ildiko Kovacs 2002
© Yanagi Miwa
153.2002.1a&b

'My Grandmothers' is a homage to ageing
and to the diverse dreams and fantasies
of women both now and in the future.
Working with a group of young women
(and some men), Yanagi asked them to
describe and image what they would be
like in 50 years' time. The accompanying
text panels contain the women's stories.
Full of irony and wit, the series is
extremely active and bright in content and
tone. Theatrical and extravagant as many
of these images and stories are, the series
is nonetheless a celebration of creative
and imaginative power. It allows us to
imagine a maternal ancestor who resides
in the future, transgressing time.

Sugimoto Hiroshi (Japan/USA b1948)
Bass Strait, Lockard 1997
gelatin silver photograph, ed 3/25, 42.3 x 64.2 cm
Purchased 1997 © Sugimoto Hiroshi
369.1997

Sugimoto Hiroshi (Japan/USA b1948)
Bass Strait, Table Cape 1997
gelatin silver photograph, ed 3/25, 42.4 x 64.3 cm
Purchased 1997 © Sugimoto Hiroshi
370.1997

The seascapes, taken in as many places on the globe as Sugimoto has been able to travel to, register the unvarying aspect of the horizon always perfectly bisecting the image. However, within each frame the texture of night and day, and the imminent movement of the sea and clouds, is also apparent. Viewing these photographs there is no particular object on which to dwell – instead of looking at an image, we look across a space and into a void.

Sugimoto uses the camera reductively. The long exposures, ongoing series and regular format of all his photographs capture in minute detail the similarities and differences from one frame to another. The artist has said that the series of seascapes are 'remembrances of the photographed past, the first memory when as a child I saw the sea. The more I take pictures the nearer I am to this first memory. The first memory of the first awareness of self.'

VIETNAM & LAOS

One of the earliest and most brilliant cultures of Southeast Asia is the enigmatic Dong Son culture, named after the village of Dong Son in Thanh-hoa province in northern Vietnam. Thought to be the earliest bronze-using civilization in Southeast Asia, Dong Son flourished from roughly the 5th century BCE until it was destroyed by the Chinese Hans in 111 BCE. Dong Son bronzes, most famously its drums, mark the apogee of indigenous Southeast Asian bronze making. Unique in their technique of casting and decorative repertoire, these distinctive bronzes have been found as far south as Indonesia: testament to the extent of intra-regional trade and travel within Southeast Asia in the centuries BCE.

Following the Dong Son period, Vietnam underwent a period of Chinese occupation during the 1st and 2nd centuries CE. It regained its independence until more invasions in 602 and a consolidation of Chinese influence under the subsequent Tang dynasty. The Chinese occupiers were finally expelled in the 11th century, and the Ly (1009–1225) dynasty was established. Both the Ly and subsequent Tran (1225–1400) dynasties witnessed the development of indigenous cultural traditions. It was with the first Ly king that the city of Thang-long (Hanoi) became the Vietnamese capital.

Vietnam was home to the Hinduised kingdom of Champa, named after the Chams, an Austronesian people who ruled coastal, central and southern Vietnam from the early 500s. Much of the Champa legacy survives in the form of stone temple sculptures, and the gallery possesses an exemplary example (see page 299). The kingdom was constantly molested by other peoples, first the Chinese, then the Javanese, the Vietnamese and the Khmer armies but continued until the early 1800s.

Ceramics have survived as the main form of portable material culture from Vietnam's past and hence dominate the gallery's collection. Vietnamese ceramics, made for export as well as consumption by the local elite, range from unpainted wares to monochromes and polychromes, often decorated with motifs and patterns unique to Vietnam. They were traded to Thailand and Burma, as well as to the Philippines and Indonesia where, from the mid 1200s to the 1500s (in pre-Christian and pre-Islamic times) they were status items to be buried with chieftains. Most pieces remained buried until the late 20th century, when they began being excavated from grave sites to satisfy the demands of a growing collectors' market. Of the several blue-and-white export ceramics in the gallery's collection, the most impressive – in terms of rarity, distinctively Vietnamese aesthetic and brushwork – is the lively dragon-shaped ewer (page 302).

Dong Son culture (c400s BCE – c100 CE)
Axe head c200s BCE

bronze, 14.5 x 14.9 cm (blade width)
Goldie Sternberg Purchase Fund for Southeast
Asian Art 1998
94.19985

Finely cast in good-quality dark green
alloy, this axe head is decorated in hollow
relief on both sides. The stylised animal,
fish and bird motifs are typical of the
Dong Son decorative repertoire. On one
side along the edges the stylised shapes
of two confronting crocodiles frame a
squid motif (at the top) and two long-
beaked aquatic birds standing in a fish-
filled pond (bottom). The other side
depicts two confronting dragon-like
animals above two humped bulls and a
man. While similarly shaped battle axes
have been found throughout maritime
Southeast Asia, the quality and elaborate
decoration on this piece indicate it was a
ritual object, probably part of the grave
goods of a community leader.

Dong Son culture (c400s BCE – c100 CE)
Drum 100s BCE

bronze, 41.8 x 70.2 cm
Gift of Dr J L Shellshear 1954
9032

Drums such as this, made by the lost wax
(*cire perdue*) method, have been found at
widely scattered sites throughout
Southeast Asia and South China. Their
purpose remains obscure, although they
were most likely used in rain-making
rituals, a theory endorsed by the frogs on
the circumference of the tympanum – in
Southeast Asia the frog is the rain and
fertility symbol *par excellence.* A wide
variety of concentric bands decorate the
top, although any meaning they may
possess has not been satisfactorily
explained. The only decorative motif
common to all Dong Son drums is the
central 'sun' or 'star' motif, yet it probably
symbolises neither as there was no known
Southeast Asian tradition of representing
the sun or stars with rays in this manner.

Central Vietnam (Champa)
**Vessel in the form of an elephant and
riders** 1200–1300s

bronze, 20.5 x 15 cm
Goldie Sternberg Purchase Fund for Southeast
Asian Art 1998
93.1998

There was probably once a vast repertoire
of zoomorphic bronze utensils such as
this, but because of the Chams' turbulent
history, surviving examples are rare. The
Chams used elephants in battles and
ceremonies, and also supplied elephants
to the Chinese for imperial processions.
This sharply observed piece demonstrates
once again the use of bronze prototypes
for ceramic traditions; the subject is
popular as a ceramic form throughout
mainland Southeast Asia.

Central Vietnam (Champa)
Seated figure of Shiva 800s–900s
buff sandstone, 90 cm
Purchased 2002
279.2002

Champa was one of the earliest Indianised cultures in Southeast Asia. The Chams adopted Shiva as the founder, protector and patron deity of their kingdom. This elegant sculpture of a seated Shiva is distinctly Cham in its stylisation. It depicts the powerful god in a relaxed yet stately posture, seated cross-legged on a stepped pedestal with his bull Nandi kneeling before him. The deity wears elaborate ornaments including a jewelled neckpiece, armbands and a sacred thread in the form of a snake worn across his chest. The three-tiered chignon (*jata*) is typical of images of Shiva. In his left hand he holds a lemon, a symbol of creation. The figure may have been a posthumous portrait of a king. Such images of deities which are also portraits of kings reflect the blending of the religious and the political within the Champa kingdom.

Thanh Hoa region
Ly or Tran dynasty
Covered jar 1100–1300s
stoneware with ivory glaze, inlaid brown vegetal
decoration, 26 x 18 cm (with lid)
Purchased 1986
87.1986

The carved decoration painted with an
iron-oxide glaze against a cream
background is a distinctively Vietnamese
type. Wood ash glaze was applied first
and then the design was created by
scraping away the glaze while still viscous
and applying iron-oxide glaze. Typically
the cream coloured glaze is finely crackled
and flaking. The lid is not the original one
for this jar.

Thanh Hoa region
**Yaozhou style bowl with moulded floral
design** 1100–1200s
stoneware with celadon glaze, 5.8 x 16.6 cm
Gift of Dr John Yu and Dr George Soutter 2002
162.2002

Chinese Yaozhou ware, a dark green
Northern celadon, was the inspiration for
this bowl and many others produced at
this time (but not later). The decoration is
a moulded design of flowers. The five stilt
marks which form a circle in the centre are
typical of this type of ware.

Hanoi region
Dish with fluted cavetto 1300–1400s
stoneware with copper green glaze, 5.2 x 23 cm
Gift of Dr John Yu and Dr George Soutter 2002
159.2002

Hanoi region
Bowl with green glaze 1300s
stoneware with green glaze, 18.2 cm (diameter)
Gift of Mr J Hepburn Myrtle 1986
88.1986

Hanoi region
Bowl with stylised floral decoration
1300–1400s
stoneware with underglaze iron black decoration
and chocolate brown wash on base,
8.1 x 16.5 cm
Gift of Dr John Yu and Dr George Soutter 2002
165.2002

Wares decorated in underglaze iron black
represent a large class of trade ceramics
produced in numerous kilns around the
Hanoi region from the 1300s to 1500s.
Wide-mouthed bowls are the dominant
early export type, as evidenced by the
discovery of similar pieces in Sulawesi.
The decoration on both the bowl and
plate (above left and centre) typically
comprises a running scroll around the rim
and a single full-petalled flower (perhaps
a chrysanthemum) in the centre, all
summarily drawn in underglaze iron black.
Pieces such as these bear comparison
with contemporary Thai ceramics and
there must have been some kind of
relationship between the two countries.
The use of a brown wash on the unglazed
base is a feature unique to Vietnamese
ceramics.

Hanoi region
Plate 1300s
stoneware decorated in iron black, 5.5 x 32 cm
Gift of Anthony Odillo Maher 1998
10.1998

Hanoi region
Stem bowl with landscape scene c1400
stoneware with underglaze blue decoration,
8.3 cm
Gift of Mr J Hepburn Myrtle 1986
89.1986

Hanoi region
Covered box with design of landscape
1400s
stoneware with underglaze blue decoration,
5 x 6.5 cm
Gift of Anthony Odillo Maher 1998
11.1998.1-2

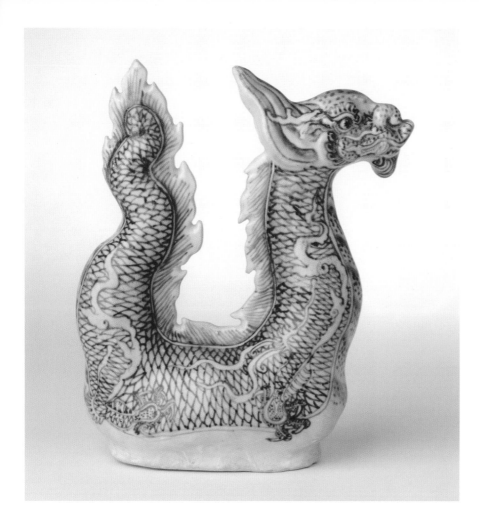

Hanoi region
Dragon ewer 1400s
porcelain, moulded, with underglaze blue
decoration, 22.7 x 17 x 7.8 cm
Purchased 2000
523.2000

Associated with the aquatic aspects of creation, dragons are central themes in Vietnamese cosmology and it was believed that fish of great age transformed themselves into dragons capable of flight. The Ly dynasty named its capital Thang Long or 'rising dragon'. The dragon has a ubiquitous presence on Vietnamese ceramics, where it appears painted in underglaze blue, applied as unglazed relief decoration and, less commonly, in moulded shapes as on this fantastic pouring vessel.

The ewer has been made from a two-piece mould with the parts luted together along a vertical seam with the dragon details realised with spirited brushwork. It was part of the important Hoi An hoard of over 150 000 ceramics, the cargo of a sunken ship found near the historic port of Hoi An near Da Nang in Vietnam and brought to public attention through controlled excavations carried out from 1997 to 1999. Interestingly a similar dragon vessel was documented (in a 1979 Oriental Ceramic Society of Hong Kong catalogue) as having been excavated with a fine gold chain around its neck from a grave on the southern coast of the Indonesian island of Sulawesi in 1972.

Hanoi region
Large dish with crane, pine and bamboo medallion 1400s
stoneware with underglaze blue decoration, 8 x 38 cm
Purchased 1991, ex Brake-Lau-Eckermann collection
7.1991

The gallery has several of the characteristic large, shallow underglaze blue-decorated dishes made specifically for export to mainland and maritime Southeast Asia. The Vietnamese equivalents of Chinese prototypes, their main market was Indonesia, where they were heaped with food in communal feasts and have been preserved as family heirlooms. This fine example decorated with a crane, pine and bamboo was acquired from the sale of the Brake-Lau-Eckermann collection. The late Brian Brake was a member of the exclusive Magnum group of photographers, and built up his collection on various assignments through Asia.

Hanoi region
Dish with design of two waterbirds 1400s
stoneware with underglaze blue decoration, 34 cm (diameter)
Asian Collection Benefactors' Fund 2003
108.2003

Covered box c1900

tortoiseshell, mother-of-pearl, lacquer, gold leaf
and silver, 10.3 x 25 cm
Edward and Goldie Sternberg Fund for Southeast
Asian Art 1992
264.1992.a-c

This box and its various compartments
held all the implements and ingredients
required for the hospitable gesture of
preparing and offering the betel nut
concoction popular in many Southeast
Asian countries. The box is skilfully inlaid
with mother-of-pearl, which has been
expertly shaped to fully exploit the
glowing tones of opalescent pink and
blue-green that can be elicited from the
shell by a careful artisan. The scene on
the cover, as well as the floral sprays
around the sides, are Chinese in taste,
and the piece could well have been made
for use within the imperial court at Hue,
the 19th-century capital of the last royal
dynasty in Vietnam, the Nguyen dynasty
(1802–1945).

Hanoi region
Dish with stylised floral decoration
1500s

stoneware with underglaze blue decoration,
chocolate brown wash on base, 5.3 x 22.3 cm
(irregular)
Gift of Dr John Yu and Dr George Soutter 2002
160.2002

Hanoi region
Dish with stylised floral decoration
1500s

stoneware with underglaze cobalt blue decoration,
chocolate brown wash on base, 5.5 x 24 cm
Gift of Dr John Yu and Dr George Soutter 2002
161.2002

Hanoi region
Dish with central lotus spray 1500s
stoneware with underglaze blue decoration,
37 cm (diameter)
Purchased 1969
EC1.1969

Hanoi region (?)
Large charger c1700
stoneware with underglaze blue decoration,
9.5 x 37 cm
Gift of Mr F Storch 1988
193.1988

LAOS

Laos is a country inhabited by Tai speakers (a linguistic group spread throughout mainland Southeast Asia). To date no written records of Laos predate the Lan Xang kingdom (1353–1707), which provided Laos with its 'golden age'. The capital, originally at Muong Swa (Luang Prabang), was moved to Vientiane in 1560 to avoid Burmese domination. After the downfall of the Lan Xang kingdom, the country was divided into various kingdoms until 1805, when the Siamese enthroned Prince Chao Anou. Anou subsequently captured and burnt Vientiane and the city was not rebuilt until 1895, when the French replaced the Siamese as its rulers. The French established a figure-head king at Luang Prabang and Laos remained part of French Indo-China until it achieved independence in 1953. The Lao People's Democratic Republic was established in 1975.

As in so many Southeast Asian cultures, textiles play an integral role in social relationships and ceremonies, and it is through textiles that the artistic language of the Laotians has been most widely preserved. Textiles were used in ancestor and spirit worship rites as well as Buddhist festivals, while clothing has been an important marker of both the weaver's artistry and the wearer's origins and status. Symbols still found on today's textiles resemble the decoration of Dong Son bronze artefacts and Indonesian textiles.

Laos/Cambodia
Wine jar 1100–1200s
stoneware with dark glaze, 64.5 x 46 cm
D G Wilson Bequest Fund 2001
157.2001

Jars like this were used in Laos at festivals or celebratory events, such as the rice harvest. Celebrants sat around the jar drinking a sweet, spicy rice wine (*ruon*) through curved reeds (*can*). The jar is typical of a type of large ceramic wine or storage vessel produced in the so-called Angkorean region of Southeast Asia, which at its zenith extended from Cambodia to southern Laos and across to northeastern Thailand. Since such vessels were produced for domestic use and not as articles of trade, they are rarely found outside Southeast Asia. Characteristically, they were heavily potted with a tall oval body, sloping shoulders decorated with pinched lugs and a narrow mouth.

Northern Laos, Tai Nuea people
(detail) Ceremonial skirt *pha sin* c1920
silk, cotton, natural dyes, weft ikat with
supplementary weft weave, 143 x 74 cm
Gift of Nomadic Rug Traders 2003
221.2003

This elaborate *sin,* or ceremonial
skirtcloth, is one of the finest textiles worn
by the Tai Nuea women of northern Laos.
Typically these cloths are made of
alternating bands of red silk with
supplementary weft decoration, indigo-
dyed cotton weft ikat and red-dyed silk
weft ikat. The sections of indigo-dyed
cotton refer to an archaic tradition where
handspun cotton was used to best bring
out the vibrant colour of the dye. This
intricately woven and dyed cloth is
decorated with the traditional *naga*, or *nak*
(snake/dragon), motif in both the indigo
and silk ikat panels.

CAMBODIA

The indigenous societies of Southeast Asia have a rich and diverse heritage of local traditions. In various degrees these have interacted with each other and with the great civilizations of India and China, whose traditions and culture were introduced by missionaries, traders and, in the case of Vietnam, invasions. While China was the dominant influence on Vietnam's culture (with the exception of the Hinduised state of Champa), in Cambodia the influence came primarily from India. The first of several revolutionary 'Indianising' changes to sweep through Cambodia occurred at the beginning of the Common Era and provided Cambodia with Hinduism, Buddhism, the Sanskrit language and the idea of universal kingship. Cambodia's history has been further tempered by its location between Vietnam and Thailand.

The history of Cambodia is often considered in three major periods: the pre-Angkor period, from the beginnings of Indianisation to c800 CE; the Angkor period, from the 800s to 1431; and a post-Angkor period, dating from the city's final abandonment about 1431 as a consequence of sustained attacks from Thailand. Much of Cambodia's surviving cultural heritage is in the form of stone and metal iconic and architectural pieces from the Angkor period and earlier. The relative paucity of objects from the post-Angkor period is due to the change to wood from stone as the primary medium of construction.

From the early period of Cambodian history, the gallery has a fine stone *linga*, a most appropriate emblem for this era since the stream of Hindu worship that dominated Cambodia was Shaivism, the worship of the god Shiva. While Shiva is often represented by the *linga*, the dominance of this form in Cambodia is thought linked to the merging of Shaivism with pre-existing cults of ancestor and mountain worship.

During pre-Angkorean times, the modern Vietnamese village of Oc-Eo is thought to have been a major port for traders and pilgrims moving between India and China, and the gateway through which Indian influences entered Cambodia. Oc-Eo may even have been the centre of an earlier principality identified by Chinese sources as Funan and considered by some to be the first historical period of Cambodia. However there are too few references or records to ascertain any early Cambodian history prior to the emergence of the magnificent and famous Angkorean period, when Cambodia was the mightiest kingdom in Southeast Asia. As with so much of early Cambodian history, our knowledge comes from surviving incised inscriptions found at different sites around the country.

It is an inscription that tells us that in 802 the monarch Jayavarman II, the founder of the Angkor empire, participated in ceremonies celebrating the cult of the *devaraja* (a Sanskrit term that translates as 'god king'). Belief in the *devaraja* system was the

foundation of the Angkor kings' power, and resulted in the building of 'temple-mountains', and the commissioning of portrait sculptures that constitute a high point of Cambodia's cultural heritage.

From the 900s to the 1100s the Angkor kings enjoyed a golden age during which they built huge cities and temple complexes, of which the most famous is Angkor Wat. This magnificent temple complex took decades to build, and construction continued even after its dedication in July 1131. Most of the kings who ruled Angkorean Cambodia were followers of Shiva, yet the king who commissioned Angkor Wat was devoted to Vishnu.

Other kings followed Mahayana Buddhism, most notably Jayavarman VII. The greatest Khmer king of all, he ruled in the late 1100s, when the Khmer empire was at it most extensive. Jayavarman VII's reign is known as the Bayon period after the magnificent state temple of Bayon that he had built. Incidentally, depicted on the temple walls is Jayavarman's defeat of the Chams in 1178, after which he ascended the throne.

Theravada Buddhism swept through Cambodia in the 1200s, although the reasons for the widespread conversion remain unclear. So too do the reasons for the evacuation of Angkor sometime in the 1440s and the removal of the capital to Phnom Penh. The Thai invasions of Angkor (the most important of which occurred in 1431) along with Cambodia's shift to a trading kingdom and its resulting need for sea access, which Phnom Penh provided, may have played a part.

As a result of constant civil war and invasion from Siam and Vietnam, there remains scant documentation of Cambodia's history from the 1300s to the 1800s, and little material culture. Those objects which have survived Cambodia's turbulent history speak of an individual aesthetic. For example, on stone and bronze can be seen ornate layers of baroque swirls and bursting foliage, as demonstrated in the small palanquin hook (page 312). Moreover, the beauty of the brown glazed Khmer pots is unrivalled in their simplicity, formality and minimal decoration, while the silk textiles are exceptional for their complex patterns and rich, deep colours. The gallery's nascent collection of Khmer art is a starting point for appreciating the magnificent heritage of Cambodia.

Mukha-linga 600s–700s
stone, 64 cm
Purchased 1996
477.1996

The *linga*, the most sacred form of the
powerful god Shiva, is composed of three
parts: the square lower section, usually
embedded in the earth, is associated with
Brahma, the Creator; the hexagonal mid-
section, embedded within a seat or plinth
known as the *yoni,* is associated with
Vishnu, the Preserver; and the domed,
cylindrical upper section is associated
with Shiva, the Destroyer. This tripartite
form symbolises the principle of
transmigration (*samsara*): that all living
beings are thought to exist within an
eternal cycle of creation, preservation and
dissolution, which continues throughout
eternity.

This piece attests to the importance of
Shaivism in Southeast Asia, where Shiva
was the tutelary deity (*ishtadevata*) of
Jayavarman II, who in 802 CE established
the Khmer empire. The *linga* became the
sacred icon of Jayavarman II's kingdom
and through the cult of *linga* worship
consolidated the notion of the king as a
devaraja ('god-king').

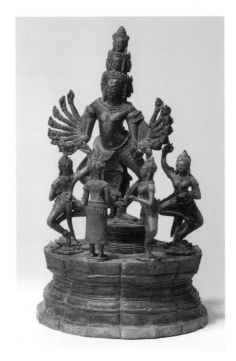

Palanquin hook 1100s
bronze, 18.9 x 10.8 x 6.3 cm
D G Wilson Bequest Fund 2000
6.2000

This 'j-shaped' palanquin hook depicts a
dwarf, or *gana,* riding a *naga,* or snake
deity, and supporting the mythical bird
Garuda on his shoulders. This highly
stylised object is intricately crafted yet
functional: it would have hung from the
pole end of a palanquin (carriage). It is
possible to reconstruct how such a piece
may have been used by reference to the
bas-reliefs at Angkor Wat, the Bayon and
other temples where various procession
scenes depict similar pieces in use on
palanquins. The ornate, deeply incised
and energetic surface decoration coupled
with the vigorous projections convey the
imminent explosion of a barely contained
energy. Similar tension and fecundity is
seen in stone architectural decoration and
is characteristic of Khmer taste.

Hevajra mandala 1100–1200s
bronze, 39 cm (height overall), 29.7 cm (Hevajra
figure), 9 x 23.5 cm (base), 13-15 cm approx
(six dakini figures)
Edward and Goldie Sternberg Southeast Asian
Art Purchase Fund 2001
1.2001

The Tantric Buddhist cult flourished in
Cambodia between the 900s and 1200s,
only to disappear with the collapse of the
Angkor empire. This work is a three-
dimensional mandala (or cosmic diagram)
of the central deity Hevajra, who often
served as a focal figure for meditation.
It is a superb example of the articulation
of complex belief systems. The base is
in the shape of an eight-petalled lotus
with Hevajra in the centre surrounded
by six dancing figures and one erect
figure offering lotus buds. Most Hevajra
mandalas have eight dancing *dakinis*,
minor female divinities in Tantric
Buddhism, one for each of the eight
quarters, but here some are missing. The
most important source of our knowledge
of the Hevajra cult is the *Hevajratantra*,
which lists the *dakinis* and their attributes.

Typically the main Hevajra figure has
16 arms fanned out like wings and eight
heads arranged on three levels in the
order of three, four and one at the top.
The uppermost head represents
Vairochana, the most important of the
Five Cosmic Buddhas. The four heads
below represent the other four Cosmic
Buddhas, each of whom presides over a
specific direction: Akshobhya to the east,
Ratnasambhava to the south, Amitabha
to the west and Amoghasiddhi to the
north. The hands each hold the correct
attributes as ascribed to Hevajra by the
Tantric texts. Hevajra's frenetic dance
symbolises the dynamics of the process
of Enlightenment, which includes
trampling underfoot the four chief evils,
personified here by a four-headed
prostrate figure. While other figures of
Hevajra survive, to find a mandala form
with *dakinis* intact is rare.

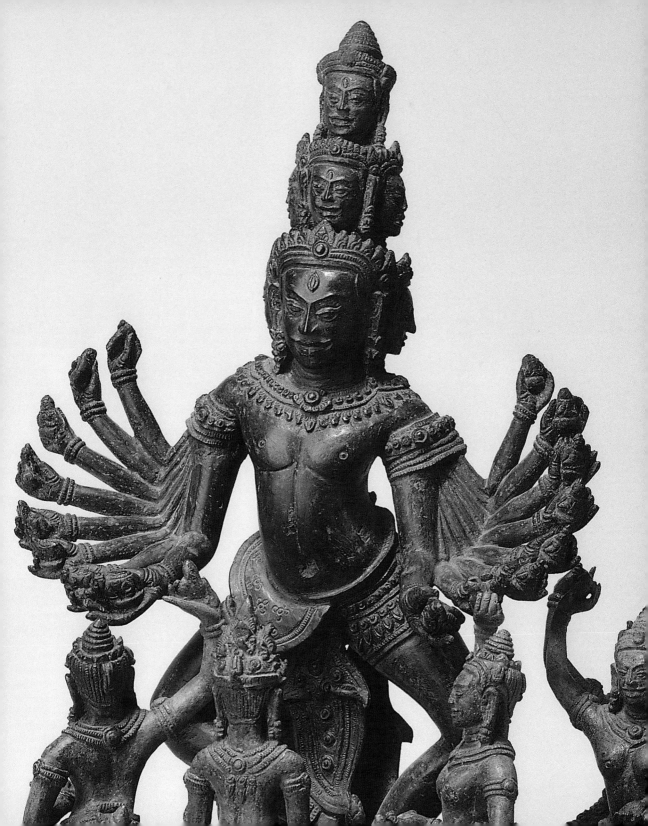

Angkor region, Koh Ker
Guardian lion c1000 CE
stone, 84 x 67 cm

Purchased 1987 with funds provided by
Mr F Storch and Ross H Adair, T R W Allen, Carl
Berkeley, Bruce R Bockmann, Madeleine Boulden,
Jaonna Capon, Graham M Cole, S M Gazal,
Bruce C Hudson, Rodney T Hudspeth, Daryl Isles,
J G Jagelman, N Jeffreson, Michael Magnus, D A
M McCathie, Rosalind O'Connor, Lesley Pockley,
G & E Sternberg, Robert Whyte, Ken Youdale
443.1987

Throughout the golden age of the Angkor
period, the kings built huge cities and
temple complexes symbolic of their power
and divinity. One of these capitals was
created in 921 by King Jayavarman IV at
Koh Ker, about 65 km from Angkor. This
standing guardian lion has come from
there. Such lions were placed on terraces
and stairways to guard the central
pyramidal structure that represented
Mount Meru, the residence of the gods at
the centre of the Hindu world. Lions were
not native to Cambodia and the Khmer
sculptors devised their own fanciful
interpretations. The characteristic full,
frontal pose and upright stance lend the
figure a composed regal air, while the
elaborately carved demonic head and
patterned chest shows the Javanese
influence so important in Khmer culture.

Bayon period (late 1100s–1200s)
Head of the Buddha 1000s–1100s
stone, 30.4 cm
Purchased 1967
EV3.1967

Bayon period (late 1100s–1200s)
Figure of a deified male 1200s
stone, 94 cm
Purchased with the assistance of funds provided
by S M Gazal, Mrs M Gowing, Bruce C Hudson,
Mr and Mrs D Isles, J G Jagelman, Mr and Mrs
A Morris, Mrs Kerry Packer, G & E Sternberg,
Mr F Storch
398.1988

The figure is most likely a Buddhist deity
since Buddhism had supplanted Hinduism
within the Khmer empire by the late
1100s. The Khmer influence is seen in the
frontality of the figure, the emphasis on
volume in the modelling and in the
clothing, in particular the short dhoti with
fish-tail pleat at the front and the wide belt
decorated with incised rosette motifs.

Kulen ware covered pedestal jar c1100s
stoneware with crackled pale green glaze, 14 cm
(with lid), 11 cm (diameter)
Bequest of Alex Biancardi 2000
39.2000.a-b

The formality and measured ornateness
of this jar in the shape of a lotus bud
suggests its purpose was ceremonial or
funerary.

Three Kulen ware bowls 1100s
stoneware with pale green glaze, 8.5 x 12.3 cm
stoneware with small brown spots, 8.5 x 16 cm
stoneware with large iron brown spots,
7 x 15.7 cm
Gifts of Mr F Storch 1994
364.1994, 365.1994, 366.1994

**Kulen ware covered jar with incised
lotus petal design on cover** c1100s
stoneware with green glaze, 14.9 x 10.6 cm
D G Wilson Bequest Fund 2000
7.2000.a-b

Vase 1100s
stoneware with brown glaze, 35 cm
Purchased 1981
254.1981

Khmer ceramics are unique in the Asian
ceramic tradition and reflect an
indigenous culture free of other influences.
Unlike other Southeast Asian ceramics,
the Khmer products were made solely for
local use and not for export.
Fundamentally a peasant pottery, the
wares were not used by the wealthy due
to the fierce competition offered by the
technically superior, imported Chinese
celadons and porcelains. Many of the
pieces have a sculptural presence and
serenity comparable to Khmer sculpture.
This vase would have been a temple
fitting, used for holding lotus blossoms in
Buddhist ceremonies.

Bottle in anthropomorphic shape 1100s
stoneware with brown glaze, 26 cm (with lid)
Gift of Mr F Storch 1981
314.1981

The iconography of this rare covered jar
may refer to a meditating sage, or *rishi*,
one of the wandering ascetics associated
with Hinduism and distinguished by
their beards. The form may be that of
a mountain, abstracted and translated
into the Khmer ceramic idiom. Since
mountains were considered the abode
of the gods and a place of retreat, they
were favourite haunts of ascetics. It is
unclear whether this vessel had a specific
function: it may be a funerary urn or a holy
water jar, or something for everyday use.
Although one of the finest examples of
this type of Khmer jar, it is still covered in
the technically flawed but characteristic
smooth, brown glaze that easily flakes.

Elephant shaped jar 1000–1100s
stoneware with dark brown glaze to lower body,
legs unglazed, 21 cm
Purchased 1981
156.1981

In Khmer society the elephant was used
both as a working animal and in ritual
processions, when it was adorned and
caparisoned as here. This jar could be an
exceptionally large example of the diverse
class of pots used to contain lime paste,
which was mixed with shavings of the
hard areca nut and smeared on *piper
betle* leaves. (The abundance of lime pots
attests to the popular addiction to betel
leaf chewing, which played an important
social role through the vast area stretching
from India to the Pacific.) This large jar
exemplifies the popularity of zoomorphic
vessels in the Khmer repertoire.

(detail) Ceremonial cloth *sampot rbauk* c1860

silk and dyes, supplementary weft design,
310 x 92 cm
Gift of Nomadic Rug Traders 2003
Provenance: Royal Palace of Phnom Penh
230.2003

This richly decorated supplementary weft textile is modelled on Indian brocade cloths, but instead of using a gold-wrapped thread for the brocade as is the Indian technique, a yellow or gold coloured supplementary weft thread has been used to achieve the rich effect. The complex and intricate design suggests that it was made for ceremonial use. The colours – with green warp and red weft to give a shot effect – suggest an association with the planetary gods Rahu and Ketu, the ascending and descending nodes of the moon. These gods are associated with Wednesday and so this cloth would have been used for ceremonial occasions held on Wednesdays.

(detail) Ceremonial skirtcloth *sampot chawng kbun* c1900

silk and natural dyes, twill weave, weft ikat,
296 x 89 cm
Gift of Nomadic Rug Traders 2003
232.2003

This Khmer weft ikat textile is less finely worked and intricate than the example to the right, however it is interesting for its clever all-over diamond and swastika design. The end borders are decorated with a pattern of alternating *yantra* and bird in a design reminiscent of Indian textile patterns.

(details) Ceremonial skirtcloth *sampot chawng kbun* c1900

silk and natural dyes, twill weave, weft ikat,
307 x 90 cm
Purchased 2003
119.2003

The design and structure of the ikat skirtcloth above and right suggest the influence of Indian blockprinted trade cloths, which originated from the Coromandel Coast. The body of the cloth is dyed in a delicate flower and trellis design, while the ends are decorated in three registers of a protective *yantra* design. The intricate pattern suggests that the cloth was made for Thai taste during a period when Cambodia came under Thai rule. Generally silk cloths such as this were not worn by Thai royalty, who preferred to wear cotton, but were used in gift exchanges among aristocratic groups. This practice continued until the mid 1800s.

THAILAND

Two potent forces have shaped, and continue to shape, Thai art and culture: the monarchy and Theravada Buddhism (today over 90% of Thai people are Buddhist). From the time of the earliest missionaries around the 5th century CE, Buddhism has permeated Thai life and provided a unity of thought and artistic activity that persists today. For centuries the inspiration for painting, sculpture and architecture has been predominantly Buddhist, and indeed the images synonymous with Thailand are ones of golden, smiling Buddhas, celestial beings and elegantly upturned temple eaves. Buddhist imagery is everywhere, even providing the decorative vocabulary for functional objects. The Thais are only one of many ethnic groups in Thailand (called Siam until World War II). It is the only Southeast Asian country not to have been occupied by a colonial power.

Bronze and clay artefacts, excavated at the village of Ban Chiang in northeast Thailand from 1967, provide evidence of settlement before the introduction of Buddhism. Dating back to around 1500 BCE, these artefacts were created by one of the various ethnic groups that settled in Thailand in ancient times. By the early centuries CE Indian merchants were traversing Thailand's northern region as well as the peninsula, which served as a base for Indian merchants trading with China and Southeast Asia. These merchants brought Indian culture: literature, language and the religions of Hinduism and Buddhism. The period of absorption of Indian culture lasted roughly from the 3rd to 5th centuries.

The Mon speaking peoples flourished throughout central, eastern and peninsula Thailand from the 400s to the 700s, and created the most familiar of Thailand's early kingdoms, Dvaravati. Known from Chinese writings by the 600s, Dvaravati lasted until the 11th century, when it was conquered by the westward expansion of the Khmer empire. Under the rule of the powerful Khmers, Khmer artistic idioms were universally adopted into the Thai vocabulary.

Another important early state was Srivijaya. By virtue of its coastal ports, Srivijaya had control of east-west trade and became economically and politically the most powerful in the region by the late 700s. Moreover, as a result of its direct contacts with India, it was instrumental in the spread of Buddhism into Thailand. The site of the Srivijaya capital is uncertain, but it may well have been near Palembang in Sulawesi. Since its ruling house was related by marriage to that of Central Java, Javanese cultural and artistic influences also entered the vocabulary of Thailand. But war with the powerful south Indian Cholas in the 11th century weakened Srivijaya and it gradually declined.

The Thai nation was established when a federation of neighbouring kingdoms in central Thailand was formed

to create the kingdom of Sukhothai in the 1200s. Simultaneously with the establishment of the Thai capital at Sukhothai, the north was united into the Lanna kingdom, with its capital at Chiang-Mai. The Sukhothai period was relatively short-lived (1200s–1400s), but its second king Ramkamhaeng is one of the great figures of Thai history, credited with many innovations including the adoption of the Khmer alphabet into the Thai language. The bronze Buddhist sculptures of Sukhothai are considered the apogee of Thai artistic endeavour, and are universally admired as a totally original expression of the Buddha image.

The Sukhothai kingdom is also distinguished by its florescence of ceramic creativity. Some wares were produced at kilns close to the city of Sukhothai, but another larger class of wares known as Sawankhalok were produced at kilns centred around the city of Si Satchanalai, north of Bangkok. There was a large export trade in these ceramics, which have been found throughout Southeast Asia, often as burial goods along with Chinese and Vietnamese ceramics.

The wares produced at the numerous kilns (not all of which have yet been identified) of the Lanna kingdoms, which dominated the northern region between Burma and Laos, are less well known than those of Sukhothai and Sawankhalok. The gallery has some fine examples of these northern wares: for example a tall, round jar from the Sankampaeng kilns in a district east of Chiang Mai in which a prosperous silk and cotton weaving town of the same name is located; a Paan ware dish with a simple, incised linear design under a celadon glaze in the slightly yellowish-green colour of young rice; and a Kalong ware dish with its distinctive, bold, black and cream design. Northern wares such as these only came to public attention in 1984, when a major archaeological find at Tak near the Burmese border unearthed numerous burial sites crammed with Chinese, Vietnamese and northern Thai ceramics.

In 1438 Sukhothai was sacked by Ayuthaya, which had been founded to the south in 1350. The Burmese conquered Lanna in 1558 and it was to remain their territory until the late 1700s. The Burmese then attacked Ayuthaya, which repelled them in the 1590s. Ayuthaya went on to enjoy nearly two centuries of peace as the capital of Thailand, becoming a major trading centre and one of the great cities of the world. However in 1767 the Burmese struck again, completely destroying Ayuthaya. The remnants of the population moved down river to Thon Buri and in 1782 to Bangkok, which has been the capital ever since.

BAN CHIANG WARE

Used as grave goods, Ban Chiang ceramics were discovered in burials along with bronze and iron artefacts and personal adornments such as glass beads. Through what now appears to have been erroneous dating methods, the Ban Chiang bronzes and ceramics were dated to 3600 BCE. This would have meant that bronze technology, and hence civilization, began in Thailand and not in Western Asia as previously thought. Widely publicised in *Time* magazine in 1976, the pots gained instant fame as proof of the earliest civilization in the world. However subsequent testing has given an average date of the 2nd century BCE. Similar dates have been given to stylistically related artefacts found at Cambodian and Vietnamese (Dong Son) sites, re-iterating the inter-connectedness of early settlements in mainland Southeast Asia. The black wares are an exception: thermoluminescence testing indicates they are much older, dating to around 1500 BCE.

Northeast Thailand, Udon Thani province
Group of Ban Chiang wares

from left:
Jar c100
earthenware with red painted decoration, 20.3 cm
Gift of the Art Gallery Society of New South Wales 1973
15.1973

Pedestal bowl with painted decoration c100
earthenware with red painted decoration, 28.5 x 19.8 cm
Gift of Dr Peter Elliott 1980
42.1980

Storage pot c100
earthenware with red painted decoration, 25.5 x 28 cm
Purchased 1974
147.1974

Vessel c1400 BCE
black earthenware with incised decoration, 26 cm
Gift of Dr Peter Elliott 1982
64.1992

Vessel c1550 BCE
black earthenware with incised decoration, 18.3 x 19.2 cm
Gift of Mr F Storch 1981
41.1981

Thermoluminiscence (TL) testing has dated this jar to around 1550 BCE.

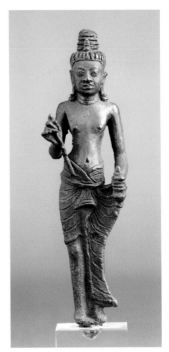

Peninsula Thailand
Standing Buddha c500s
bronze, 28 cm
Bequest of Alex Biancardi 2000
41.2000

This early Buddha figure is interesting for its strongly modelled robe, which reflects the stylistic fusion of early Buddhist South and Southeast Asian images. The piece is cast in the south Indian style of the Nagapattinam school (Nagapattinam was a port town in Tamil Nadu in south India and a renowned Buddhist pilgrimage centre from early times). In this style, the robe is worn as seen here: the right shoulder bare, the robe falling in heavy folds, finishing short of the hem of the undergarment. On the left, the folds of the robe fall in wavy lines to the Buddha's ankles, while he gathers the edges of his garment in his left hand.

Srivijaya period (700–1200s)
Avalokiteshvara 800s
copper alloy, 10 cm
Bequest of Alex Biancardi 2000
4.2000

The high headdress (*jatakamukuta*) containing an image of the Buddha Amitabha identifies this figure as the bodhisattva Avalokiteshvara. Together with the long dhoti, with vertical folds in the middle and a cloth belt tied into a knot either side of the body, this denotes the influence of the Pallava school from southern India. The piece is attributed to the Srivijaya culture, which dominated parts of Indonesia and Peninsula Thailand from the 600s to 1200s.

Buriam province, Prakon Chai
Figure of Maitreya 700s
bronze alloy, 10 cm
David Wilson Bequest Fund 1999
131.1999

Carried in the robes of travellers and pilgrims, it is small figures such as this that have survived the vagaries of turbulent histories. This unassuming figure of the Future Buddha Maitreya (identified by the stupa in his headdress) carries a lotus bud in his right hand and the end of his robe in his left.

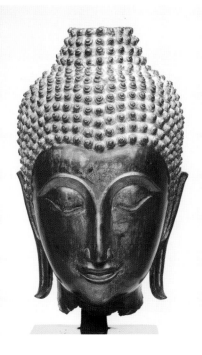

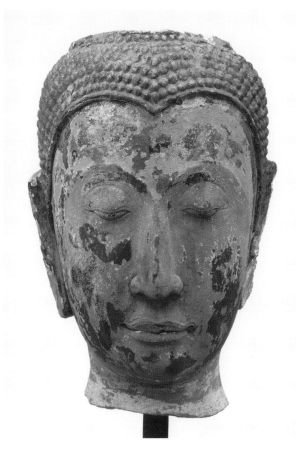

Sukhothai period (1200–1400)
Head of a Buddha 1300s
bronze, 26 cm
Watson Bequest Fund 1963
EV1.1963

All Buddhist statuary is governed by strict and well-defined canons of Buddhist iconography. No liberties or personal whims on the part of a sculptor can be tolerated. This elegantly shaped head of the Buddha follows exactly the prescriptions set down in the Pali canon: 'The shape of the head is like an egg; the chin like a mango stone; the nose is like a parrot's beak and the eyebrows like drawn bows. The curls of the hair are like the stings of scorpions'. In reverting to original Pali texts for guidance, Sukhothai artists succeeded in creating a unique and easily recognisable style of which this head is an excellent example. It is missing the flame that once topped the protuberance (*ushnisha*) on top of his head – since the flame was cast separately, it is often missing from Sukhothai buddhas.

Thai bronzes were made by the 'lost wax' method in which a wax mixture was applied to a modelled clay core, etched with the desired features, and covered with a thick layer of clay. The entire piece was then baked in a kiln, causing the wax to melt and run out. After cooling, the clay mould was filled with molten bronze, which occupied the areas vacated by the melted wax. When the bronze had hardened, the mould was broken away and discarded.

Ayuthaya period (1350–1767)
Head of a Buddha 1300–1400s
sandstone with traces of lacquer, 60.4 x 44 cm
Gift of Mr F Storch 2000
136.2000

This exceptionally large head, once glowing with a coating of gold lacquer, belonged to a figure at least 15 metres high. The piece dates stylistically to the Ayuthaya period, when Buddha images drew on the Sukhothai heritage but exaggerated features to create a face distinguished by its oval shape, arched eyebrows and pointed nose. Other features of the Ayuthaya style are the small hair curls and the clear band separating the forehead from the head.

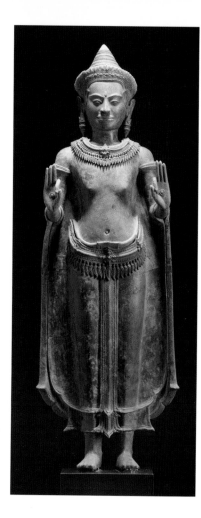

Lopburi or northwest Thailand
Standing crowned Buddha late 1100s
bronze, 86.4 cm
Gift of the Art Gallery Society 2002
156.2002

This imposing bronze Buddha holds both hands upright in the gesture of reassurance, known as *vitarka mudra* (the holding of both hands in this same *mudra* is unique to Khmer and Thai bronzes). A wheel motif – one of the 32 marks, or *lakshana,* that distinguish a Buddha – is ascribed on each palm. Other distinguishing marks include the spiral between the eyebrows (*urna*) and the protuberance on top of the head (*ushnisha),* which symbolises the Buddha's extraordinary abilities and wisdom.

Confident in the spiritual power he embodies, the Buddha emanates a serene assurance. Crowned with a diadem and richly adorned with an elaborate neckpiece, armbands, a jewelled girdle and heavy drop earrings emblematic of Khmer royalty, the Buddha wears transparent monk's robes that reveal his smooth form. His clothing alone defines the paradox of Buddha: he is at once World Ruler (symbolised by his crown), and World Renouncer (symbolised by the humble robes of a monk). This Buddha

may have been created around what is now the town of Lopburi in Thailand. In the early 1100s this area was part of the magnificent Khmer empire, which has left Angkor Wat as its most enduring architectural monument. The sculpture has been finely cast in several pieces. Originally it would have had an accompanying aureole that made it an impressive altarpiece. It has a large rectangular hole in the back, which is quite unusual and indicates that it was made in a Thai workshop rather than a Khmer one.

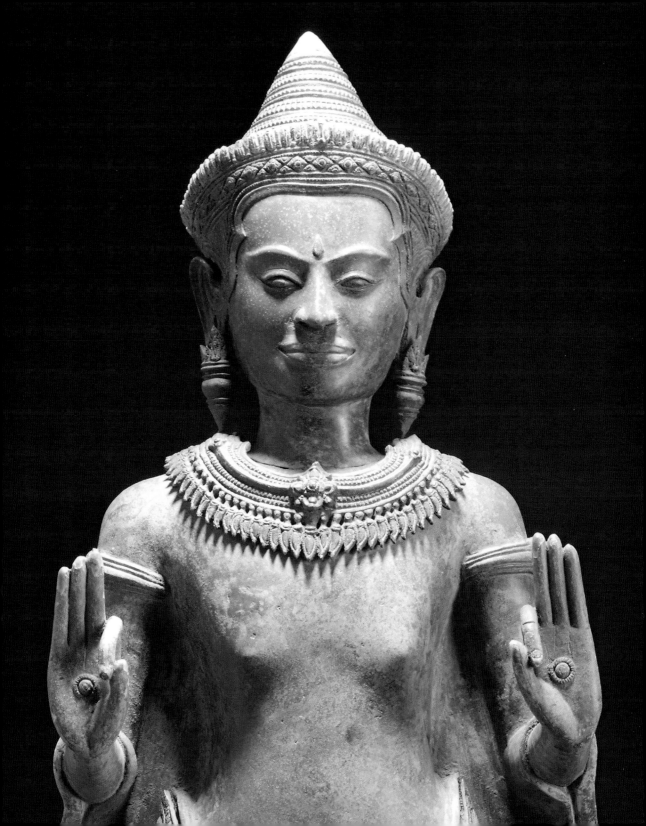

SAWANKHALOK WARES

Sawankhalok kilns produced an astonishingly wide variety of wares ranging from large water jars and architectural ornaments to tiles, ewers, *kendis,* dishes, jarlets and miniature figures. Sawankhalok wares can be divided into several categories on the basis of their decoration: the largest category is the underglaze black decorated wares, of which there are examples in the collection. Typical of the ware is the medium grey, black speckled body, and the compartmentalised patterns of geometric and vegetal motifs. The most common shape is the covered box, which may be indebted to Indian metal reliquary boxes. Sawankhalok wares were widely traded throughout Southeast Asia, and examples have been found in burial sites at Angkor and throughout the Philippines and Indonesia.

Dish with single flower motif 1300s
stoneware with pale celadon glaze and underglaze iron decoration, 6.5 x 26 cm
Gift of Mr F Storch 1988
195.1988

Jar 1400s
stoneware, 14.7 cm
Gift of Mr F Storch 1981
44.1981

This pot is typical of the large class of functional, domestic unglazed stonewares made in the Sawankhalok kilns. It was produced at Ban Ko Noi village, located about 6 km north of the old city of Sawankhalok. Ongoing archaeological research indicates there were hundreds of kilns around Ban Ko Noi, making it a major production centre for Sawankhalok wares. The decorative applied whorl motif is a purely Thai motif that can be traced back to the incised designs on bronze artefacts found at the ancient site of Ban Chiang.

Covered box 1400s
stoneware with underglaze iron-black decoration, 16.5 x 15 cm
Purchased 1968
EC4.1968

Covered bowl 1400–1500s
stoneware with underglaze iron-black decoration, 11.6 x 20.9 (bowl), 10 x 21cm (lid)
Purchased 1991
4.1991

Kendi early 1500s
stoneware with underglaze iron black decoration, 14.1 cm
Gift of Anthony Odillo Maher 1998
7.1998

Figure of kneeling woman 1400s
stoneware with underglaze iron-brown decoration,
7.2 cm
Purchased 1989
88.1989

Waterpot in the form of a puff fish
1400s
stoneware with underglaze iron-brown decoration,
5.4 cm
Gift of Mr F Storch 1987
444.1987

The shapes of these two pieces are
unknown in the underglaze black
repertoire, but found in the so-called
'brown and pearl' wares. These
characteristically small examples are a
waterdropper in the form of a blowfish,
and an incense holder in the form of a
kneeling woman. Miniature wares are a
hallmark of Sawankhalok, and not found
in the more limited Sukhothai repertoire.

Jar 1300s
celadon, 14 x 19 cm
Purchased 1967
EC6.1967

Two-handled jar 1300–1400s
celadon, 14.3 cm
Purchased 1991
5.1991

Deep circular bowl 1400s
celadon, 31 cm (diameter)
Purchased 1991
6.1991

Huge quantities of Thai celadons were
made for the export market. Pieces similar
to these have been found throughout
Indonesia, from Aceh in the northwest to
Sumatra, Java and Bali.

SUKHOTHAI WARES

Dishes such as these, with a central single fish motif and water weed on a plain slip background, are found all over Southeast Asia and are characteristic of Sukhothai wares. The Sukhothai range of shapes is more limited than that of the Sawankhalok kilns, which are considered to have begun production earlier and produced greater quantities of ceramics.

Dish with single fish 1300s
stoneware with underglaze black decoration,
8 x 25 cm
Gift of Anthony Maher 1998
8.1998

Dish with single fish 1300s
stoneware with underglaze black decoration,
8.1 x 27.2 cm
Gift of Dr John Yu and Dr George Soutter 2002
170.2002

Dish with design of fish and waterweed 1300s
stoneware with underglaze black decoration,
8 x 28.5 cm
Gift of Dr John Yu and Dr George Soutter 2002
171.2002

Dish with design of fish 1300s
stoneware with underglaze black decoration,
8 x 26.7 cm (irregular)
Gift of Dr John Yu and Dr George Soutter 2002
172.2002

NORTHERN WARES

The various states in northern Thailand were consolidated into the Lanna Kingdom, with its capital at Chiang Mai, at the end of the 1200s. The ceramics produced at the different kilns are stylistically diverse.

Sankampaeng ware vase 1200–1300s
stoneware, 28 cm
Gift of Mr F Storch 1986
86.1986

Kalong ware dish 1400s
stoneware decorated in underglaze iron black on creamy white slip, 20.5 cm
Purchased 1989
87.1989

The largest concentration of northern kilns has been found at the village of Kalong.

Lanna kingdom, Phayao
Three jars 1200–1500
left: celadon, 42 x 33.5 cm
centre: celadon with three bands of decoration to shoulder, 49 x 40 cm
right: celadon with brown glazed neck and four horizontal bands of decoration, 42.5 x 36 cm
Goldie Sternberg Southeast Asian Art Purchase Fund 1999
103.1999, 104.1999, 105.1999

These large celadon jars from the Phayao kilns to the east of Kalong are similar to ones found in temple grounds with metal and terracotta votive plaques within them.

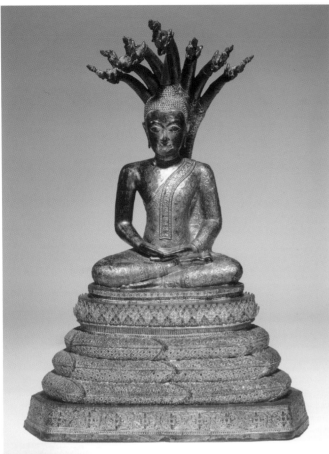

Rama III period (1824–51)
Two-tiered receptacle *phan waen fah*
black lacquer with mother-of-pearl inlay, 38 cm
(height overall), 33 cm (max diameter)
Purchased 1993
523.1993

Bangkok period (from 1782)
Buddha enthroned under the seven-headed naga 1800s
gilt bronze, 64.5 x 74.5 cm
Purchased 1948
8337

In the Bangkok period, the patronage and glorification of Buddhism continued as the principal theme of the arts. This seated gilt Buddha sheltering under the seven-headed *naga* is typical of the showy glitter cherished at this time. Its iconography relates to the life story of the Historical Buddha, Shakyamuni: in the fifth week of the seven weeks he meditated after attaining Enlightenment, when he was seated at the edge of Lake Muchalinda, a terrible storm arose, causing the waters of the lake to rise. Seeing that Buddha was lost in meditation, the serpent (*naga*) king Muchalinda slipped his coils under Buddha's body, lifting him above the flood. At the same time, he spread the hoods of his seven heads to shelter him. This image is found throughout Southeast Asia.

Understandably the requirements of Buddhism have influenced many forms of Thai art apart from sculpture and painting. This receptacle was used by monks in Buddhist ceremonies to offer a robe (placed on the upper tray) before an image of the Buddha. A uniquely Thai form, the piece is decorated with seated *thepanom* (minor Buddhist deities) and floral-inspired ornamental motifs that echo the Buddhist decorative style. Thailand is renowned for its distinctive *hoi fai*, or flaming mother-of-pearl, made from the shell of the turbo snail that is native to the Gulf of Thailand. Great skill is required in preparing mother-of-pearl inlays to obtain the full palette of colours that glitter mesmerisingly in the soft lamp or candle light of temple interiors.

Montien Boonma (1953–2000)
Untitled: two acts II 1996
brass, 33 x 90 cm
Purchased 2002 © Montien Boonma Estate
216.2002 a-m

Boonma was a devout Buddhist whose life was struck with tragedy when first his wife died of cancer and then he himself contracted the disease. Made when he was dealing with the reality of pain, this work is a piercing and disturbing expression of the void that is encountered when we confront our mortality through the veil of pain. The bowl is shaped like the traditional alms bowl used by monks to beg for food – here Montien begs for relief from the pain and unknown future of oncoming death. The inside of the bowl is blackened, its surface covered with a pattern of teeth. Gripping the rim, like ciphers of pain, are moulds of Boonma's clenched fists. The bowl is meant to be filled with whiskey, or some other intoxicant-cum-painkiller which can then be drunk with the scoop provided. The scoop, modelled in the form of the artist's mouth and teeth, reiterates the desperate need for physical and spiritual relief.

INDONESIA

Modern Indonesia is a vast archipelago comprising over 3000 islands. Over the centuries these islands have witnessed many waves of cultural influence, which have interacted with strong indigenous traditions. The most notable influences were Hinduism, Buddhism and Islam. The gallery's collection to date is too small to represent this cultural richness, yet it can allude to the magnificent heritage of indigenous sculpture, Hindu-Buddhist icons, gold jewellery, metalwork and textiles.

The islands have been part of an extensive Asiatic trade network that existed from the first millennium BCE, bringing to Indonesia objects as varied as Dong Son drums (such as the one on page 298), religious icons and export ceramics from China, Thailand and Vietnam. Many of these works have impacted on local styles, while other indigenous traditions have continued unaffected. Intra-regional trade was extensive, with gold ornaments, textiles and sea products being bartered throughout. Cloves and nutmeg from the Moluccas found their way to China in the Han dynasty, and to the Roman empire via Arab traders. The lucrative spice trade brought the Portuguese to the Moluccas, the 'Spice Islands', in the 1500s followed by the Dutch who, through trading textiles from India for spices, succeeded by the 1600s in controlling all the spice trade. No doubt this constant use of boats, plus myths about the arrival of the Indonesia's first inhabitants, accounts for the predominance of the ship motif across media as diverse as architecture and textiles.

The earliest signs of Buddhist and Hindu influence in Indonesia are sculptures from about the 4th century CE. Early stone Hindu statues, and nearly all Hindu temples in Java, were Shaivite. The popularity of Shiva would explain the numerous images of Ganesha, son of his consort Parvati, such as a Javanese example in the collection (page 11).

The important dynasty of Srivijaya entered recorded history in the 600s when the capital, in the area of present-day Palembang in south Sumatra, was described by the itinerant Chinese pilgrim Yijing (635–713) as a cosmopolitan centre of learning. Srivijaya embraced Peninsula Thailand within its kingdom, reinforcing the networks of contact between different parts of Southeast Asia. Numerous states and courts (*kraton*) proliferated in subsequent dynasties, particularly in the island of Java, which remained the centre of Hindu-Buddhist culture for centuries. During the Central Java period (700s to c930) the country witnessed an extraordinary building boom with hundreds of temple complexes, both Buddhist and Hindu, being constructed from andesite, a volcanic stone found in abundance all over the region. Many of the complexes have now disappeared, survived only by the sculptures they once contained. The most splendid

of those which remain are the Buddhist complex of Borobudur and the Shaiva temple at Prambanan. A sudden halt to the building occurred around 930, when the rulers moved their *kraton* to East Java. The exact reason for this move has never been ascertained, although an active volcano may have been the motivation.

During the East Java period (929–1293) and the succeeding Majapahit period (1293–1527), Buddhism and Hinduism continued to be influential among the elite but by the 1400s Islam had begun to take hold in Java. Carried by protagonists from the state of Gujarat in northwest India (a district with which Indonesia had long had trade links) Islam had gradually spread to other parts of Indonesia from the 1100s. By the 1500s it had widely replaced Hinduism and Buddhism, and the only territory to have retained its Hindu-Buddhist character to the present day is the island of Bali. From the 1500s the arrival of the Europeans – first the Portuguese then the Dutch – and their control of ports and trade, ushered in a new era.

One of Indonesia's most significant visual and cultural forms are its textiles, particularly the richly designed, high-quality cloths used by the court aristocracy and in ceremonial and ritual contexts. In Indonesia, as in other parts of Southeast Asia, textiles played a significant role in social and political relations and reveal much about the cultural and economic exchanges that were taking place in the region in the period prior to modernisation. The most significant trade in textiles occurred between India and Indonesia where, as early as the first centuries of the Common Era, cloths where being traded by communities of Indian merchants resident in the various commercial centres of Southeast Asia. By the 1400s cloths from India were being made especially for the Indonesian market. Of particular significance were the highly sought-after silk double-ikat cloths known as *patola*, which originated from Gujarat. The influence of *patola* designs is evident on a wide range of textiles from Sumatra right across the Indonesian archipelago to Flores and other outer islands.

The variety of textile forms and production methods suggest the complexity of exchanges and influences that shaped the visual culture of Indonesia. Arguably more than any other artform in Southeast Asia, textiles express the desires and aspirations of the society, indicating a person or community's status, wealth and milieu. Often providing a link between the human and divine realms, they also embody the spiritual aspirations of a society.

Borneo, Dayak people
Hampatong 1900s
carved wood, 297 x 35 cm
Gift of Nomadic Rug Traders 2003
197.2003

The use of carved wooden ancestor and protective figures was widespread across the islands of Indonesia. Protective figures, called *hampatong,* were placed at entrances to their villages and communal longhouses. Each *hampatong* was carved for a specific purpose and personified a particular spirit or deity. They were made and displayed to celebrate occasions such as a successful headhunting expedition or the funeral of an important person.

This figure of a woman standing on a pedestal is decorated in relief with an *aso* (a kind of underworld dragon-dog representing the very powerful female spirits), stylised leaves and lotus flowers. In this case, her regalia comprises an elaborate headdress extending down her back and prestige necklace, bracelets and earrings. A small animal clings to the side of the pedestal at her feet and a serpent-like creature is grasped at the waist. The other hand clasps what is possibly a *kris,* or sword. Many *hampatong* have aggressively exaggerated features such as bulging eyes, gaping mouths and long protruding tongues, but this one is more naturally rendered and exudes a calm and reflective quality.

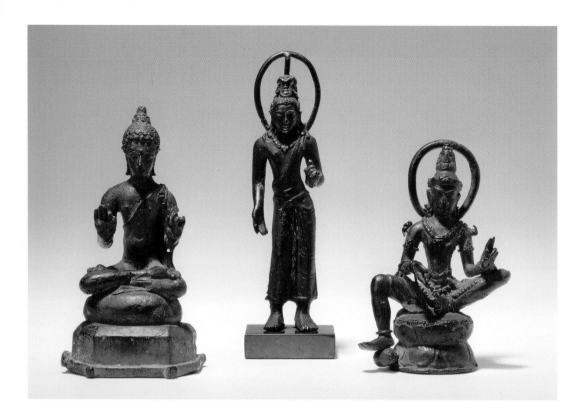

Central Java
Buddhist figures 800s
left: seated Buddha, copper alloy, 12.5 cm
centre: Avalokiteshvara or Manjushri, copper alloy
with traces of gilding, 13.8 cm
right: bodhisattva, copper alloy, 11 cm
D G Wilson Bequest Fund 2000
1.2000, 2.2000, 3.2000

The enormous variety of images produced in veneration of Buddha can be gauged by contrasting the dominating monumentality of the stone Amitabha (opposite) with this selection of small, elegantly modelled bronzes, all from Central Java and of approximately the same period. Such bronzes, made in large quantities by the lost wax (or *cire perdue*) technique, were objects to be revered and were made for wall niches in temples and monasteries, as well as for worship at home.

Although Indian styles fuelled the development of Javanese Buddhist art, by the time of these bronzes a distinctively Javanese aesthetic had already developed. Often small individual pieces such as these belonged to a group, of which the most famous is the late 10th-century Nganjuk Mandala, whose most important figurines were found near Nganjuk (East Java) in 1913. A piece once thought to be Nganjuk is the graceful bodhisattva seated in the relaxed seated posture of *lalitasana,* where one leg is raised (right). The Buddha (left) is the Historical Buddha, Shakyamuni, seen as a renunciate monk, seated in the classic meditation posture with both hands in the teaching gesture. The small, lithe young bronze figure of an ascetic (centre), who could represent either of the bodhisattvas Avalokiteshvara or Manjushri, is dressed simply, the sacred thread (*upavita*) across his chest, his hair piled high in the style known as *jatamukuta.* His right hand is stretched down in the gesture of charity while the left holds a manuscript which would suggest the identification with Manjushri, the bodhisattva of wisdom. A halo sanctifies this ascetic figure.

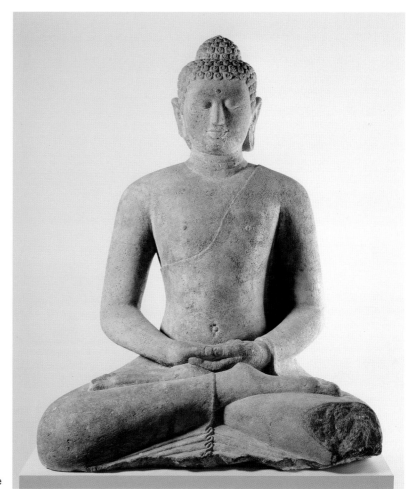

Central Java
Amitabha Buddha 800s
andesite, 105 x 88 x 65 cm
Purchased with funds provided by the Art Gallery
Society 2000
144.2000

This monumental stone image of the seated Buddha Amitabha, the Buddha of the West, sits with his hands held in the meditation gesture (in Sanskrit known as *dhyana mudra*), his feet in the *vajrasana* position of both soles upwards, and wearing the thin diaphanous robe of a monk. Deeply immersed in meditation, the Buddha emanates the serenity, wisdom and spirituality expected of the central icon of Buddhism. It is likely that originally this Buddha was part of a specific grouping. For example, Amitabha, together with Shakyamuni, the Historical Buddha, and Maitreya, the Buddha of the Future, constitutes the powerful triumvirate of Past, Present and Future Buddhas. As well, Amitabha as the Buddha of the West, appears in mandalas on the western quarter.

The concept of the mandala, a diagrammatic representation of the invisible forces that govern the cosmos, was brought to Indonesia with Vajrayana Buddhism. Vajrayana mandalas commonly have five Buddhas: the Buddhas of the Four Directions, presided over by Vairochana, the Buddha of the Centre. The largest three-dimensional mandala, and a site of world cultural significance, is at Borobudur, an astounding 9th-century monument that contains nearly 500 Buddhist statues. Stylistically this Buddha is close to those at Borobudur, and presumably belonged to such a set that once constituted a temple mandala, with Amitabha Buddhas presiding over the west.

SOUTH INDIA, Coromandel Coast
(produced for the Indonesian market)
**Sacred heirloom textile *ma'a* painted
with a scene from the Ramayana** 1700s
handspun cotton with natural dyes and mordant,
93 x 462 cm
Gift of John Yu 1998
122.1998

Large painted cotton *ma'as*, or ceremonial
cloth hangings, were made in south India
especially for the Indonesian market. This
ceremonial cloth depicts a scene from the
Hindu epic the *Ramayana* and shows
Rama, the protagonist of the story,
battling the multi-headed and multi-armed
titan Ravana. These cloths are unique to
Indonesia and were especially popular in
Sulawesi and Bali, where they were used
as backdrops for performances.

INDIA, Gujarat
(produced for the Indonesian market)
(detail) Ceremonial cloth with elephant and tiger design late 1800s
silk and natural dyes, double-ikat technique, 370 x 99 cm
Purchased with funds from the Asian Collection Benefactors' Fund 2003
111.2003

Patola are a type of bound and resist-dyed cloth. An exacting level of technical skill is required to achieve the extraordinary density and complexity of design for which they are so highly prized. In India, *patola* saris had special significance and were used by certain communities for weddings and important life ceremonies. In Indonesia they were symbols of rank and prestige, and were valued gifts in social and political exchanges. But they were also regarded as ritual and magical cloths, their significance indicated not only by the manner in which they were preserved as heirlooms but by their influence on local textile design and production.

The repeated elephant and tiger motif on this *patolu* is one of the major design types exported to Indonesia, predominantly Bali and Java. This design was highly prized, particularly in the courts of Central Java, where its use was restricted to princely houses. Other popular design motifs included variations on floral and geometric patterns, which became incorporated into the design language of the local textile traditions.

Bali, Tenganang
(detail) Geringsing 1850
handspun cotton with natural dyes, double-ikat
technique with embroidery, 212 x 48 cm
Purchased with funds from the Asian Collection
Benefactors' Fund 2003
Provenance: Raja of Amlapura
113.2003

The *geringsing* demonstrates the
translation of the double-ikat technique of
the *patolu* into a local idiom, often to
dramatic effect. Traditionally, *geringsings*
were worn as breast wrappers or shoulder
cloths during religious ceremonies. Their
sacred value is suggested by the rituals
and rites associated with each step of
their manufacture to ensure their purity.
The embroidered decoration on the two
ends, the threads of which were once
couched in gold, also reflect the
importance and value ascribed to them as
ritual cloths.

Geringsings were exclusively
manufactured in the village of Tenganan in
east Bali but were an important textile
among the various Balinese communities.
This impressive example was made for
the rajas of the Karangasem court, who
presided over the Amlapura district of
eastern Bali. Its distinctive design is
known as the *wayang kebo,* which draws
its inspiration from the wayang puppets
and temple reliefs of 14th-century
Hinduised Java. In this highly stylised
design the length of the cloth is divided
into four sections by three elongated four-
pointed stars, or mandalas. In the spaces
between are groups of three people –
possibly a male priest wearing a large
headwrap or turban and two smaller
female figures, one of whom raises her
hand in a gesture of reverence.
Interestingly the figures wear textiles with
a star pattern suggestive of the *patola.*

SHIP CLOTHS

Another significant centre of textile production in Indonesia was a region at the southern tip of Sumatra called Lampung. Lampung textiles represent a unique and important tradition, and one that developed largely distinct from outside influences. The most significant of the Lampung textiles are the so-called 'ship cloths', textiles of various dimensions which often feature a ship motif. Ship cloths were used as food wrappers, seat cloths, in gift exchanges or as ceremonial hangings during rituals associated with life transitions such as birth, circumcision, naming, initiation, marriage and death. The ship motif, apparently a symbol of transportation or transition, was a fitting design for such occasions. The most common of these ship cloths are the *tampan,* small, roughly one-metre square cloths woven in an undyed cotton and decorated with a supplementary weft weave design. Larger ship cloths are known as *tatibin* while the largest, often more than three metres long, are called *palepai.* The use of *tatibin* and *palepai* was restricted to the aristocracy and they are thus less common.

South Sumatra, Lampung region
Blue *tampan* with design of two mirror reversed ships late 1800s
cotton and natural dyes, supplementary weft, 77 x 71 cm
D G Wilson Bequest Fund 2003
114.2003

This fine *tampan* is decorated with a motif of two blue ships mirrored against each other. Riding on each ship is a mythical creature, perhaps derived from a horse or elephant, bearing a stylised human figure. The intricately woven design is cleverly framed with a complex border and three bands of red.

South Sumatra, Lampung region
Red *tampan* with design of mythical birds late 1800s
cotton and natural dyes, supplementary weft, 66 x 64 cm
D G Wilson Bequest Fund 2003
115.2003

Although ship motifs predominated, other popular *tampan* designs included mythical birds and creatures, horse and rider motifs and abstract interlocking and repeated patterns. This bold design of two mirrored mythical bird-snake creatures is associated with creation myths and with concepts of death and resurrection or new birth.

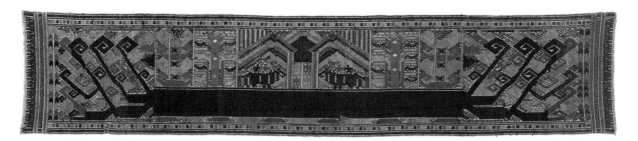

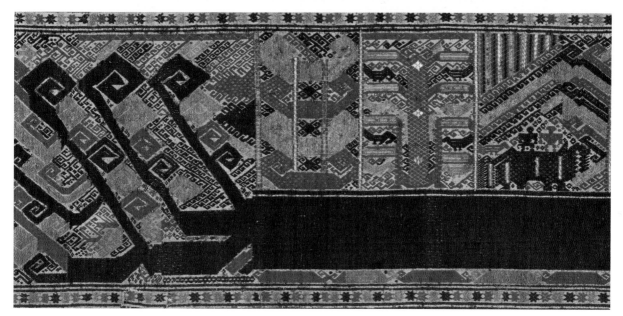

South Sumatra, Lampung region
**Ceremonial hanging *palepai* with
design of large blue ship** late 1800s
cotton and natural dyes, supplementary weft,
263 x 25 cm
Purchased 2003.
Provenance: von Koenigswald, Berlin
116.2003

This example of a classic *palepai* (literally
'ship') shows a single large blue ship
carrying a fleet of smaller boats, as well as
human figures riding stylised elephants
and abstracted bird and tree-like motifs.
While we can only speculate as to the
underlying meaning of this imagery,
scholars have suggested that the blue
ship is associated with the earthly realm
while the motif of the red ship, as appears
on other *palepais,* suggests a sacred
realm. *Palepais* had a purely ritual purpose
and were primarily used as hangings to
demark a ritual space.

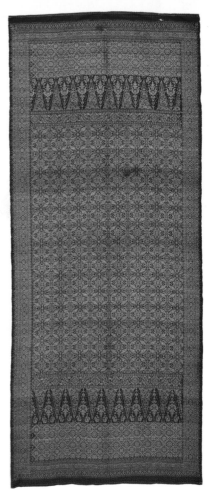

East Sumba
Ear pendant *mamuli* c1900
gold, 9 cm
Edward and Goldie Sternberg Southeast Asian
Art Purchase Fund 1992
265.1992

Ear pendants (*mamuli*) were part of the
store of sacred heirlooms, along with old
textiles and porcelains, handed down
through the noble families of the island of
Sumba, at the eastern end of the
Indonesian island chain. *Mamuli* served as
amulets, bridewealth goods and ritual
objects that mediated between the human
world and the world of the ancestral
spirits (*marapu*). They were brought out
only rarely, on special occasions such as
a funeral, for fear that their great powers
would bring havoc and disaster upon
those who saw them. At these times they
would be removed from their store by the
rato, or priest, and placed on a sort of
altar. It is only relatively recently, as
modernisation and social change engulfs
Sumba, that such important objects have
even entered the public arena. This
mamuli is a finely wrought example with
an intriguing design each side of a rider,
most likely a warrior, and horse
accompanied by a servant holding an
umbrella.

South Sumatra, Palembang region
Textile *kain songket* c1900
silk, gold thread and natural dyes, supplementary
weft weave, 85.5 x 200 cm
Gift of Dr John Yu 1998
119.1998

One of the most prestigious of locally
produced cloths is the colourful silk weft
ikat textiles of Palembang in Sumatra.
This elaborate 'red and gold' example is
woven with an intricate pattern in a
supplementary weft weave (*songket*)
which replicates the motifs of the coveted
patola, and uses, as in this piece, gold
metal-wrapped threads. These textiles
were folded lengthwise and worn over the
shoulder or wrapped around the waist.
They were usually worn on important
ceremonial occasions. The richer and
more sumptuous the display of gold on
any particular textile, the greater the
wealth and prestige of the wearer's family.
Palembang, on the eastern coast of
Sumatra, was the capital of the ancient
kingdom of Srivijaya. As a wealthy trading
power in Southeast Asia, it attracted
Indian and Chinese traders, who
introduced silk and the technique of silk
weaving. A social class wealthy enough to
enjoy such luxurious textiles ensured their
production.

CHRONOLOGIES

The chronologies presented here are selective, with some dates approximate.

INDIA

Indus Valley civilisation c2500 – 1700 BCE
Kushan dynasty 50 CE – c600 CE
Gupta dynasty 320 – 540
Pallava dynasty c574 – 600
Pala and Sena dynasties c730 –1250
Chola dynasty c850 –1150
Chandella dynasty c900 –1100
Hoysala dynasty c1100 – 1310
Sultanate kingdoms 1206 – 1555
Vijayanagara dynasty c1336 –1565
Deccani kingdoms 1489 –1687
Rajput kingdoms 1500s – 1600s
Mughal empire 1526 –1748
British Raj 1858 –1947
Independence 1947

HIMALAYAS

Tibet
　Middle Ages c970 – 1570
　Mongolian control c1580 – 1720
　Chinese rule 1720 – 1795
　Independent rule 1795 – 1950
　Chinese rule 1950 to present

CHINA

Neolithic c5000 – c1700 BCE
Shang dynasty c1700 – 1027 BCE
Zhou dynasty 1027 – 221 BCE
Qin dynasty 21 – 206 BCE
Han dynasty 206 BCE – 220 CE
Northern and Southern dynasties 220 CE – 581
　Northern Wei dynasty 386 – 534
　Eastern Wei dynasty 534 – 550
Sui dynasty 581 – 618
Tang dynasty 618 – 906
Five dynasties 906 – 960
Liao dynasty 907 – 1125

Song dynasty 960 – 1279
　Northern Song 960 – 1125
　Southern Song 1127 – 1279
Jin dynasty 1115 – 1234
Yuan dynasty 1279 – 1368
Ming dynasty 1368 – 1644
　Hongwu 1368 – 1398
　Yongle 1403 – 1424
　Xuande 1426 – 1435
　Chenghua 1465 – 1487
　Hongzhi 1488 – 1505
　Zhengde 1506 – 1521
　Jiajing 1522 – 1566
　Longqing 1567 – 1572
　Wanli 1573 – 1619
　Tianqi 1628 – 1643
Qing dynasty 1644 – 1912
　Shunzhi 1644 – 1661
　Kangxi 1662 – 1722
　Yongzheng 1723 – 1735
　Qianlong 1736 – 1795
　Jiaqing 1796 – 1820
　Daoguang 1821 – 1850
　Xianfeng 1851 – 1861
　Tongzhi 1862 – 1873
　Guangxu 1874 – 1907
　Xuantong 1908 – 1912
Republic 1912 – 1949
People's Republic 1949 to present

KOREA

Three kingdoms
　Kokuryo dynasty 37 BCE – 68 CE
　Paekche dynasty 18 BCE – 663 CE
　Old Silla dynasty 57 BCE – 668 CE
United Silla kingdom 668 CE – 936
Koryo period 918 – 1392
Chosun dynasty 1392 – 1910
Japanese rule 1910 – 1945
Republic of Korea in the south;
Democratic Republic of Korea in the north
1948 to present

JAPAN

Jomon to c200 BCE
Yayoi period c200 BCE – c250 CE
Kofun (Tumulus) period c250 CE – 552
Asuka period 552 – 646
Nara period 646 – 794
Heian period 794 – 1185
Kamakura period 1185 – 1332
Nambokucho period 1333 – 1392
Muromachi period 1392 – 1568
Momoyama period 1568 – 1615
Edo (Tokugawa) period 1615 – 1868
Meiji period 1868 – 1912
Taisho period 1912 – 1926
Showa period 1926 – 1988
Heisei period 1989 to present

VIETNAM

Hong Bang dynasty 2879 – 258 BCE
Thuc dynasty 257 – 208 BCE
Trieu dynasty 207 – 111 BCE
Chinese rule 111 BCE – 939 CE
Ly dynasty 1009 – 1225
Tran dynasty 1225 – 1400
Le dynasty c1420 – 1787
Nguyen 1802 – 1945
French colonial rule 1860 – 1945

LAOS

Lan Xang kingdom 1353 – 1707
Independence 1953
Lao People's Democratic Republic 1975

CAMBODIA

Neolithic period c4000 – 100 BCE
Funan period c100 CE – 400
Chenla c400 – 550
Pre–Angkorian period c500 – 799
Angkorian period 802 – 1431

Post–Angkorian period 1431 – 1804
French colonial rule 1804 – c1950
Independence 1953
Democratic Kampuchea 1975 – 1979
People's Republic of Kampuchea 1979 – 1989
State of Cambodia 1989 to present

THAILAND

Prehistoric to 100 CE
Indianised (Hindu) period 100 – 500
Dvaravati (Mon) period 500 – 1000
Srivijaya period 700 – 1200
Lopburi period 900 – 1300
Sukhothai period 1200 – 1400
Lanna period 1200 – 1500
Ayuthaya period 1350 – 1767
Thon Buri period 1767 – 1782
Bangkok period 1782 to present

INDONESIA

Srivijaya late 600s – early 1200s
Central Java:
　Sailendra period c750 – 929
East Java:
　Kadiri 1049 – 1222
　Singhasari 1222 – 1292
　Majapahit 1293 – 1527
Islamic kingdoms 1300s – c1700
European involvement 1500s – 1942
Independence 1949

NORTH KOREA

o Seoul

SOUTH
KOREA

Kutani ▲

Bizen ▲ ● Kyoto

● Arita Shigaraki ▲ o Tokyo

Nagasaki ●

KYUSHU

JAPAN

PAPUA
NEW GUINEA

o Port Moresby

● Darwin

AUSTRALIA

...then gold powder is sprinkled while the lacquer is still moist

Mandala literally 'circle', a sacred diagram for meditation

Manjushri an important bodhisattva, the embodiment of wisdom

Mara the Lord of Death

Menuki a metal piece on each side of the hilt of a Japanese sword to enhance the grip

Mingqi a term for objects, mainly ceramic, made specifically to be placed in a Chinese tomb

Mudra a 'seal' or gesture made with one or both hands

Naga mythical serpents

Nihonga Japanese-style painting, as opposed to yoga, or 'Western-style painting'. The term emerged in modern times to describe all painting styles practised before the introduction of oil painting

Nirvana a state of eternal happiness that can be attained by humans in becoming Buddhas

Oxidisation a term used for the firing of a kiln when abundant air is allowed to enter the kiln during firing

Pali Indian language in which the canonical texts of the Theravada are composed

Patolu (plural patola) double ikat silk textile from the state of Gujarat in India composed

Prabhutaratna Sanskrit name for the Buddha of the Past

Qingbai literally 'bluish white', a Chinese term referring to the bluish-tinged glaze colour of southern porcelains

Rajput literally 'son of a king', one of the Hindu rulers of North India's princely states

Ramayana one of India's two great epics (the other being the Mahabharata); it relates the life of Rama, who is exiled to the forest and must rescue his wife when she is abducted by the demon Ravana

Reduction firing a term for ceramics for the firing when the amount of oxygen entering the kiln is restricted during firing, resulting for example in blue and green toned glazes

Samantabhadra the bodhisattva who protects those who propagate the Law

Samsara the cycle of birth, death and re-birth

Sancai literally 'three colours', a type of glaze decoration for Chinese ceramics

Shakti the female energy, the energising counterpart of male deities

Shakyamuni the Historical Buddha

Ship cloths textiles of various dimensions which feature a ship motif and were produced in the Lampung region of the island of Sumatra

Shiva one of most popular gods in the Hindu pantheon, Shiva is associated with asceticism and the destruction of evil

Sino-Tibetan a term for a distinct class of wares, mainly metal, made by Chinese artisans in Tibetan taste for Vajrayana temples

Stele an upright slab bearing sculptured designs or inscriptions

Stupa an architectural monument symbolic of the Buddha

Suibokuga pure-ink painting

Suki a Japanese term for cultivated, creative taste manifested in a personal style

Sutra literally 'thread', discourses of the Buddha

Swatow a large family of coarse provincial porcelains produced for export during the 1500s and 1600s. The term comes from the Dutch name for the port of Shantou in southern China

Tampan small square 'ship cloths' of Indonesia

Tantra (Tantrism) esoteric and ritualistic doctrine of Buddhism

Taotie a fearsome animal-mask motif that appears on many Shang and Zhou dynasty Chinese vessels

Tara the female complement to Avalokiteshvara, the embodiment of wisdom

Tenmoku Japanese term for Chinese Jian ware

Thangka a portable icon usually painted on cotton, framed with brocade, which can be rolled up

Theravada literally 'teachings of the elders of the order', a school of Buddhism that emphasises the liberation of the individual. Also known as Hinayana, the Lesser Vehicle

Tribhanga the pose of three bends with the knee bent and the hip projected

Tsuba a Japanese sword guard

Urna a spiral or tuft of hair between the eyebrows, one of the 32 marks or lakshana of the Buddha

Ushnisha a protuberance at the top of the skull, one of the 32 'marks' of the Buddha

Vahana a deity's animal mount or vehicle

Vajra the adamantine or diamond thunderbolt; a sceptre used in tantric practice

Vajrasana a sitting posture with legs crossed and the soles of both feet showing

Vajrayana literally 'Diamond Vehicle', a school of Buddhism that developed out of the teachings of Mahayana

Varada mudra the gesture of charity, with the hand held out, palm upwards and the fingers pointing down

Vishnu one of the most powerful gods in the Hindu pantheon, Vishnu is known as the Preserver for his ability to restore the cosmic balance of the universe

Vitarka mudra the teaching gesture, with the palm facing out and the index finger and thumb forming a circle

Wabi literally 'poverty and simplicity', an aesthetic quality

Wakizashi the shorter of the two swords carried by a samurai

Wucai literally 'five colours' in reference to Chinese ceramics decorated in underglaze blue and overglaze enamels

Yoga Japanese 'Western-style painting' as opposed to nihonga. By convention, 'yoga artists' include watercolour painters and print artists

Zashiki the formal Japanese-style room used for the reception and entertainment of guests

Zen see Chan